Locker Room Talk

Tiffany,

My fellow Rower and
dear Friend, with love
and affection —
Onward,
Melissa Ludtke

Locker Room Talk

A Woman's Struggle to Get Inside

MELISSA LUDTKE

Rutgers University Press

New Brunswick, Camden, and Newark, New Jersey

London and Oxford

Rutgers University Press is a department of Rutgers, The State University of New Jersey, one of the leading public research universities in the nation. By publishing worldwide, it furthers the University's mission of dedication to excellence in teaching, scholarship, research, and clinical care.

Library of Congress Cataloging-in-Publication Data

Names: Ludtke, Melissa, author.
Title: Locker room talk : a woman's struggle to get inside / Melissa Ludtke.
Description: New Brunswick : Rutgers University Press, 2024. | Includes bibliographical references and index.
Identifiers: LCCN 2023045149 | ISBN 9781978837782 (cloth) | ISBN 9781978837799 (epub) | ISBN 9781978837805 (pdf)
Subjects: LCSH: Ludtke, Melissa. | Women sportswriters—United States—Biography. | Sexism in sports journalism—United States. | Sports journalism—United States. | BISAC: SPORTS & RECREATION / Cultural & Social Aspects | PERFORMING ARTS / Television / History & Criticism | LCGFT: Autobiographies.
Classification: LCC GV742.42.L85 A3 2024 | DDC 070.92 [B]—dc23/eng/20240227
LC record available at https://lccn.loc.gov/2023045149

A British Cataloging-in-Publication record for this book is available from the British Library.

♾ The paper used in this publication meets the requirements of the American National Standard for Information Sciences—Permanence of Paper for Printed Library Materials, ANSI Z39.48-1992.

rutgersuniversitypress.org

*To my mom, Jean, who passed down her love of baseball to me, and
my daughter, Maya, with whom I enjoy the game today,
and to the memory of unforgettable sportswriter friends,
Robin Herman, Jane Gross, and Alison Gordon, who were
pioneers with me.*

Contents

Prologue

I reported on Major League Baseball in the 1970s for *Sports Illustrated*, then the world's premier sports magazine. I was the only woman in the nation doing this job full time, though a few other female writers dipped in and out. Working my dream job, I spent all the time I could around a game that I'd loved since my mom introduced me to it when I was a child. I could *never* have imagined in 1974, when I accepted my position at *Sports Illustrated*, that a few years later I'd be the plaintiff in the federal legal case *Ludtke v. Kuhn* that opened locker room doors for women journalists.

Locker Room Talk tells the story of how my reporting catapulted me into *Ludtke v. Kuhn* and what it felt like to be broadsided by sexist backlash from men who feared I was leading a women's invasion into their well-fortified game.

It turns out I was.

In 2023, women manage and coach Major League Baseball teams, train and counsel ballplayers, and scout opposing teams. Front-office, high-level female team officials trade players and run the business side of baseball operations. Young women hit and pitch on baseball teams at every level—from Major League affiliates to collegiate and high school teams. And one woman, Jen Pawol, is inching closer to becoming Major League Baseball's first female umpire.

Today, women broadcast baseball games on TV and radio doing play-by-play and color commentary. Notably ESPN, but other networks, have also hired women as sports producers and directors. Women do podcasts and edit

newsletters spotlighting women in sports, and in newsrooms, both digital and print, they hold high-level jobs on the sports desk. There are many more women sportswriters and columnists than in my day. Much has changed from when my story begins, but nearly a half century later, women in sports media remain a distinct minority.

* * *

When I walked into Judge Constance Baker Motley's Southern District courtroom in Manhattan on April 14, 1978, I knew she couldn't open locker room doors for me. No federal judge had the power to do that since none could tell a private business, like baseball, *how* to run its internal operations. Only if my lawyer, Frederick August Otto "Fritz" Schwarz Jr., could persuade the judge to rule based my Constitutional equal rights protections would Commissioner Bowie Kuhn be forced to treat women and men reporters the same. So, if he decided to keep having male writers interview the players in their locker rooms, then I'd be there, too. Or if Kuhn decided to bar all sports writers, then the locker room doors would be shut to women and men alike. That choice would be his, but as press coverage about my case increased, I knew that a court victory for gender equality would be seen as a victory for women well beyond sports. We took baseball to the court only after our negotiations with Kuhn showed us that he refused to budge after he'd barred me from the locker rooms at the 1977 World Series. At the end of December, Time Inc., *Sports Illustrated*'s corporate owner, filed a gender discrimination complaint with the Southern District Court which launched my legal case.

Before Judge Motley would hear my case, the sports media described it in ways that highlighted the barriers that women in the workplace then faced. Because sex sells in ways that a story about women's rights does not, sportswriters threaded their stories with sexual inuendo and sexist puns aimed at their male readership. Radio talk shows and TV commentators added fuel to the fire by ridiculing me and my cause. Cartoonists depicted me as an overly buxom woman peering up at hulking, hairy-legged men. Sports columnists hinted at my deficiencies, suggesting I lacked a moral compass, rather than accepting that the commissioner's policies merited scrutiny. What "lady," these men asked, would think of invading the ballplayers' privacy? Had I replied, which usually I didn't, I'd have asked, "What privacy?" After all, dozens of male writers were in those locker rooms with ballplayers, as I needed to be to do my job. Pop culture bellwethers like *Saturday Night Live* (SNL) and the *Tonight Show* parodied my plea for equal treatment. SNL's

comedienne Laraine Newman, as the "girl" reporter, stood toe-to-toe with a bare-chested O. J. Simpson, who'd draped his towel around his neck. From the West Coast, Betty White wrapped a towel around *her* body to join her soaped-up host Johnny Carson in the shower. With Americans watching such comic portrayals and reading the caustic commentary, it's no wonder that our side had already lost in the court of public opinion before my case was heard by the judge.

* * *

But then something remarkable occurred: we won in the only court that mattered—the one presided over by Judge Motley. On September 25, 1978, she ordered Kuhn to grant me the same access that he gave male sportswriters. Equality, she observed, would not be achieved by putting me in a separate place and bringing players to me, as Kuhn wanted to do. The principle that Motley had invoked—that separate was not equal—was familiar to a judge who relied on the Fourteenth Amendment in her many years as a lawyer fighting racial discrimination in the Jim Crow South.

Locker Room Talk takes readers inside of my story as we travel from Judge Motley's courtroom to ballparks where I was the only woman at nearly every game I covered. I also take us back to my childhood when I came to love baseball. As a girl growing up in the 1950s and '60s, I played and watched every sport I could though baseball was always my favorite. I did this so much that I talked about sports like boys did.

Raised in the rural university town of Amherst, Massachusetts, I was a tomboy at a time when few girls in America competed in sports. However, in my town, we had competitive teams, so I played on nearly every team I could—volleyball, basketball, tennis—excelling in all of them. In my teens, I also watched civil rights protesters be attacked in the South and heard Martin Luther King Jr.'s "I Have a Dream" speech on the *CBS Evening News*. Each weeknight, as my family ate dinner, Walter Cronkite brought the news to us and my parents encouraged us to talk about what we saw. Similarly, I watched as the women's movement grew from small gatherings to loud, massive marches. By the time I graduated from Wellesley College in June 1973, the Vietnam War protests, in which I'd participated, were winding down, and women's court battles were knocking down our legal barriers so my generation could "have it all." As we know, that turned out to be more myth than reality.

Shirley Chisholm, who was the first Black woman elected to Congress, welcomed me into our revolutionary times with the marching orders she gave

in her commencement speech to our all-women class. "The myths which suggest that women are too fragile, too emotional to be advanced in our society have been exploded. Senseless stereotypes, dismissing members on the basis of sex and color to participate fully in the American system have been broken, one by one, especially during the past decade," she assured us. After sharing her efforts to advance racial and gender equality, this dynamic, petite woman peered down through her large spectacles and declared to all but our Black classmates, "If I can do it as a Black woman, you can do even more as educated white women."

I left campus that afternoon with every intention of becoming involved. However, once I was hired by *Sports Illustrated*, my waking hours were gobbled up by daytime fact-checking of writers' stories, nights reporting at ballparks, and weekend writing of my own stories I hoped *Sports Illustrated* would publish. My heart was with the women activists, but my mind and body were otherwise engaged. But, as I learned in fighting my own court case, all I did in trying to advance as a woman at *Sports Illustrated* would not be enough without the persistent activism of this energized societal movement pushing for the changes that all of us needed. When my locker room case burst into the national headlines, some commentators likened me to those "troublesome women libbers" invading male territory. Now, I take their criticism as flattery.

* * *

In recent years despite the great progress we've made, we're seeing startling reversals in women's equity. I wrote this prologue on the one-year anniversary of the U.S. Supreme Court's decision in *Dobbs v. Jackson Women's Health Organization*, which overturned settled law in *Roe v. Wade*. In the court's 1973 landmark ruling in *Roe*, the justices held that the due process clause of the Fourteenth Amendment "protects against state action the right to privacy, including a woman's qualified right to terminate her pregnancy." [1] In his dissenting opinion in *Dobbs*,[2] then-justice Stephen Breyer wrote that "those responsible for the original Constitution, including the Fourteenth Amendment, did not perceive women as equals, and did not recognize women's rights." When the Fourteenth Amendment was ratified in 1868, it provided formerly enslaved people in America with "equal protection under the laws." Not until I was in my twenties did our highest court catch up with Abigail Adams's eighteenth-century plea for the men to "remember the ladies" and raise the scrutiny that judges give gender. With *Dobbs*, the court backslid on

women's rights. To Justice Samuel Alito's majority opinion in *Dobbs*, Breyer responded that the decision "consigns women to second-class citizenship," and added that "after today young women will come of age with fewer rights than their mothers and grandmothers had."

Maya, my daughter, turned twenty-six-years old in the year of the *Dobbs* decision. She was then the age I was when Judge Motley heard my gender discrimination case. Then, the *Roe* decision was five years old and already demonstrating its profound impact on my generation's lives. With the right to make our own reproductive decisions, we had gained control of our lives as no other generation of women was able to do. Around us, meaningful breakthroughs and huge strides were happening in expanding our opportunities in the workplace, with new possibilities in our personal lives as well. My twenties offered hope, progress, and promise, especially for me, as a highly educated, white woman. Maya's twenties were punctured by the Supreme Court's denial of a woman's fundamental right to make her own decision about her reproductive care as well as by waves of limitations on states' voting rights, which determine what rights legislatures will protect.

Maya knows my locker room story. She has heard me tell it more times than she might have wished to hear it. Yet she knows little about how my case was won in a court of law, including the critical role played by the Fourteenth Amendment. I wrote this book for her and others in her generation, just as I did for those in my generation as we live in uncertain times. I hope that watching two lawyers and this judge wrestle with the legal issues of my equal rights inspires renewed appreciation for the Fourteenth Amendment's promise of equal treatment under law for all Americans.

In reading letters to the editor written soon after the Supreme Court's *Dobbs* decision, I paused in reading this sentence that a sixty-year-old woman doctor wrote about her twenty-one-year-old daughter. "The younger women don't know the battles, so how can they see the benefits?" she wrote.

I hope *Locker Room Talk* demonstrates why it was worth fighting for equal rights, then, and why this remains a vital endeavor today.

Locker Room Talk

Chapter One

In the fifth inning of the first game of the 1977 World Series, Major League Baseball commissioner Bowie Kuhn deputized his second-in-command to tell me the press pass giving me access to the teams' locker rooms was useless. My press pass said I could be there when the male reporters were, but Kuhn, his deputy told me, had barred me from going into the Yankees' and the Dodgers' locker room. It didn't matter to him that both teams had told me I could. A week or so earlier, the Yankees' PR director had given me a clubhouse pass to use for the last two games of the season, and I'd reported inside that team's locker room then. Nobody kicked me out, nor did any sportswriter write about me being there. I'd also worked inside that locker room at the American League Championship Series, and again nobody complained or tossed me out or wrote about me being where Kuhn decided I didn't belong.

With the Dodgers in New York for the World Series, I had thought I ought to give those players a heads-up before the series began since I might be working in their locker room. No one told me to do this, but I knew no woman covered that team. I did this as a courtesy since I didn't want to shock the ballplayers by walking in. At Monday's workout, I'd talked with the Dodgers' player rep, Tommy John, who listened patiently as I told him how I worked in the Yankees' locker room. He looked at my press pass with my name on it and saw that I had permission to be in the teams' clubhouses. Then he asked a few questions before telling me that he believed I had the right to be there. But my request was new for his teammates, so he wanted to talk this over with them. They'd take a team vote, he said, and he'd tell me the result before Game 1 on Tuesday night.

Yankee
Stadium

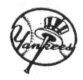

New
York

1977 American League Champions

1977 WORLD SERIES

Name _Melissa LUDTKE_

Affiliation _Sports Illustrated_

Location _9 G 16_

**WORKING PRESS, RADIO,
TV, PHOTOGRAPHER**
Good for Admission to Stadium,
Field, Clubhouse and Interview Room

This Badge must be worn where it can
be seen at all times. Not transferable.

NOT FOR USE BY ANYONE UNDER 18

N⁰ 336

My 1977 World Series pass granted access to both teams' clubhouses, which entitled me to
interview ballplayers in their locker rooms.

"It wasn't unanimous, but we go with the majority and a majority said you have the right to be there," John said when we met at the backstop after batting practice before the first game.

With the Dodgers' affirming vote, my prior experience with the Yankees, and a press pass certifying my right to work in both clubhouses, I'd done all I could to ensure that my locker room reporting worked as well as it could. So, as I heard the commissioner's deputy forbidding me to enter, I wondered what transpired after my meeting with John to have both teams' locker rooms be off limits to me.

My answer came swiftly. After Kuhn learned about the Dodgers' vote, he decided that I wouldn't be going inside. Applying his dictatorial power, Kuhn banned me from the locker rooms. Then, for good measure, he had his deputy inform me that I wouldn't be working in any team's locker room as long as he was commissioner. At fifty, and only a few years into the job, he was young and, I imagined, happy enough in his job to stick around for a while.

Kuhn's reasoning boiled down to anatomy—mine, above my bra line, and the ballplayers', below their belts. That my press credential dangled from a string around my neck and came to rest on my breasts made all the difference. Midway through Game 1, Kuhn's media director told me I was to stay out of the locker rooms. He reminded me that the ballplayers' privacy had to be protected even though not one player had requested this protection. Guided by his own moral compass, Kuhn stopped me because he could, and by doing this, he stole from me the first World Series reporting opportunity I'd had, and one that I'd worked hard for two seasons to attain. Just a few weeks earlier, when *Sports Illustrated*'s (SI's) baseball editor, Peter Carry, told me I'd be part of the magazine's team covering the biggest sporting event of the year, I'd skipped back to my office, hopping on air with "I made the team" ringing in my head.

I was elated.

In hearing Kuhn's edict, my mind flipped back to my anticipatory excitement when I'd ridden the subway from my office in midtown Manhattan to Yankee Stadium in the Bronx that Monday afternoon. Approaching the 161st Street station, I felt an adrenaline rush in envisioning myself at batting practice talking with players and managers while surrounded by the hundreds of sports media people who were in New York for the first two games of this World Series. Before the first game, I'd been with the other sportswriters at batting practice, but now Kuhn had dashed any hope I had of this series being a breakthrough moment for me as a baseball reporter. Being denied the access I needed to report, I wasn't much use to SI.

This broke my heart especially because I knew I couldn't appeal Kuhn's decision. In baseball, his authority was absolute. Few challenged a commissioner's decision. Team owners were careful not to second-guess his judgment, at least publicly, and those working in baseball knew not to tread into his territory. This is the way things had been in this game since the owners signed an agreement in 1921 saying that any commissioner had their authority to act, as he saw fit, in the "best interests of baseball." This clause had also proven to be a commissioner's most reliable protection in court.

On October 11, 1977, a Tuesday night, Kuhn believed that my exclusion from locker rooms was in the "best interests" of his game, so he acted, as only he could.

* * *

By the late 1970s, the National Football League had overtaken Major League Baseball as the country's most popular professional sport. Still, each October, the spectacle of the World Series rekindled Americans' love for their national pastime. With the Dodgers and Yankees playing in the 1977 World Series, baseball's TV ratings would soar to heights rarely seen before or matched since in this six-game series. Kuhn always touted baseball as being America's most family-friendly game. One big-money advertiser, eager to identify with the nation's touchstone values, wove the game into its popular jingle—"Baseball, hot dogs, apple pie, and Chevrolet, they go together in the good ol' USA." At this same time, members of men's clubs clung to the way things had always been by pushing back against the intrusion of women. As just one woman in baseball's sea of men, apparently my presence frightened them. They, too, were holding tightly to their diminishing hold in these times when women were fighting discriminatory treatment and emerging with decisions that forced institutions to abandon their gender-restricted zones. For decades, baseball's men had held to the hope that women would stay away from their game. When the occasional woman showed up, they'd done what they could to restrict her capacity to work, encouraging her to go away.

Since baseball's beginnings in pre–Civil War America, it was men who told its stories. They broadcast its games on radio, then on TV, transmitted its lore, and scrutinized its statistics. Even in the heat of the 1970s women's movement, baseball was still a man's world. Women rarely wrote its stories, and no woman, at least for very long, wrote daily about any team. To be a baseball writer was considered the pinnacle of a sportswriter's career. A man

paid his dues to get there by covering sports like hockey, basketball, or college sports while keeping his eyes on this prize. In the mid-1970s, when a few pioneering women were hired as sportswriters, the editors assigned them to the sports where fewer eyes would fall on their stories. No writer was about to relinquish his high-status, year-round byline on the baseball beat to a rookie, and certainly not to a woman. Nor would any editor make such a request. At SI, job assignments worked differently than at newspapers. We had reporters *and* writers assigned to baseball. On our baseball beat, I was the junior of two reporters, with the senior one being a writer-reporter. So, I was the fact-checker on our team, staying in New York while the other reporter, Jim Kaplan, traveled more often with the writers. However, my role came with benefits like an American and a National League pass giving me entry into any ballpark for any game. With that card as entry, I could work on the field at batting practice, had a seat in the press box, and ate a pre-game meal with the writers in the team's dining room. Since I consistently showed up at games from one season to the next and displayed my appetite for hard work, New York sportswriter men grew accustomed to me being among them, though many remained unhappy I was there.

In the spring of 1976, I started off as the girl who stood out. In two full seasons of work, I'd become the woman reporter who fit in.

Meanwhile, newspapers were hiring women to write sports, and putting them mostly at basketball and hockey press tables. This happened after legal cases had put a gender spotlight on discriminatory hiring and promotion practices at media companies. Hiring a woman for its sports section was an insurance policy as a newspaper's requisite nod to fairness and diversity on pages of the paper unacquainted with a female byline. With women working the National Hockey League (NHL) and National Basketball Association (NBA) beats, it's not surprising that these two leagues led the way in adapting their media policies and practices to the changing demographics of their press corps. Early in 1975, men directing the NBA and the NHL urged their teams to provide equal access to every member of the press. Interviews took place in the locker room, so women covering those leagues started working alongside the men. When Kuhn heard about these media policy changes, he was so alarmed that he worked with his media director Bob Wirz to come up with baseball's no-women-in-the-locker-room policy. With no women working at ballparks then, he saw no need to share it publicly, so the two men stowed it away. Kuhn would make his policy public if a woman ever claimed that her access to ballplayers should be the same as the men's.

That Tuesday night, I did.

* * *

Kuhn's keep-the-ladies-out plan fit snugly with baseball's long history of excluding any woman who showed up to work at a ballpark. The men's instinct always was to bar her from whatever places she needed to be to do her work. In 1957, Boston's baseball writers had told *Cleveland News* writer Doris O'Donnell that she couldn't leave the grandstand for batting practice or sit in Fenway Park's press box. She was traveling with the Cleveland Indians only because her editor thought it would be fun—and funny for his readers—to have his star female news reporter go on a four-city East Coast trip with the team. When Boston's baseball writers kept her out of the press box, she mocked them in a story for her readers back home.[1]

Cleveland girl had fun trying to crash Fenway press box

Female writer was blocked access by vote of peers

By Doris O'Donnell, May 22, 1957

Boston sports writers are sissies.

They banned me from the all-male sanctuary—the Red Sox press box—because they are afraid to establish what they consider—dangerous precedent. Women reporters are by tradition here in Boston persona non grata in the press box. No traveling female reporter from Cleveland is going to shatter that rule. The finality of the writers' decision had all the boom of a strike called by Umpire Bill Summers.

"It was a close vote, five to four," said *Globe* sportswriter Bob Holbrook apologetically.... The gallant Mr. Holbrook said, after the vote, and a trifle lamely: "Well, we could let you in, but how about the other girls on the Boston papers. They've wanted to get in a long time ago."

I had fun trying to crash the press box.

The Associated Press (AP) covered her exclusion:[2] "Ladies, take heed. The baseball press box will remain a male sanctuary—in Boston, at least." O'Connell saw her press box experience as a hiccup in her distinguished journalism career. "I've tested tanks for the Army. I'd ridden an elephant in the circus. I've driven cabs. Last year, I went to Russia for the paper, and let me tell you it was easier to get inside the Kremlin than it is to get into a baseball

press box," the AP quoted her as saying. Denied the writer's customary path of access to ballplayers, O'Donnell paired doggedness with feminine affability to snare an interview with taciturn Red Sox outfielder Ted Williams. They talked from either side of the hip-high wall that kept her from the field. When the Boston writers saw her story, they could only envy her access to Williams. He wasn't speaking to them.

In a profile published decades later,[3] O'Donnell's baseball road trip was just a snapshot in her decades-long journalism career.

> When the trip ended, O'Donnell had been thrown out of two press boxes, told she should be home making babies [by an opposing manager] and came up with a rare one-on-one interview with [Ted] Williams while leaning against that wall. Shortly after her return, she was the subject of a front-page story in *The Sporting News* in which she was quoted saying of sports writing: "I'd rather see a son of mine driving a bus." The story also had advice from Williams, who said after hearing she had been ejected from the press box: "Don't let those guys push you around."
>
> O'Donnell's attitude the entire trip: "I just wanted my story."

A bit more than a decade later, in September 1972, the junior PR director for the Red Sox was given the job of informing *National Observer* writer Diane K. Shah that she would not eat with the other sportswriters. He told her this only after her editor and the magazine's lawyer, both men, had telephoned the senior Red Sox PR person to secure access for their writer to the field and get her a seat in the press box. When she had requested press credentials, the Red Sox had denied her a field pass and press box seat. It did not occur to her bosses to ask the Red Sox where their writer would eat, nor could they imagine that the team would set up a picnic table with a sign reading "Ladies Pavilion," and tell Shah she was eating there by herself. The Red Sox waited to tell Shah until batting practice was over and they'd walked her to the ballpark's roof with her expecting to join the other writers in the team's dining room.[4]

A few months later, in January 1973, the Baseball Writers of America Association (BBWAA) tossed Stephanie Salter out of its annual gala in New York City. She was then the junior baseball reporter with *Sports Illustrated*. An editor at *Sports Illustrated* had given Salter his ticket when he couldn't attend. To join other *SI* staffers—all men—at it company table, Salter transformed a fancy black dress into an outfit approximating, as best she could, a tux. Yet, before she'd sipped her soup, men marched over to the table to tell Salter she

had to leave. Based on Salter's brazen attempt to infiltrate the men's dinner, columnist Frank True[5] dedicated his sports column in Florida to warning fellow writers of the advancing invasion of women and urging them to stop us.

> Now it might be argued that the dialogue in the [BBWAA dinner] show could be cleaned up to a point where it might be acceptable to feminine ears, but major league press boxes represent an entirely different situation, in as much as they're not a one-night stand but are inhabited throughout the season by uninhibited males who refuse to relinquish their rights to express themselves in any language they see fit during the progress of a game. . . . Yes, the girls themselves may know all the "words," but when you make a "coed chorus" of it you've created the verbal atmosphere of a brothel in a press box, haven't you? Any gal capable of writing a good sports story today deserves more respect than that accorded a wench in a hippie commune.

> The average baseball writer insists upon an "unmixed" press box for the same reason that he wouldn't be stupid enough to take his wife or girlfriend to a stag party. Someday press boxes may be built with male and female compartments. But they'd better be soundproofed.

A few years later, on a September evening in 1976, after I took a seat in the press box at Comiskey Park, Chicago's sportswriters reacted as True urged them to do. I'd been sent on a two-week reporting trip by *Sports Illustrated* to work with Roger Kahn on a feature story about baseball's old-timers. Kahn knew these men well from his 1950's newspaper days covering the Brooklyn Dodgers, when he wrote *The Boys of Summer* about their 1955 breakthrough season. We came to Chicago to spend a few days with Bill Veeck, the flamboyant owner of the White Sox. In his lengthy career, Veeck had staged weddings at home plate, hired a clown to coach his team, and signed the three-foot seven-inch "midget" Eddie Gaedel to a one-game baseball contract in which he told his manager pinch-hit him without swinging. When the pitcher failed to adjust to his shrunken strike zone, Gaedel walked to first base to guffaws and applause from fans. There, his baseball career ended. Following Veeck's orders, the manager pulled him from the game, and then Veeck sent him home.

On this September night in Chicago, the writers saw me walk into the press box, find a seat toward the back, then go to talk with Kahn who was seated next to Veeck in the first row. I didn't pick up on the men's whispering campaigns at the time, but Kahn recounted them in his 2004 book, *October Men: Reggie Jackson, George Steinbrenner, Billy Martin and the*

Yankees' Miraculous Finish in 1978.[6] "Some old-line baseball writers variously stared and ogled. One writer came up and said intensely into my ear 'Your girlfriend doesn't belong here. You know that. What do you think this is, ladies' night at the Turkish bath?'" Kahn hadn't shared this exchange with me, so I only learned about it in his book when he wrote about swatting the man's words away by telling him I was his *Sports Illustrated* reporter. Later that evening, however, Chicago's sportswriters forced our exit from the oak-paneled Bards Room, which was their after-game lounge in Comiskey Park. "A few sportswriters glared at her and then at me and though I knew some of them, no one offered a nod or even a friendly look. It was as though I had brought a harlot into the temple," Kahn wrote. "But Melissa was hardly a harlot, and the press room was hardly a temple; we stood quietly waiting for Veeck. After a bit the bartender motioned me aside and whispered, 'Sir, your secretary will have to drink outside in the hall.' I snapped, "She's not my secretary, she's a reporter, and if she has to drink in the hall I'll drink there, too."

Neither the players' privacy nor nudity was at issue that night; my exclusion *was*. This was just one more attempt in a string of many previous ones when baseball's men didn't want a female writer to be where they were. The men set the rules and they had the power to enforce them. Of course, aside from keeping me out, they hoped word would travel back to editors so they would not send women to cover baseball games. They couldn't deliver the story that a man would.

About a year later, at Yankee Stadium, nudity surfaced as *the* reason for Kuhn's swift denial of my right to report in locker rooms. After Time Inc. filed its gender discrimination complaint with the Southern District Court, naming me as its plaintiff, Kuhn told *ABC Sports* broadcaster Howard Cosell in a nationally televised interview that he'd barred me from working in locker rooms to protect his players' "sexual privacy."

In that January 1978 interview,[7] Kuhn explained his rationale:

COSELL You're opposed to women going into the clubhouse. Why?

KUHN Well, Howard, it's our view that it's not a fair thing for our players. This is an area where they're dressing and it's an area where we think they're entitled to some—some reasonable privacy. We don't think it is really fair to the rest of the press. And we also don't think it's fair to a lot of our fans who would have great reservations about this.

COSELL Not fair on the grounds of sexual privacy?

KUHN Yes. I think they would feel that the players are entitled to sexual privacy.

A few years later, when Kuhn spoke at Princeton University, his alma mater, he said that his Catholic faith had been a significant factor in him taking the commissioner's job.[8] He saw the job, he told students, as a "platform that I could utilize to say to others what I felt, to convey a sense of spirituality." Perhaps his spirituality was guiding him on that October evening when he judged me a misguided girl who ought to know her proper place and should respect his. In his depositions and affidavits, and when he was quoted in press accounts about my case, Kuhn implicitly questioned my morality as "a lady" for wanting to be in a place where men might be naked. He could depend on a chorus of baseball's men to sing his same tune in challenging my judgment and planting seeds of doubt in people's minds about my moral character. Kuhn's argument boiled down to this: What "girl" would go to court to try to do what no respectable American believed any respectable girl should do? The influential *Sporting News* came down squarely on Kuhn's side complaining that I was "invading the domain of male privacy." This widely read, national publication weighed in about my lack of judgment in its lead editorial, "What's Sauce for the Goose" signed by its editor and publisher, C. C. Johnson Spink:[9] "The name of 'chipmunks' has been applied to the new inquisitive breed of young men sportswriters. Perhaps 'sparrows' ought to be the name for the young women who want to go everywhere to pick up crumbs of information. What they're lacking is a sense of restraint, not to mention good judgment."

I was graduating from high school in 1969 when baseball's owners elected Kuhn to be Major League Baseball commissioner. Then forty-two, he was the youngest commissioner in the game's history, as well as its tallest at six feet five inches and heaviest at 240 pounds. He cut an imposing figure and with his ascension he inherited the singular power to run baseball as he saw fit. As I later discovered, his extensive power in professional baseball wasn't enough for him. In Ridgewood, New Jersey, where he was raising his family, he oversaw his suburban town's Little League, applying these same beliefs about the inopportune mix of girls and sports. At a time when girls in New Jersey were fighting in court to win the right to play Little League ball, the local *Ridgewood News* and the *Bergen Record* quoted Kuhn as saying that "girls playing sports would ruin it for the boys." Kathleen A. Doyle, who was a sports-loving student at Ridgewood High School in the 1970s and knew about my legal case, emailed me to share her memories. She recalls Kuhn directing his "venom against young girls in our town who wished to play sports. . . . There was great pressure coming from Bowie Kuhn to denigrate girls who did play sports." The girl who wanted to compete in sports, Doyle

added, "had to fight for after-hours time on the fields. Only the boys' teams were given uniforms and trophies."[10]

Kuhn's beliefs about girls in sports, and me, in particular, in his game, would be put to a legal test by a judge in the Southern District Court. He'd inflamed fans with incendiary words about me as a wayward girl hectoring his unprotected naked men, but my attorney was preparing to challenge his discriminatory treatment of me in ways that no commissioner had experienced in baseball's other court cases. I didn't work for baseball. I only reported on its games. While Kuhn had absolute authority within baseball, in court we'd test whether his power extended to me.

When on Friday afternoon, April 14, 1978, I went to the Southern District Courthouse to hear my lawyer argue my case, I knew that lots of Americans were rooting against me. In a few hours, we'd have a better sense of whether my lawyer had convinced the judge, who disliked baseball and rued the day she'd been assigned my case, to rule in favor of his female client who loved the game.

Chapter Two

Driving into Lower Manhattan's Foley Square, I pressed my face against the taxi's side window trying to spot my lawyer in front of the courthouse. In our phone call the day before, he told me to meet him here twenty minutes before our 4:00 P.M. hearing, so I'd added a generous cushion of time for inevitable traffic slowdown.

I couldn't be late. Fritz Schwarz Jr. never was.

He'd asked me to call him Fritz when we met in December. At six feet three inches tall, he was easy to spot in a crowd. Lean and long and in his forties, Fritz had the look of a man who could still be stroking the Harvard varsity crew on the Charles River. Just about everywhere he went, Fritz walked with a purposeful stride and nimbleness that moved him easily through New York's crowds. The first time I walked with him, I had a hard time keeping up. On this Friday afternoon not many people were lingering there, so I saw Fritz right away, helped by the wind catching his thick forelock of hair and tossing it skyward. He raised his hand to brush it back to his forehead when I saw him. Even from a distance I knew it was him, and since Fritz was never alone when legal matters were at hand, I saw his associates, Calvin R. House and Catherine M. Raymond, nearby. Set against the backdrop of the Southern District Court's majestic Corinthian columns, my lawyers seemed like dollhouse miniatures. Drawing closer, I inhaled deeply to calm my rattled nerves. When I released that breath, I startled Eric, my fiancé, sitting next to me.

Since January, when I'd penciled the words "court hearing" on the April 14 page of my desktop calendar. I'd anticipated this trip to the courthouse. If I flipped past that notation and saw my words, I felt eagerness and dread. For the lawyers and Judge Motley, these hearings were routine but not for me.

I'd never been in a courtroom to hear a case being argued, just as I'd not been a plaintiff, especially one drawing copious and contentious publicity worldwide. The case the judge would hear was about gender discrimination, which wasn't what Americans thought. They believed my case was about naked ballplayers whose sexual privacy I wanted to invade.

The Southern District Court has a storied history of memorable cases. In it, Judge Irving Kaufman sentenced Julius and Ethel Rosenberg to die in the electric chair after both were found guilty of conspiring to commit espionage with the Soviets. Here, too, Judge Henry W. Goddard sentenced Alger Hiss to a five-year jail term after he was convicted of being a Cold War spy. When the U.S. government went court to stop publication of James Joyce's *Ulysses*, Judge John M. Woolsey, who had read the novel, declared that he had not found on its pages "anywhere the leer of the sensualist." Joyce's classic was, Woolsey said, neither pornographic nor obscene. His ruling went a long ways in affirming literary free expression. Here, too, Judge Richard Owen asked for a piano to be rolled into his courtroom, then for a pianist to play two songs, John Mack's "He's So Fine" and George Harrison's "My Sweet Lord." Owen, who composed music when he wasn't hearing cases, listened, then found Harrison guilty of copyright infringement for plagiarizing Mack's 1962 song. "I do not believe he did so deliberately," he wrote, speculating that his transgression was "subconsciously accomplished."

Before the hearing, each attorney—Kuhn's and mine—had submitted a motion to request summary judgment. Judge Motley accepted both, so there would be no trial, only this hearing that was likely to last a few hours. These requests for summary judgment signaled to her that the two sides had no factual disputes that needed to be resolved. So, no witnesses would be heard in our hearing. Only the attorneys would speak, addressing the core issue of whether by preventing me from participating alongside the men in baseball's interviews with players Kuhn had discriminated against me due to my gender. I would not testify, nor would anyone else, though in affidavits that I and others submitted to the judge we had sworn to the veracity of our testimony. As the case's named plaintiff, I wasn't required to be in the courtroom for the hearing. I could have stayed in my office and Fritz would have called me to tell me how it went. But I wanted to hear Fritz explain to Judge Motley how my case came to be and why we believed she should use her judicial power to rectify Kuhn's discrimination. I also wanted to hear how baseball's lawyer defended the commissioner's actions against me.

It never occurred to me not to be there.

* * *

On April 14, 1978, few Americans knew my name, but millions felt they knew me, or least knew about the "girl" in New York City asking a judge to order baseball to let her into locker rooms to gawk at naked men. The ways that sportswriters, columnists, and radio and TV broadcasters found to detour around my case's equal rights rationale in no way fairly described my case. But it did perform well as an emotive synopsis if you wanted your readers to dismiss my case as being wrong-headed and frivolous. For months, most of these men writing about my case had ignored my to-do-my-job intention and gone for sexual titillation. Instead of engaging with the legal merits of my case, the media enjoyed turning me into a temptress who'd misuse her equal access to seduce ballplayers. Few of my castigators bothered to inform readers that Kuhn also had barred me from before-game interviews in the locker room when no player changed out of his uniform. Then, no player would be parading naked, and the male writers were there, doing their work, and I wasn't. Nor did sportswriters who knew how clubhouses worked inform readers that the shower area was off-limits to *all* reporters. There, ballplayers had time and privacy to put on underwear or clothes or wrap a towel around their body before returning to the locker room to talk with the press.

By routinely calling me "girl," these writers infantilized me in an effort to diminish the likelihood that readers would see me as a woman fighting for equal rights. Some of them used a different tack by portraying me as a "women's libber," leaving the impression that I was barging into locker rooms, where no woman should want to be. For the record, I never tried to walk into—or barge—into any team's locker room. On the few occasions when I tried to gain access, I asked permission of one of the men who wrote and enforced baseball's rules. When they said no, I stayed out and tried to get players to come out to talk with me. This didn't work well. The truth is that when I was around baseball, I handled myself more like an obedient participant in a game of "Mother, May I" than a bruising blocker in roller derby.

Nor did I respond to the men who mischaracterized me and told half truths about my situation. Mostly I stayed silent about their inaccuracies, except when I was invited to speak about my case or a writer or broadcaster interviewed me. Even then, I saw that often what I'd tell writers about why I was fighting Kuhn's edict was left on the cutting room floor. Usually, writers didn't bother to speak with me before opining about it or me, and even fewer

of them included the core issue of gender discrimination in their coverage. Instead, derisive put-downs amused their readers while they cushioned writers from touching the third rail of equal rights. Those who wrote about my case usually parroted Kuhn's contention that the ballplayers' right to privacy superseded any rights I might have, including those that fall under the Fourteenth Amendment guarantee of equal protection under the law. The men did embrace equal rights—their own—when they wrote wistfully about them being in the women's locker room when Chris Evert or the Dallas Cowboy cheerleaders were in stages of undress. If the judge ruled in my favor, this would be welcomed recompense.

In the months leading up to this hearing, I tried to retain a sense of humor in the midst of this demeaning coverage, but it was hard to do. Any equanimity I had I found in trusting my lawyer to construct and argue a compelling argument. To lose in court after enduring this public pounding was not an option I was willing to consider. When I needed a sanity check, I'd count the days until this media circus might be over. Such tricks of my mind turned my focus back on doing this job I loved. But as Fritz was building my case, cartoonists were earning chuckles at my expense with exaggerated sketches of hulking ballplayers next to extremely well-endowed women. In one cartoon, ballplayers cowered behind a bench they'd positioned at their midriffs to shield themselves after our invasion. Their expressions screamed trepidation, conveying that they should fear us. By inking such locker room scenes, the cartoonists came up with creative ways in which ballplayers could hide their anatomical parts they didn't want us to see. One ubiquitous prop was the towel. In another cartoon, a ballplayer gripped the towel around his waist and waved another one at a befuddled woman reporter. With a mischievous smile, he said, "If you wear a towel, we can ALL get comfortable!" Wrapping myself in a towel wasn't what I had in mind, nor should it have been. While a *Tonight Show* sketch of Betty White wrapped in a towel was cute, it missed the point. I was in court to be treated the equal of male sportswriters, not the ballplayers. Still, TV parodies and cartoons amplified how topsy-turvy all of this was becoming as Kuhn and the sportswriters took aim at an easy target—me.

In our actual negotiations with Kuhn before taking our case to court, we had proposed solutions like teams providing towels and bathrobes for the players. Kuhn summarily dismissed these and other suggestions as too burdensome to impose on *his* players. Evidently, he considered it less of an imposition to bar my access—and prevent me from doing my job—than to supply bathrobes to ballplayers. Just a few weeks after we had filed our complaint

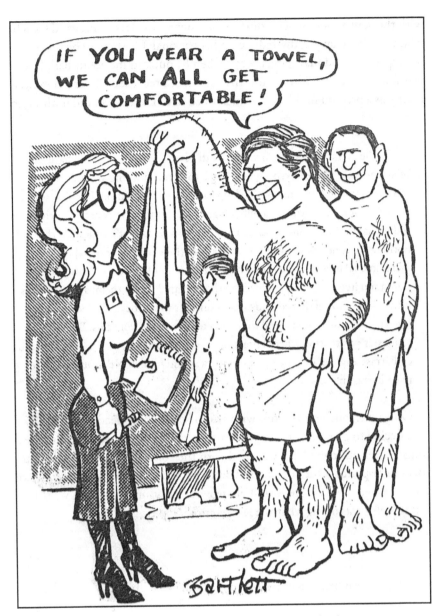

This is typical of the many newspaper cartoons published about my legal case.

with the Southern District Court, ABC Sports broadcaster Howard Cosell, who was also a lawyer, invited me on his national TV show to be broadcast on Super Bowl Sunday, January 15. When he quizzed me about ballplayers' privacy, I wove humor into my answer since I regarded players' potential nudity as a pretend problem that men liked to talk about but did nothing to rectify.

> As for the privacy question, if you can call a locker room where you have 30 men who didn't have anything to do with the game walking around and talking to you and still maintain that that's a private situation, I don't buy that. It's a situation where they're a public figure at that point, they're not a private individual in their home. And as many people have said, it's a question that nothing short of a towel won't solve. Cannot these players who make these incredible salaries afford to buy a towel? And it would make a terrific concession stand item, to get these towels with the team logo on them, and say, "This is the kind of towel that so-and-so puts on after the game in the locker room." I mean, the teams could stand to make a terrific profit from this. But to be serious: it's a situation where I don't mean to embarrass anyone. I don't want to embarrass anyone. I would go out of my way and have in NBA situations not to embarrass players.

Only when our negotiations with Kuhn kept hitting dead ends did Time Inc. decide to give him the opportunity to display his obstinance before a judge. After our complaint was filed with the court, Kuhn released a statement to respond: "Our position has been that if they could satisfy us that we have violated any law, we would change our position." In court, we'd find out if Kuhn was doing what the law required him to.

* * *

In 1976, the year before Kuhn banned me from locker rooms, *New York Times* sports columnist Red Smith became the second sportswriter awarded journalism's highest honor, the Pulitzer Prize. In bestowing this honor, the judges cited his work as being "unique in the erudition, literary quality, the vitality and the freshness of viewpoint." During the baseball season, Smith showed up at a few games, then more often in the postseason, as columnists do in rendering opinions about big moments like the World Series. In 1977, his Pulitzer Prize made him the dean of American sports writing and his syndicated *Sports of the Times* mandatory reading for fellow sportswriters and millions

of Americans wanting to be in the know about sports. Each column was sent by wire to hundreds of smaller newspapers, so his words were reprinted throughout the country.

On January 9, 1978,[1] Smith dedicated his column to denouncing my case and laughing at me. It was headlined "Another View of Equality," thanks to the *Times'* first woman sports editor, even if equality wasn't the point of his words. Instead, his words tilted toward the sexual nature of my endeavor, telling readers that at the end of a challenging year for sports, I had struck "a saving note of low comedy by contending in court that [I] could not cover the World Series for a weekly magazine unless [I] could watch Reggie Jackson undress." In addressing Kuhn's denial of access to my sources, Smith patronized me with the words, "Lucky girl," then concluded his opening paragraph by offering two historical analogies in one sentence. With each, he meant to bolster his case against me: "Move over, John Peter Zenger, and make room for Melissa Ludtke, *Sports Illustrated*'s Joan of Arc." Then, to make his legal thesis accessible to readers, Smith followed with a tight paragraph of three humorous comparisons to help readers understand my "landmark case." Each failed in describing the actual legal arguments that Fritz would make in court.

1 Freedom of the press vs. the laws governing indecent exposure.
2 The public's right to know what kind of pitch [Yankee catcher] Thurman Munson hit in the fifth inning vs. Munson's right to privacy.
3 The equal rights movement vs. the manly modesty of Catfish Hunter.

But that wasn't his point. With this column, Smith set the tone of what sportswriters' coverage of my case would be. In Americans' minds, he'd left the indelible image of a laughable case involving a lucky girl who couldn't get naked men off her mind. His influence showed in the subsequent stories that echoed his views. In fact, Smith's view and tone became the dominant narrative about my case as the men played the same old tune about how no "lady" whose feminine sensibilities anchored her moral core would think of entering a room where strange men might be undressed. The drumbeat of this insinuation led readers to conclude that I wasn't a "lady," and explains, in part, why writers—and headline writers—were comfortable referring to me as "girl," "gal," and "damsel."

By April 14, I was the talk of many towns, and people called me many names.

My locker room case shared news cycles with anti–women's lib stories about the surging movement led by conservative political activist Phyllis Schlafly. In her national campaign to stop passage of the Equal Rights Amendment (ERA), she gained traction by stoking American's fears about men and women having to share public restrooms, if the ERA was ratified. Sportswriters, columnists, commentators, and broadcasters implied that my situation posed similar threats to Americans. If allowed in baseball locker rooms, the logic went, I'd harm baseball *and* destroy our nation's bedrock values. After all, baseball was America's national pastime. If I went into its locker rooms, the players' camaraderie would cease and their esprit de corps would collapse, or so such thinking went. Then, with a wink and a nod to boys-will-be-boys ways, it was intimated that my presence would tear down the patriarchal privileges that were under siege because of the women's movement and its ERA. Sealing the deal, a few commentators insinuated that I was a wanton woman, akin to the biblical Jezebel. The ridiculousness of such an argument was of small comfort to me. It was still painful to be hit with such gross distortions since this wasn't the person I knew myself to be.

Diane K. Shah's experience at Fenway Park in 1972 was instructive. As the only woman writer at a late-season baseball series, she told *New Yorker* baseball writer Roger Angell for his story "Sharing the Beat"[2] what she heard from baseball's men: "Well, that girl can come in if she behaves herself. And I didn't know what that meant." Back then, the Red Sox PR director had told her she couldn't be on the field for batting practice, sit in the press box, or eat with the other writers in the team's dining area. Going into the locker room wasn't imagined. By the time I got to baseball, those gender issues had been addressed leaving me with only the locker room as a forbidden zone. Although the American public was titillated by the specter of me being around naked ballplayers, Fritz reminded me that equality, fairness, and most important, the law was on our side. "I always say to young lawyers, 'You reach the judge by showing that you have fairness on your side,'" Fritz told me, "and then get to the law."

The more Fritz schooled me in how the law intersected with my case, the more I believed we had good shot at showing Kuhn that he had, in fact, violated a law. As much as I'd tried to ignore what was said about me in the press, disparaging words found their way to me. The PR folks at Time Inc. used a clipping service to direct media coverage of my case to them. In turn, thick stapled bundles of clips were delivered frequently to my desk, and even though I could have moved these clips from that inbox to a desk drawer, curiosity got the better of me. So I skimmed the headlines, and I read a few stories all the way through.

With the tide of public opinion running against me, I had to rely on Fritz's assurance that neither headlines nor stories would guide the court's judgment. It's likely that our judge would have read this ridicule of my case and saw the shaming of me but she also knew that sexualizing a woman in a court case is what sells newspapers. After all, *Sports Illustrated* wasn't a stranger to using this same strategy. In the winter dead zone of sports, SI published its swimsuit issue showcasing slender, shapely models posing in bathing suits as skimpy as contemporary social norms would allow, and then some. I was grateful that Judge Motley would hear my case. Fritz had told me that she'd persevered in hostile southern courtrooms to battle racial discrimination for her plaintiffs. As a judge, I believed she'd listen hard to each side's legal argument and take seriously what we'd submitted in affidavits and depositions. Because she'd set legal precedent with a few of her cases, I felt she'd weigh heavily how legal precedent applied to mine. The media had rendered their decision; now, in the Southern District Court, I hoped she'd render a different one.

Judge Motley had been assigned to our case a few months earlier when the clerk of the Southern District Court did what he always did when assigning a judge to a new case. After putting cards with the name of each available judge into this court's historical wood box, he spun it. When it stopped, he reached in to pull a card out. On it was the name "Judge Constance Baker Motley."

She'd hear my case.

Motley was the only woman judge in this court's history dating back to 1789 when this was the first court in our nation. She became a federal judge because President Lyndon B. Johnson set his moral compass in the direction of equality, then applied his legendary arm-twisting to move her nomination through an unwelcoming U.S. Senate. It was hard enough to convince the nearly all-male Senate[3] to confirm a woman as a federal judge. Until then, its members had confirmed only four women to this post and none to a court as prestigious as Manhattan's Southern District Court. Gender was a hurdle, but Motley's race and her court fights against segregationist laws had stacked the odds even higher against her. Her impressive record of significant legal victories, including nine victories in the U.S. Supreme Court, made her abundantly qualified to be a federal judge. But less than laudatory assessments of her were sent to the Senate Judiciary Committee due to racist views held by members of bar associations. The judiciary committee was chaired by Mississippi senator James Eastland, and he also used his considerable power to scuttle Johnson's early attempt to nominate Motley for the Court of Appeals, as President John F. Kennedy did with her former NAACP colleague

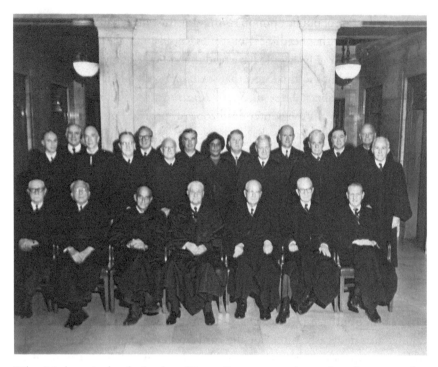

When Motley arrived at the Southern District Court in 1966, she was the only woman judge (middle, back row) in its storied history. She was also the first Black woman to be appointed to the federal bench in our nation's history. (Courtesy of Motley family.)

Thurgood Marshall. By the time Motley's nomination for the district court reached this southern segregationist senator, Eastland was so enraged by the congressional passage of the 1964 Civil Rights Act and 1965 Voting Rights Act that just hearing Motley's name ignited his fury. After all, Motley was the lawyer who secured James Meredith the legal right to enroll as the University of Mississippi's first Black student. To Eastland, this unforgivable offense was reason enough to thwart her nomination. He tried mightily, but ultimately Eastland failed.

Once confirmed, Motley resigned from her elected position as Manhattan Borough president, where she'd been the first Black woman to hold that office. In preparing to transition to the Southern District Court, Motley knew that J. Edward Lumbard, the chief judge of the Second Circuit Court of Appeals, was among those who led the legal establishment's opposition to her nomination. Decades later, Motley revealed in her autobiography[4] that "just the mention of my name caused Lumbard to tremble with anger." Arriving at the courthouse as judge, Motley knew Lumbard wasn't alone in his

animus toward her appointment. In September 1966, Motley was sworn in as America's first Black woman federal judge. Despite the historical significance of this event, the *New York Times* buried its story on page sixteen under the headline, "Mrs. Motley Inducted as Federal Judge."[5] Only the first two paragraphs of that three-column story focused on her induction. The rest of this story speculated about prospects of the political figures vying to be the next Manhattan Borough president.

Fritz told me only a few things about Judge Motley's time as a civil rights attorney. Had I dug deeper into her life in this pre-Google time, I'd have discovered how her legal acumen had shaped much of mid-twentieth-century American history. In *Brown v. Board of Education*, she'd drafted that case's complaint and was part of the legal team that laid out the winning argument for how the post–Civil War's Fourteenth Amendment did not permit public schools to be segregated by race. Cases she'd litigated bore the name of plaintiffs—Charlayne Hunter-Gault, James Meredith, Vivian Malone, the Freedom Riders, and Martin Luther King Jr.—that many Americans knew. From the mid-1940s into the early 1960s, she'd argued racial discrimination cases in places where people were hostile to her presence and judges were dismissive of her and her arguments. She did this while far away from the comforts or safety of her family life in New York City. Her courtroom skills planted the roots of arguments used today to secure the equal justice promise of the U.S. Constitution's Fourteenth Amendment.

When Fritz stood to argue my case before Judge Motley, he was addressing a judge who with every fiber of her body believed that the Constitution's bedrock guarantee of equality was a requisite to fairness and showed the way to fight injustice.

* * *

Early in March, about a month before our hearing, Fritz questioned Commissioner Bowie Kuhn under oath in his deposition. The transcript—along with all of other depositions taken in this case, including mine—would be put into big binders that would be on Motley's bench during the hearing. Fritz's objective was to get Kuhn to confirm his firm attachment to the media policy he'd used to segregate me from the male writers. Several weeks later, Kuhn's lawyer would be my inquisitor in a two-day deposition. He was a distinguished litigator with Shea Gould Climenko & Casey, where, by the time we met, he was a named partner. To my young eyes, he was as ancient as Coleridge's mariner. With thinning white hair, old-man spectacles, and a

persistent slouch, Jesse Climenko seemed the archetype of a man who didn't
like it when a woman spoke her mind. Even worse was when she said things
that he didn't expect her to say. I could tell my answers irritated him as his
frustration showed. It turns out his seventy-fourth birthday was on the sec-
ond day of my deposition. I didn't know his age then, but I couldn't help but
compare his slower gait, wrinkled visage and crotchety demeanor with my
cheerful, energetic, and youthful forty-two-year-old attorney. Fritz's father
and Climenko, I later found out, were classmates in Harvard's class of 1924,
which was the year my parents were born. The two men were also together at
Harvard Law School, graduating in 1927.

I was glad the younger guy was on my team.

On March 30, the day of my deposition, Fritz picked me up at my
Rockefeller Center office, and then we walked the ten blocks to Climenko's
Madison Avenue law firm. There, we were ushered into a small conference
room with nothing on its walls. I was told to sit in a corner chair facing east
so the bright winter sun stared back at me.

Climenko's first question was to verify that I was twenty-six years old and
had graduated from Wellesley College. "That is correct," I replied. Then, he
wanted to know how long I'd had my job at *Sports Illustrated*. "Four years,"
I told him. From there, we established an easygoing rhythm until he hit a
speed bump when he asked if I believed that a woman belongs in a men's
locker room. Fritz rose to object, and Climenko amended his query. It wasn't
long before he asked a series of questions about the Yankees' locker room at
the World Series, and again Fritz stood to object. Only this time, what earlier
was a courteous dialogue between these two lawyers suddenly heated up.

CLIMENKO "Well, on the occasion of the sixth game did you ask to get into the
 locker room?"

LUDTKE "I was told at the locker room door by the guard who allows people
 entrance to that locker room that he [Kuhn] told him that evening that no
 woman would be allowed into the locker room that night."

CLIMENKO "But you knew that in advance, didn't you?"

SCHWARZ "What do you mean 'knew that in advance'?"

CLIMENKO "You had already been told that the commissioner had said that you
 couldn't get in?"

SCHWARZ "Was the commissioner meant to be like God in that you can't
 continue to challenge his positions?"

CLIMENKO (TO SCHWARZ) "Don't argue with me."

CLIMENKO (TO ME) "Didn't you know that?"

LUDTKE "Yes, I knew that."

CLIMENKO "Did you ever consider the privacy of the players in connection with your request to get into the locker room?"

LUDTKE "Yes."

From that point on, Fritz objected more often, and each time he did, it became more apparent that these two lawyers didn't like each other. Of course, I had no way to know what usually went on between attorneys at depositions, but I sensed a deep well of animosity between these two men. Their verbal sparring intensified as my deposition was reaching its end and Fritz had a chance to ask me any clarifying questions. He'd barely said a word before Climenko pounced. This time their hostility was palpable. I cringed as more interruptions followed making it difficult for Fritz to ask me anything.

SCHWARZ (TO ME) "When Mr. Climenko tried to suggest to you that in some way you have done something improper by trying to get access to the Yankee locker room."

CLIMENKO "I object to that form to the question. I ask that you not suggest that on the record."

Acknowledging his complaint, Fritz pressed ahead, but Climenko stopped him repeatedly. Each interruption led to exchanges of nastier insults. Finally, with my deposition over, the lawyers continued to bicker.

CLIMENKO "I regard you as having gone out of your way to be gratuitously insulting and I want you to know it and I will refer to it at the proper time."

SCHWARZ "Of course, I was not doing that, and you know I wouldn't do that."

CLIMENKO "I'm sorry. This record will speak for itself. We can litigate this case without your going out of your way to be needlessly insulting."

SCHWARZ "You know I wouldn't do that. Certainly . . ."

CLIMENKO, SPEAKING OVER HIM "You and I speak one language. It is English, and I understand exactly what you said, and I don't want to hear it from you again."

SCHWARZ "I will continue to take whatever position I think it right."

Fritz then leaned down to gather documents he had spread on a table when Climenko admonished him again.

"Try to act like a lawyer," he scolded.

Maybe Climenko simply wanted his words to end their skirmish. It was 3:30 P.M. on April 3 when the second day of my deposition was officially over.

On my solo walk back to my office, I thought more about the lawyers' verbal tussle than I did my answers. Would such combativeness happen at the hearing? I hoped the judge, serving as the court's referee and the person to whom each lawyer had to show respect, would be a moderating influence. Time Inc. and Major League Baseball had spared no expense in hiring two of Manhattan's top lawyers to argue this high-profile case. I certainly could not have paid Fritz's bill, especially when I realized all the hours that went into preparing my defense. Not only did he and his associates thoroughly research every legal angle, but Fritz talked with those who knew Judge Motley as a friend to get a sense of her attitudes about topics related to our case. When he stood before her, Fritz wanted to know everything he could know about her.

From these conversations, Fritz learned she was disinterested in sports of any kind, and she disliked baseball most of all. If she had a choice, Fritz believed she'd never watch or hear another baseball game, but that wasn't possible since her husband, Joel, was a die-hard Yankees fan and listened to games on the car radio when she was with him. At home, when he watched them on TV, she could be in another room. In hearing my case, Judge Motley would hear more about baseball than she'd like to, so it was incumbent on Fritz, a lifelong baseball fan, to come up with ways to present baseball as part of American culture. After all, baseball had played a groundbreaking role in racial equality in the late 1940s, when Jackie Robinson, a Black ballplayer, integrated the Major Leagues while playing for a team in New York City.

There was no doubt that Climenko would try to persuade Motley that ballplayers had no choice but to be naked when writers were in the locker room. I knew Climenko would relish the opportunity to raise this issue since he'd asked me about ballplayers' "sexual privacy" when he deposed me. He'd argue, as sports columnists had, that ballplayers should not have to cede their "right" to be naked in their locker room to satisfy my desire to be there. To hear baseball's men tell it, walking around nude in locker rooms was as much of a baseball ritual for them as Cracker Jacks were to the grandstand fans. We'd find out how Judge Motley would react to the lawyers' clash of arguments as she steeled herself for hearing about a game she didn't like and traditions she didn't understand. One thing was certain: Kuhn's lawyer would tell her that locker room routines were sacrosanct. They could not be disturbed. Fritz would disagree.

Fritz knew Judge Motley needed to get acquainted with the layout of the Yankees' clubhouse. To do this, he submitted blueprints of the clubhouse as exhibits. He'd used those to show her its many rooms where ballplayers could be but *no* writer was allowed to go. In this way, he'd demonstrate that no ballplayer *had* to be naked in front of any writer. There were lots of places where he could put on his clothes after a shower. Since women writers had worked in pro basketball and hockey locker rooms for several years, Fritz would have some of them write affidavits to tell Judge Motley how things worked for them and the players.

I also knew Fritz would not raise the specter of naked players. He'd let Climenko do that.

Just about all I could control on the day of the hearing was what I'd wear to it. At some point I thought Judge Motley might look my way. In a brief journal entry on April 7, I wrote: "Diet starts today. 135." I don't remember if 135 was my target weight or if it was my weight that day. Although I didn't write down my weight or what I wore on Friday, April 14, and I have no photos from that day, I'm guessing that I wore one of the flowery Laura Ashley frocks that I wore to ballparks on spring days since they exuded a girlish femininity. With their flattening, high-cut bodices, the dresses hid any hint of cleavage. I had little to hide, though covering up what I had was good to do when going to work at the ballpark. Laura Ashley dresses had puffy short sleeves and lace overlaid near my neckline to accentuate a light, cheerful vibe. Best of all, at ballparks their full skirts fell discretely below my knees so when I sat in dugouts talking with the manager or players, I could cross my legs with impunity. I dressed like a "lady" should, more the maiden than a model. Wearing these dresses, I expressed femininity in a place that otherwise sucked those feelings out of me. In baseball's hypermasculine zone, these dresses bucked me up, giving me the fortitude I needed to keep up with the men at ballparks along with the freedom to carve out my own stylish niche of comfort as I did this job.

For the plaintiff in *Ludtke v. Kuhn*, there was no better fit.

Chapter Three

After handing the taxi driver a ten-dollar bill, tip included, I grabbed my door's handle. In tugging it down, I felt only air. Looking up, I saw Fritz looking down at me. He'd seen my taxi gliding to a stop at the time I was due, so he'd taken the chance that I'd be inside. When he saw I was, he opened my door, and I slid out. Eric followed. At that moment I wished that I'd taken the subway to City Hall and had walked into the plaza to join Fritz. In our time together, I'd never ridden in a cab with him nor seen him get out of one. I was embarrassed to be getting out of this taxi in front of him. Doing this hadn't been my plan until Eric called to say he'd join me to go downtown. On my own, I would have taken the subway. But Eric was as addicted to cabs as he was allergic to walking. To avoid arguing, I'd said nothing in our elevator ride downstairs from my office, and once outside, he immediately dashed between cars and hailed a cab. On our ride downtown, we said little.

Once I was out of the cab, I saw that Fritz had in his other hand his compact bag containing the key documents for his argument before Judge Motley. He'd rehearsed it until he knew it cold, but he brought these materials just in case he needed to refer to them. In his bag was the initial pleading for *Ludtke v. Kuhn* and the legal brief he submitted to the judge in which he highlighted the Yankees' long-term lease of their Stadium from the city of New York. Kuhn's lawyer had copies of everything Fritz sent to the judge, and vice versa, so they and judge knew the significant role this city lease would play in Fritz's argument at the hearing. After laying out the essence of his argument, he'd asked Judge Motley to grant "an injunction enjoining defendants and anyone subject to their direction and control from denying plaintiff

Ludtke and any other accredited representatives of plaintiff Time access to professional baseball clubhouse on the ground of their sex."

With Eric standing with us, it dawned on me that he'd never met Fritz. We had not socialized and Eric wasn't involved in our legal meetings. So, I introduced the two men, and as they exchanged greetings, I waved to the associate lawyers standing with the big legal briefcases at a spot closer to the courthouse. Then, I suggested to Eric that he walk over to say hello to them. I did this so I'd have Fritz to myself. I was nervous, and I felt that being with Fritz would soothe me as his words had leading up to this day. In our four months working together, I felt like I was part of his close-knit legal family. They'd supported me when I needed it. Though our work together was intense, I enjoyed it because I was with them. But with Fritz and I left on our own now, my anxiety got the better of me. I found I had nothing to say except idle chatter, and Fritz didn't want to hear that. I always tried to keep my responses crisp and on point, telling him only what he had asked to hear. By now, the purpose of our earlier exchanges was realized. Now was his time to achieve our goal and my time to leave him with his thoughts rather than clutter his head with mine.

* * *

Fritz and I had been introduced just before Christmas. At that time, I didn't even know Eric. Yet, in the few months Fritz and I worked together, Eric and I had gone from being strangers at a dinner table to an engaged couple moving in together with a wedding date in late May, just six weeks after the hearing. I'd walled off my roller-coaster ride of a relationship from my legal case in my meetings with Fritz. I had no photos of us in my purse, so Fritz hadn't seen a visual of us together. There was the day, however, when Fritz noticed the diamond ring on my left finger and asked about it. Sparse in my reply, I let him know our wedding date. Only by separating my personal life from my legal case and my work could I retain the focus I needed on each, especially now that I'd taken on another beat at *Sports Illustrated*.

Soon after the 1977 World Series, Scot Leavitt, the pro basketball editor at *Sports Illustrated*, had asked me to be the reporter on the NBA beat, working with writer John Papanek. I knew Papanek well from when we were reporters and had offices in the cluster we called the bullpen. The bullpen was the first stop for new hires, so named because it was where we warmed up for whatever career path was ahead. Papanek was there when I arrived, but he'd been promoted to writer earlier that year and moved out. Leavitt flattered me by saying

that Papanek had asked for me to be his reporter. I said I'd do this only if I didn't have to give up the baseball beat, which was a nonstarter. After learning of my hesitancy, Papanek stopped by my office to repeat how much he wanted to get me on the road to report stories. He knew that getting chances to report and write stories was what I liked most about the baseball beat. With his pep talk *and* the agreement that I'd remain on baseball, I joined him. My decision was based on an exquisitely simple equation: the more reporting I did, the likelier I was to find stories of my own to write. The more of my stories published, the likelier it was I'd be promoted. Or so I thought.

By then, I'd been at *Sports Illustrated* three years and was on a bit of a roll. So I figured, why not keep going? I'd written TV/radio columns after being assigned to that column as my first researcher-reporter "beat." Bill Leggett wrote it and he took me along on his interviews. I learned by watching him work. Soon I was bringing story ideas to him, and generously he'd tell me to report them, and then encourage me to write them, which I did, and a lot of them were published. When I was moved to the baseball beat, I applied this same strategy—learn how to report the game, come up with story ideas, then write them. I did, and accumulated bylines on baseball stories making me feel I was improving my odds of being promoted to writer-reporter, the next editorial step. By taking the NBA beat, I'd have more opportunities to report and write, and perhaps one day take the next step of writing a story on deadline.

Still, I went into my new assignment with my eyes wide open. I'd seen enough to know that men at SI were promoted more often than women were. Even getting more bylines might not be enough for me to be promoted at *Sports Illustrated*. However, I saw outside the magazine that in the mid- to late 1970s there was a gold rush for talented women sportswriters. Newspapers and other magazines were hiring SI's female reporters as writers and editors when decision-makers at *Sports Illustrated* were not promoting them. In August 1974, when *World Tennis* magazine recruited Susie Adams, who was the tennis reporter at SI to be its editor, I was hired.

To think I'd be an exception to this gendered pattern required lots of magical thinking.

In that winter of 1977, my ambition had gotten the better of me. What I actually needed was a breather. With a bruising baseball season behind me, the last thing I needed was to leap into a new beat to cover a league about which I knew relatively little. But I said yes, so I had to get up to speed quickly, which added weeks of homework to a schedule I'd already overbooked. I'd promised myself to rope off my weekends to write my first feature story about the strategic back-and-forth between home plate umpires and catchers.

During the season, I'd filled notebooks with quotes, anecdotes and observations. Piled high in my desk drawer were taped interviews waiting for me to transcribe. That task alone would take many weekends. Then, I'd read what I had, get information I still needed, then retype draft upon draft to get to a final version. Just thinking about how I'd find time for this froze me in my tracks. Before I got to SI, I'd never written a sports story. Any writing I did was term papers replete with passive verbs. This was more a curse than comfort in trying to write an entertaining, fast-moving, multilayered story good enough that my baseball editor would say yes. And this had to happen many weeks before the baseball season started up in early April.

On top of all of this, when contemplating the NBA offer, I'd heard rumors of a potential lawsuit if Kuhn didn't come up with a remedy for my situation. If there was a lawsuit, I'd need more hours to work with lawyers.

Now I'd just committed myself to being on the road with pro basketball too.

* * *

When Kuhn's lawyer deposed me in March, he had demanded I tell him the names of everyone at *Sports Illustrated* with whom I'd spoken about locker rooms or mentioned the possibility of a lawsuit against baseball. Leavitt topped my list. When he talked about me joining the NBA beat, he had emphasized that women having locker room access factored into him offering me the assignment. In 1975, the NBA Commissioner Larry O'Brien had urged his teams to provide equal access. In the two years since he'd made that request, most teams had done so.

When I responded to Climenko's question, a certified court reporter typed my words.[1]

> LUDTKE "I told him [Scot Leavitt] I was going to be delighted to work on a sport where I would have equal access to locker rooms."
>
> CLIMENKO "What did he say?"
>
> LUDTKE "He said, and I am paraphrasing, 'I am aware that you have been working on baseball for two years, and since you will be the only reporter on pro basketball you will be requested to do files and a number of things for the writer in which locker room access will be essential.'"

My answer rattled him. I'd entered into the court record that without the NBA's equal access media policy, this editor was unlikely to have lobbied me

for this assignment. Likely he would have given the job to a man if I couldn't be with players and coaches in the locker rooms. What use was I, as a reporter, to Papanek or him without it? By answering as I had, I'd underscored a key point in Fritz's argument about how media policies that kept women from doing their jobs in sports also kept them from getting assignments. In his pleading to the court, Fritz had made the point that when I reported in the NBA, I was routinely working in teams' locker rooms. "If reporters are denied access to news sources ... *Time* and *Sports Illustrated* will be unable to assign their reporters," Fritz wrote. One reason Time Inc. filed my case is that its corporate leaders had signed a conciliation agreement in 1971 pledging not to discriminate based on gender.

When Climenko ended this line of questioning, Fritz was smiling. I'd added flesh to the bones of his courtroom argument. By Kuhn refusing equal access, *Sports Illustrated* could not depend on me for essential reporting at critical times. At the World Series, I was not able to participate in reporting as I hoped I would, which had implications for promotion possibilities. When you can't display your abilities, you'll be left behind.

When Climenko deposed me, I was working in basketball arenas most evenings. After work, I'd be on the Broadway subway from Fiftieth Street to Madison Square Garden at Thirty-Fourth Street for a Knicks' game or rent a car to drive to New Jersey where the Nets played. By the time I was seated at the press table, I'd already put in a full day at the office. Then, after the games, I was in locker rooms talking with players before heading home to end my eighteen-hour days. Before Knicks games, I often ate my pregame meal with Jane Gross, *Newsday*'s NBA writer. Her father, Milton Gross, had been a syndicated sports columnist with the *New York Post*, and Jane once told me he was dismayed when she followed him into the business. Of course, he set this in motion by taking Jane, when she was in primary school, to spring training in Florida, then to boxing bouts and basketball games at Madison Square Garden. At Long Island's *Newsday*, she was first woman hired in sports. She'd also been the first reporter I knew at SI who left to take a sportswriter's job. At *Newsday*, she was made its beat writer with the then–New York Nets, an American Basketball Association team led by superstar Julius "Dr. J." Erving. When assigned to the Nets, her editor phoned its PR person to say that he expected Gross would be given the same access to players as male writers had. The Nets obliged.

On the night when she filled in for *Newsday*'s Knicks writer, Gross brought change to the NBA. When she got there, the Knicks didn't have an equal access media policy, in part because no female writer covered the team. But

as the teams warmed up that night, Knicks' coach Red Holzman saw Gross at the press table and sent word that she was welcomed in the locker room after the game. So, in the late winter of 1975, Gross became the first woman to work in an NBA locker room. When the NBA commissioner heard about this, O'Brien sent a memo to the other teams encouraging them to provide equal access to all credentialed members of the press. His proactive stance echoed what the National Hockey League president had done earlier that winter when he requested that his teams do the same thing.

These men's actions spared *Newsday*, and other news organizations, the money and time to fight for equal access in court, as Kuhn's ban of me forced Time Inc. to do.

* * *

In early January 1978, Eric Lincoln, an assistant sports editor at *Newsday*, showed up in the Knicks' dining room. He'd taken the night off from his paper's news desk to see the Knicks at Madison Square Garden, or so I thought. Only later did I figure out that the game was secondary. He'd come to this game to meet me.

At a prior dinner, Gross had told me about an editor at *Newsday* who was asking her about me. I chalked his interest up to curiosity. Since my World Series run-in with Kuhn, a number of sportswriters who had avoided me now wanted to chat. I figured he did too. At that time, I was trying to figure out my on-again, off-again relationship with a *Sports Illustrated* photo editor. Was it salvageable? Did I want to try? I wasn't looking for a boyfriend. So when Eric came to table where I was sitting with Jane, and asked to join us, I wasn't thinking about the *Newsday* editor who said he wanted to meet me. Only when the three of us went downstairs for the game and Eric sat down next to me at the press table did I start to make this connection. Then, when the game ended, he walked a few steps behind me into the locker room, and after I finished talking with players, he followed me out. We shared the elevator upstairs, and no one else was in the room where we collected our winter gear. Eric chose that time to ask if I'd have dinner with him. He had a date in mind. I gave him a hurried "okay," then asked him to remind me with a call at work. Then I walked away to catch a bus home.

Eric called with that reminder while I was still pondering my ongoing relationship. Having dinner with him struck me as a good distraction. Our first date was Chinese takeout in my dining room. For our second dinner,

Eric brought the food and cooked it at my apartment. Soon, we were having weekly at-home dinners, always at my place, and it wasn't long before Eric proposed marriage. Nothing he'd said or done leading up to that evening led me to suspect he'd pose that question. But he popped it in my bed just seconds after we had extinguished the short butts of our deeply inhaled, post-coital cigarettes. Long ago, I forgot what words he came up with to ask me to marry him, but I distinctly remember it being more of a transactional request than a romantic proposal. He'd brought me no flowers and had no ring to offer, nor had he gotten out of bed to ask on bended knee. Later on, after I learned of his two prior marriages and divorces, his tone and approach made sense.

His marriage proposal shocked me. In retrospect, he likely shocked himself. But when he asked, I said yes without hesitating. No man had asked me to marry him until Eric did, which was odd since I'd known Eric for much less time than I had any of my other boyfriends. What stood out to me was Eric's timing: he'd picked a time of incredible vulnerability for me. While my gut screamed caution, I didn't listen. I hardly knew Eric, yet I said I would marry him before setting foot in his Queens apartment. Nor had I met his family or friends. He mentioned that John, a magazine writer, was his closest friend and when he called John from my apartment he would hand me the phone and expect me to talk with him. We'd exchanged pleasantries but little more, and in the months leading up to our wedding, and in all the years we were married, I never met John. He wasn't in our wedding party, nor did he attend our wedding. Eric did introduce me to three friends who had taught with him at a private Manhattan high school, and each of them was a groomsman. An Episcopalian priest at that school married us.

After saying I'd marry him, I called my parents to tell them, though when I did I couldn't recall if I'd even told my parents that we were dating. It turned out I hadn't. My parents were fond of my long-term *Sports Illustrated* boyfriend, so I should not have been surprised when they responded with alarm and disappointment. I told them we'd visit them in a few weeks. Soon, Eric introduced me to his long-widowed mother, who was his only living relative, at dinner at a Fifth Avenue restaurant. By then, Eric had told me that he was two years old when his father died and his mother had lived alone in her Washington Heights apartment since then. I'd never been to that part of New York City but discovered that getting there entailed a long crosstown bus ride and a West Side subway ride from which we exited via an extra-long elevator ride to the street. On one ride to visit her, Eric told me that his

mother had enrolled him in the Cathedral School of Saint John the Divine on the Upper West Side when he was quite young. He'd boarded at the school and sang in its celebrated boys' choir.

His upbringing and mine could not have been more different. Add in his two failed marriages by the age of thirty, and our lives veered apart in every imaginable way. When I asked about his marriages, he told me little, and I didn't press for more. Given his family life, it was understandable that he leaned into the solitary life more than I did. I was the oldest of five active children raised in a gregarious, at times quarrelsome family that was steered by two extremely engaged parents. I was happiest when encircled by family and good friends. When I said I'd marry Eric, I didn't know all of this about him, though I should have. At a different time in my life, I would have insisted on knowing him a lot better before agreeing to marry him. I'd have dismissed his midnight proposal with a friendly chuckle. But I didn't, and after I said yes, I wasn't feeling as joyful as I thought I should. I kissed him lightly on his cheek before rolling onto my side with my back facing him, pretending to be on the edge of sleep. I wasn't. I just wanted to be left alone.

I slept fitfully, and the next morning the magnitude of my late-night promise hit me. Eric was asleep, given the later start to his workday. So I showered, trying to push away the enormity of what had happened by focusing on my workday ahead. Once I was dressed, with a banana in hand for my walk to work, I went into the bedroom to tell Eric I was leaving. At the office, I shared my news with no one, nor did I telephone close friends. This was my way of pretending Eric's proposal didn't happen. But it did, and even with these feelings I had, I refused to backtrack. Instead, days later I choose Monday of Memorial Day as the date for our wedding in Hyannis Port, Massachusetts. Monday was a good day for my *Sports Illustrated* friends, as a leisurely conclusion to our workweek leading into our Tuesday–Wednesday weekend. This venue was the village where my mother had come each summer with her family since she was a baby and where my family spent our summers. With our wedding happening six weeks after my April hearing, somehow I believed I'd have ample time to transition from my day in court to getting married. Then, we have a honeymoon, and I'd plan that too.

Clearly, I was living in my fantasy world with my blinders tightly secured.

Chapter Four

Rather than face up to the reality of marrying Eric, I'd concocted my fairy-tale wedding. I imagined myself as the bride arm in arm with my beloved father walking down the aisle of the beautiful stone church perched on the highest hilltop in Hyannis Port. Since I was a child, I'd admired this Episco-palian church on walks through our village. Sailing on Nantucket Sound, its tower on the hill served as a distant beacon guiding us back to the harbor. Known as Sunset Hill, its view west over the marshlands to the ocean lived up to its name with brilliant red skies behind the setting sun. At my early evening wedding, I was sure that Mother Nature would paint the sky in fiery hues as the sun descended and I posed with my wedding party for my for-ever photos.

Or, at least, I tricked myself into believing this would happen. Meanwhile, my insides roiled with uncertainty about marrying a man I wasn't sure I loved. I wasn't at peace. In my jumbled mind, I'd convinced myself that in becom-ing a wife, I'd find refuge from the rancorous attacks against me as news of my locker room case intensified. Sportswriters played up the angle of a single woman as a temptress for the ballplayers. Some implied, while others said, that I chased ballplayers for more than quotes. "Ms. Ludtke, who is a top-flight writer for *Sports Illustrated*, also sashayed around some of the other [Detroit] Tigers, asking pertinent little questions," columnist Douglas Bradford told his Detroit readers.[1] "The answers were woven into a fine story, I'm sure. I can only wonder if the highly reputable Melissa accepted any of the various invitations—mostly for drinking and carousing—from the Tigers."

Such accusations upset me, though I tried not to show it. I did not con-front writers who said what they said about me, even when their descriptions

didn't align with the truth. Where, I wondered, was their portrayal of me as a sports-loving woman who grew up loving baseball as passionately as her mother did? Where was the tale of my mother passing her love of the game to me? And where was I, the baseball reporter wanting only to have the opportunity to excel at this job I loved? I saw the press coverage as unfair, especially when I knew many of these sportswriters worked with me at ballparks. There, I'd given them no reason to characterize me as they did. I'd never thrown a tantrum or screamed at anyone, even though I had the right to be angry due to my treatment. I hadn't ever created a scene to demand equal treatment, nor had I pushed my way into a locker room to draw attention to the injustice of baseball's media policy. Yet I knew that if a male reporter had been treated as I was, he would not have shown the same restraint. Around the game, I obeyed rules while showing deference to men who'd done this job longer than I had.

On occasion, out of necessity, I'd been mother of invention in creating workarounds to the limitations imposed on me. In my second season, I'd sometimes ride to the ballpark with Reggie Jackson in his Rolls-Royce. That way we had time to talk, which was hard for us to do at the ballpark. Nothing I did tinkered or interfered with the men's access to players despite how their rules inconvenienced me. At ballparks, I took a gradualist approach in trying to gain equal access. Privately I prodded those who held the power to give it to me, though I never pushed for it publicly. In talking with women sportswriters working in the other leagues, I found out that all of us worked as best we could within limitations we had, while privately pushing for access each of us needed. As pioneering women working among men, none of us had the leverage to demand the change we needed. By working hard to earn respect from our colleagues and bosses, we hoped their support for our equal treatment would follow.

During the 1977 baseball season, I spoke often with Yankees PR director Mickey Morabito since I was at Yankee Stadium more than at any other ballpark. After the All-Star break, he came to me with a plan. After games, he'd walk in the front door of the clubhouse, then meet me at the clubhouse's unguarded side door, where I'd be waiting. From there, Morabito would escort me down the short corridor into the manager's office. I stay there for as long as I wanted, while Morabito returned to the locker room. I'd leave on my own through the side door. Just past Billy Martin's office was the door into the locker room which the writers used to shuttle between the manager and ballplayers. I didn't use it.

This was my routine until the season's last two games when Morabito left me clubhouse passes. His gesture shocked and delighted me. I spoke with him

on the field and he told me he'd alerted the guards at the clubhouse's front door to let me in. At those games, I stuck with my gradualist approach by using the clubhouse pass to talk with the players in the locker room only between batting practice and the start of the game. I didn't use it after those games because I had no assignment calling for me to be there. It felt wiser for me to be with the ballplayers in the more relaxed pre-game setting—without the issue of nudity being part of their concern—rather than in the more chaotic moments when they'd be changing out of their uniforms. I wanted the players to grow accustomed to my presence in this quieter, calmer forty-five-minute pre-game interlude when they played cards, signed baseballs, or sat near their cubicles talking with the media. At this time, they had no reason to worry about a woman being there. Yet, until Morabito gave me those clubhouse passes, I'd been kept out of the locker room before and after games.

When I was in the Yankees' locker room, no writer viewed my presence as newsworthy since none shared it with their readers. Nor did the ballplayers protest me being among them, though a few players had a few things to say about me being there. During the American League Championship Series, I was back in the Yankees' locker room, and still no writer found this newsworthy and no player tried to get me to leave. Again, a few players signaled disapproval by shouting unkind words, which I heard but ignored.

With the World Series approaching, I had every reason to believe my gradualist approach was working. How I'd handled myself with ballplayers and the writers had everything to do with why no one wrote about my expanded access. Flirting wasn't natural for me, and that was a good thing given the job I had. At ballparks, I knew that a cascading neckline and high heels were no-go to avoid being taken as a flirtatious fan. My short dresses and miniskirts stayed on hangers when I dressed for ball games. My inattention to makeup and absence of fashion sense came in handy since I didn't dress for the male gaze. Comfort came first. In those days, designers were trying to get career women like me to dress like men did by creating tailored blazers and trousers to mimic men's suits with neckpieces resembling ties. My outfits, some of which I sewed, suited more my 1960s hippie sensibilities. Wearing them, I felt feminine without being sexy. To look sexy in my job would only confirm some of the men's suppositions. For the record, I never went on a date with any ballplayer, coach, or manager. If anyone was watching, the closest I came to giving my naysayers a reason to suspect me was a lunch I had with Cincinnati Reds catcher Johnny Bench in a New York City hotel dining room in July 1977. *Sports Illustrated* picked up the tab since our conversation launched

my *Sports Illustrated* feature that was published as a lengthy spread in our 1978 baseball issue.

Still, for all of my efforts to fit into baseball, in many men's minds by being a woman I upended the cultural status as our national pastime that was bestowed on baseball before the Civil War ripped our nation apart. Factory workers, college students and sandlot kids, and later soldiers, played this game that Americans embraced as a unifying activity that was said to improve players' health by uplifting their well-being. Poets and writers, composers and authors saw this game as opening a window into America's soul. But by sticking around the game, apparently I endangered this. In a *60 Minutes* TV counterpoint commentary on April 16, 1978, conservative Jack Kilpatrick replied sharply when liberal Shana Alexander defended me. His stereotypical pocks revealed his sappy reverence for retaining men's modesty in this remaining bastion of baseball.

> Pushy, pushy, pushy, Shana, you gals are always pushing. Once we had some all-male colleges and some all-female colleges, and students could keep their minds on their work. Then we got coed dormitories and higher education went to the bow-wows. There used to be a rule against women on naval vessels—that rule went by the boards and now the Navy's down to 450 active ships. Once we had father and son events in the schools, we had all boy choirs. The federal government has done them in. Is no bastion of masculinity to remain? Must we reach a point where all, including modesty, is lost? Is it truly necessary in the holy name of equal rights for the gentle Melissas of this world to experience the roughness of a baseball locker room? There, they would hear language unfit for tender ears. Their downcast eyes would be affronted, their maidenly cheeks would soon be overcome by blushes, and all this just to get a quote from a swell-headed outfielder. No, Shana, say not so. Let us adhere to the grand design in which boys pursue girls and not vice versa. For after all, that's the national pastime.[2]

Playgirl postulated that I was the reason the Dodgers lost the 1977 World Series. In its story, "New Theory Explains Why the Dodgers Lost the World Series,"[3] manager Tommy Lasorda said, "Melissa is terrific; she's done a great job. But a lot of guys on our club feel uncomfortable naked in front of their wives." Memo to *Playgirl*: Since I wasn't allowed to enter the Dodgers locker room, no player could have felt uncomfortable in front of me. But that didn't matter to those who want to blame an activist woman for disrupting their lives. Rick Hassler, a sportswriter in New Mexico, wove the "women's

libber" bit into his story in another tiresome thread of men deserving equal treatment with female athletes in their locker rooms.[4] He wrote,

> If we look at the situation [the legal case against baseball] from a distance, we might be tempted to laugh, citing the matter as "just another area the women's libbers want to infiltrate." Taking that stance would be a mistake.... We should realize that the matter was bound to come up sooner or later, what with the growth of the women's movement, equal rights, Title IX, and all the rest. In short, we are for it as long as male sportswriters like us are accorded the same privilege at the same time. Having one without the other is not fair, but then again, Steinem has been saying the same thing about women's rights in a different form for years. For once, we agree with her. We never thought we'd agree with Gloria Steinem on anything.

Memo to Hassler: In the professional sports in which women competed in the 1970s—tennis and golf—the male writers had the same access that we did to those athletes since the interviews took place outside of locker rooms. All of the writers asked questions of the athletes at the same time.

Amidst this media storm, I had deluded myself into believing that I'd be treated differently if I were a man's wife and not a young, slender, blond, single woman. As silly and nonsensical as this sounds in voicing this feeling decades later, this notion was in play when I said yes to Eric and persisted as I forged ahead with my wedding plans against strong winds of opposition from family and friends. When I told friends I was engaged, they weren't happy for me. Their reactions were tepid, at best. "Are you sure?" some asked, their tone screaming "Don't do this." They quizzed me about how long I'd known Eric and what I knew about him since I'd said yes so fast that most of my friends had not met him. I tried to allay their misgivings by having Eric join in activities with them, but inevitably he'd cancel at the last minute. I started finding his excuses difficult to believe. Friends cornered me telling me not to marry him, or at least not so quickly. They offered sensible alternatives. "Postpone your wedding until you know him better. Then if you still want to marry him, okay," one friend suggested, after I'd rebuffed another friend's advice to break the engagement. "Okay, say you're engaged but get married next summer," this friend pleaded. "Just don't do it *this* summer."

What my friends said made sense, but I heeded none of their advice. "This isn't like you," another close friend told me. She was right, but I offered little in the way of explanation. I'd lost my way, I was embarrassed to admit that what men were writing about me had burrowed its way so far under my skin

that marrying Eric seemed an opportune exit ramp. The men held the media megaphones to reach Americans' ears, and they were telling *my* story as *they* wanted to have it told. Seeing no way to change this, I soldiered ahead by telling myself that I'd find ways—and marriage became one of them—to plow through. Temperamentally, I was not a fighter, so when conflict arose I raced to find the middle ground. In younger years, I'd believed that if I let time pass, then confrontation could be avoided. I brought this frame of mind into the public arena where it wasn't my instinct to strike back. Word punches came at me, and I ducked. Nor did I raise fists to fight. But I found that the longer I absorbed what they said about me, the more stressed I felt.

* * *

Late in January, Eric and I made my promised visit to my family in Amherst, Massachusetts, where my two younger sisters lived with my parents. On our way there, Eric asked me to turn off the highway in Springfield to drive through American International College, his alma mater. By the time we arrived in Amherst, we ate supper, then Eric and I sat with my parents in front of the fireplace in the living room. My mom and dad asked plenty of get-to-know questions with marriage in mind. Eric was uncomfortable, which I could tell by his progressively shorter, stilted responses. When this get-to-know exercise was over, my sisters joined us. That night Eric and I slept in my brother's bedroom. I was up for breakfast before Eric was, and I could tell my parents were not impressed with him as my future husband. They'd adored former boyfriends, and one had moved in with them for his senior year of college. Their vibes were very different about Eric. Still, after I'd eaten, my mom asked if I'd like to try on her wedding dress. Her offer surprised me, but I accepted. I left Eric at the table with my dad, who could talk with anyone at any time. In my parents' bedroom, I saw on the bed a large, heavy box that my mom had opened to reveal the carefully folded, ivory-colored, satin wedding dress that she'd worn thirty years earlier. She lifted the dress from its shoulders, holding it briefly against her body with its hem brushing the floor. I'd seen her wearing this dress in black-and-white photos of their wedding. A few moments later, she helped me wiggle my body into her dress. Once in it, her dress felt like a tailor had sewn me into it. I told her I wanted to wear it. For the first time during this visit, my mom's expression brightened. If I was marrying Eric, she seemed happy I'd be in her dress.

When I backed the car out of the driveway to head home, my mom's wedding dress—now mine—had been refolded and its box was on the back seat.

I'd checked "dress" off my wedding to-do list, signaling progress of the kind I liked. Cruising on autopilot, I moved things along so I didn't have to sit with my thoughts. I needed to buy a veil and shoes, choose my bridesmaids' dresses, order bouquets for me and them, and select flowers for the church and reception. I also had to hire a photographer and a band or DJ. Then, I'd plan our honeymoon.

In May, I'd walk down the aisle.

Meanwhile, at work, my life was frenzied. I'd been invited to speak before groups of people in locations from Fort Wayne, Indiana to Washington, D.C. These, plus radio interviews, gave me the opportunity to tell *my* story rather than surrender its telling to men. In my speeches, I explained why I needed the same access the men had. This was my only chance to speak up for equal access since I knew that I couldn't depend on phrases like "equal access" or "women's equality" showing up in stories. Male writers didn't tend to use those words. Yet in *my* speeches, these ideas were at the core of my remarks. But to give a speech meant I had to set aside time to write it, and speechwriting wasn't something I'd done before. When no one at Time Inc. volunteered to help me do this, I had to figure out how to do this on my own while also reporting NBA stories and writing my baseball feature story.

Even before Eric entered my life in January, its pace had been more frantic than usual. And I wasn't hitting the pause button when I should. Since my contretemps with Kuhn in October, my life had been spinning out of control. After games, I usually went to Runyon's, the popular East Side sports bar, to join a table full of sportswriters. I'd wash my late-night order of a burger and fries down with a drink or two. Some nights, I'd have three, which was more than I could handle. Late that fall I'd left Runyon's one night with a sportswriter I knew well but had not dated, nor did I think it likely we ever would. I wasn't staggering as I left with him, but I'd had enough to drink that I didn't resist when he walked us to his nearby apartment. Alcohol had loosened my restraint, and I'm sure I was pleased that at last I'd caught this man's attention. He led me directly to bed. My diaphragm was at home, and he did not use protection. Seven weeks later, after missing a second period, I went to a doctor who confirmed my unintended pregnancy soon after my legal case was breaking news nationwide. I knew instantly that if word of my pregnancy slipped out, baseball and its allies would use this circumstance to their advantage. It would make it easier for them to get the public to see me as a vixen who didn't belong near the ballplayers.

I worried this could doom my legal case.

I didn't hesitate in asking my doctor to schedule an abortion. Fortunately, I was not in any way conflicted between my own desire to end this pregnancy and my understanding of what was best for my legal case. This alignment in my feelings made this decision less difficult for me to make. I knew I wasn't ready to be a mother, certainly not a single one, and I wasn't about to get married to the man who had impregnated me, nor would I consider parenting with him. In fact, I had no intention of even telling him about the pregnancy. I wanted my life to remain as it was so I could do the job that I was fighting in court to do. Before my doctor set up my appointment, I explained that he had to register me as his patient using a fake name. He'd heard about my case and understood, agreeing to make this work for me. I made up a name, which he used when he made the call. The earliest appointment he could get was on the second Wednesday in January, which was five days away and conveniently on my day off from work.

Only an hour or so after I left this doctor's appointment, I had my first date with Eric. This was the one we'd agreed to after that Knicks' game. Although I was reeling from this news, I didn't cancel our dinner. Instead, I told him I wasn't in the mood to go to a restaurant. That's why we ordered takeout from a Chinese restaurant that he picked up. Then, after dinner, I said I was tired, so he left and I went to bed. In the morning, I walked to work as usual, but by lunch I felt sick. Without a pressing need to stay at work, I asked if I could leave, then took the bus home and slept. On Sunday, I relished the relatively empty streets and uncrowded sidewalks as I walked to the office for what I knew would be a long, busy day. Monday afternoon I went home early again to nap. I set my alarm so I'd be awake when Eric came by for a movie. On Tuesday, I slept in. That afternoon I took the subway to the Bronx to play tennis indoors with Peter Carry. We split two hard-fought sets, but in the third I was exhausted and didn't win a game.

On my subway ride home, I wanted to lie on the subway's long bench and sleep.

Wednesday morning, I took a taxi to the clinic in Lower Manhattan. In the waiting room, alone with my thoughts, I filled out medical forms using my fake name as I waited to be called for my abortion. All morning long I hadn't been able to shake from my mind that a week earlier I'd gotten up before it was light outside to appear on the *Today Show* talking about my case. That morning I didn't feel well, but I'd done my best to help viewers understand why I needed the access the men had.

One week later, I wanted none of them to ever find out where I was.

I left the recovery room about an hour after my abortion and took a taxi to the Upper West Side where Carry and his wife, Virginia, lived along the Hudson River. He was the only person whom I'd told about my pregnancy. I'd done that after we'd played tennis the day before. He'd kindly suggested that I recuperate at their apartment so I wouldn't be alone. Thanking him, I said I would. Riding there, I was glad I did. He set me up in a room where I slept for few hours on a comfy couch under a soft warm blanket. When I woke up, Peter made lunch for us. Later that afternoon, I took another cab to the East Side to join friends in a bridge game I'd scheduled long before. I carried on as if this were my usual day off from work.

Two days later, on Friday afternoon, January 13, I walked a few blocks from the office to the Ed Sullivan Theater, where I'd be back in front of TV cameras with another inquisitor. This time it was *ABC Sports* broadcaster Howard Cosell. I felt good about my interview with him, in part because he was also a lawyer and his gung-ho attitude about my prospects in court gave me an emotional lift I needed. At home, I made comfort food, popping a big bowl of popcorn with lots of butter on it. With my bowl in hand, I propped myself with pillows to watch the Nets play the Celtics and the Knicks take on the Warriors.

I was happy to be watching basketball in my living room, while from fourteen floors below me I could hear the sound of people showing up at Maxwell's Plum. The *New York Times* described Maxwell's as "a flamboyant restaurant and singles bar that, more than any place of its kind, symbolized two social revolutions of the 1960s—sex and food."[5] Sitting above this rowdy New York nightlife, I felt fortunate and content to be a young woman living in this time and place. At twenty-six, I had the job I loved and a company backing my case for equal rights. With the *Roe v. Wade* decision five years earlier, I'd had an abortion I both wanted and needed.

Most of all, at that moment, I loved being alone and away from the tumult taking shape around me.

Chapter Five

The courthouse portico was a good place to pause after rushing up the stairs. Fritz and his associates had gone inside when I stopped to take a few calming breaths and wait for Eric to catch up. When Fritz had sped up, Eric fell behind. Once he reached the portico, we went inside where I saw that my legal team was putting their New York Bar Association IDs back in their wallets after showing them to the guard. He waved them through the turnstile and, on Fritz's word, signaled us to follow. We fell in behind Fritz, and with a steady tap-tap-tap of Catherine's heels on the marble floor, we made our way to the courthouse bank of elevators, where we waited for its notoriously slow elevators to fetch us. Our express ride zoomed us to the thirteenth floor, where the five of us walked to Judge Motley's courtroom, room 1306.

Fritz held the door for me, and I walked in first. Soon, he'd brushed past me on his way to the far side of the courtroom and the plaintiff's table. I stared in awe at my new surroundings. An elegant light resembling a collection of upside-down glass bowls hung from the high ceiling infusing the courtroom with subdued light. Rays of sun angled through the south-facing windows accentuating the gleam of the courtroom's polished oak walls with classic arches and columns of wainscoting. Looking around, I noticed a door barely distinguishable from the wall. Only its knob protruded. It was next to the judge's raised bench, so I figured it must be Judge Motley's private entrance. From there, she had a few steps to reach her upraised seat, where she'd look down on the proceedings.

Fritz got to work quickly, spreading his documents across the wooden table where he and his team would sit. When I got there, I noticed how meticulous he'd been in separating each document from the others. This way he'd

easily find the one he needed in the heat of the hearing. His assistants' chairs were a bit back from the table, and their black briefcases with flaps open were on the floor near them. I watched them run their fingers over the files, separating them one from the other. Even this brief tactile reconnection with the case files readied them for a moment when Fritz would ask them to find a document quickly. From there, Eric and I walked up the aisle separating the defendant's side from the plaintiff's side and chose the bench two rows behind my team as our seats. Once we were settled, I scanned the courtroom and was surprised not to see familiar faces. After the abundant coverage of my case, apparently no editor had felt the need to assign a writer to cover this hearing. I got it, sort of. Why bother with reporting on the legalities of gender discrimination and equal access when nudity and sexual tension were selling their newspapers?

Kuhn's team of lawyers entered the courtroom a few minutes later, so I looked in their direction, curious if they'd prepare like my team did. Soon, Mary Gibbons, the lawyer assigned by Time Inc. to monitor my case, walked in, and after saying hello to Fritz, she slid in behind us and nodded hello. I didn't wear a watch, nor did Eric, so I didn't know how close we were to four o'clock. So I fixed my gaze on that hidden door. When I saw it open, I figured it would be four o'clock, trusting Judge Motley to be on time.

* * *

It was quite late in the fall when Time Inc. approached Fritz about my case. Kuhn and his lawyer had made it increasingly clear that the commissioner wasn't going to budge from his policy of giving me *separate* accommodations outside of the locker room. Evidently, he believed that by doing this he'd made our access *equal* to what male writers had. Time Inc.'s negotiating team— *Sports Illustrated*'s baseball editor and its in-house attorney, Harry Johnston— were adamant that equal meant equal, as in the same for me as it was for the men.

Once Time Inc. decided to file a complaint with the court, its outside law firm handled the case. This was routine for the company's court cases. Time Inc.'s outside counsel was one of Manhattan's oldest law firms, Cravath, Swaine & Moore, founded in 1819, and Fritz, a partner at that firm, was assigned to us. Time Inc's usual court cases involved First Amendment challenges, but mine was different. Although Fritz raised First Amendment protections in our legal brief, the Fourteenth Amendment would drive his argument. When Johnston initially called Fritz to discuss this potential case,

Fritz's New York office patched the call through to a White House operator who, in turn, relayed it to Vice President Walter (Fritz) Mondale's office, where Fritz was meeting with "the other Fritz." Their friendship had blossomed during hearings of the Church Committee,[1] named for its chairman, Frank Church. Mondale, then a U.S. senator, was a committee member, and Frederick A. O. "Fritz" Schwarz Jr. was its chief counsel. At thirty-nine, Fritz was youngest chief counsel in the Senate's history when this committee hired him to lead its investigation of unauthorized activities of U.S. government agencies. In this role, Fritz unearthed 110,000 documents and examined, with his staff, 800 witnesses. Then he testified in public session about what they'd found.

Among the documents Fritz surfaced were ones showing that the Central Intelligence Agency had "enlisted Mafia leaders in its plots to kill Cuba's Fidel Castro." He also described secret cables the Federal Bureau of Investigation (FBI) sent Martin Luther King Jr., explaining that the FBI went "so far as to mail anonymous letters to Dr. King and his wife." One cable suggested: "King, there is only one thing to do, and you know what it is. You have just 34 days in which to do it." Thirty-four days later, King would be in Sweden to receive his Nobel Peace Prize.

When Fritz read as testimony that letter's last words, "You are done," he shook his head.

"If I could interrupt," Fritz Mondale said to Fritz Schwarz. "That was taken by Dr. King to mean a suggestion for suicide, was it not?"

"That's our understanding, Senator," he replied.[2]

After Mondale was elected vice president in 1976, he would invite "the other Fritz," who had resumed his litigator role at Cravath, back to Washington for consultation about moving the Foreign Intelligence Surveillance Act (FISA) from the committee's vision into law. Based on what was learned by the Church Committee, FISA was created to impose judicial approval and congressional oversight onto government surveillance activities.

Fritz told Johnston that day that he wanted to take my case.

Years later, he told me: "I remember feeling I wanted to do your case. It seemed a natural extension of the principles of the civil rights movement to the women's movement. And it fit with my ambition in coming to Cravath not only to succeed in private practice but to find ways to participate in controversial and important public policy issues." Later, in a law review article, "An Awakening: How Civil Rights Movement Helped Shape My Life,"[3] Fritz wrote of the roots of his lifelong adherence to the principles of equal rights and his activism in promoting them. In his last semester at Harvard Law

School in 1960, Black university students were arrested during their sit-ins at segregated lunch counters in Greensboro, North Carolina. Fritz organized students in "sympathy picketing" at Woolworth's on Brattle Street in Harvard Square. At this time, only eight women and one Black man were among the 525 members of his law school class. Three years later, Fritz traveled from New York to participate in the March on Washington that August. He wrote later of how that march affected his life: "Of course, I did not know that within a few months I'd be working with the architects of the March on Washington[4] or that 12 years later my job with the Church Committee would reveal that right after King's speech the Federal Bureau of Investigation resolved to destroy him."

To prepare my case, Fritz unearthed and read documents just as in his prior job. As part of my case's discovery process, Kuhn had to hand over private, confidential memos related to the creation in 1975 of his no-women-in-the-locker-room policy, along with all interoffice memos in which my case was mentioned. The Yankees and New York City, as named defendants, also had to produce documents that dealt with the Yankees' lease of the stadium from the city, as well as information about taxpayer funds that they city dedicated to Yankee Stadium's recent reconstruction. Relatively early, Fritz had concluded that winning my case meant tracking the dollars that went between the Yankees and the New York City coffers. If Fritz could convince Judge Motley that New York City was engaged in ways that connected them as a "state actor" with the Yankees and their stadium, where Kuhn banned me, then the Fourteenth Amendment could be brought into play. Without Fritz establishing, to the judge's satisfaction, the presence of a "state actor," then that amendment's due process and equal protection clauses could not be applied.

* * *

In the early rounds of *Sports Illustrated*'s meetings with Kuhn, the negotiators handed me an opportunity to test Kuhn's notion that separating me from writers in the locker room would give me a reporting experience equal to theirs.

Just before I left my apartment to go to Game 6 of the World Series at the stadium, I received a phone call from *Sports Illustrated*'s lawyer. He presented me with the plan that the men negotiated for me to use after that game. Larry Shenk, the Philadelphia Phillies PR man, would meet me outside of the locker room of my choosing, which presumably would be the winning team. Shenk

would be my runner. I would be stationed just outside the locker room door while he went in to fetch the players whom I would ask him to bring out so we could talk. Only under protest did I agree to do this, knowing it wouldn't work. By Kuhn assigning Shenk as my "male escort" that night, he was also admitting to us that his "separate accommodations" policy was nothing but his PR stunt. If such arrangements already existed for us, then he didn't need to give *me* my own escort.

I bluntly told Johnston that this plan concocted by men without input from me wouldn't work. Until his phone call, no one at SI had shared with me their thinking on this matter, nor had anyone sought my advice in negotiating with Kuhn. So it did not surprise me that they devised an unworkable solution. Still, I agreed to this "fetch a player" idea, hatched in their afternoon meeting in Kuhn's Rockefeller Center office. I told Johnston it was lunacy to expect me to report under the conditions they'd bargained. During the season, I had asked friendly writers as they went into the locker room to ask specific players to come out to talk with me in the dugout. Few of those players showed up. At the height of this World Series, why did these men think that a player would come out to talk with me especially if his team was celebrating in the locker room? Johnston wasn't a reporter, so he had no way of knowing this, and Carry had covered the NBA for *Sports Illustrated* before female writers had equal access. Neither man knew how baseball worked, nor had they asked me what I knew. I'd just waited for them to tell me what to do, and then I did it.

By the time I got to Yankee Stadium for Game 6, batting practice was underway. On the field, I introduced myself to Shenk and we agreed to meet outside of the winning locker room after the game. Johnston had also asked me to find Bob Wirz to tell him I was cooperating with their plan. When I found Wirz, I repeated that I was cooperating under protest. In that game, the Yankees' Reggie Jackson hit three home runs, each on the first pitch, propelling the Yankees to their first World Series win in fifteen years. After the final out, New York fans charged out of the stands toward Jackson who with his head down and elbows out was running as fast as he could to safety. I watched Jackson descend into the dugout, and from there the tunnel would take him to the locker room door. I headed to the media interview room, passing by the door to the Yankees' clubhouse, where boisterous fans were congregating already. After this short press availability with individual players, I walked back to the Yankees' clubhouse door where Shenk said he'd meet me. By then, the unruly crowd of fans was much larger, so he and I had to elbow our way to the door. He shouted to be heard even though I was standing

next to him. Then I yelled back the name of the player with whom I wanted to speak.

"Reggie," I screamed. It's likely he read my lips since it was impossible to hear each other over the fans' deafening cheers.

Shenk signaled for me to wait there, then he went inside. The raucous scene outside the locker room was becoming rowdier, bordering on unmanageable. The New York police showed up to hold the fans back as they tried to keep a path to the door open for writers to get inside. As I stood near the door, strangers' bodies squished against mine, flattening me against the concrete wall. I seethed when the guards at the door let men inside who showed no credential permitting them to be there. My press credential said I could be in the clubhouse, yet I was kept outside while a champagne celebration happened inside. Stories I read told me that Reggie had hugged George Steinbrenner and Billy Martin. Only weeks earlier Reggie and Billy had to be held back from throwing punches at each other in a Fenway Park dugout. Throughout America, women were able to see inside of the locker room thanks to a live TV camera. Standing outside, I saw and heard nothing about what was going on inside.

If Shenk somehow managed to get Reggie to come out to talk with me, he wouldn't hear me and I wouldn't hear him. The screams from his fans would be unbearable, and I didn't think he'd be safe with people all over him as they were on the field. But as things turned out, Kuhn's plan worked even worse than I feared it would. Shenk came out and yelled to me that he wasn't able to produce Reggie for me. "He's surrounded by press," he mouthed. In Shenk went again and, a while later he came out with a player who hadn't even played in the game. I tried asking him a few questions, and strained to hear his answers. When Shenk was ready to head back inside, I asked him to bring the next ballplayer into that corridor leading to the manager's office. I knew that place from my excursions to Martin's office. It would be quiet there.

"Bring Reggie," I shouted just before Shenk vanished inside.

As I walked to side door of the clubhouse. I was tired of playing the hands these men were dealing me. I'd shuffle the deck by going into that corridor so I could actually speak with players. But when I got there, I discovered guards posted inside the door who said I couldn't go into the corridor even though it was separate from the locker room. Kuhn had ordered tighter security for Game 6. When I asked the guards why tonight was different, they slammed the door abruptly, catching my foot in it. When they opened it a crack, I pulled it out, Then, they pulled the door shut, and I heard them lock it.

I returned to the clubhouse's front door. It was almost midnight, and with the crowd of fans there thinning, Shenk emerged to tell me that Jackson was

still surrounded by reporters. He could not bring him out. When I'd also asked for Billy Martin, since I couldn't get to his office, Shenk said a dozen writers were with him, so he could not come out either. While I waited again for him to deliver Jackson or Martin, I asked Sal, the guard I knew well, if he'd been given instructions that day about women in the clubhouse. "Sal, no ladies allowed," he said a man from Kuhn's office told him before the game. This was the first time he'd been given these instructions. Of course, it was assumed for years that no woman was allowed in, but Sal also knew that Morabito told him at the end of the season that it was okay for me go in.

Now I couldn't.

Twenty minutes later, I was still standing against the concrete wall near the locker room door and watching men casually walk in and out without showing any credential. In the hour and a half that I'd been there, Sal had asked me more than once to step aside to let a group of men by on their way inside. Suddenly the door opened from the inside and Jackson, dressed in his street clothes, stood in front of me. The remaining fans encircled him, pleading for him to sign a scrap of paper or an item of clothing. While he obliged a few, he shouted "Hey, Melissa, I've said everything I have to say. I'm heading downtown." With that, he went back into the locker room and likely left through the side door to avoid the fans. Martin hadn't shown up and I was tired of waiting. I said good night to Shenk and headed downtown too.

I went home.

* * *

Fritz came to the April hearing convinced that Kuhn's separate-but-equal media policy would not withstand constitutional scrutiny. Yet he also knew that Judge Motley would only apply the Fourteenth Amendment to our case if he could concretely connect the discriminatory action Kuhn took with me with government "entwinement," the word found in legal precedent. In his public statements, Kuhn said he fully trusted his lawyer to convince the judge that "the personal dressing quarters of players cannot reasonably be regarded as a place of public accommodation." Climenko stressed this in his legal brief. Kuhn seemed sanguine that this case did not intersect with any Supreme Court ruling like the 1954 decision in *Brown v. Board of Education* that occurred four years after his graduation from the University of Virginia Law School. In that unanimous ruling, the justices struck down the court's 1896 ruling in *Plessy v. Ferguson* in which "separate but equal" had been established as a rationale for segregated policies involving public facilities. Kuhn's media

policy wasn't much different; he believed that he could separate me and still call my access to the team equal. But if Fritz could convince Judge Motley of his "state action" argument, then she could turn to the U.S. Constitution to decide my case.

To ground his "state actor" argument, Fritz would emphasize the location where Kuhn had issued his edict against me. In that way, Yankee Stadium would become his lever for arguing that the "state action doctrine" ought to apply. Its contemporary version had been spelled out in the 1961 U.S. Supreme Court ruling in *Burton v. Wilmington Parking Authority*. In that racial discrimination case, a privately owned restaurant in Wilmington, Delaware had refused to serve a Black man. That restaurant—the Eagle Coffee Shoppe— was tucked into a corner of a public parking garage. The city paid for the garage's heating and gas services and helped maintain the restaurant with taxpayer funds. Fritz saw parallels between my case and the circumstances in Wilmington since in the mid-1970s the city of New York had spent $50 million in taxpayer dollars for the stadium's reconstruction and held a thirty-year lease on it with the Yankees. If Kuhn had discriminated against me in a ballpark built and sustained with private funding, then Fritz could not have asserted that "state action" applied. But with Yankee Stadium standing in for the Eagle Coffee Shoppe, Fritz would show that each entity was tethered to city funds. Switch the prior plaintiff being a Black man to me being a woman, and Fritz saw a legal pathway to why the Fourteenth Amendment should be applied in my case.

The State Action Doctrine[5] extends back to 1875. But it was in the 1960s when judges and justices were hearing numerous racial discrimination cases, that the U.S. Supreme Court updated the nearly century-old doctrine. For a federal judge to rule on a claim of discrimination brought against a private entity or person, she must first find the existence of a "close nexus" between activity by a "state actor" and the defendant's action. Only when persuaded that such an entanglement exists can a judge then render a decision based on constitutional protections. If a lawyer can't prove this "close nexus," the judge cannot use the Fourteenth Amendment.

If Fritz failed in this step of the case, we'd likely lose.

* * *

Back in the courtroom, the door in the wall opened. When Judge Motley entered the courtroom, I saw Fritz and all of the other lawyers rise, so I rose too and remained on my feet until she was off hers. She spent some time

repositioning on her bench the piles of papers and stacks of three-ring binders that contained the deposition transcripts, numerous affidavits, case documents and labeled exhibits that were sent to her before the hearing. Then, looking down at the lawyers who outnumbered the spectators, she raised her right arm. When she lowered her gavel, its booming sound signaling the start of the hearing in *Ludtke v. Kuhn*.

Immediately, she engaged the attorneys in saying yes or no to her request to enter into the record the amicus brief submitted by the American Civil Liberties Union. Hearing no objection, she then proceeded to excuse from this case three New York City defendants, including the city's mayor, Abe Beame. She saw no reason for them to remain part of this case since there were no facts in dispute. The defendants agreed with her, but Fritz didn't. She dismissed them. Had our hearing been a trial in which witnesses were called, it's likely she would have had them stay.

"We will proceed with the plaintiff's motion for summary judgment," she announced.

Fritz rose and walked to the center of the courtroom, stopping about ten feet from Judge Motley's bench.

At last, I'd hear the argument that we had spent months together preparing.

Chapter Six

That I was at this courthouse.

That I was the plaintiff in this notorious gender discrimination case with Major League Baseball.

That Time Inc. and the editors at *Sports Illustrated* backed me by taking this legal action.

That all of this was happening bordered on miraculous, especially in light of how poorly the baseball writers and the managing editor at *Sports Illustrated* had treated Stephanie Salter when she was the junior baseball reporter four years earlier.

In January 1973, the New York chapter of the Baseball Writers Association of America (BBWAA) held its winter gala at which men exchanged their ballpark leisure suits for tuxedos. It was billed as a stag event with risqué entertainment to titillate the guys. On deck as the evening's keynote speaker was Casey Stengel, the former manager of the Mets and the Yankees who was known as the "philosopher of baseball," though on occasion he'd advised ballplayers on their sex lives: "Being with a woman all night never hurt no professional baseball player," he'd said. "It's staying up all night looking for a woman that does him in." When *Playboy* publisher Hugh Hefner showed up at spring training with a bevy of his "bunnies," Stengel joked that he ought to take the women to another field "and find out if they can play on the road."[1] This, and much more he'd said, made him the perfect speaker for an event that one sportswriter described as "the largest, oldest and most prestigious affair run by the association." He could have added "stag," since women were told to stay away.

When SI's baseball editor couldn't use his ticket, Salter asked for it. "Stephanie, you can't go," he explained. "It's men only." When she pressed him, he

gave it to her. By then, she wrote, "we were in agreement that the stag nature of the event warranted a challenge." When a reporter asked why she went to this men-only event, she said, "I wanted to hear Casey Stengel in person since I never had, and I wanted to challenge the male exclusivity. I didn't know until my editor told me that it was male only. I couldn't believe no woman had tried to challenge it before." At the gala, as the only woman in the gigantic ballroom, Salter didn't last long. After eating her fruit cup, she was sipping chicken consommé when the headwaiter told her to leave. She refused. When a BBWAA officer issued her a get-out-of-here order, Salter showed him her ticket as fellow baseball reporter, Jim Kaplan, defended her right to be at the *Sports Illustrated* table. When the man insisted that she had to leave, Salter told him she'd consulted a lawyer before coming to the dinner and he'd told her to sue the BBWAA if such a thing happened. She remained seated. Soon, a uniformed security officer came over to tell her to leave, which she did "under protest." Writing in *Newsday*, columnist Steve Jacobson, after observing the contretemps, compared Salter with women's rights activists fighting discrimination. "She had fought a battle of women's liberation against the male sanctuary of the Baseball Writers Association and lost," he wrote. However, the headline his editors put on his column—"Writers Block a Damsel at the Plate"[2]—did everything but convey this message.

The *New York Times* story about Salter's expulsion applauded baseball's men for holding the line against her audacious invasion of their sacred—and segregated—tradition. Its headline aligned well with its non-bylined story— "Baseball Dinner Keeps a Tradition, Ousts Woman."[3] In it, Salter was quoted as saying, "I'm going to sue. What they did was unconstitutional." The *New York Post*[4] also quoted Salter on this point: "The fact that I had a black tie on and because it was in a public place (the Americana Hotel) and because they were not turning away male sportswriters without black tie indicated that my constitutional rights were violated." She added, "I'm going to carry it personally as far as I can go, if it's financially feasible." The New York *Daily News*' headline spotlighted her intention—"Ousted by Writers, She Plans Suit,"—while the *Spokane Daily Chronicle*'s reprint of the Associated Press story employed a more prosaic, if less informative, headline, "Dinner Bars Gal Writer."[5] Its use of *gal* condescendingly conjured up a *gal Friday*, aka the woman as a man's efficient and faithful assistant, which wasn't a good fit with what this twenty-three-year-old baseball reporter had just done.

The headlines' evocative, eye-catching words were filled with puns and dripping with cuteness. They were also devoid of context and obliterated the

purpose of the woman's action by focusing on its harm to men. In referring to Salter and me as "girls," men diminished our role as adult actors. "Damsel" did a similar disservice. Although "damsel" refers to a young, unmarried woman, when readers saw that word, they thought of *a damsel in distress*. Seeing that word in a headline brings to mind the black-and-white films when the male hero gallops toward a train barreling down on a damsel tied to the tracks. Of course, the man rescues her. "Writers Block a Damsel at the Plate" proclaimed Salter's helplessness, even as *Newsday*'s columnist lauded her challenge to the gala's gender barrier.

The headline drawing men's eyes to the story rendered the reality of Salter's action immaterial.

* * *

At the time, Salter believed Time Inc. would back her and take legal action against the BBWAA. For many decades, she also believed SI's managing editor backed her. Reluctantly he signed the letter that SI sent to protest the BBWAA's actions, but internally he did everything he could to avoid supporting his baseball reporter.

"We [Time Inc.] have a women's agreement with Time Inc. and in cases like this, the management is supposed to stand behind it," Salter told the Associated Press.[6] Back at her desk, Salter wrote to Time Inc.'s vice president, Bob Steed, who oversaw the compliance agreement corporate executives signed in 1971 to end the legal challenge by its female editorial employees. In their petition, the women had cited seventy alleged gender discrimination incidents related to practices at Time Inc. publications. In signing this conciliation agreement, Time Inc. did not accept fault though its leaders pledged to treat men and women equally in hiring, pay, and promotion. After Salter told Steed what had happened to her at baseball's gala, she asked for support: "I sincerely hope that Time Inc. will see fit to support me in this incident and subsequent legal case," she wrote.[7]

It had been the women at *Newsweek* who in 1970 first acted against their company's unfair gender practices. Soon after their victory, twenty-three female staffers at *Sports Illustrated* joined more than one hundred women at Time Inc.'s other magazines—*Time*, *Fortune*, and *Life*—in filing similar discrimination charges against their employer. In all, 35 percent of the company's professional female staff demanded that Time Inc. halt its discriminatory gender practices in hiring, promotion, and compensation. At *Sports Illustrated*, a lot of women staffers decided not to sign the petition. Some

said they were okay with how things were for them while others worried about how their careers would be affected if they did. Years later, one woman told me she believed that she'd lose whatever slim chance she had of being promoted if she signed the petition. It's likely she was right, at least as long as André Laguerre remained as managing editor. He'd created *Sports Illustrated*'s money-making swimsuit issue, and had had let it be known that if a woman at SI signed the petition, her climb up the editorial ladder was unlikely. He was a man of his word.

Sexier is better, Laguerre had assured his art director, referring to the covers with skinny women in skimpy bathing suits. By the time I got SI in September 1974, scanty swimwear on beautiful women was a *Sports Illustrated* institution *and* the conciliation agreement in support of equal treatment of women was three years old. A few things were changing, mostly for the men. *Sports Illustrated* was hiring more men as reporters, which until then was the usual entry point for women. Then, the job's title was "researcher," but whatever name the job had its basic task was to fact check writers' stories. Except for two women editors, neither of whom oversaw any major sports league, *Sports Illustrated* was top heavy with men.

Once I settled into my entry-level job, I realized that a woman's success depended largely on how well she made the men around her shine. This concept of women's work at Time Inc. had originated at *Time*, soon after Henry Luce and Briton Hadden, graduates of all-male Yale University, founded this magazine as the first newsweekly in 1923. A *Time* editor wrote a memo setting the parameters of this "girl" fact-checker job. Until then, checking facts at newspapers had been one of many tasks assigned to copy editors who were not given the time to apply the painstaking precision that was expected of fact checkers at Time Inc. From the start, *Time* classified this as a role for "girls," attesting that its requisite duties were especially well suited for them. "Any bright girl who really applies herself to the handling of the checking problem can have a very pleasant time with it and fill the week with happy moments and memorable occasions," this *Time* editor wrote. Among the girls' "happy" obligations was being the insurance policy to protect male writers and editors from bearing responsibility for errors or mistakes. This girl's job was to scrub stories clean of any writer's or editor's mistakes. Constantly at the ready, she was his *Gal Friday*. Then, as if speaking directly to these fact-checkers, this editor wrote sternly, "Remember that when people write letters about mistakes, it is you who will be screeched at."[8]

Before Time Inc.'s conciliation agreement, "any bright girl" who wanted to work at a magazine there gamely assumed the selfless task of ridding men's

stories of errors. By the time I got there, this job title had been upgraded to reporter to provide the illusion that it offered a wider range of possibilities for the person doing it. This change happened when men were hired as fact-checkers, which wasn't coincidental. For many of them, the job was a place-holder until they were moved up to be writers while most of the women stayed put as fact-checkers. A lot of the women reporters at SI were a decade older than I was. They had done nothing but fact-check stories in their many years there, and they seemed reconciled to doing this until they retired.

I wasn't.

As other news organizations experienced employee-led legal challenges to their patterns of gender discrimination, metro newspapers went look-ing for women to hire to write sports. Editors seeking top female talent looked to *Sports Illustrated* where the women were not finding opportuni-ties to advance. A few months after I arrived, Jane Gross had been hired by *Newsday* to cover pro basketball. A while later, Stephanie Salter left her reporter job and moved to the West Coast. Soon she was covering baseball and basketball for the *San Francisco Examiner*. I was hired to fill the slot left empty when reporter Susan B. Adams took a job as editor of *World Tennis* magazine. I was inspired by these three women who'd put thou-sands of red checkmarks above writers' words to confirm their accuracy; they'd left to be writers and an editor at major sports publications. Although I loved reporting baseball at *Sports Illustrated*, I wondered if one day I'd need to leave the magazine to advance my career like they did. If they'd stayed at SI, their climbs up the editorial ladder would have been long and hard. I knew that working hard and putting in tons of hours might not be enough for me to be promoted either. Changing the male culture of *Sports Illustrated*, one that permeated all of sports, was neces-sary if I had any hope of advancement.

* * *

For decades, Salter had believed that SI's top editor, André Laguerre, had sup-ported her after her run-in with baseball's men. She'd been given a copy of the letter he signed that was sent to the BBWAA officers in which he con-veyed displeasure at how his reporter had been treated. But in the discovery phase of my legal case, when both sides had access to heretofore confidential documents, previously undisclosed memos that Laguerre exchanged with others at Time Inc revealed his hostile attitude toward Salter and her com-plaint. Had Laguerre been left on his own to decide whether to respond to

this incident, he would have hung her out to dry. No letter would have been sent to the BBWAA.

But after Salter wrote to Steed, he contacted Laguerre about her request for the magazine to support her in the wake of her ouster from the BBWAA gala. At first, Laguerre responded that he saw no reason to respond: "Miss Salter, a reporter, is not a member of the baseball staff, and her connection with the sport has been negligible. She was not on assignment at the time of the incident. Her personal rights may or may not have been violated, but she was hardly discriminated against in the pursuance of her duties. . . . A fair assumption is that Miss Salter set out to provoke a political incident and was not at any time concerned with writing a story for *Sports Illustrated* or with otherwise furthering the interest of the magazine." In fact, Salter was a working member of his baseball staff. Laguerre's demeaning words about her offer a glimpse at how he devalued the work of his reporters, most of whom were women. Even if her primary job was fact-checking, Laguerre was disingenuous in dismissing her claim that she was discriminated against "in the pursuance of her duties." No employee of *Sports Illustrated* seated at that gala table—with Time Inc. paying for their tickets—was on assignment that night, but each represented the magazine at the gala. When I read Laguerre's memo saying that she was not "furthering" the interest of SI, while leaving aside the presence of his male writers and editors at this same table, I found his words achingly tough to read.

When I shared them with Stephanie, she was shocked and angry. She felt betrayed.

Five days after Laguerre sent Steed his first memo, Steed replied with firmness coated in diplomacy. "Miss Salter's report makes it evident that she consciously went to the BBWAA dinner to test the validity of its stag nature," Steed wrote Laguerre, before advising that "some action ought to be taken in order to honor the principle underlying the agreement [the 1971 conciliation agreement] we made and to demonstrate that we will back staff members who have been discriminated against." Steed counseled Laguerre to write and sign a letter that was in "the form of a dignified protest to the BBWAA" addressing the "exclusionary nature of their function [which] seems to S.I. to be out of keeping both with the law and current mores." After all, he reminded Laguerre, the BBWAA "certainly wouldn't exclude Black male reporters."

Laguerre still didn't write this letter, but he did forward Steed's to his deputy editor, Jack Tibby, telling him to draft a response. The next day, Tibby sent Steed a note along with his draft: "Would this be okay to send to the

chapter's BBWAA president, Joe Durso?" When Steed approved Tibby's words, he sent the letter to Laguerre, who signed it. On February 8, 1973, it was mailed to BBWAA officers.

> In the aftermath of the Baseball Writers' Dinner at the Americana on January 28, I must register with you and other officers of the New York Baseball Writers' Association *Sports Illustrated*'s protest with regard to the expulsion from the dinner of one of *Sports Illustrated*'s women reporters, Stephanie Salter. I do not propose to enter into an account of the affair although my information is that Salter was addressed with verbal rudeness. The point I do wish to make is that the exclusion of this professional reporter from your dinner, on the sole grounds that she is a woman, seems to us to be out of keeping certainly with current mores and indeed perhaps with the law. We suggest that a reexamination of your exclusion of Salter would be appropriate.
>
> Very truly yours, André Laguerre, Managing Editor

Two years later, Salter left *Sports Illustrated*, and I was given her job as junior reporter on the baseball beat. Like her, I partnered with Jim Kaplan, a writer/reporter assigned to baseball, who often traveled and was given opportunities to write baseball stories. As the junior reporter, I usually stayed in New York to fact-check the stories when they came in. But after I was assigned to the baseball beat, I was determined to learn how to report the game, which I did by being at games as often as I could be. I'd be there for batting practice so I could watch and listen to the writer who covered this game, so I could learn by mimicking them. I apprenticed by observing, then I practiced what they'd taught even if they didn't know they were my teachers. In time, I gained enough confidence to add to the men's lessons a few touches that reflected the sensibilities I stirred into the mix.

After two seasons of doing this, and when I was feeling quite comfortable on the baseball beat, Kuhn upended me at the 1977 World Series. Just as Kaplan had defended Salter at the gala in 1973, he backed me fully when I was baseball's target. I was grateful for his support but *Sports Illustrated*'s managing editor would decide if I received institutional support. If Laguerre had still been directing *Sports Illustrated*, Time Inc. might not have paid top dollar for Fritz to argue my case. But his successor, Roy Terrell, did not hesitate to back me. This no-nonsense, buzz-cut Texan, who had been a Marine fighter pilot in World War II, said yes without lengthy discussion with his baseball editor or a meeting with the lawyers or corporate officers. On the

morning Carry knocked on his office door and Terrell waved him in and heard what happened at Yankee Stadium, he gave these marching orders to Carry: "Do whatever you need to do."

A few days later, *Sports Illustrated* started negotiating with Kuhn to see if we could find a just resolution that would keep us out of court. But when Kuhn kept on refusing to make my access equal to the men's, Time Inc. brought Fritz on board, then he filed our complaint with Manhattan's Southern District Court.

Which is why late on an April afternoon, I was in Judge Motley's courtroom to hear my lawyer speak on my behalf.

Through it all, Terrell never wavered.

Chapter Seven

"My name is Frederick Schwarz. I represent the plaintiff Melissa Ludtke and the plaintiff Time Incorporated," Fritz began. "We seek here a summary judgment, challenging a Major League Baseball policy refusing to let female sports reporters do what male reporters find essential in doing their job."

The hearing on *Ludtke v. Kuhn* was underway.

Hearing Fritz introduce himself as my attorney, then to hear my name said aloud as this case's plaintiff, buoyed my spirits. Fritz speaking in court was new for me, but I realized instantly how comfortable his congenial tone sounded. He wasn't bombastic, though he spoke loudly enough that I heard him clearly even with his back facing me. I didn't know much about our judge but from what Fritz told me I expected her to be stern and serious, self-disciplined and polite. Her courtroom demeanor was legendary from her years as a lawyer arguing cases in southern courtrooms when she was trying to overturn Jim Crow. As a Black woman, she knew that she needed to hold her emotions in check as she kept a steady focus on the law in addressing white male judges. She could ill afford to give these men any reason to discipline her or penalize her client for something she did or said that they considered out of line. When she had to use the bathroom or make a phone call, she had to leave the courthouse since Black people, by law, were not permitted to do such things in the courthouse where she tried her cases. Often, when she walked to places where she could do these things, southerners hollered racial slurs attacking her for coming to their communities to overturn their laws. In taunting her, they wanted to provoke an outburst from her, but she never gave them that satisfaction. Maintaining decorum protected her in places

where it was dangerous for people who looked like her to go, especially when they were fighting against the white power structure.

In some courts when she rose to speak on behalf of her clients, the judge turned his back denying her judicial courtesy of eye contact and engaged listening. At times, Motley's clients mistook her strict internal focus as being inattentive rudeness. But these self-imposed safeguards were essential if she was going to succeed in court and protect her personal safety. *New Yorker* writer Calvin Trillin traveled to Georgia to watch her argue a case about two Black students, Charlayne Hunter and Hamilton Holmes, who were trying to enroll in the segregated University of Georgia. Trillin told readers about Motley's unwavering poise and dignified calm in the face of the horrid treatment she encountered in the course of presenting that case. He described her as being "dead serious [and not] going to be distracted into talking." When Trillin spoke with Gary L. Ford Jr. for his biography of Motley, he said, "She scared the hell out of me. She was a very imposing person."[1]

Given her own courtroom temperament, Motley appreciated attorneys who displayed an even-keeled disposition and demonstrated the same disciplined focus she'd shown under trying circumstances. A lawyer appearing before Judge Motley would be wise to bury the impulse for courtroom theatrics and stick with on-point legal arguments. Mine was the last hearing of her day—and her week, so Fritz knew Judge Motley would be displeased by extraneous talk from either attorney. Dally, without making a relevant point, and she'd show her impatience. With measured cadence and crisp enunciation, Fritz seemed a perfect fit. If Fritz stayed crisp, clear, and cogent, we'd be in good shape. His tight argument should last for half an hour or so, he'd told me, but he cautioned that if the judge broke in with questions or comments, it could go longer. Her queries could turn into colloquies diverting him onto detours that would stretch the time of his argument. Fritz took no papers with him when he left the plaintiff's table and walked to where he wanted to speak.

"This case is about sports and sports reporting. Sports, as you know, for millions of Americans, at least, are a matter of great public interest," he began. By inserting "at least" in this opening supposition, Fritz was leaving wiggle room for Judge Motley, knowing she didn't count herself among those millions of Americans. She was utterly disinterested in sports. Still, she wasn't about to quibble with his assertion that many Americans, like her husband, Joel Motley, did see sports as "a matter of great public interest."

Growing up in New Haven in the 1920s and 1930s, Judge Motley didn't play sports in school, nor did she in college. By her mid-twenties, the law

consumed all of her waking hours. While finishing her studies at Columbia University's Law School, she'd also interned at the NAACP Education and Legal Defense Fund, aka the Inc. Fund, in New York City. In 1946, soon after graduation, she had married Joel. After passing the bar exam, she'd transitioned to paid work as a lawyer at the Inc. Fund. Even had she been inclined, Motley had no time in her life to track the exploits of white men who hit balls, leaped to catch passes, shot balls through baskets, or slapped pucks into nets. At home, when her husband watched and listened to Yankees games, she worked in another room. In the car, however, he turned the radio dial to WINS, making her captive to Mel Allen's play-by-play of games on their weekend drives to visit family in Connecticut. When the World Series ended, she welcomed months of quiet before the teams headed south for spring training.

On the day of our hearing, the baseball season was a week old. In the six games the Yankees had played, the World Champions had lost four. On Thursday afternoon, they had won their home opener against the Chicago White Sox with me there to see Reggie Jackson hit his first home run of this season and Ron Guidry pitch a complete game win.

With diplomatic tact, Fritz wasn't about to try moving Judge Motley past her disdain for sports and into an appreciation for the joy I had in covering them. "Sports is the entire focus of my client Time Inc.'s magazine, *Sports Illustrated*," he told her. I suspected that she hadn't read *Sports Illustrated*, at least until being assigned my case. Perhaps then she skimmed a few of my stories. Nor was it likely she'd thought much about how unusual it was for a woman to be a sports reporter before she got my case. It's something I doubted she'd ever considered. "Sports reporting in the past has traditionally been written about men, has been written for men, and has been written by men," Fritz told her, adapting the lyrical flourish of Abraham Lincoln's closing words of the Gettysburg Address. His choice of words wasn't incidental. Fritz surprised me by saying this, but I understood instantly the visceral connection he'd made. How could Judge Motley not hear these words as Fritz intended her to hear them? Fritz wrote in a later article that he considered the Gettysburg Address and Martin Luther King Jr.'s "I Have a Dream" oration as "the two greatest speeches in American history," from which he took inspiration. It wasn't by chance that Fritz used Lincoln's words to usher Judge Motley into the gender divide in sports writing. With baseball's unequal policies preventing me from fully performing my job, Fritz was subtly reminding Motley of the war that had freed enslaved people as well as the injustices she experienced in her own life such as being forced

to leave the whites-only train car on her first railroad trip south. She was told to ride in car set aside for Negroes. And when she argued cases in the South, she couldn't stay in hotels in cities where she came to fight racial injustice.

Fritz was nudging her to now see injustice also through the lens of gender.

* * *

Motley had not argued a case in which her client faced discrimination due to gender. The North Star in her legal cases revolved around racial discrimination, just as she saw her own challenges as due more to her race than her gender. She had learned how to handle herself in segregated environments in which laws, rules, customary practices, and regulations dictated her treatment based on the color of her skin. Nothing so directly and brutally affected her life as did her skin color. Nor had she embraced the struggles or activism of women in the 1970s as she did those of people who'd fought racial discrimination in preceding decades.

Around the time Motley stopped litigating discrimination cases, the women's movement was starting to apply legal tactics similar to hers to overcome the laws biased against them. Indeed, some of America's finest legal minds were taking on gender discrimination by relying on precedents that Motley and her fellow Inc. Fund lawyers set in their Fourteenth Amendment cases. Despite such linkage to her legal approach in achieving equal justice, Motley didn't align herself with women's battles for equality, even after being a first for women in many positions she held. "Although I was the first Black woman in the New York State Senate, the first woman Manhattan borough president, and the first woman on the federal bench in New York, I have no particular attachment to the newest women's rights movement," Motley wrote later in her life. The women's movement, she observed, "emerged about 1965, the year I became borough president. . . . In my view, I did not get to the federal bench because I was a woman. I understood my appointment as based on my accomplishments as a civil rights lawyer."

She apparently did not see women as being targets of systemic discrimination in the ways that she saw Black Americans treated—and how she'd been treated too. From her own telling, she did encounter unfair treatment as a woman in politics in the mid-1960s. There was the time when as Manhattan Borough president she was seated with the politician's spouses, aka wives, on the balcony at the city's Inner Circle dinner, instead of sitting with the other political leaders, aka the men, on the ballroom floor.[2] Even this second-tier treatment due to gender inspired in her nothing close to the passion that had

driven her to risk her life in the South fighting segregation. As the 1960s moved on, Motley was consumed by her judicial work and paid little attention to changes happening around her in the lives of girls and women. It was not until the mid-1970s, nine years after becoming a judge, that Motley left her chambers to give her first speech to law school students at the University of Connecticut. After meeting them, she admitted to "suffering culture shock" when half of them were women. After a female student approached her that day to say, "you are a role model for us," Motley wrote of feeling "particularly moved" by her words. She admitted that "I never before had seen myself in that light."[3]

It's hard for me to imagine that Judge Motley did not see race and gender as moving on parallel tracks of discriminatory injustice and deserving of legal remedy. Yet, when she was in court focused on racial injustice, few lawyers were bringing gender discrimination case to court. Whenever they did, male judges mocked them, deriding their claims of discriminatory treatment. That's why in the early 1970s, Ruth Bader Ginsburg purposely took on male plaintiffs who faced discrimination due to gender. When she argued those cases, judges treated her more seriously than when her client was a woman. In her mind, it was court finding gender discrimination that mattered, not her plaintiff's sex.

* * *

"Sports in the past, as I think you also know, has traditionally by itself been a male preserve," Fritz said in continuing to paint the backdrop for my case. By saying, "sports in the past," he was perhaps prompting Judge Motley to see Jackie Robinson in her mind's eye, not so much as a baseball player but as civil rights icon. In April 1947 when Robinson was the first Negro to play a Major League Baseball game with the Brooklyn Dodgers, her work in nearby Manhattan was all about demolishing racial segregation in America. Surely, she taken note of Robinson's groundbreaking moment. To mark this historic occasion, Fritz's father had pulled his then-twelve-year-old son out of school and taken him to Ebbets Field to see Robinson play. Until that day, Fritz had not seen Blacks and whites doing things together. On one school trip, he'd seen Black inmates at a New York City jail, but his family had no friends of color and his classmates at his private school in Manhattan and later at a Massachusetts boarding school were white. It wasn't until he attended Harvard University in the mid-1950s, where he rowed with a Black classmate, that he experienced what Robinson's teammates did on April 15, 1947.

Within three years of Robinson's breakthrough, Motley had drafted the legal complaint that the Inc. Fund submitted in its racial discrimination school case, *Brown v. Board of Education*. In 1954, the Supreme Court ruled unanimously that "de jure racial segregation" violated the Equal Protection Clause of the U.S. Constitution's Fourteenth Amendment, declaring that separate was not equal. But even with the highest court instructing states to dismantle Jim Crow "with all deliberate speed," segregation persisted in the South, which had forced Motley and other Inc. Fund lawyers to go into southern courts to challenge specific laws. Now, on this April afternoon twenty-four years after the *Brown* decision and three decades after Robinson played his first game with the Dodgers, Fritz was talking baseball with the woman whose legal acumen had cracked, then demolished the foundation that had borne the weight of America's separate-but-equal practices.

Fritz had to believe Judge Motley heard in his presentation echoes pointing to the legal hollowness of Kuhn's claim that his *separate* accommodations for women could provide *equal* access to what his client's male colleagues had. Fritz also wanted her to understand why I needed this access to ballplayers to fully do my job. So before the hearing, he'd sent her the foundational document of my case—the Plaintiffs' Memorandum in Support of Their Motion for Summary Judgment. Despite its long, legalistic title, Fritz had written lyrically in it, such as this sentence crafted purposefully with her in mind: "Just as our courts ultimately rejected the notion of 'separate but equal' as applied to race, so here this Court should reject baseball's imposition of its separate, and by definition, unequal policy based on gender."

Fritz could draw no straighter line than this one to connect Motley's cases as plaintiffs' attorney with his argument in defense of me. In rereading this document decades later, I wish I'd been a fly on the wall in her chamber when Judge Motley read his words. Did she reach for a pen to underline that sentence? Did reading it tug her back to her decades-long pursuit for racial justice? Did she see equality as my fight too? After connecting those dots, Fritz underscored the point that there ought not to be any tension between the ballplayers' right to privacy and my ability to be treated equality. He wrote, "There is no conflict between the right of privacy and the right of female reporters to be treated equally. Because it is only recently that women have begun to gain acceptance in the field of sports journalism, vestiges of sex discrimination are particularly injurious to female sports reporters, and any excuses for continuation of such vestiges must be closely examined so that New York's strong policy (against sex discrimination) will not be undermined."

With his deliberate use of that phrase "vestiges of sex discrimination," once again he was sending an unambiguous signal to Judge Motley. It had to remind her how "vestiges of segregation" was used to describe smoldering embers of racial segregation, thus signaling the core role he wanted the Fourteenth Amendment to play in our case. But to convince her of this, Fritz had to construct his case's scaffold with legal precedents. So in his legal brief, Fritz drew the judge's attention to the U.S. Supreme Court's 1973 landmark gender discrimination decision in *Frontiero v. Richardson*. In that case, Ruth Bader Ginsburg, representing the American Civil Liberties Union (ACLU) as amicus curiae, had addressed the Supreme Court. Remarkably, the justices listened to her argument for nearly eleven uninterrupted minutes, which was exceedingly rare. Usually justices interrupt lawyers when they've spoken only a sentence or two. Discrimination, Ginsburg told them, keeps a "woman in her place, a place inferior to that occupied by men in our society." This case was a vital part of her legal strategy that, in time, would compel the U.S. Supreme Court to raise the level of scrutiny that courts need to apply to gender discrimination cases. She wanted this scrutiny to be at or close to the highest level that judges gave to cases involving race. She succeeded.

In *Frontiero v. Richardson*, the plaintiff, Sharron Frontiero, was a military officer, and as a wife, her family benefits were treated differently than those of married male officers. Ruling eight to one in her favor, the justices agreed with Ginsburg that Frontiero's family was not treated equally to families in which the father was the military officer. By underscoring this case, Fritz was also reminding Judge Motley of what Chief Justice William J. Brennan wrote in his majority opinion. "There can be no doubt that our nation has had a long and unfortunate history of sex discrimination. Traditionally, such discrimination was rationalized by an attitude of romantic paternalism which, in practical effect, put women not on a pedestal, *but in a cage*." Baseball's standing offer of "separate accommodations," Fritz told her, would leave me standing "not on a pedestal but in a cage." In reporting baseball, he reminded her, "women are barred, solely on the basis of their sex, from working the way their male competitors customarily do." Then he described the effects of this segregated policy on women doing this job. "The impact of the baseball defendants' discriminatory policy, moreover, is not simply on a woman's right to compete in a marketplace. For here the discrimination hampers women who are trying to compete in the marketplace of ideas. Thus, baseball's policy is unlawful sex discrimination and an unlawful infringement of the freedom of the press" (Fritz's emphasis).

Fritz also cited the 1974 U.S. Supreme Court decision in *Cleveland Board of Education v. LaFleur*, pointing out that the Fourteenth Amendment requires that the defendant search for the "less restrictive means" of accommodating the plaintiff. In other words, instead of banning me from the place where interviews take place, it was incumbent on Kuhn to show Judge Motley that he had explored "less restrictive" options in giving me access. He hadn't, as Fritz told the judge. Kuhn's "ban is not the least restrictive means of serving the interest which defendants claim to rely upon," he wrote. Given that Kuhn's interest was players' privacy, Fritz offered Judge Motley suggestions: "a cubicle with a curtain," he told her, would accommodate my equal access while dealing with privacy concerns. In the off-season, my team of lawyers had visited the Yankees clubhouse and measured the ballplayers' cubicles. This led him to conclude that a curtain could be drawn across its front to shield a player if he was dressing. He had other suggestions too. "Or wear a bathrobe" or "simply a towel," Fritz proposed. By offering these possibilities, he'd channeled what I'd said on TV when Howard Cosell asked how I'd deal with ballplayers' nudity. "Let them wear towels," I'd told him. Fritz also made sure the judge knew that "the shower and toilet facilities are completely separate from main locker room to which press"—and here he meant male writers—"traditionally has been granted access."

Later in his memorandum, Fritz reconstructed for Judge Motley Kuhn's rationale for keeping me out. It revolved around me invading the "privacy" of his ballplayers. Fritz contended that his rationale fell short of the Supreme Court's "least restrictive alternative" precedent in *Cleveland Board of Education v. LaFleur*. Baseball, he wrote, could not justify its "ban upon access to the locker room by female reporters . . . because the ban is not the least restrictive means of serving the interest which the defendants claim to rely on." In closing this loop, Fritz circled back to Justice Brennan's insight about paternalistic practices putting women, like me, "in a cage." It was worth repeating.

"There are many less restrictive means of protecting any interest in player privacy without leaving women out in the hall ('in a cage') separated from their male competitors who get favored access to the news and the newsmakers," Fritz wrote.

* * *

When Motley had been assigned my case, Fritz thoroughly reviewed her cases as a lawyer and her rulings as a judge. Since he was well versed in the Inc.

Fund's civil rights cases, and acquainted with Motley's customary legal strategy, he devoted additional time to familiarizing himself with her judicial temperament since he hadn't argued a case before her. He tapped the insights of lawyers who had appeared before her, while at the same time querying her friends to learn about her unfamiliarity with sports. After distilling these discoveries, Fritz transformed what he learned about her into his practical courtroom tools.

When he stood to address Judge Motley, Fritz's straight-backed posture accentuated his tall, slender frame. He didn't shuffle his feet, rock side to side, or gesticulate which kept Judge Motley focused solely on his words. At the start of his argument, she was sizing him up, just as Fritz was finding his comfort zone with her. Even though this was their first meeting as lawyer and judge, Fritz had argued cases before other judges in this courthouse, so Judge Motley knew of him by reputation, just as he knew her record as judge.

"The times have been changing," Fritz said, as he moved from Lincoln's battlefield eulogy to Bob Dylan's lyrics of a century later. With each, he'd substituted the passive tense. Hearing Fritz, who is from the generation before mine, weave Dylan's iconic protest ballad, "The Times They Are A-Changin'," into his argument carried me back to my college years when I heard Dylan's creaky voice in my head as I marched against the Vietnam War. If Judge Motley reacted to Fritz's reference, it was with the tiniest of grins. Still, my smile widened as I gently poked Eric with my elbow as if to say, "Hey, isn't that cool?"

"Women's sports today are a matter which is receiving across our country great emphasis and great support," Fritz continued. "In the last few years at the same time as women athletes have been receiving increasing support, young women professionals have begun to try to make a career for themselves in sports writing." After drawing her back to women's emerging roles in sports, Fritz spotlighted our work as storytellers. "In this town, in this city, both the *New York Times* and the *Daily News* have assigned women to cover men's professional hockey," he told her. "*Newsday* on Long Island has assigned a woman to cover men's professional basketball," Fritz said. "In those sports—basketball and hockey, as well as others such as soccer—women are able to do the job. They are able to write for the best papers in this country, and in those sports the leagues treat women reporters the same as they do men reporters."

Fritz paused, giving Judge Motley time to acclimate herself to his fresh path of argument. When he resumed, Fritz contrasted hockey and basketball's new media policies with baseball's old-school one. "It's not so in

baseball," he declared. "In baseball there is an official policy forbidding the teams from granting equal access to women reporters. It is the legality of the issue before the Court today." By keeping these remarks brief, he'd sharpened his point of contrast.

He'd echoed Lincoln, then enjoined Dylan, so I wondered whose words he'd borrow next. When he wrote for his sixtieth Harvard reunion, Fritz told his classmates why he embedded the lyrics of Dylan, the Rolling Stones, and Woody Guthrie in his oral arguments: "Persuasion should not be pedantic or stilted. Reaching for the heart helps the head." After reaching for Motley's heart, Fritz was about to fill her head with the legal reasoning connecting race and gender in the U.S. Constitution.

It had taken a century for the Supreme Court justices to apply the U.S. Constitution's Equal Protection Clause to gender issues in the ways it had been used in cases about racial discrimination. Not until the mid-1970s, when then-ACLU lawyer Ruth Bader Ginsburg brought forth her series of gender discrimination cases, did this court elevate gender from its run-of-the-mill "rationale basis review" to the higher level of judicial scrutiny known as "intermediate scrutiny." That placed gender closer to the "strict scrutiny" that courts applied to race. This happened in 1976—a year before my case was filed—with the Supreme Court's decision in *Craig v. Boren*, which Ginsburg described as "a non-weighty interest pressed by thirsty boys."

Ginsburg's case about the age when men and women could purchase alcohol changed how courts scrutinize gender. It revolved around the ages— twenty-one for men, eighteen for women—when each was permitted to purchase "near beer" in Oklahoma. Ginsburg had signaled to the justices in her legal brief that she believed that gender merited "something in between" the court's rational basis review and strict scrutiny. The justices ruled that Oklahoma's statute "invidiously discriminated against males," and in this same ruling granted gender the "intermediate scrutiny" that Ginsburg sought. With this ruling, the court created a stronger foothold for women seeking protection with the Fourteenth Amendment. Wisely, Ginsburg had recognized that discrimination cases decided in favor of men could end up serving women well.

* * *

In reviewing Motley's prior cases, Fritz took note of a well-known 1975 gender discrimination case involving a New York City law firm. In it, women claimed that Sullivan & Cromwell, a prestigious Manhattan firm, had

systematically discriminated against them in hiring and pay, in the firm's exclusionary culture, and in the assignment of cases. This case, *Blank v. Sullivan & Cromwell*, was among the first cases to test the anti-discrimination principles of Title VII of the 1964 Civil Rights Act. Even before the case was heard, lawyers representing the firm requested that Judge Motley recuse herself. They argued that because it was likely she had experienced workplace discrimination due to her race and/or gender, she could not be impartial in deciding this case. Motley refused to recuse herself and wrote a vigorous defense against the firm's argument why she should: "It is beyond dispute that for much of my legal career I worked on behalf of blacks who suffered race discrimination. I am a woman, and before being elevated to the bench, was a woman lawyer. These obvious facts, however, clearly do not, *ipso facto*, indicate or even suggest the personal bias or prejudice required by § 144. . . . Indeed, if background or sex or race of each judge were, by definition, sufficient grounds for removal, no judge on this court could hear this case, or many others, by virtue of the fact that all of them were attorneys, of a sex, often with distinguished law firm or public service background."[4]

In her *Columbia Law Review* article "Identity Matters: The Case of Judge Constance Baker Motley,"[5] Harvard Law School constitutional scholar Tomiko Brown-Nagin posits that Motley "distinguished the roles as lawyer and judge" by steadfastly refusing "to view herself as a representative of her race or her gender." Perhaps this is why her stirring self-defense in *Blank* resonates with legal scholars who routinely quote from it in explaining why a judge should not be disqualified from cases due to their gender or race. Still, Sullivan & Cromwell's lawyers were not alone in believing that personal bias did influence how Judge Motley ruled. However, her judicial record tells a different story. When Motley defended herself in *Blank*, she "repeatedly had ruled *against* plaintiffs in civil rights cases, including women in workplace discrimination actions," Brown-Nagin observed in "Identity Matters." "Instead of showing favoritism, Motley's rulings demonstrated her *impartiality*." In 1986, when Judge Motley left active service on the federal bench, Brown-Nagin's empirical analysis of more than one thousand of her decisions shows that Motley overwhelmingly ruled "against plaintiffs in discrimination cases and against defendants in criminal law cases." In fact, she decided "against plaintiffs alleging Fourteenth Amendment violations in 57% of cases."[6]

No one who knew Judge Motley should have been surprised by her fighting the request that she step away from that gender discrimination case. By the age of fifteen, she'd decided to be a lawyer despite no one in her family

encouraging her ambition. Their reluctance to do so was grounded in the segregationist realities of 1930s America, a time when very few women, and even fewer Black women, joined this profession. In her autobiography, *Equal Justice under Law*, Motley said she was not "the kind of person who would not be put down. I rejected the notion that my race or sex would bar my success in life." In her teens, she'd recognized that being a lawyer played to her personal strengths of persistence and her ability to carry herself with stoic dignity even as she confronted adversity. She paired her logical thinking with an exemplary work ethic, yet it was impossible to deny that her family's poverty was a daunting obstacle to her attending college, which had to be the first step to becoming a lawyer. But when New Haven philanthropist Clarence Blakeslee heard her speak publicly about why Black youngsters were not coming to a community center—she'd said they'd been given no voice in what went on there—he invited her to visit him at his office.

"I was very impressed with what you had to say the other night," Blakeslee said before mentioning that he knew she'd graduated high school with honors. "I want to know why you are not in college."

"I don't have the money to go to college," she replied.

"What would you like to do?" he asked her.

"I'd like to be a lawyer."

"Well, I don't know much about women in the law, but if that's what you want to do, I'll be happy to pay your way as long as you want to go. I am sending my grandson to Harvard Law School. I guess if I can send him to Harvard, I can send you to Columbia," Blakeslee told her.

When she stood to leave his office, he told her, "Never be afraid to speak up; as Abraham Lincoln said, an independent voice is God's gift to the nation."[7]

A decade later, she did earn her law degree at Columbia. After that she joined Thurgood Marshall, who was her boss at the Inc. Fund, and in a few years, he sent her South to overturn its Jim Crow laws. Travelling there by train, Motley was stung by segregation when conductors forced her to ride in the "colored car" or wrapped a screen around her to shield white passengers from seeing her. "I remember being infuriated from the top of my head to the tip of my toes the first time a screen was put around me," Motley wrote.

Motley was the first Black woman to argue a case in a Mississippi court. Marshall had given her what he believed was an unwinnable case. If she won it, James Meredith would be the first Black to enroll at Ole Miss, the state's flagship university. Residents of Jackson, this state's capital, regarded Motley as a curiosity *and* treated her as a threat. With laws forbidding Blacks to be

in whites-only places, Motley slept in the homes of civil rights leaders. On some nights, bodyguards with machine guns stood on those rooftops. Cognizant of "southern justice," in which whites, taking the law into their own hands, killed Black people and disruptive whites, Motley slept fitfully, if at all, and worried that an explosive device might be thrown into the house. In 1963, civil rights leader Medgar Evers was killed on the front lawn of his Jackson home that Motley had visited regularly when she argued cases there. After his murder, she went through a lengthy period of inconsolable grief and stopped going south. In 1964, she left the Inc. Fund and was elected to the New York Senate; she was the first Black woman to serve there.

In her lengthy Inc. Fund career, decisions judges made in her cases ended the segregation of recreational facilities in Memphis, Tennessee, secured Martin Luther King Jr.'s release from jails in Georgia and Alabama, enrolled the first Black students at the University of Georgia, the University of Mississippi, and the University of Alabama. Of the ten cases Motley argued at the U.S. Supreme Court, she won nine on decision, and the one she lost, a subsequent ruling reversed. She also assisted attorneys in nearly sixty other cases that they argued at the U.S. Supreme Court.

* * *

Sullivan & Cromwell ended up negotiating a settlement in which the law firm partners promised to "recruit, hire and pay women lawyers on the same basis as men." However, they agreed to change their practices without admitting that they had discriminated against women, just as Time Inc. directors had escaped accountability six years earlier with their no-fault conciliation agreement with its disgruntled women. Fritz had shared the Time Inc. agreement with Judge Motley to make her aware of the antidiscriminatory gender promises that my company had made. He'd reiterate these in his verbal argument.

Baseball's attorney also knew how ardently Judge Motley had fought the charge of bias in that gender discrimination case. Any thought Kuhn's attorney might have entertained of asking her to recuse herself from our case based on a similar rationale had been vanquished by the force of her rebuttal. But in gossip I'd picked up at ballparks, apparently Kuhn was extremely distressed when he heard that Judge Motley was assigned our case. Even though we heard that Kuhn thought it likely that she'd rule against him, he had put his faith in the Second Circuit Court of Appeals overturning her decision, if he had to appeal.

All white males sat on that circuit court.

Still, Kuhn's lawyer wanted to win the case in Judge Motley's courtroom. But he knew, as Fritz did, that her decision hinged on how she evaluated the state action claim that Fritz would make and Climenko would argue against. This would be my case's key pivot point since private entities like baseball presented a much more complex challenge for a plaintiff who relied on Fourteenth Amendment protections. Only if our judge first found that an "authority of government" was entwined in our case could she rule on constitutional grounds.

Should Fritz fail to prove such entwinement to her satisfaction, we'd lose.

Chapter Eight

By avoiding mention of men's nudity, Fritz intended to steer clear of the customary locker room talk associated with my case. There was no upside in him drawing Judge Motley's attention to cartoonists' sexist renderings or the objectifying puns in headlines and stories about my case. That click-bait had hooked the American public, but it should be irrelevant for a judge weighing the merits of a discrimination case.

Ludtke v. Kuhn was about women's equity, not men's nudity. Either Kuhn could let me in the locker rooms at Yankee Stadium or keep the male writers out. If he lost this case, no one thought he'd kick the men out, especially after many of them had warned Kuhn that he'd be in a fight with them if he took away their customary access to players. Kuhn was willing to battle with me, but fighting with the men on whom he relied for baseball's free media that put people in the stands was an entirely different matter. What these writers gave his game was much too valuable to mess with.

Besides, those writers were right. Being in the locker room was the best way to report on the team dynamics involving the ballplayers, coaches, and the manager. Without such direct, spontaneous, conversational access to everyone on the team, it wasn't possible to capture the sights and sounds that writers used to illuminate how a team, as a whole, and players, as individuals, reacted to victory or defeat or explain how that result happened. Seeing a player wipe away a tear or a teammate drape his arm over another player's shoulder are moments that convey the human experience more effectively than what a player says in a sterile interview room. To help Judge Motley understand this, Fritz might have shared with her what Roger Kahn wrote

after the Brooklyn Dodgers' crushing loss to the Yankees in the 1953 World Series. With emotive descriptions, he showed men coming to terms with their devastating loss, each in his own way. She would have seen how a skillful writer evokes singular, intimate moments to humanize this experience for readers who'd gone through their own emotional response.

> The Dodger clubhouse was sepulchral. . . . If you knew the players and saw them silent, humiliated, it was like crashing into a sick room. . . . Reporters hurried to Carl Furillo, who had tied the game by rocking a home run off of Allie Reynolds in the ninth. "I showed 'em," Furillo said. "I showed 'em I could come back after breaking that hand." This black-haired powerful man was dominated by his private triumph. Five minutes after losing the Series he was issuing victory statements. Everywhere else the men, with whom I had traveled for two years, and whose vitality I so enjoyed, were motionless and sorrowful and waxen.[1]

No writer who was forced to wait outside the locker room after that game could have told this story as Kahn did. In no interview room had scenes of such heartbreak played out as they did in the locker room. Writers are there to observe and listen as much, if not more, than they are to query the players. And what one player says or does will spark in a writer's mind a reason to head over to question another player. In the locker room, he goes to find that player. No writer standing outside the locker room can do this.

My plea for equal access wasn't about changing the men's routines or restricting their access. I simply wanted this same opportunity to converse at length with players in the forty-five minutes before the games, then be with them after the game to observe and talk with players. Though the men had made it clear to Kuhn how much locker room access mattered to them, most of them seemed to be fine with denying me this opportunity. In his February 1978 column, "No Skirting the Issue: Keep Out, Gal Warriors," baseball writer Joe Falls jokingly put the blame on me before engaging with the broader issue at hand.[2] "It ain't fair," he wrote. "Melissa Ludtke promised me I could get into the tennis dressing rooms at [Detroit's] Cobo Hall but the gals down there tell me I have two chances: slims and none." Falls intentionally added the *s* to "slim" as a play on the Virginia Slims Tour, the women's tennis circuit of that time. Later in that column, Falls admitted it was "darn tough" to cover a sports team without being able to be with the players, but he ended with a who-really-cares-about-gals flourish.

At the same time, I don't think they [women] should be allowed in because how can any guy carry on an intelligent conversation if he is standing there naked with a girl standing in front of him? . . . I don't know if they can keep all the guys out of the dressing rooms because there are more guy reporters than gal reporters and I don't think the guys would tolerate such a thing. The majority rules I'm afraid. . . . I think we're going to have to make some changes because the gal reporters deserve some consideration, but I don't think it includes walking into a male dressing room. Those players deserve something, too, like their privacy.

* * *

It felt good to be in this courtroom where puns and hyperbole, mockery and macho humor were extraneous to the task at hand. Fritz's laser focus was on Kuhn's discriminatory act. He wasn't there to discuss his client's morality. Instead, he brought to the judge's attention three New York women sportswriters—Lawrie Mifflin, Jane Gross, and Robin Herman—to show her how media policies in two other sports leagues had erased this dividing lines of gender. (By then, just a few teams in the NBA and NHL did not provide equal access to writers.) These women's bylines were familiar to sports fans, especially in New York City. All of them reported in NBA and NHL locker rooms, but none of their New York readers had raised a ruckus about them doing so—and it's likely few even gave a thought to how these writers got their story. No one seemed concerned when they shared player quotes or wrote about the ambience in the locker room. Sports fans read their stories, then went on with their daily lives unaffected by whether or how a woman delivered the story. Not until my case reached Manhattan's Southern District Court did the sausage-making details of how we did this job tumble into public view to create a storm of controversy.

All of a sudden, women's news-gathering practices were everybody's business. Some people had a tough time dislodging the popularized image of naked ballplayers cowering as a woman with a notepad came into the players' space. It didn't help that the men telling our story rarely mentioned the equal access aspect of my case. Nor did they tell readers that ballplayers showered and could change into street clothes in an area of the clubhouse that was off-limits to *every* reporter. By relaying this one fact, writers would have reassured readers that *no* ballplayer *had* to be naked in the presence of *any* reporter. The Dodger pitcher Tommy John had tried to tamp down

this hyped-up controversy when he was asked about my presence in the locker room: "I mean when the guys [male writers] are there, I don't stand around naked." But sexual intrigue won out, with writers rarely including comments like John's.

Like John, Fritz left this hyped controversy at the courtroom door. His message to Judge Motley was exquisitely clear: Kuhn should do what the NHL president and NBA commissioner had done in calling for equal access for all credentialed reporters at their games. "It is the legality of baseball's policy which is the issue before the court today," Fritz said, before specifying for Judge Motley the two fundamental questions he would pursue: "First, does baseball's policy of favoring male reporters over their female competitors violate the law? Second, does this court have jurisdiction to rule upon the legality of baseball's policy?"

With only a short time to present his two-step argument, Fritz had to be cogent, concise, and direct in focusing on the law. He had no time during the hearing to share the anecdotal experiences of female sportswriters. So prior to the hearing, he'd sent Judge Motley a bunch of affidavits[3] including one from Herman, an NHL writer with the *New York Times*, Lawrie Mifflin, an NHL writer with the *Daily News*, and Jane Gross, an NBA writer with *Newsday* and then the *New York Times*, along with one from Betty Cuniberti, who wrote about college football and basketball for the *Washington Post*, and Sheila Moran, a copy editor on the *Los Angeles Times* sports desks. He sent my affidavit too.

Although none of would speak at the hearing, Judge Motley heard from us.

Reading these women's affidavits boosted my spirits in the weeks leading up to my day in court. They helped me feel that I was not alone in my frustrations with how I was treated by baseball's men. Usually, I was the only female reporter at a ballpark, and this made it hard for me to remember that other women sportswriters had endured similar experiences and had feelings similar to mine. On my own, I'd tried to hold inside my complaints and frustrations. When I felt a flash of intense anger rise, I'd hold the rage inside. If I let it explode, I knew that plenty of the men would dismiss me as being tempestuous and volatile. Once tagged as such, my job would be even more challenging. Better to get along with them than to be marked an enemy. If I found myself on the verge of crying, then sheer willpower took over. I refused to let the men see me hurting. These other women's words made me feel I was staring into a mirror.

The first woman to report in NBA locker rooms, Jane Gross, told Judge Motley in her affidavit about being sent to cover two New York Mets games

in 1976. Early on, Gross described how in her basketball reporting she'd be "the butt of a couple of jokes" when she entered a team's locker room for the first time. But, she assured Judge Motley, "the players quickly forget about me," and she did her job.

With baseball, Gross told a different story to tell.

My editor called the Mets, and the team arranged to have me wait in either the manager's office or another room no bigger than a supply closet and said they would have one of their PR men bring players out to me. These arrangements were completely unsatisfactory. I had to wait up to an hour for the most important players, and some players would not come out to speak with me at all. The players who did come out were so tired of answering the same questions over and over again. Moreover, I could not ask other players follow-up questions. Most important, I was unable to see what went on inside the locker room. If one player yelled at another or threw a deodorant can at him, I was dependent on my competitors to tell me about it. Even if they did tell me about it, I was unable to catch the general ambiance. . . .

It is my belief that newspapers tend not to assign women to "beats" precisely because female reporters are unable to get into locker rooms. Women are assigned instead to cover feature stories, personalities, and women's sports. Because of my and others' breakthroughs, they are now also assigned to cover basketball and hockey. To the best of my knowledge, Melissa Ludtke is one of the few female reporters who has been assigned to the baseball "beat." If baseball continues to exclude her and others from the locker room, she may be one of the last.

None of the women who wrote these affidavits in support of my case routinely covered baseball. Except for Gross, none was a friend. Our paths didn't cross since we were assigned to cover different sports. I'd never met Betty Cuniberti, but I marveled at how well she quantified the value of working in locker rooms after games. "Over 50% of the material used in my stories comes from information obtained in post-game interviews," she wrote to Judge Motley, before adding in the value of spontaneity in capturing players' raw emotions right after a game. "It is precisely because women are prohibited from entering male locker rooms in certain sports that sports editors do not hire more women to cover 'beats.' [This is] the biggest injustice of all because of the high value of a beat assignment to any sports reporter's career." Ever practical, Cuniberti wrote that players want to leave as soon as possible, especially after a home game, which makes them reluctant to take extra time

to talk with a female reporter posted outside the locker room. If she is among the press in the locker room, then a player can finish dressing and pack up his belongings while he answers their questions. In writing about the NFL Oakland Raiders the prior season, Cuniberti testified that she "never once got a chance to conduct a postgame interview of the Raiders' quarterback Ken Stabler" despite many requests. Stabler refused to leave the locker room to speak with her.

In her affidavit, Sheila Moran emphasized the penalties that women paid for lack of access. In 1973, the *New York Post* had assigned her to the Yankees' beat. At spring training, the Yankees kept her out of their locker room, so she had "to try to interview players by waiting in the dugout or the parking lot or by tracking them down at their hotels." It required lots of extra effort and time on her part to give readers the coverage they expected. "Male sports reporters grumbled because a woman was sent to do a man's job." Moran answered her critics by working double-time in a playtime atmosphere. "She turned out so much good copy that she ruined the leisurely pace of spring training for her competitors," a *Women's Wear Daily* writer concluded in a contemporaneous profile of Moran.[4] Editors had told Moran that she would be at Fenway Park to cover the Yankees' opening series, but she wasn't. In early April, Vic Ziegel was given the Yankees' beat. When asked to explain why he'd replaced her, Ziegel said, "She [Moran] couldn't get into the locker room. It would have hurt the paper. During spring training, it wasn't as vital but once the season began, it became crucial." He'd won the assignment because of being a man; Moran lost it because of being a woman. Instead of fighting baseball's discriminatory ways, the editors benched Moran, never again assigning her to a baseball game.

I also shared my experiences with Judge Motley in my affidavit. I told her what I'd learned by reporting in NBA locker rooms after the 1977 baseball season. "Now I have been in a locker room after a game I realize even more than I could before how important it is. Immediately after a game, as well as the hour or so before, the locker room provides an informal setting from which a writer gathers material not readily available without having such access," I wrote. "I don't feel I can perform my job fully without equal access to athletes."

Even as I worked in NBA locker rooms without incident, sportswriters kept busy that winter convincing Americans that the *real* problem wasn't Kuhn's unequal treatment but my lack of feminine sensibility. If only I would accept the limitations of my gender, Kuhn would have a satisfactory solution to fulfill my needs. But after reading my colleagues' affidavits, I felt

more strongly that nothing that Kuhn would offer—shy of equal access—would suffice. Still, by challenging Kuhn, I was also up against the men's characterization of me as an aggressively ambitious women whose intent threatened all that was right and good about our national pastime and American values.

The words "locker room" alone triggered in Americans' minds memories of their gym classes where personal privacy wasn't attainable. But in baseball's clubhouses, this wasn't so, even if sportswriters acted as if they didn't want readers to find out. This left readers only with visions of herds of sweaty kids running through squirting showerheads, then dressing in an open space. However, the Yankees' clubhouse had nine rooms, and seven of them including the shower and toilet area, were off-limits to *all* reporters. Writers knew this, but they choose to imply that ballplayers would be trapped in a state of nakedness while leering women writers encircled them. Many knew better from their experiences in NBA and NHL locker rooms that equal access actually worked for the players and the writers. Again, it usually involved nothing bigger than a towel. If a writer didn't know, he could have asked colleagues on those beats. But they didn't since that wasn't the story the men wanted to tell.

Despite knowing better, a lot of the sportswriters characterized my equal access request in baseball as aberrant. It wasn't, and in baseball equal access would work better than in the NBA where in relatively small NBA locker rooms we'd find ourselves wedged in among very tall, muscular players when we did our interviews. In baseball clubhouses, even the locker room was like Versailles when compared with professional basketball's space. Still, NBA commissioner Larry O'Brien made women's equal access happen, but Kuhn would not.

By working in NBA locker rooms, I figured out how to read and react to a player's body language. These silent interactions often worked better than exchanging words. When I saw a player tighten the wrap of his towel around his waist, I took that as a sign of unease with me nearby. I'd move away, making a mental note to circle back. Or when I was talking with one player and I saw that another player close by was starting to undress, I made a point of turning my back to him to signal my respect for his personal space. In each team's locker room, a bit of give and take was all it took for our interactions to work well. Of course, there was always the wild card player who might decide to broadcast his opposition to me being in his space with a crude joke. If he cranked up his discontent, I'd give him a wide berth while trying my best to ignore his commentary, as long as his

actions didn't create an intolerable situation. If they did, I told myself I'd leave and report the incident. I felt prepared, but that line was never crossed with me. Instead, my NBA experiences confirmed that what the public was told about women writers disrupting the team and disturbing the men was poppycock. And it was being fed to them by men practicing willful ignorance.

* * *

Fortunately, a few writers spent time in NBA locker rooms before writing about my case. One of them was the *New Yorker*'s Roger Angell, who visited the New Jersey Nets' locker room after a game at Madison Square Garden. I was there when he walked in. In the baseball season, he and I often sat next to each other in the press box, but in the off-season our paths rarely crossed. He'd come to the game that night to talk with players who knew something about women writers working in their locker rooms. Angell would use what he learned in the story he was writing for "The Sporting Scene," the section in the magazine where his stories had appeared since 1962. Mostly, he wrote about baseball. With my case in the news, Angell had decided to focus his next story on women sportswriters.

When he'd told *New Yorker* editor William Shawn his story idea, instead of his editor replying, "Sounds good," as he usually did, he'd said, "I hope it's going to be funny." Angell knew it wouldn't be, but he didn't say this to Shawn.[5] Months later, when Shawn read Angell's story, he went to his office to apologize: "I am sorry about what I said. That's so terrible." He had expected Angell to fill pages with humorous asides about our encounters with naked men and our reactions to the pinups of naked ladies in players' lockers. Instead, Angell had steered "Sharing the Beat" off the track that had derailed a fair telling in the hands of other writers. Angell's feature story moved across fifty pages, sharing space with many advertisements, in the April 9, 1979, issue of the *New Yorker*.

Angell humanized us while taking seriously my equal access claim. He did this by talking with male and female sportswriters at length, especially about the time they'd spent in locker rooms. Those people featured in his story seemed comfortable in expressing honestly how they'd feel about changes that my case might bring. Their words cooled the overheated rhetoric encircling my case. As a baseball man, Angell evidently had made other baseball men feel okay with telling him how they felt about me working among them. Although I'd sensed that many of them didn't want me around *their* game,

Angell's story brought to light the utter distaste some of them had for me as they bundled this personal dislike with fears about the ground shifting under them due to evolving gender roles.

The liberal in me says that women reporters are entitled to be in the clubhouse and to get all the courtesies I get. The chauvinist and realist in me say they don't belong. . . . I suppose the fact that this was an all-male world was what made it so exciting to me at first. And now that it's being invaded and eroded it's much less attractive. Maybe I'm a chauvinist—I don't know. The press box used to be a male preserve—that was its charm. I'd rather not have a woman as a seatmate at a World Series game. It wouldn't be as much fun.—Jerome Holtzman, senior baseball writer for the *Chicago Sun-Times* and the fifty-two-year-old father of four daughters

Just as I can't become pregnant, women shouldn't become sportswriters. When I was ten years old my father began taking me to baseball games, and this relationship was very significant to me. It was male. It was something that separated me from my mother. Baseball is our most traditional game, and on an emotional level I don't want to break away from those traditions. . . . Maybe I don't want this changed because I want to think of sports as being unchanged, still juvenile. I want to go on thinking about baseball as being a part of our life that doesn't have the same values as the rest of it. Something about the joy of the game is going.—Maury Allen, columnist with the *New York Post*, father of an eleven-year-old daughter who wanted to become a sportswriter

Fritz decided which voices Judge Motley would hear in affidavits.[6] In the chorus of voices he chose, Angell's was his featured soloist. Before "Sharing the Beat" was published, Fritz knew that Angell's distinctive, elegant prose about the game and the place it held in American culture would resonate our judge who rarely, if ever, read about baseball. It was not possible to read Angell's words without feeling his abiding love of baseball seep through and, through this, to appreciate its meaning to Americans, including those people who treasured Jackie Robinson.

Angell's affidavit did not disappoint.

"Baseball is almost fixed in its rules and customs, yet in the past two decades it has undergone convulsive alterations that reflect some of the profound changes and ironies that we have experience in our society at large with the rise of great black ballplayers, whose prowess on the field has brought them national fame and a level of wealth so far attained only by a very small

percentage of their fellow American blacks." He also told Judge Motley about baseball's recent "bitter labor struggle," describing how players, until recently, had been bound to their team owners. In writing this, he was alluding, of course, to those who'd been enslaved. He wrote about the courage of Curt Flood who had taken Kuhn to court to try to win his freedom from his team's owner. Though he lost his case, Major League ballplayers had secured their freedom a few years later, when in 1978 they could sell their services to other teams and be paid what the marketplace said they were worth, not what their owner was willing to pay. Angell told Judge Motley that this change had a "profound effect on how millions of Americans think about 'their' players, labor relations, race relations, stardom, and the place of entertainment in our lives." After contextualizing these enormous changes that had happened in her lifetime, Angell brought Judge Motley into a baseball locker room through his experiences as a magazine writer. Like him, my job as a magazine reporter differed from that of a daily writer who had to rapidly produce a game story for the next day's newspaper. I was grateful to Angell for describing the access we needed for our work.

> The magazine writer is in search of more subtle material—the "feel" of the event, the possible cause of victory or loss, the state of mind of the star or the "goat" of the game, the morale of the club, the relations between the players and between the players and the manager and the owner. The sounds and sights of the clubhouse itself—tomblike after a mid-season loss, tumultuous and champagne-drenched after a great season-ending or Series-ending victory— are an essential story in themselves. Many of the sportswriter's most valuable insights and stories come only after he has sat, sometimes for hours, in the company of ballplayers in the clubhouse. Here a player will suddenly give vent to his wrath, or to an impulsively stated wish to be traded, or an expression of awe or derision over the performance of a rival player. These revelations are unplanned, and they almost never emerge in formal interviews; they are rarely repeated—the reporter outside the clubhouse has missed them forever. . . . Only in the clubhouse is he [the player] off-duty and likely to relax and speak his mind.

In conclusion, Angell said that he'd seen me "standing outside the door of the Yankee clubhouse after the last game of the 1977 World Series." Then he explained why Kuhn's ban left me "at a severe disadvantage . . . unable to perform their assignments as well as male reporters." "Some players, but not all of them, will stop and talk to female reporters outside the clubhouse after

they have showered and dressed. These interviews are invariably unsatisfactory. The players are generally in a hurry; they must catch a team bus, or they are anxious to meet their waiting families and friends and go home. They have already spoken to reporters inside the clubhouse and whatever they say has a hurried, warmed-over, unspontaneous air. The game is no longer fresh in their minds, and caution and formality have replaced spontaneity." Excluding female reporters, he told her, "is not just iniquitous; it is unnecessary." "Players who might feel embarrassment at their presence have access to other rooms within the clubhouse enclosure in which they may disrobe or begin to dress, in male privacy. . . . A robe or even a towel can also serve if modesty so demands. These inconveniences, in my opinion, are trifling in comparison with the serious deprivation of equal working rights and equal access to information currently denied to female sportswriters in their pursuit of their profession."

Reading Angell's affidavit took me back to that winter evening when he and I were in the Nets' locker room. When he walked in, I was sitting on a narrow bench in front of the lockers talking with Phil Jackson, who was the Nets' player coach. Angell approached us and I watched the two men shake hands. Jackson made space for Angell to join us, and soon they were talking about women working in locker rooms. Jackson assured Angell that "nobody thinks about it anymore." In the prior season, when he was playing with the Knicks, a few of the rookies "were a little tight about it—a few guys ran into the training room—but we told them to shape up, and they did," he told Angell. Then, suddenly, Jackson shifted gears and gave Angell an unsolicited opinion: "I don't know why baseball makes so much of it all. Nobody cares or notices."

I stayed quiet. Then Jackson surprised me by turning to look at me while he kept talking with Angell. He had mischievous grin on his face when he told Angell, "Nobody looks—except Melissa here. Melissa is a peeker, a regular Peeping Thomasina."

The three of us howled with laughter at his humorous aside. His light-hearted frivolity gave all of us a moment to exhale. When our laughter died down, I realized how tired I was of the biting, demeaning humor and the tiresome, insulting jokes that too many men seemed never to tire of repeating. How refreshing it was to be with these men whose conversation about my situation was tinged with the kind of humor that made me forget the nasty stuff. That people were making such a huge stink about a circumstance that was relatively easy to fix irked me.

Years later it delighted me, as well, to discover that the first female writer to work in an NHL locker room also used sardonic wit to counter the

absurdity of how most men wrote about equal access to locker rooms. "I found myself forced to muster Supreme Court–worthy arguments for an inane essentially logistical problem that could easily have been solved by a few big towels," Robin Herman wrote on her *Girl in the Locker Room* blog.

In "Sharing the Beat," Angell nailed the end of our encounter with perfect-pitch words: "He [Phil Jackson] laughed, and we laughed, and he put on his underpants."

Chapter Nine

Judge Motley's courtroom was not a welcoming place for humor. Even outside of her courtroom, I couldn't imagine our judge chuckling at Phil Jackson's quip calling me a "peeping Thomasina." In contrast, Fritz's hearty laughter infused our meetings, and this worked to good effect in helping me ignore the zanier things said about me. But in court, Fritz was singularly focused on the cogent flow of his argument. Next up was his make-or-break moment to carry our case over its highest legal hurdle.

Major League Baseball and its teams operate as private businesses. When a privately operated business is the defendant, the plaintiff must show that some "state" entity is "entwined" in some way with those who discriminated. "Entwined" meant that this "state actor" had a legal or financial entanglement, like a contract or lease. If Fritz demonstrated that a such binding connection existed in my case, the judge could use the Fourteenth Amendment's Equal Protection Clause in her ruling. Of course, laws passed by Congress pertain to discriminatory behavior in the private sector, notably Title IX, which in 1972 mandated equal opportunities be given to men and women in publicly funded educational institutions. Title IX, known for spurring gender equity in sports, did not apply in my situation. So Fritz would put before Judge Motley evidence of the Yankees' stadium lease agreement with the city of New York. Central to his argument would be the $50 million in public funds that the city put into rebuilding the stadium in the mid-1970s.

"Before turning to the issue of illegality," Fritz told Judge Motley, "I want to make just one short point on jurisdiction." In making his "short point," Fritz aimed for a precision landing that he hoped would trigger Judge Motley's memory. "We are here under the so-called state action doctrine," he

said. "As I will explain later, in detail, the Yankees are sufficiently entwined with New York City so that baseball's discrimination against women is before Your Honor under the state action concept." By this time, he'd lost me. I did not have a clue what this "so-called state action doctrine" was, nor did I know if the phrase "state action concept" meant the same thing but it sure sounded like it did. My head was spinning as Fritz barreled ahead. I leaned forward, as if by doing so I'd have a better chance of catching a familiar word if one floated by. "This court is familiar with the *Burton v. Wilmington Parking* decision of the Supreme Court in 1961," Fritz said confidently. Hearing no objection, he charged ahead. If Fritz told me about the *Burton* case, I'd forgotten, so I wondered how a ruling about another city's parking authority was relevant to my case.

"There are many similarities between this case and that case," Fritz asserted. "Just let me speak to one now before I get to the sex discrimination part of the case." Pausing long enough to steal a breath, he resumed. "In *Burton*, the Eagle Coffee Shoppe, as you know, kept out blacks."

For the first time since Fritz rose to speak, Judge Motley interrupted. "I think I know the facts since I was counsel," she told him, curtly.

Her sonorous voice startled me, in part I think, due to her brusqueness. Her tone seemed harsher, more serious than earlier when she'd dispatched with a few items of court business before calling Fritz to speak. Since then, Fritz had said what he'd come here to say before a silent courtroom. Her interjection caught me off-guard. I knew that a judge could interrupt a lawyer with a question or to request a clarification, or to reprimand him for an oversight or error. In this case, she'd done none of those things. What she did was exactly what Fritz hoped she would.

* * *

In *Burton*, a Negro councilman in Wilmington, Delaware was refused service at a restaurant in August 1958. William H. Burton had parked his car in the public garage, where the Eagle Coffee Shoppe was located. When he entered the restaurant asking to be seated, his request was denied due to his race. In suing Eagle Coffee Shoppe, he charged that it "had abridged his rights under the Equal Protection Clause of the Fourteenth Amendment." When he took the lower court's ruling to the state's supreme court, judges there also found the restaurant's refusal to serve this Negro man within its legal rights since Delaware law permitted restaurants to do this "if a person was disturbing other customers." The lawyer representing Burton appealed that

decision to the U.S. Supreme Court, where six justices, after hearing the plaintiff attorney's argument about the entwinement of the city, agreed that "the State was a joint participant in the operation of the restaurant, and its refusal to serve appellant violated the Equal Protection Clause of the Fourteenth Amendment." The lease between the city of Wilmington and the restaurant had been viewed by the court as a key factor in establishing that "a symbiotic relationship may exist between the state and a private party that will transform private conduct into state action."[1]

Although I didn't know this at the hearing, when Judge Motley's said she was counsel in the *Burton* case, she'd stretched the truth, at least as I'd heard her rejoinder to Fritz. In fact, she was not the counsel of record in that case; Louis L. Redding[2] was. He was also Delaware's first Black lawyer. After graduating from Harvard Law School in 1928, he'd come home to practice law. Thereafter, he argued every major case involving racial discrimination tried in Delaware. In *Brown vs. Board of Education*, Redding and Motley had known each other by assisting that case's lead attorney, Thurgood Marshall. A few years later, when the U.S. Supreme Court agreed to hear *Burton*, Motley worked as a consulting attorney on this case with Redding. In the late '50s and early 1960s, Inc. Fund attorneys typically took on consultative roles when racial discrimination cases went to the nation's highest court.

Even though Motley was not *the* counsel on *Burton*, she was as well versed as anyone with the "state actor" argument that Redding used to confirm the applicability of the "state action doctrine." *Burton* reaffirmed this as precedent, and there seemed no reason why this doctrine could not be applied to gender as well. Fritz had researched Motley's influential role in shaping the winning argument in *Burton*, so it was gratifying, though not surprising, for him to hear her assert her counsel role in that case. That was what Fritz hoped she'd do when he gave her that opportunity. Her eagerness in acknowledging her role reinforced his decision to use *Burton v. Wilmington Parking Authority* to assert the presence of a "state actor" in *Ludtke v. Kuhn*. With its many parallels, Fritz believed that Judge Motley would regard the Yankees' financial connection with New York City as a justifiable "state actor" claim for him to make in our case.

Fritz had highlighted the parallel circumstances of these cases in his legal brief and memorandums he sent to Judge Motley before the hearing. The Eagle Coffee Shoppe being in the city-funded parking garage and its lease with the city of Wilmington was the same as the locker rooms inside the stadium that was rebuilt with city funds and the Yankees' stadium lease with the city of New York. Fritz noted that in *Burton*, a privately owned and

operated business had denied service to a man based on his race; in *Ludtke* a privately owned and operated business had denied access to a woman based on her gender. Both plaintiffs turned to the federal court for relief, hoping their lawyers would convince the court to rule based on violation of their constitutional rights. Now it fell to Fritz to convince Judge Motley that the argument in *Burton* could be applied in our case too. "That is why I mentioned your familiarity with the case," Fritz told Judge Motley, before he pressed on without displaying any sign of the relief he likely felt in hearing her respond to *Burton* as she did.

"Part of the Supreme Court's reasoning is that case seized upon the statement by Eagle that 'for it to serve Negroes would injure its business,'" Fritz said, reiterating the argument he'd laid out in documents submitted prior to the hearing. "Since the Eagle Coffee Shoppe had leased the restaurant from the government, the Supreme Court seized on that statement and emphasized that on Eagle's theory the government itself was profiting from discrimination." After vocalizing his summary of that case, Fritz paused again, perhaps expecting Judge Motley to interject again. When she didn't, Fritz posed a rhetorical question to tighten the snug fit he made between *Burton* and *Ludtke*.

"Why is that relevant here?" he asked of nobody in particular.

Clearly he'd piqued Judge Motley's interest by uplifting *Burton*. Now he wanted her rapt attention as he made his next crucial point in responding to his own query with plain-spoken assuredness. "The reason is that baseball in this case makes precisely the same argument as Eagle made in that case," he told her, before directing the judge to the legal brief that Major League Baseball submitted in this case. He referred her to pages 37 and 38 of a document which he knew she had next to her on the bench. She didn't reach for it. Dipping into specifics, Fritz pinpointed connections between actions the commissioner took against me at Yankee Stadium and Kuhn's words about running baseball as a profit-making business. In his legal brief, Kuhn's lawyer explained why the commissioner developed a media policy that did not give female writers the same access to the ballplayers. He'd done this, Climenko said, to "protect and preserve the national image of baseball as a family game [and] . . . to preserve baseball's audience and to maintain its popularity and standing." To Fritz, this showed that Kuhn's motivation for preventing me from fully performing my job was his belief that baseball was America's "family game." If he didn't stop me from going into teams' locker rooms, he'd lose customers and jeopardize the game's profits.

After spotlighting these assertions, Fritz contested their relevance, accusing Kuhn of trying "to justify the exclusion of women by saying the policy is

necessary 'to the preservation of baseball's audience.'" Citing Kuhn's affidavit, Fritz highlighted a key point he'd made to the judge: "As Commissioner Kuhn puts it, the financial support of baseball depends on its image, and that image, he said, will be ruined if baseball treated women reporters in the same way as basketball and hockey in this City do." Holding the judge's attention, Fritz illuminated more overlaps with *Burton*. "Just as in the Eagle situation in *Burton*, the challenged discrimination is said to be important to profit. Just as in *Burton*, the government, here, the city, shares in the discriminator's profit under the lease," he reminded her. In *Burton*, the U.S. Supreme Court had found that the restaurant had a "symbiotic relationship" with the Wilmington Parking Authority. When the parking authority needed to secure additional funding to construct its garage, the city had entered into long-term leases with business tenants, including the Eagle Coffee Shoppe. It signed a twenty-year lease to operate in a first-floor corner of the garage. Neither the parking authority nor the state of Delaware required that the restaurant serve all members of the public, but in arguing *Burton*, the lawyer convinced a majority of justices that Eagle and the city were "entwined" in their financial interdependence. By doing this, a "state actor" was brought into the case and, in turn, so was the U.S. Constitution. As consulting counsel in *Burton*, attorney Constance Baker Motley had played a significant role in developing and advancing its legal argument. Her contributions to this case made her rapid ownership of her counsel role completely understandable.

Fritz stressed why the parallels in these case mattered, but he also maintained that our claim of an entwined "state actor" was stronger than in *Burton*. "Under the lease involved in this case the point is more powerful than in *Burton* because the rent paid to the city slides up as the attendance at Yankee Stadium increases, whereas in *Burton* there was a flat fee rent of $28,000 a year," he said. The facts of the Yankees' lease with New York City were undeniable. Fritz had sent the 198-page lease agreement to Judge Motley, accompanied by financial records related to it. In reviewing them, the judge learned that in August 1972, the Yankees signed a thirty-year lease with the city of New York for its use of the stadium, which, after all, was meant for public use. According to the terms of the lease, the amount that the Yankees paid the city each year increased as the stadium's attendance rose. In both 1976 and 1977, the Yankees had paid New York City about $1 million. Relevant, too, was language in the lease recognizing the direct line between the publicity the Yankees received from the media and paid advertising and the number of people attending the team's eighty-one home games.

With me in the baseball press corps, Fritz felt it was important to point out the essential role media coverage played in this lease. Another clause in this lease called on the Yankees to comply with "all present and future federal, state and local laws" that affect the team's operations at the stadium, even though the Yankees assumed daily control of what happened there. Additionally, the city retained the right "to enforce and assure compliance not only with local but also federal and state laws." Because of the stadium lease, Fritz had named three city government officials as defendants in our case, including Mayor Abraham Beame and the two department heads tasked with monitoring the stadium lease. Early in the hearing, Judge Motley had dismissed them from the case. Even with them removed as defendants, Fritz pounded home to the judge the fact that the city of New York leased to the Yankees the place—Yankee Stadium—where Kuhn had delivered his discriminatory edict against me. If he'd done this in a privately owned ballpark, such as Dodger Stadium, Fritz would not have had the *Burton* lever to use.

After fortifying our state action claim through its kinship with *Burton*, Fritz moved on. He figured he had about forty-five minutes to present his entire case, though Judge Motley had prescribed no specific time limit. It was simply understood. Talk too long and he'd try her patience. So, with several critical points still to be underscored, Fritz switched gears to examine the legality of Kuhn's denial of equal access.

* * *

"Let me turn to the issue of legality," Fritz said, starting down the evidentiary path to show that Kuhn acted against me solely due to my gender. "It's not a complicated case on the facts," he assured Judge Motley. "The question for the Court is whether, as we say, the admitted facts give rise to a conclusion of unlawful sex discrimination." Then he set out to methodically parade various admitted facts before her. "It's admitted that women reporters are excluded from the access to ballplayers which traditionally is granted to male reporters," he said. He'd confirmed this core fac when he deposed Kuhn, who had sworn to tell the truth. During several hours of back-and-forth with the commissioner, Fritz drew him out on specific points he'd tagged as key building blocks in constructing his argument.

Fritz had learned of a lunch that Kuhn and his wife hosted during the 1977 World Series with the outgoing and incoming presidents of the Baseball Writers Association of America. Had they talked about his client at that lunch? Fritz asked Kuhn. This line of questioning seemed to surprise the

commissioner, who replied warily, "The subject of Melissa Ludtke did come up in that discussion." Then he paused, as if to collect his thoughts, and without Fritz asking another question, Kuhn elaborated saying that he was "pretty sure that we did discuss the suitability of access which we provided outside of the clubhouse. There was a feeling on the part of these men that it was a suitable access for a reporter."

Fritz's next question was based on information he'd found in one of Kuhn's confidential memos. "Is it correct that they [the baseball writers] were saying something about being concerned that in some way if women were permitted into the clubhouse, then they might have less access to players?" Again, Fritz seemed to catch Kuhn off-guard though he should have been prepared. After all, Leonard Koppett, a West Coast sportswriter for the *New York Times*, had raised this point in a November 1977 phone conversation with Bob Wirz, Kuhn's media director. Wirz sent Kuhn[3] a memo relaying Koppett's concern that the men did not want their access to the players to be restricted in any way by Kuhn capitulating to my demands. Koppett had called Wirz after he'd read a *San Francisco Examiner* story by Stephanie Salter. Her story was the first to speculate that Time Inc. would take my situation with Kuhn to court. After they hung up, Wirz had phoned the San Francisco Giants PR director to have a copy of Salter's story faxed to him in New York.

Two days later, Wirz summarized in his confidential memo to Kuhn what he'd learned from the story and Koppett's call. The memo's subject line was "Melissa Ludtke Developments" and he copied Kuhn's in-office counsel, Sandy Hadden. When Fritz read this memo he'd gotten in the discovery phase of our case, it presented Fritz with key insights that he used in deposing Kuhn and Wirz.

Wirz's preface of that memo was two sentences long: "There are a few developments which indicate a stronger possibility of legal action by Melissa Ludtke. I want to keep you up to date with as much as I know on this subject." Later he assessed for Kuhn how he regarded the prospect of legal action: "This obviously would be a turn-around from what they had previously indicated to us, if the story turns out to be true."

In item 3, Wirz summarized his phone call with Koppett, while sharing details from Salter's story about a potential lawsuit:

> 3. Leonard Koppett called me to say that Stephanie Salter of the *San Francisco Examiner* has written a story on Monday in which she went into considerable detail regarding the Ludtke situation. He read much of the story to me and

while there was considerable truth to what was printed, there also were a number of statements which were not true. We have also been told that there is a follow-up story, which is to appear today, but I am not certain of the accuracy of that information at this time.

Koppett believes that if we use the point of her being excluded merely on a sex basis that we have very shaky legal ground. His primary concern, however, was that we have ulterior motives and might in some way use this in finding some way to make further exclusions of the male writer in the clubhouse. I assured him we did not have any such thing in mind. He also offered his opinion we should leave these decisions up to the players because he did not feel that a woman journalist could have success in overcoming the objections of a player that she might in overcoming our male v. female stand.

Koppett was probably the first sportswriter to raise such concerns, but he wasn't the last one to caution Kuhn against disrupting their routines to placate a woman.

"Well, I think to be more accurate, what they said was that if there were a female reporter in the clubhouse, the players would be less apt to be communicative and, indeed, might not be available," Kuhn said, responding to Fritz's question about the baseball writers' concerns.

Fritz pressed him. "And that would injure them in some way in trying to carry out their function as professional baseball reporters: Is that correct?"

"Yes, that is correct. I think I have covered it," Kuhn said, attempting to bring this back-and-forth to an end. As commissioner, Kuhn was accustomed to being the king of his realm. There, he decided when conversations began, where they went, and when they ended. But as the lawyer doing the deposition, Fritz held the upper hand, so Kuhn's sense that he'd fully dealt with this topic did not matter. In fact, by expressing eagerness to end Fritz's line of questioning, Kuhn had thrown red meat in front of the lion's mouth.

Fritz pounced. "You said these gentlemen indicated—my notes tell me the men were *feeling*—that access outside the clubhouse was suitable."

"Yes," Kuhn replied, his monosyllabic answer demonstrating his hesitancy. His yes was perfunctory at best, leading Fritz to sense something more was behind it.

"By that you mean access for women outside the clubhouse?" Fritz asked.

"Yes," Kuhn agreed.

Fritz stayed quiet, leaving Kuhn room to elaborate. "I am quite confident I told them exactly what we are proposing to do and had been doing,"

Kuhn said. "I guess that would be more accurate. They thought that was suitable."

"Did any of the men say, 'Well, gee, that's the way we would like to do it ourselves?' Did either of them say that?" Fritz asked Kuhn. He'd framed his question to bait a trap.

"I am not sure that they did or didn't," Kuhn replied, perhaps sensing this intent.

Since he was a lawyer, Kuhn knew well litigators' tactics with oppositional witnesses. His own lawyer must have prepped him to expect this treatment, so he must have known that mealymouthed answers would only tempt Fritz to up the ante. Still, Kuhn tried one more dodge, describing for Fritz how reporters would seek him out after press conferences for separate interviews, as if this was analogous to his policy of "separate accommodations" for me. Kuhn's point was that what he said to that one reporter would hold greater value since he alone had that quote or new information that he'd revealed. He implied that by giving women the opportunity to interview players apart from prying eyes and listening ears of the rest of the press corps, they would have something of greater value than if they were with the ballplayers in the clubhouse. In the words of Chief Justice Brennan, Kuhn was indulging in "romantic paternalism." He was putting me *on a pedestal*, where he believed I ought to be happy being put. In actuality, he was holding me *in a cage*, as Brennan wisely went on to observe.[4]

As Kuhn embellished his rationale, he was actually spoon-feeding Fritz follow-up questions. "Has anybody ever said to you, 'Mr. Kuhn, please don't let us come to your press conferences so we can have the chance simply to interview you after the press conference?'" Fritz said to Kuhn, pushing him to say more on this topic.

"No, I can't imagine they would put it that way logically," he replied. "What they would say to me is, 'Would you give us some time separately?'"

Fritz pressed on hoping to pierce Kuhn's logic by exposing its fault lines. "Has any male reporter ever said to you, 'Please, Mr. Kuhn, bar us from the locker room so we can have the right to see players on the outside of the locker rooms?'"

"No, but I think—" That was all Kuhn managed to say before Fritz interrupted him. "Answer my question," he demanded.

Jesse Climenko, seated nearby, rose to his feet and spoke. He entered the fray in an attempt to protect Kuhn's interests.

"You let him answer it his way," Climenko shouted at Fritz.

"You answer it my way and I will give you an opportunity," Fritz said, staring at the opposing lawyer.

"Excuse me, Mr. Schwarz," Climenko said. "He will answer his way in the first instance since this is an argumentative question. He is going to answer the question his way."

After the lawyers settled down, Kuhn spoke. "At these particular events like a World Series and the All-Star Game, where we provide interview rooms and put the major players and managers and so forth into those interview rooms, I think you will find that many reporters find that more than adequate for their purposes," he said blandly.

"Now, would you answer my question?"

"Tell me," Kuhn said, "how I have not?"

After more wrangling, Fritz repeated his question.

"Has anybody ever said to you, 'Please, Mr. Kuhn, exclude me from the locker room and limit me to seeing players outside the clubhouse?'"

"No."

When he heard Kuhn admit this, Climenko interjected for the record. "The question has been objected to as already answered and the witness is instructed not to answer." His complaint was duly noted in the transcript sent to Judge Motley.

Knowing that Kuhn had affirmed that blatant gender discrimination was being practiced by baseball, Fritz happily moved on.

Over the course of this deposition, Fritz's questions led Kuhn to affirm that he had singled me out for unfair treatment due to my gender. Neither he nor baseball writers saw anything unfair about parking me outside the clubhouse while the men worked inside. When I'd read Kuhn's deposition, what hit me hard was his patronizing remark about giving me an enviable advantage by keeping me from my sources—the ballplayers—while other reporters were with them. Of course, when Fritz had pressed him, Kuhn had conceded that no male writer would sign up for the deal he said I was lucky to have. I'd have exclusivity, according to Kuhn, but at a hefty cost in being kept away from the place where stories unfolded with the male writers there to watch. This exchange between Fritz and Kuhn drilled to the core of my case: Was Kuhn's media policy discriminatory in keeping female writers separate from the men, who were advantaged by being with our news sources?

Fritz was going to make Judge Motley understood that it was.

Chapter Ten

When I showed up at ballparks, I found no road map to use. I relied on my gut. Blown like the weathervane atop a church steeple, I moved as the men around me did. If they were near the batting cage, so was I. When I saw them head to the dugout, I followed. It didn't occur to me to ask anyone on our baseball reporting team at *Sports Illustrated* for advice, nor was any offered. As men, they could not relate to my ballpark experiences. I kept complaints to myself. I didn't air my frustrations or react to my detractors. In the late 1970s, there was no organization supporting women sportswriters; the Association for Women in Sports Media was founded in the 1987. Nor did I find mentors at the ballpark. In time, a few male writers befriended me, but when I first showed up, I was on my own.

To have complained publicly about my treatment would have meant finding a writer to tell my story in those pre–social media times. But my story would have been a tough sell since neither sportswriters nor editors much cared about a woman's difficulties in baseball. Most of them just wished I wasn't there. But that challenge alone wasn't what kept me from going public. Before I did that, I'd need to tell my editor at SI about what I couldn't do for the magazine due to my gender. I loved my job too much to risk losing it by revealing my deficiencies. I might be replaced like the New York *Daily News* had done with its female baseball writer a few years earlier. Also, it wasn't in my DNA to admit defeat. It was better for me to push privately within baseball rather than jeopardize my job. When I got frustrated or felt angry, I'd find a place where I could cool down. The ladies' restroom did the trick. I could release a few tears, splash water on my face, then soldier on. Patience won out over posturing. If I persisted, I was sure

my access to ballplayers would expand over time. At that time, my abundant joy in being around the game more than compensated for the sexist ways baseball treated me.

* * *

Soon after 1976 baseball season began, I went by subway to the Bronx for my first outing as a member of SI's baseball team. Even though I earned my paycheck for fact-checking baseball stories and tracking weekly stats, I wanted to learn how to report at ballparks. I saw this as my bonus opportunity, even if I wasn't paid for the hours I spent there. After my first game at Yankee Stadium, I was eager to return for my second, then my third and fourth games. And so it went through that season, then into the next. I rarely missed a night game at Yankee Stadium or at the Mets' Shea Stadium, when the Yankees were on the road.

As much as I loved being there, I knew from that first game that I had a steep learning curve ahead of me if I was to report for *Sports Illustrated*. Unlike my SI peers, I had never written anything about baseball, or any other sport before I was hired. I was a total rookie, so when I stepped on the field at Yankee Stadium that first day and saw writers chatting with each other and players at batting practice, I decided to join them. As I approached, the men turned to stare at me, and I realized I was the only woman on the field. Nobody said hello, and their body language hinted that I need not greet them. At the batting cage, I felt out of place. For starters, I didn't know how to stand. Even though this surely sounds silly and trivial, I stood differently than the men did. Theirs was a wide, swaying stance as they leaned on the metal bar wrapped around the batting cage. If I did that, I'd send a message of assertiveness, which on my first day was not the vibe I wanted to transmit. Should I cross my arms and rest them on that metal bar as some men did? As their bodies slanted away like the lengthy side of a triangle? That didn't feel right for me. So how should I stand? I wanted to fit in, but standing like they did wasn't working. To feel like "the other" didn't feel good either.

I also worried that I might unintentionally do something stupid in front of the men. I didn't want to make myself the butt of their jokes. Had I felt more confident, this fear of making a mistake would not have haunted me as it did. But I never wanted to hear one man say to another, "Wow, that girl asked a really dumb question." The men did see me as a "girl," and with that strike against me the questions I asked a ballplayer or a manager had to be rock solid. Each of these men *had* to know that I knew what I was talking

about. After trying a few one-on-ones with ballplayers, I was relieved that nothing I feared would go wrong had gone wrong. Still, in the dugout, I kept up with my reporting lessons. After the manager posted his starting lineup, the writers often surrounded him. I stayed on the periphery of this scrum of writers and listened to them lob questions, paying attention to their repartee so I could feel the rhythm of their verbal dance. When a manager sidestepped a question, I listened as writers tugged him back to the issue at hand, always keeping in mind how I, as a woman, would handle my own back-and-forth with managers who were generally a decade or two older than the players. If a young woman like me approached, I knew some would tag me as a bimbo before I could ask my first question. Through trial and error, I short-circuited this misimpression by asking sharp questions that displayed my seriousness and knowledge. I also tried to steer us into conversation, which worked better than me barraging him with questions. To my delight, I found that when I could put them at ease, wondrous stories flowed like spring rivers.

It was in dugouts, too, that learned to keep my dresses and skirts out of range of gross, gooey tobacco juice that ballplayers expelled while we talked. One day before a game, Dave Kingman, then with the Yankees, slid next to me in the dugout and thrust a wad of chewing tobacco at me. He said nothing, but I knew it was an invitation to partake. I had not chewed tobacco but decided to give it a try, so I reached out my hand to accept his offer. I popped a good-sized ball of tobacco into my mouth and rested it between my cheek and gum. Side by side we sat spitting out tobacco juice. Kingman spit his to the floor, while I caught mine in a paper cup. Spitting on the dugout floor seemed a step too far for me. To avoid his spit, I positioned myself so my dress and legs were out of his range. Some Yankees on their way to the locker room paused to take in this scene. My face must have looked like a chipmunk's hoarding acorns, and I held a cup of foul-smelling goop in my hand. I sensed the players knew exactly what was going on. A few seemed amused or intrigued by Kingman's stunt, and they lingered, curious to see how this standoff would end.

Kingman was trying to embarrass me. By then, I'd been around baseball a while and his distaste for women writers was well known, and that's why I chewed what he'd offered me. I thought I might gain some street cred in calling his bluff. I figured that some players were likely to joke about my escapade in the locker room, but I thought the benefits would outweigh that ridicule. I took his gambit to beat him at his own game, and I did. Kingman turned out to be the one who didn't know what to do next as I just kept on chewing and spitting. A decade later, with his career was in decline, Kingman had a box delivered to Oakland A's baseball writer Susan Fornoff in the press

box. He put a live rat inside. After she opened it, the A's punished Kingman. Our dugout encounter ended with a whimper, not the bang he was looking for. I think he counted on me swallowing the vile tobacco juice and maybe throwing up in the dugout. Instead, after I'd kept that ball of tobacco it in my mouth for quite a while before I extracted the wad, spit out the juicy residue, then at the water fountain washed the foul taste from my mouth. When I turned around, Kingman was gone. The two of us never spoke about chewing together or anything else. I kept my distance. When the baseball writers voted in 1993 on Kingman's first nomination to Baseball's Hall of Fame, he received so few votes that he lost his eligibility. Few women writers shed a tear. I believe that his treatment of us contributed to making him the only player to hit four hundred home runs and not be voted into Cooperstown.

Of course, hanging out in dugouts also meant laughing at jokes men told. In my effort to fit in, I laughed even punch lines came at the expense of women. It pains me to admit this, but I even retold a few of those jokes at bars after games. Away from ballparks, I brushed up on baseball stats, too, since they are the currency of baseball. I scoured the newspapers' box scores, and inhaled game stories taking note of records. I also had some catching up to do with the oldie-but-goodie stats that the men tossed around like doubloons thrown from a Mardi Gras float. Of course, I knew that Ted Williams kept himself in both games of the final doubleheader in 1941 even though doing so could jeopardize his .400 batting average. (Going six for eight at the plate that day, Williams improved his record-setting average to .406.) Such moments are de rigueur for any baseball writer. No longer was it good enough for me to know "a lot for a girl"; I had to know what the men knew and talk baseball with an alphabet of stats and a memory trove of highlight reel moments extending beyond "the catch" (Willie Mays), "the pitch," (Ralph Branca) and "the asterisk" (Roger Maris). So I played catch-up. Unlike the guys, I hadn't memorized baseball stats from the age of five. At the age of twenty-five, I told myself I would.

* * *

Despite my initial deficiencies, I felt in time I'd fit in. I was a workhorse, not a show horse, and I believed the men would grow accustomed to me being with them. And when they did, I'd have the same access to the players that they did. With stories I'd write, the reporting I'd do, the doggedness I'd show, and my get-along attitude, I'd change how they saw me. Trusting this, I pushed

aside mounting evidence of the oversized role that entrenched sexism played. With my wistful thinking, I dug in. Determined to prove myself right, I devoted an untold number of unpaid hours to perfecting my reporting skills and brought back story ideas to the magazine. In other off-the-clock hours, I wrote stories on spec, and most were published. I grew addicted to seeing my byline in *Sports Illustrated*. Wanting more, I was drawn more deeply into my exhausting habit of extending my hours of work, which made me miss out on the social life my friends enjoyed. I was grasping with naive hope and magical thinking at my payoff being promoted to writer. What I hadn't factored into my equation was the fierce resistance I'd confront. Or the possibility that even with all this effort, I wasn't good enough to be a writer.

When my legal case was filed, the press pretty much sandpapered my naivete away. Commentary and news coverage put me face-to-face with the reality of these systemic barriers and the strongly held attitudes working against me. Even in a rare column favorable to my case, the sex angle got top billing. In Philadelphia's *Evening Bulletin*, columnist Rich Ashburn opined that my case rested on solid legal ground, but his headline writers led with a more enticing angle: "The Naked Truth: Melissa Has a Case."[1] Although Ashburn explained why he thought I'd beat Kuhn in court, he couldn't resist revealing his own naked truth in his column's parting words: "It will only be a matter of time before women will know for sure that all men aren't created equal." Though nodding facetiously at the Declaration of Independence, Ashburn barely mentioned the equal protection clause in the U.S. Constitution. It was hard to find a headline that did not merge sexy puns with baseball lingo. In late January, NBA writer Bill Schey weighed in against equal access when the Seattle Sonics' coach opened his team's locker room to female writers; his headline writers doubled down with "fluff in the locker room."[2] At the *News-Press* in Fort Myers, Florida, sports editor Chuck Roames speculated that although "women libbers won't like it, many people, including me, feel that unless it works both ways [with men going into women's locker rooms], female reporters should stay out of men's locker rooms." His column appeared with headline, "'Battle of the Sexes' Invades Sports' Locker Rooms."[3]

The headlines galled me, as did many of the stories, but I didn't write letters to the editor or send personal notes to writers. Nor did I telephone them to correct the record. I didn't believe that anything I said would change their minds or temper their next story about my case. I worried that by responding I might add fuel to the fire. Early in 1978, Detroit sports columnist Doug Bradford joined the fray by poking fun with hyperbolic descriptions of me at work—"wiggled her little finger," "cooed one question

after another," "sashayed around some of the other Tigers," with her "super slim silhouette." None of these descriptions came close to touching the reality of how I did my job at ballparks.[4] Bradford infuriated me with his intimation that I was trolling for after-hours escapades with ballplayers, but I didn't call or write him or his editor. I wish I had. He left his readers believing I had unfair advantages when precisely the opposite was true. My access to ballplayers was severely limited; his wasn't. It was me, not him, who waited in dugouts hoping a player whom I had asked to leave the locker room to talk with me would show up. It was me, not him, who wasn't permitted to be in the clubhouse for the forty-five minutes before the game when players were fully dressed. It was me, not him, who was forced to wait outside the locker room door while a male runner went inside to try to get ballplayers to come out to do interviews with me.

Like many other sportswriters, Bradford shoved equal access so far out of view as to render it invisible. Instead, he wanted readers to see me as a temptress who would use her sexual wiles to do a job that no woman should be doing. His brazen mischaracterization of me reminded me of the *New York Times* anonymous letter writer who had described hockey writer Robin Herman as a "harlot disguised as a reporter" after she went into a locker room at the 1975 NHL All-Star Game. He wrote that he hoped she was "kicked out on [her] your prostitutional [*sic*] ass."[5] Maybe having his byline on his column tempered what Bradford wrote about me, but his implication was the same.

Still, I didn't give up on my go-slow, gradualist approach and can-do attitude despite making little headway in expanding my access to players. Being the only woman working at most games tamped down any impulse I might have had to forcefully assert my right to equal access. Like other women sportswriters, at work I was one among the many men, including some who wrote baseball's rules and had power to enforce them. My ability to act in my own best interest stretched only so far, and it wasn't far enough to tackle the patriarchal culture of this game. Tug too hard or grab for equality too fast and I risked the cord of progress snapping back at me.

Chapter Eleven

Fritz wanted Judge Motley to see this "bastion of male sectarianism," aka the Yankees' clubhouse. Were Fritz doing this now, he'd show a video from his iPhone on the courtroom monitor. But in 1978, the blueprints of the stadium's remodeled clubhouse and photos he and his associates took on an off-season visit had to suffice. He'd gone there to undercut Kuhn's oft-repeated claim that separate accommodations were necessary for me to interview players. Let me first point out that if there were "separate accommodations" at ballparks—and Kuhn said there were then they in no way could replicate the men's unfettered access. But in my years of covering baseball, no PR director ever took me to such a place before or after a game, and no one even told me such an accomodation existed. With his show-and-tell clubhouse tour, Fritz would assure Judge Motley that Kuhn was wrong on both points.

Before taking her into the clubhouse, Fritz posed a rhetorical question about my case's first "admitted fact" that female writers were not provided the same access to the clubhouse that their male peers had. "Where does this occur, Your Honor?" he asked, though he didn't expect a response. What he wanted was for her to look at this exhibit while he told him where this evidence would lead.

"Have you got the book called the 'Physical Layout Volume' that I submitted with my moving affidavit?" Fritz asked.

"Yes, I have that," she replied.

"There is a chart showing the entire Yankee clubhouse," Fritz began, as she appeared to reach for a binder to look at his exhibit. "This was part of the facilities that were renovated at the cost to the government of $50 million. This was included." he said, reinforcing that the city was a "state actor" in our

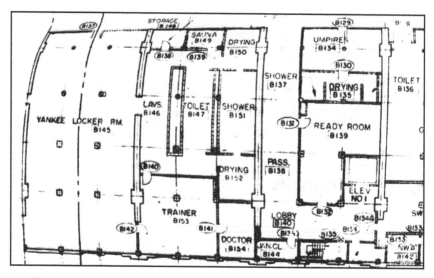

This blueprint shows the refurbished clubhouse after the old Yankee Stadium was rebuilt in 1976 with the use of $50 million in New York City funds. The clubhouse included toilets, showers, doctor's office, trainer's room, a sauna and drying area, the locker room, and manager's office. Every room except the locker room and the manager's office (not shown in this graphic) were off-limits to all reporters at all times. (Courtesy Cravath, Swaine & Moore.)

case. Moving to clubhouse's side door, Fritz reminded her that in the last half of the 1977 season the Yankees' PR person met me there to escort me into the manager's office after games. When Morabito suggested this creative way to get me into Martin's office, I'd agreed to do this right away. Sitting in the manager's office, I was in the media's fray as writers returned from the locker room to question Martin based on what the players told them. Hearing their questions and Martin's answers, I filled my notebook with information I'd never had access to before.

The blueprint wasn't easy to read, so Fritz ushered her to the key areas related to my case. "The Yankee locker room and manager's office are the only two parts of the clubhouse involved in this lawsuit," he told her. They were the only places in the clubhouse where the writers could go. The players' lounge, the toilet and shower room, doctor's and trainer's areas were "private enclaves for the players," he said. Fritz was quiet as he saw Judge Motley studying the blueprints. By seeing the layout of the space, he hoped she'd appreciate that there were many zones of privacy for the ballplayers. It was their choice to use them. After showering, the men could towel dry in privacy, then return to the locker room wearing a bathrobe or with a towel around the waist or in underwear or pants. Again, their choice. No man *had* to be naked.

When Fritz resumed, he underscored another of Kuhn's admissions in his deposition. "The Commissioner of Baseball admitted that even he had never been in those other rooms," he told Judge Motley, challenging Kuhn's credibility when it came to the locker room. Fritz next drew her focus to a photograph of "those cubicles against the far wall," explaining that "they go all the way around the room and each Yankee player has his own cubicle." By now, she was showing impatience with this tour, so Fritz had to plead to get her to look at his last photo; it showed an empty cubicle with floor-to-ceiling side walls and two boards across its width. On the higher one, players stored personal items, while the lower board could be used as a seat, though players didn't usually sit there. They preferred to sit on a stool or chair in front of their cubicles. Fritz told her this was a visual placeholder for the legal argument he'd make later.

"When I come to arguing the so-called 'least restrictive alternative concept,' I'll come back to the cubicle," he said. "Because they are important on that matter."

Judge Motley had seen sketches of clubhouse spaces and photos of empty cubicles, but sportswriters took readers on very different tours of these places. In Baltimore's *News American*, my former *Sports Illustrated* colleague Mark Kram teamed up with graphic artist Stokes Walesy to give readers a bird's-eye view of a baseball locker room. With his zeal for exaggeration, Walesy decorated his locker room with items demeaning women—from sexy posters to centerfolds of naked women. The editors played Walesy's cartoon large on the page, pulling eyes from Kram's less pugnacious prose. This story and image appeared under the headline, "What Do You Say to a Naked Relief Pitcher?"[1]

"Find a towel," was my answer.

This *News American* story regrettably typified the coverage of my case. Even though my gender discrimination case was being fought in a courtroom, few headlines or stories mentioned its legal angles. Instead, the scent of sex permeated headlines.

Locker Room Sex
Babes in Boyland
Women in the Locker Rooms Not a Broad Issue
Grab Your Towel, Mean Joe Green
No Skirting the Issue: Keep Out Gal Writers

Other popular headlines heralded my supposed connection to the boisterously pugnacious women known as "libbers"—the nickname for women seeking liberation from the pervasive, systemic dominance of men. I rooted

for those women to succeed, but decades later it pains me to admit that I didn't participate in any meaningful way in their movement back then. Only years later did I march in Washington, D.C., several times for women's rights. But in the 1970s, sports consumed my life 24-7, so I mostly hung out in baseball's patriarchal bubble. Still, my lack of affiliation with these women activists never deterred commentators, cartoonists, and headline writers from pairing my case and me with them.

Reporters in the Undress Circle Carry Liberation a Bit Too Far
How Far Does Equality Go?
Locker Room Lib: Sex and Logistics
Might Casey: A Swing and a Ms.
Hell Hath no Fury . . . Gal Throws Baseball a Curve
Lib in the Locker Room
Call It a Lock-Her Room

* * *

It was now time to address "the second important admission made by baseball defendants," Fritz said. This admitted fact, he told Judge Motley, was that "a significant portion of the news written about baseball emanates from news gathered by male reporters in the clubhouse of professional baseball teams." At this point, he reminded her that he'd submitted thirteen affidavits from "professional journalists [that] show how important that access is." Since Motley didn't read the sports pages, Fritz knew to tread lightly so as not to inadvertently insult her. "For people who read the sports pages, it's self-evident," he began. "It was particularly evident during last season when the main story about the Yankees were the controversies between players and between the players and the manager and between all of them and the owner." Indeed, that season was a nonstop headline-grabbing soap opera of personal conflicts displayed on and off the field. "You don't have to look at our affidavits. You simply have to have read the sports news for the last year to make the point," he said, before introducing the third "admitted fact" related to the press going into locker rooms, which he confirmed when deposing Bob Wirz.

"Let me give just one example of the admissions that were given to us, Your Honor," Fritz said. "When we deposed Mr. Wirz, who runs publicity for baseball, I asked him four questions on this subject. We were speaking, Your Honor, in the context of a conversation between the commissioner of baseball, Mr. Wirz, and two professional baseball reporters; one was president of

the Baseball Writers Association of America (BBWAA), the other was the president-elect. Both men opposed allowing women the same access as men."

For the first time, Fritz picked up some papers from the plaintiff's table to read the questions he'd asked Wirz, along with his responses.

QUESTION (FRITZ SCHWARZ) Did Mr. Lawson and Mr. Liston [presidents of the baseball writers' association] indicate, in this conversation, that access to, as you put it, the news and the newsmakers was important in carrying out the function of the baseball reporter?

ANSWER (BOB WIRZ) That access to them?

QUESTION Yes.

ANSWER Yes, certainly.

QUESTION And by "access," we mean in the questions and answer access to them in the clubhouse, right?

ANSWER Yes. All reporters, of course, do not go there.

QUESTION But the subject of your conversation was, as you put it, going there in the sense of going to the clubhouse?

ANSWER I would say it centered on that.

QUESTION And that they said in their professional opinions, as the president and president-elect of the Baseball Writers Association of America, this was important to carrying out one's functions as a baseball reporter?

ANSWER To those individuals and many other members, "yes."

He hoped that in reading this exchange Judge Motley appreciated the lengths to which baseball officials went to avoid acknowledging how essential it was for writers, including me, to have access to their news sources.

After returning those pages to the table, Fritz reminded Judge Motley that she had BBWAA president Bill Liston's affidavit that Kuhn's attorney submitted to bolster its case. Liston wrote for the *Boston Herald American*. "Contrary to the journalists we have put before you [in our affidavits], he [Liston] opposes granting the female competitors the access which he says is important in carrying out one's function as a baseball reporter," Fritz said. He used this moment to raise for her the concerns expressed by the *New York Times* sportswriter Leonard Koppett who called Wirz in November 1977 to say he worried that Kuhn might decide to keep men out of locker rooms to avoid a court case with me. "I assured him [Koppett] we did not have any such thing in mind," Wirz had passed on to Kuhn in a contemporaneous memo. In his affidavit, Liston expressed a slightly different worry: "I fear that if the law were to mandate the admission of women to baseball

locker rooms, their presence would make the players so reclusive as to render access to them virtually impossible." That had not happened in the NHL or the NBA, so it was curious that this baseball writer thought it would in his game.

"I wholeheartedly support the right of women to work in my profession," Liston went on to write. His use of "my," as in *my* profession, leaped out at me. I thought it was *our* profession. So, I wasn't surprised that his proposed solution was a carbon copy of Kuhn's. He wanted female reporters to be brought to "rooms adjoining the locker room, which have been established by Major League Baseball for this purpose." My key takeaway was that the incoming BBWAA president couldn't be bothered to check his facts before signing his name to an affidavit in which he parroted Kuhn's false information. There were no such "adjoining" places. He should know this or he should have made it his business to find out. By latching himself to Kuhn's solution, he asserted that this space would "fairly accommodate all of the different interests," as if mine was "an interest" and not a necessity of my job like it was his. With Liston's scheme, the "interests" of men would be served. Mine would be ignored.

"Let's examine his [Liston's] argument for a minute," Fritz told Judge Motley. "It cannot be accepted, and its premise demonstrates, I submit, why we should prevail."

I hung on his last four words—"why we should prevail."

"Liston tells us he fears if women reporters are allowed the same access as their male competitors, the men will have a harder time getting their already difficult job done," Fritz said. "Your Honor, that does not make discrimination lawful." To emphasize this point, he reminded Judge Motley of similar excuses made in the time when she battled racial discrimination. "A feared reduction in the privileges of one group is hardly an excuse for discrimination against another group," Fritz said. "Surely, it's not so when the second group is struggling to compete with the first group."

Having reinforced the fundamentals of our case, Fritz set out to explore new territory. "Given that women are being excluded from access to ballplayers after the game, which is a significant part of a job as a reporter—let's turn to baseball's excuses for its policy," Fritz said.

I'd heard plenty of excuses from baseball. Now I was eager to hear Fritz package them for this judge.

Chapter Twelve

To succeed, I had to stick around baseball long enough to outlast the men's inclination to say no.

Up until I'd shown up, a woman who went to work at a ballpark stayed only a few games. Long enough to write a story, then she was gone. While there, she'd been the only woman in a sea of men who were doing what they could to make her work life more difficult than theirs. Often a team's media director restricted her access to players and separated her from her fellow writers in as many ways as they could.

At first, baseball's men told women they could not go on the field during batting practice. The men were there, but they kept the woman in the grandstand where she could watch them talk with players at the batting cage and managers in the dugouts. The writers also told her she couldn't sit in the press box. Nor could she eat the pregame meal with the men. In early 1970s, the Red Sox set up a rooftop picnic table for a female writer, where she ate by herself while the men ate in the team's dining room. In Houston, the Astros also brought their one female TV reporter her meal on a tray, which she ate apart from the men. Then, as my *Sports Illustrated* colleague Stephanie Salter found out, men evicted any woman who had the temerity to show up at their winter gala. I experienced this same excluding treatment in September 1976 when a bartender in the Bards Room, a writers' lounge inside Comiskey Park, said I had to leave while he poured drinks for the men.

What's the common denominator of these discriminatory actions?

Not on the field nor in the press box, not at a gala nor in a room sipping after-game drinks, were any of the men naked.

Baseball's history of denying access to women had nothing to do with nudity. Its propellant was the men's desire to exclude us. They held the power to shape and enforce baseball's rules, so they were not going to cede even an inch of territory to even one woman. If these doors opened, men feared that more women would charge in. Over time, each limitation on women writers' access was lifted as more females were hired to write sports and editors assigned them to beats. Grudgingly, baseball's men had moved the needle closer to equity by the time I was reporting baseball, so the clubhouse—with its locker room—was all that remained off-limits to me.

On October 11, 1977, the locker room door became baseball's last stand. That happened when Kuhn banned me from clubhouses during the first game of the World Series even though the teams told me I could be there. His decision set in motion a series of negotiations in which Time Inc. began to believe it had no choice but to take Kuhn to federal court. By then, baseball was flying solo in its legal battle over equal access. In 1975, professional hockey and basketball had responded to the gradual influx of female writers by urging all their teams to provide equal access to *all* members of the press. While it took time for every team to comply, teams tended to respond favorably when they had women at their press table. This opening of access took place out of public view, which is how the leagues wanted it to happen.

Professional hockey led the way. On January 21, 1975, Robin Herman, the *New York Times*'s first woman sportswriter, went into a locker room to report at the National Hockey League All-Star Game in Montreal, Canada. Before that night, Herman had spoken privately with several NHL coaches and PR directors to ask for the locker room access she needed to do her job. She was, after all, competing with male writers on stories and they were in there with the players, and she was kept outside. She needed to be there too. The answer she got was always no. They'd bring players to her in the corridor outside the locker room door.

Then at the All-Star Game press conference, Leo Monahan, a hockey writer with the *Boston Herald*, asked the coaches if the two female writers at the game—Herman and a Montreal radio reporter, Marcelle St. Cyr—could report in the locker rooms. The coaches' response shocked Herman, as she told Roger Angell for his *New Yorker* story "Sharing the Beat." The coaches "sort of looked at each other and shrugged and said it would be O.K. that night," she told him. It's likely they did this because the All-Star teams were not their actual teams. The All-Star Game was a one-night stand, and the coaches figured that what happened in Canada would stay in Canada. So why not? It was "treated like a joke," Herman said.

Those coaches' "joke" set in motion the erasure of discriminatory sports media policies. That spring, the NHL president and the NBA commissioner, with little fuss or fanfare went about the work of equalizing women's access. A few teams lagged behind, but generally this transition moved ahead smoothly. With neither league challenged in court, the press hardly paid attention. By the early 1980s, the NFL, which had left the decision about media access up to each team, faced a brief court skirmish in San Francisco when the 49ers head coach denied access to Michele Himmelberg, a writer with the *Sacramento Bee*. She won, and after that, the NFL set out a league-wide equal access media policy. Kuhn's stubborn unwillingness to devise a workable solution is what led to our contentious fight in court and lifted the locker room issue into national and international spotlight.

* * *

At that January hockey game in Montreal, the final horn mercifully ended the lopsided All-Star Game and the two female members of the press joined the parade of men going to the locker rooms. As Herman walked there, she knew that her experiences as an NHL beat writer were about to dramatically change, even if she didn't know how the league would react. A few weeks later, in the *New York Times*, Herman described her feelings when walking to the locker room. It was, she wrote, "as if I had been a cripple regaining use of a limb." Given this rare opportunity to be with the players, she promised herself not to squander a moment of her precious time.

For the first time, she'd be able to grab a lot of quotes while taking note of all she observed. When she got to her typewriter, she'd weave all of this into her story, as she'd enviously seen the men do. On this night, she would not be stranded outside the locker room while a PR man dipped inside to try to bring players out to talk with her. She'd endured many frustrating times waiting to talk with one player whom she felt was key to her story only to learn as her deadline approached that he wasn't coming out to talk. When games didn't go into overtime, she usually had about forty minutes to do interviews, write her story, and send it—not with a click of a mouse but by fax or Western Union—to her news desk in New York. At first, as the only woman covering hockey, Herman had no choice but to do her best with the limitations the league and teams imposed on her. If she protested these arrangements, she risked losing even her limited access to players and the coach.

That was the reality for female writers, like me, who worked in sports with a bunch of men.

To be a woman in sports media meant having to weigh factors that no man had to think about. On nights when players didn't quickly come out of the locker room to talk with Herman, she had to weigh the potential benefit of continuing to wait for him (not knowing if he would appear) against cutting the time she'd leave herself to write and send her story. Should she wait in the hope that this player would come out? Or should she head to her typewriter? Tight deadlines stressed every writer, but a woman had to constantly weigh these options, and in doing so, her insides churned. Without today's technology, she could not know if a player was going to come out to talk. Or if so, when? When the men had finished asking their questions? Would that be in fifteen seconds? Or ten minutes? Once her runner went into the locker room, Herman lost contact with him, so she couldn't monitor his progress. All she could do was wait, and as she did, she'd see men leaving the locker room on their way to their typewriters. If, in seeing her standing there, any of them felt she was being treated unjustly, none spoke up to say the policy excluding her ought to be changed.

"I was wasting time I simply didn't have—and I personally found it mortifying," Herman wrote. What galled her was knowing that with her parked outside one locker room, she'd never get more than half of a game's story. The opposing team wasn't going bring players out to talk with her. Meanwhile, the other writers moved freely in and out of both teams' locker rooms.

When that All-Star Game was over, Herman had gone to report in the Campbell Conference team's locker room since some of its players were on the Islanders, the team she covered. It didn't matter that the Campbell team lost seven to one. As she later wrote, when she walked into the locker room, it "filled with laughter and turmoil," telling her that the coaches had not heeded the advice she'd given them after they gave her the go-ahead to work in the locker rooms after the game. She had urged them privately to alert the players that women writers were going to be in the locker rooms that night. It was only fair, she told them, to warn the players, for their sake and for hers. The coaches ignored her request.[1]

"Is that a broad?" Phil Esposito, a Boston Bruin, asked Red Fisher, a Canadian reporter standing near him.[2]

Fisher turned and looked. "Yep," he replied.

"Boy," Esposito said, "she's got balls!"

Herman anticipated confusion along with a certain amount of chaos in the locker room. She had prepared herself for crude jokes aimed at her, even if the coaches had told the players that she would be among them. But they hadn't so the players were shocked to see her in the locker room. Turmoil

ensued as players lunged for towels and photographers scurried for shots that would convey the bedlam. When the other writers realized she was in the locker room, her presence became *the* story. All-Star Games are irrelevant to the league standings and with the Wales Conference's blowout win, those in the losing team's locker room saw that a much livelier story was developing. Soon, the male writers were feasting on the novelty of her invasion.

The male writers encircled Herman and Cyr and pummeled them with questions.

"Why are you here?"

"What are you doing?"

"How are players going to get dressed?"

Queries popped at them from all directions. Herman could barely tell which guy had asked what question. It didn't really matter since she responded to each with the same words. "But I'm not the news," she said, hoping by repetition to prevent more questions. Had they forgotten what the coaches said at the press conference about them being in the locker room after the game? Maybe the men mistook that question and answer session for a joke and figured the coaches were just kidding and didn't believe the two women would actually do it.

"But I'm not the news," Herman implored again and again. "The game is the story, not us," she said, trying to extricate herself from the moving scrum of inquisitors. Still, as a writer, she knew that the meaningless game wasn't news the way that women in the locker room was. Herman kept looking for a breakaway moment when she finally could use her rare access to report her own story. But when she tried swerving away to talk with a player, writers went with her thrusting tape recorders toward her. Photographers leaned in, and their staccato flashbulb bursts of light scared Herman when they seemed closer to her face than they probably were. As new writers joined in, fresh queries came at her, all revolving around the same topics that by now were tiring to Herman. "I'm just doing my job," she shouted back.

She could have added "just like you!"

Herman, like the men, had a tight deadline to meet. Unlike most of them, she focused her story on the game, not on being in the locker room. For this story, she needed at least one player's voice in it. Since she knew Denis Potvin from the Islanders, she went to him. While talking with Potvin, the Vancouver defenseman Tracy Pratt ripped Potvin's towel off of him, which left Herman, watched by the male writers, standing next to a naked man. She was angry and embarrassed. As one writer observed, there were "a lot of jokes and pranks" in that locker room that night, all aimed at the women.

Herman, just twenty-three years old, was in a foreign country with no easy way to reach her editor and working in an NHL locker room for the first time. With her deadline fast approaching and her nerves frazzled, she gave up trying to talk with players. She left the locker room, wrote her story, filed it with her news desk, then went her hotel room to try to sleep before flying to New York in the morning. A few weeks later, Herman's editor asked her to describe for *Times* readers what it was like to work in a pro hockey locker room. In her Reporter's Notebook story, Herman said it was the incessant light bulb flashes that hurt her eyes, and not the towel incident with Potvin, that hastened her exit that night. "I had prepared myself mentally for the nudity," she wrote, "but I had not prepared for the [media] attention."

On her return from Montreal, Herman also had found a pile of messages that colleagues had taken for her. On most of them was a reporter's name, phone number, and a request to call him back. After an Associated Press writer transmitted by wire his women-in-the-locker-room story from Montreal, many U.S. and Canadian newspapers had published his account of these two women going where no female writer had gone before. What happened in Montreal had not stayed in Montreal. Once this story was out, sportswriters and columnists throughout Canada and the United States who were not at the All-Star Game wanted to speak with Herman.

"Tell us what you saw!" turned out to be these writers' *real* question, even if they couched their desire for juicy tidbits by asking about her experience in the locker room. Herman wasn't interested in sharing salacious sightings, so she stuck with her message about her need for equal access. Herman was disciplined in how she handled these interviews, which left writers disappointed. On her next road trip with the Islanders, the writers in the cities she visited showered her with the predictable questions. By now, coverage of her locker room "invasion" had shown her how the men were going to tell her story. An equal access policy that she believed was sensible, necessary, and fair would be construed by the men as comical, intrusive, and impractical. "Girls" in the locker room, they said, would disrupt *their* routines, making their jobs more difficult by sending players scurrying out of the locker room into places they couldn't go. As I experienced a few years later, instead of dealing with our discriminatory treatment, the men decided to blame us while questioning our morality. Although Herman and I knew the athletes did not need to be naked when we were with them, the men knew they had a better story to tell if they were.

Along with phone messages, Herman began finding letters from all parts of the country, including an unsigned one from Georgia. Addressed to

Miss Robin Herman, its writer had exhaled onto paper a depressing whiff of the reactionary views that many people held:

"Dear Miss Herman: It's hard to address a harlot disguised as a reporter, but I just want to warn you that you cannot do such a thing with impunity. It's wrong, no matter how many women libbers might dumbly applaud. If there had been any real, real men in that locker room, you would have been kicked out on your prostitutional [*sic*] ass. May that happen, if there is anything to wake you up to your horrendously bad example. Surely you shall regret this and regret it bitterly."[3]

In her Reporter's Notebook column in February,[4] Herman told readers, who didn't know how reporters do their jobs, what it was like being a woman covering "a male sport on a full-time basis." The *Times*'s copy desk helped out with the headline—"A Look at Equal Rights and Hockey." In her intimate essay, Herman quoted from her personal journal. She didn't try to entertain readers. Instead, she educated them about aspects of her job that her male colleagues rarely, if ever, considered. "No one has ever asked the athletes if male reporters are intruding on their privacy," she observed. She was right. The fraternity of sportswriters seemed oblivious to this oddity in their daily work. In no other line of work did fully dressed men interview men who were naked. Even in a doctor's office, patients draped a paper robe over their body for the exam, then dressed to speak with the doctor after it. Yet sportswriters talked with naked men every day. Only when women said they should be there too did men pay attention to this peculiar dynamic. Even then, in writing about Montreal's All-Star Game, the men focused primarily on the bedlam and awkwardness the women's presence caused them. The men decided the way to end the chaos and soothe their discomfort was to keep women out. Then, without skipping a beat, some of these same men breathlessly wrote about the time when "equal rights" would let them to be with female athletes when they were naked in their locker rooms.

Women saw locker room access with different eyes than men did. This is why I wasn't surprised in February 1978, when Sheryl Flatow, working as a United Press International (UPI) sportswriter, contextualized this issue in a compelling story about women working in men's locker rooms. When her feature article was sent out on UPI's wire service, large and small newspapers throughout the country published her lengthy story and editors topped it with various headlines. *Republican and Herald* editors in Pottsville, Pennsylvania thought that "The Unholy Locker Rooms: Women Sportswriters Invade Inner Sanctum"[5] would be a fitting title, while the *New Haven Register* in Connecticut chose "There's a Girl in Our Locker Room."[6] The

Pittsburgh Press went the political route with "Lib in the Locker Room."[7] Whatever the headline was, Flatow's opening paragraph catapulted readers into the rampant sexism that women confronted by being in the boys-will-be-boys sports culture. "It was one of the last bastions of male sectarianism, a place where grown men could act like little boys; where language was raunchy and unrefined; where a young Sparky Lyle, dressed in his birthday suit, could plop into a cake with total abandon. The locker room: a sweaty, smelly salon where athletes could act natural au naturel; where women were put down, pinned-up and prized, but never permitted," Flatow wrote.

With the drumbeat of misogyny swirling around me and my case, it was hard for me to get a word in edgewise about the gender injustice I'd set out to fight.

Chapter Thirteen

Fritz was a fierce advocate for gender justice. His argument was persuasive, at least it seemed so to me though I was listening with biased ears. Still, I knew a strong argument when I heard one, and his was convincing. Of course, Kuhn's lawyer would counter with what I assumed would be a worthy defense, though I felt Fritz's argument would be hard to refute.

When the Southern District Court had assigned a woman judge to my case, there were people who believed that her gender would sway her to rule in my favor. Fritz knew differently, in part because he appreciated that gender didn't resonate with Judge Motley in the way that race did. She'd encountered racial segregation in ways that seared that injustice within her. Not so with gender. By reminding her of the racial discrimination cases she'd fought, Fritz would try to transport her to the common ground of unjust treatment in gender discrimination.

Judge Motley would want her order in my widely publicized case to be legally tight so the appellate court would not overturn it. No district court judge wants her decision to be overturned, but Motley had strong reasons to feel this way. The Second Circuit's appellate judges were white men, some of whom had opposed her nomination when it was before the U.S. Senate. Kuhn had signaled early on that if she ruled against him, he would appeal, while also expressing confidence that she'd rule in his favor. In prehearing documents, Kuhn's lawyer exuded the upbeat belief that she would agree with him that protection of the ballplayers' privacy mattered more than rectifying what Kuhn had called my "minor hindrance" of him denying me access. Not everyone in baseball agreed with Kuhn,[1] but nobody who worked *for* baseball would contradict Kuhn's optimistic prognostication.

After Kuhn's attorney revealed his argument in his legal brief, Fritz built his argument with the goal of exposing its fallacies. "Basically, two excuses are put forward by baseball," he told Judge Motley. Its first excuse revolved around the role of public opinion. It was Kuhn's stated view that baseball fans generally "would oppose giving women equal access," and to a large extent, he relied on their views to defend the action he'd taken against me. Yet his lawyer submitted no public opinion survey or factual data to support Kuhn's supposition. Apparently, surmising this to be true was enough for Kuhn to make it so.

Kuhn contended that baseball's "image and its revenues would be grievously injured were baseball to follow the same [equal access media] practices as professional basketball and professional hockey" Fritz told the judge. In framing his argument in this way, he hoped she'd absorb the better-than-thou view that baseball held of itself. If she saw how baseball regarded itself as far superior to those *lesser* leagues, she'd understand better why Kuhn believed he should be exempt from the societal forces pressing the other leagues to update their media policies. To Kuhn, those leagues were merely kids trying to play with the big boy on the block. At this time, it's true that neither the NBA nor NHL had attained the cultural place that baseball held as America's pastime. To Kuhn, any notion of their equality with his game was ridiculous. After all, baseball's lore writ large in poems (e.g., "Casey at the Bat"), in songs, (e.g., "Take Me Out to the Ballgame"), in books (e.g., *The Boys of Summer*), in films (e.g., *The Pride of the Yankees*), and in ritualized ballpark moments like the seventh-inning stretch. These touchstones had been lovingly handed down through generations, and they weren't replicated in these other sports. Why should baseball follow them in making this cultural shift? Similarly, Kuhn saw baseball as immune from the court's discipline. In prior court cases, commissioners had prevailed largely due to baseball's antitrust exemption that protected its monopolistic tendencies.

Baseball's rule maker *and* enforcer was one man—the commissioner. What Kuhn said was baseball's policy became its practice.

He'd created his ban-the-ladies media policy as *his* game's father figure protecting *his* players from women like me. In deposing Kuhn, Fritz made sure to get him to confirm that he had developed his separate accommodations policy without seeking or receiving input from even one player. By doing this, Fritz could tell the judge assuredly that Kuhn blocked my access to the locker rooms without any player input, while reminding her that players on both World Series teams had said I could work in their clubhouse. Even so, Kuhn continued to claim in public and in his deposition that players needed his protection

for their "sexual privacy." His choice of this phrase—sexual privacy—hinted at *his* squeamishness at the prospect of me being with *his* ballplayers. By using that phrase, he was injecting sex into the flow of conversation about my case. Sportswriters were fine with singing his tune, but in doing so, they effectively wiped the slates clean of any equal rights dimension.

Fritz's job was to reinsert equality into my case.

* * *

By wielding his imperial powers as commissioner, Kuhn could weave his personal beliefs into his determinations of what constituted "the best interests of baseball." No one who read *Sports Illustrated*'s in-depth profile of Kuhn in 1974 would have been surprised that he carried his personal modesty into his shaping of baseball's locker room policy. Frank Deford, who wrote this story, introduced Americans to Kuhn and to the other men controlling professional sports—the commissioners in the NBA and NFL and the president of the NHL. Each one was becoming a household name as all of them negotiated contracts with three TV networks—ABC, CBS, and NBC. These contracts infused their leagues with millions of dollars and thrust these men into the ranks of corporate titans. In *Over Time: My Life as a Sportswriter*,[2] Deford explained why he wrote this story: "My idea was simply to present them as personalities, sans issues. I wanted, if possible, to humanize commissioners. Three of them made the cut." Kuhn was Deford's outlier. even if he fit well with the game he ruled. "The people in baseball are more traditional," Kuhn told Deford. "I mean, the fans, everybody. The operators merely reflect the conservative nature of the fans, their conservative side. You can change rules drastically in football and basketball and hardly get a ripple. In baseball, change a rule and, well, you'll get a lot more than a ripple."

Deford gave each man ample opportunity to reveal his personality, temperament, and interests. The other three men took good advantage of his offer, but Kuhn stuck close to a just-the-facts-ma'am rendition of his life—his graduation from Princeton University, then the University of Virginia Law School, his career at a white-shoe New York City law firm, then his time as legal counsel for the National League before baseball team owners chose him to be their next commissioner in February 1969. In ending his time with each man, Deford asked a question that he thought would help sports fans relate to them as "average Joes." In his memoir, he tipped his hat to tabloid columnist Sidney Skolsky for road-testing this literary conveyance. "Skolsky's gimmick was to end [his celebrity profiles] by asking the star what clothing, if any, he or she

slept in," Deford wrote. "All the nuggets that I read always concluded with the stars going along and happily revealing their sleeping attire. So, I thought it would be cute to end my ante-Facebook summaries with this information."

Two commissioners played along, as did the NHL president, displaying friendly humor befitting a public figure.

> NHL PRESIDENT, CLARENCE CAMPBELL "For sleeping, I'm always in the raw. I used to have to own some pajamas because we traveled by train in the league then and you had to have something to wear on the trains, but since we stopped going on trains, hell, I don't even know if I have any pajamas left."
> NFL COMMISSIONER, PETE ROZELLE "Sometimes I do sleep in the nude but, you know, with all these new kids (grandkids) around the house I'm usually at least in my bottoms. Mostly in my pajama bottoms, I would say."
> NBA COMMISSIONER, WALTER KENNEDY "I've always been an early-to-bedder—11/11:30. I sleep in pajamas most of the year, but in the summer, when it's hot, then I sleep in the nude."

Kuhn refused to engage.

"Commissioner Kuhn says that it's nobody's business what his bed fashions are," Deford wrote in that *Sports Illustrated* story. Years later, in his memoir, Deford contrasted Campbell's easygoing reply with Kuhn's frigid response: "Old Campbell, in particular, was tickled pink to let the hockey world know that its czar slept bare-ass naked. But Bowie Kuhn was beside himself with indignation that I had dared make such a raw personal inquiry. He flat-out refused to answer the question about what he slept in and took me to task for prying."

"I assumed he must've slept in a stuffed shirt," Deford added.

Deford wasn't alone in his characterization of Kuhn. Before our hearing, one sports editor described this legal fight as a "public confrontation between a resolute young woman unafraid of the undraped male form and Kuhn, whose appearance always seems to suggest his underwear is too tight." Deford later opined on Kuhn's final act in baseball: "Subsequently, Bowie did, however, make the Hall of Fame at Cooperstown, if for no good reason whatsoever."

* * *

At the 1977 World Series, teams had supported my right to work in their locker rooms. However, as soon as Kuhn learned this, he overrode their

permission with his regal declaration and sent baseball's media director Bob Wirz to deliver it to me. Only the commissioner could grant this permission, Wirz declared, and he never would.

In Judge Motley's courtroom, Fritz would do what he could to dismantle the reasoning that Kuhn used for keeping me out. "The policy of total exclusion of women—and I emphasize *total*—is required in the name of player privacy and what is called outrage from the wives of the players," Fritz said, echoing the reasons that Wirz told me when I asked why Kuhn did what he'd done. First, he'd told me the players' wives would object to my presence there, then he said the players' children would be ridiculed by their classmates.

"That has not happened in basketball and hockey," Fritz reminded Judge Motley.

In telling her this, Fritz was generally right, but that wasn't the full truth, at least when it came to the NHL wives' initial reactions. After the Montreal All-Star Game, the New York Rangers wives had expressed outrage at the possibility of Herman being in the locker room with their husbands. They also had persuaded their husbands to call for a team meeting to vote on whether to let her inside—with the result preordained. Herman would not be reporting in the Rangers' locker room. So Herman continued to interview players in the corridor, which wasn't good for her, but it was all she had. In the next season, there was a new coach, John Ferguson, who was also the team's general manager. In the fall of 1976, Ferguson gave the two female writers locker room access. By then, Lawrie Mifflin was also covering the Rangers for the New York *Daily News*, so Herman and Mifflin reported alongside their male colleagues in the locker room. Ferguson told them that he'd ban *all* reporters from his locker room if its opposing team would not let them into its locker room. He did this to gain the cooperation of male writers who didn't want to lose their ability to report in both locker rooms. "We didn't want that [provision]," Herman told the *New Yorker*'s Roger Angell. "Can you imagine how that would have gone over with the other writers?" Just imagining the impact, Herman mused. "Wow."

By the time of my hearing, Herman's experience in the locker room in Montreal was three years in the past. In the intervening years, she'd continued to speak privately with the NHL coaches and owners who had not changed their media policies to treat women equally after the league's president urged them to do so. In her 2004 post on her blog, *Girl in the*

Locker Room,[3] Herman recounted the gradual uptake of equal access in the NHL:

> Eventually, over the course of a year, through sheer force of my persuasion and gathering momentum kicked off by the All-Star game, the other NHL teams, one-by-one, allowed me into their locker rooms. It turned out not to be the young players (all the same age as me) so much who'd been objecting to the times a changin'. It was usually an owner or general manager or coach from an older generation who simply couldn't accept the idea of a woman in this historically, culturally, and very literally and nakedly all-male territory. The reaction was instinctive and visceral. I remember one silver-haired coach apologizing over and over, insisting that he liked me, that he liked women. He couldn't help but say no. I don't think he even understood why himself. It had much to do with sex roles and sexuality and power and all that—a big cliché, but one with undeniable force—the closed locker room as a metaphor we were all living—but that barrier crumbled away, along with a lot else, in the face of the Woodstock generation's free-thinking and righteous ways.

* * *

By the time of our hearing, five of the then-twenty-three NHL teams—Chicago, Buffalo, Toronto, Detroit, and Saint Louis—still were not allowing women writers into their locker rooms. In the NFL, Minnesota and Philadelphia were the only teams that did have equal access policies in place, as that league's commissioner left this decision to the teams. In the NBA, every team except Boston and Phoenix were on board with equal access. In baseball, two teams had signaled their okay—the Yankees and the Dodgers—and no female reporters, except me with my access to the Yankees' clubhouse before the World Series, had worked in a locker room due to Kuhn nullifying those votes.

Fritz wanted Judge Motley to hear from the women who had worked in locker rooms. So he asked Herman, Mifflin, and Jane Gross, among others, to submit affidavits to describe their experiences and explain why my fight in baseball mattered. Mifflin, who had worked in locker rooms of ten NHL teams, assured the judge that she had encountered "no objection to my presence there." Then, she described how the players responded to her being among them: "If a player is in a hurry to dress, he can simply wrap a towel around his waist and pull on his pants underneath the towel. That is what some of the Rangers do. It is that simple." She provided such specifics, in part, because

Fritz alerted her to our judge's overall dislike of sports and her lack of knowledge about them. This is also why Mifflin detailed what sports fans expected she'd give them in her stories. Since Judge Motley didn't read the sports pages, Fritz knew details like this would help.

Readers, Mifflin wrote, needed to know how the game was played and what the players had to say about it afterward. "A sportswriter who writes only about the first is scorned by his fellow reporters. To write about the second, a reporter must have access to the locker room," she informed Motley. When forced to wait outside the locker room, Mifflin told Motley how often she'd had to dash to her typewriter without being able to wait for players' quotes that she should have had in her story. "If I had to wait for each of those players to come outside and talk, it would take forever," she wrote. Inside the locker room, Mifflin said she "gets the answers quickly and efficiently." To illustrate this point, she gave examples of news she would have missed if she was not in the locker room:

> If I had been excluded from the [New York] Cosmos' locker room after their star player Pelé's last competitive game, I would have missed seeing Pelé being carried around the room on his teammates' shoulders. Everyone was chanting his name and he had tears in his eyes.

> If I had been excluded from the Rangers' locker room after the game against St. Louis in which Phil Esposito scored his 605th regular-season goal, putting him in second place on the all-time NHL goal-scoring ladder, I would have missed the lead for my story on the game. In the locker room after the game, 21-year-old Don Murdoch called to his captain, "Hey, Espo, those 605 goals don't make a career." Steve Vickers rejoined: "But it's a good start." At that, several more of the Rangers picked up the ball and began laughing and snickering about what an easy team St. Louis was to beat. Esposito's response was serious: "I wouldn't laugh at any team in this league. They could've beaten us, anyone in this league can beat you."

In her affidavit, Herman also provided the perspective of a writer who'd been kept out of the locker room. She had to work that way after the New York Islanders' players voted to let her into their locker room, but the team's management refused to go along.

> As a result, after each game I was forced to rely on the Islanders' public relations staff to go into the locker room and bring out the players I wanted to interview. This system was totally unreliable. The public relations man would

go into the locker room after one player at a time. Meanwhile, I was forced to wait idly (but frantically) in the hallway, looking alternatively at the door and my watch, as the time before my deadline flew by. Often, the PR man was unable to drag a particular player out to speak to me until almost all of the other reporters and players had left. The players who did come out sometimes were "talked out" after having already been surrounded by reporters for close to an hour inside the locker room. Moreover, not only did I miss that group discussion, but I also missed seeing the players interact with each other.

"The total experience was both humiliating and frustrating," Herman wrote to Judge Motley. She also confirmed that opposing teams did not assist her in speaking with their players, so she could not report on the opposing team. Like Mifflin, she contrasted her segregated experience with the ease of reporting once the Rangers' coach let her work in the team's locker room. "Any problem arising out of giving equal access to women reporters can be solved by a simple terry cloth towel," she concluded.

Judge Motley read these women's affidavits before our hearing, along with others we'd submitted and the affidavits that baseball sent her to bolster its case. Fritz was confident that in reading our affidavits Judge Motley better understood the challenges these women—and I—dealt with in trying to do our jobs. With that background in place, Fritz could move ahead in his argument testing the veracity of claims that Kuhn's lawyer made in his legal memorandums about "the way in which our constitution is meant to work." In hearing Fritz say "constitution," I sensed where he was heading since he'd schooled me in how he would use the U.S. Constitution in arguing my case. The Fourteenth Amendment's due process clause spoke to my "liberty" to pursue my profession, while its equal protection clause granted me fair protection of our laws, which addressed discrimination.

"First, the public opinion rationalization does not wash," Fritz asserted, in revisiting baseball's "excuse" that he'd mentioned earlier. "It doesn't square with the Constitution whatsoever. As I understand it, the very purpose of our Bill of Rights and the Fourteenth Amendment was to protect the rights of unpopular minorities," Fritz said. In this case, his client was the unpopular minority. It would be hard to contest how unpopular I was with lots of Americans simply because my name was on this case. And, as a woman, already I was in a minority with fewer rights than men had and was less well represented in our government. In 1978, only two women held seats in the U.S. Senate, eighteen in the House of Representatives, and no woman had served on the U.S. Supreme Court.

As Fritz affirmed, the U.S. Constitution protects a minority from major-ity rule when life, liberty, and the pursuit of happiness—the principles articulated in the Declaration of Independence—are threatened. "The Supreme Court, in cases with which Your Honor is more familiar than I, has taught us that in this country public opinion polls do not control the Constitution," he said, referencing her efforts to fight de jure segregation imposed by the powerful majority. With this framework in place, Fritz turned to *Brown v. Board of Education*, a case on which Motley worked for many years at the Inc. Fund with its lead counsel, Thurgood Marshall. "As the Court said in the *Brown* case, it should go without saying that constitu-tional principles cannot be allowed to yield simply because of disagreement with them," my lawyer continued, knowing Motley's key role in research-ing and drafting the pleadings in that case, along with a "model complaint" as *Brown v. Board of Education* went to the Supreme Court. In that writ-ing, Motley had emphasized what the nine justices echoed in their 1954 ruling. With her extensive pretrial work so integral to the courtroom strat-egy, Marshall had made her "of counsel" on this case; its other counsel were men.[4]

"One more point on the claim of public hostility upon which baseball defendants try to rely," Fritz said, his tone softer and more restrained. "It is, I submit, Your Honor, a *sad* point," he said, elongating that word "sad." "Look at *what* they rely on to try to make their point," Fritz told her, even if that "what" he kept secret, refusing then to reveal his *sad* surprise. "I find it sad that baseball which calls itself the national game would rely on the kind of exhibits that they have put before Your Honor," he continued. Still, no one in the courtroom, except perhaps his associates, knew what Fritz was talk-ing about. I certainly didn't. On he went reminding the judge that Kuhn's lawyer had submitted "an exhibit that attacks this lawsuit as 'nitpicking for human rights' and goes on to complain that this country is becoming a nation of individuals and minorities instead of the majorities."

Perhaps Fritz would finally reveal his surprise. Do it now or I feared he'd exhaust Judge Motley's patience. Quickening his pace, he delivered his final clue: "I also find it sad that baseball which now tells the Court that it's not going to allow women to do something, would rely on exhibits which, for example, contend that women are only 'here for display in bathing suits.'"

"What?" Judge Motley exclaimed.

Fritz had achieved his goal. Her response did not happen by accident. Fritz's repetitive buildup of "sad" had her fully engaged. He'd devised this

approach after some of her friends told him that she could "be a bit of a prude." With his slow reveal of this *sad* point, she'd reacted just as he expected, so he was prepared when she said, "What?"

"They [baseball] rely on an exhibit that suggests that women in this country are only 'here for displaying bathing suits,'" Fritz told her. Pausing to permit her time to ponder his reveal, Fritz then described the exhibit. "It's a letter from a subscriber to the magazine [*Sports Illustrated*] which they say demonstrates hostility to this lawsuit and therefore Your Honor should take into account in ruling on this motion," Fritz said before reading the letter's salient words: "I was going to cancel my subscription to the magazine when I read about your lawsuit, but then I saw you had some pictures of women in bathing suits, and now I know that you really understand what women are here for, so I will not cancel my subscription."

Hearing this subscriber's words for the first time angered me, especially with his view of why women exist: *I know that you* [Sports Illustrated] *really understand what women are here for.* I also was puzzled by why baseball featured *this* letter in its memorandum to the court. If Kuhn's lawyer had played things out, maybe he could have foreseen how Fritz could turn this man's words against his client. Why select this letter when there were so many others sent to SI more explicitly criticizing my action? Had they instead selected this letter, typed in all capital letters, Judge Motley would have read these words:

RE: SUIT OVER ADMISSION TO LOCKER ROOM
TO THE ABSURD PARTICIPANTS IN THIS SUIT,
ONCE AGAIN, A BLACK EYE FOR EQUALITY BECAUSE SOME
INSIST ON PUSHING THINGS BEYOND ALL PROPER BOUNDS OF
TASTE, PRIVACY, THE RIGHTS OF OTHERS' MODESTY, ETC. ALL
IN THE END FOR THE "ALMIGHTY" DOLLAR SINCE AFTER
ALL NO ONE HAS SUCH RIGHTS, WE ARE ALL MERELY COM-
MODITIES. I AND OTHERS WILL DO EVERYTHING POSSIBLE TO
DEFEAT YOUR ADDING TO THE LIST OF CURRENT
MADNESSES.

Or baseball could have highlighted the letter signed by "A Woman (who wouldn't want my privacy invaded, so . . .)." To choose the one they did made sense only if what this man wrote reflected Kuhn's view of women. I suspected it did.

Baseball's lawyers had taken possession of SI's letters to the editor during the discovery phase of our case. With the majority of subscribers being men, so too were its letter writers, and most of them could not fathom why their sports magazine was backing a woman against Major League Baseball. One man ripped into it for capitulating to "this spoiled brat of a reporter." Irate subscribers, like the man whose letter Fritz read in court, believed women were better seen than heard. A male lawyer from Florida assured Time Inc.'s directors that he would not support "your asinine lawsuit to compel entry of a female sportswriter" into places where men deserve privacy. "Is it really even sane," he wrote, "to contend that a lady has a constitutional right to be present while you take a shower, treat your jock itch, and discuss the ancestry of officials?" A subscriber in Berwyn, Illinois shared this advice: "Use a man for men, use a woman for women, don't waste tax dollars, don't waste court time, and send me a refund for my cancelled subscription." From Tokyo, Japan, Bob wrote, withholding his last name, to offer what he said was the "one and only solution." He'd addressed his letter to me: "I am sure that the New York Yankees and other professional baseball teams would be more than glad to have you if you removed your clothes along with the players. This way, you would not only be able to write your story with the same opportunity as any other sportswriter or newspaper person but would be able to get your facts even easier than they because you not have to go to the players with questions; instead, they could come to you." Cartoonists had visualized his complaint. In one cartoon, a player tossed me boxer shorts. In the bubble above his head, he told me, "You gotta dress the part, Sweetheart."

From Fresno, California, Ralph wrote as the father of an eleven-year-old girl, sharing what his daughter said about me: "She's stupid, Daddy." Then, treating me as if I was a naughty daughter hanging out with a boyfriend he despised, he wrote: "The case you are causing makes any sports fan want to vomit. I would not waste my time reading what you write but I am now cancelling any publication by Time. In psychology they say aggressive women have gravel in their breasts, not milk, and the only thing [Reggie] Jackson has of size is his mouth. You deserve each other."

Back in the courtroom, Fritz wasn't done with the word "sad."

"Similarly, I find it *sad* that baseball would rely on exhibits from sports reporters who suggest with a wink and a smirk that my client, Melissa Ludtke, here in court, just wants, as one of the reporters puts it 'to see Reggie in the buff.'" There, he was referring to what syndicated columnist Red Smith wrote about me in his derogatory column published early in January 1978.

As the only Pulitzer Prize winning sportswriter, his demeaning words about me and my legal case pretty much had developed the conventional narrative that other writers used in their stories.

Fritz turned toward me, hoping to get Judge Motley to look my way too.

"That is not what *she* wants to do," Fritz declared. "Simple justice for her is to do what her male competitors say is the job, and to do what basketball, to do what hockey, has allowed women reporters to do."

Chapter Fourteen

Baseball is fathers and sons . . . the generations, looping backward forever with a million apparitions of sticks and balls. . . . Baseball is fathers and sons playing catch, lazy and murderous, wild and controlled, the profound archaic song of birth, growth, age and death. This diamond encircles what we are . . . joining the long generations of all the fathers and all the sons.

—**DONALD HALL**, "Fathers Playing Catch with Sons"

My mom and I didn't play catch, but she passed on her deep affection for baseball and her lifelong devotion to the Red Sox, which her father had passed on to her.

On May 27, 1951, as the New York Yankees were on a train going to their three-game series in Fenway Park, my mom checked into University Hospital in Iowa City to have her first child, me. I was breeched and had the umbilical cord wrapped around my neck, so to deliver me the doctors numbed my mom with spinal anesthesia. Then, they forgot to warn her against sitting up. When she did, her incapacitating headache forced us to stay longer in the hospital. While she recuperated, my dad paid $2.65 to telegraph news of my

birth to her parents in Milton, Massachusetts and telephoned his parents in Waterloo, Iowa.

The next day, the Red Sox beat the Yankees 3–2 even though its star player, Ted Williams, went hitless.

I was four days old when my grandfather in Milton rolled a sheet of lightweight paper into his typewriter and wrote to my mom. "My dearest Jean," his two-page, single-spaced letter began. After declaring me a "smart girl," he misspelled my name as "Millissa" and expressed his excitement at my birth. Quickly, however, he transitioned to the vital news of his day—the Red Sox had swept the Yankees. As a teenager, my mom had been his Fenway Park seatmate and their baseball bond endured their separation. From afar, he typed his rat-a-tat-tat, play-by-play account of Red Sox's double-header win that sent the Yankees on their way to Detroit.

```
            Well we were thinking of you and in fact have been
doing so ever since the event and yesterday from I.30 P.M. and on
we were listening to the Red Sox wang the Yanks,-twice in a row.
     What a ball game that first one was -I5- innings and some job
of relief pitching by Scarbourough did.   when the Yanks came up
with those 7 runs in the 7th. inning and made the score 6 to I0
with two innings to go we thought it was about all over, and when
Ted Williams hit that home run in the last of the 8th. to tie it
up we thought that this time the Yanks were in for a real battle
and they were.   They just couldn't get Ted to hit the ball where
they were ganged up on him, he has been hitting a lot to left fix
eld the last two weeks and the Yanks gave up shifting for him and
then he banged em to right and centre and all over the place.
```

This is a paragraph from my grandfather's letter to my mom after my birth.

When I found his letter in my mom's papers, his words affirmed my visceral connection with baseball. But when I was born, the notion that I, or any girl, would grow up to cover Major League Baseball for the world's leading sports magazine was so laughably absurd as to be out of the realm of possibility. My mom's pedigree as a baseball fan did give me a running start, but the odds that my life would turn out as it did were slim to none that day when her Fenway Park seatmate welcomed me into the family. Seven years later, my mom took me to my first baseball Major League game at Fenway Park. As we fell in with a crowd of people pressing through the short passageway taking us into the ballpark, my mom squeezed my hand tightly. When we emerged into the old ballpark, I tugged her hand to tell my mom to stop. I turned my head slowly to take in the full measure of the compact ballpark until my eyes settled on its pristinely mowed grass shimmering in the afternoon's bright sun. I admired, too, its finely combed infield dirt. When we walked to our grandstand seats near third base, the park's towering

left-field wall with its embedded scoreboard seemed enormous. I'd seen this so-called Green Monster on TV but being this close was magical.

By this time, my father was driving my sister and me on Saturday afternoon road trips to root for the University of Massachusetts football team. After earning his PhD in Iowa, he, my mom, and I had moved to Amherst, a rural town about ninety miles from Boston, where he was a professor of finance at the state's flagship university. He'd brought east his Midwestern habit of attending a college football each Saturday and enlisted his daughters as seatmates. On these outings, he taught me lots about that game, but nothing about football made me feel as exuberantly happy as being at a baseball game at Fenway Park. Soon after my mom and I reached our seats that day, I went as close to the field as I could get and leaned over the low wall, as far as I could, to try to touch the field. I couldn't, but I wanted to try. Years later with *Sports Illustrated*, whenever I was at Fenway Park, I reached down to touch the grass, rekindling joyful memories of my first game.

Baseball hooked me that first day. It never let go.

* * *

Fenway Park was much on my mind on my first day at *Sports Illustrated* in September 1974. Even then, I hoped one day to be assigned to baseball. I promised myself I'd take on every task I could find to demonstrate my devotion to and knowledge about the game. A year in, I volunteered for the tedious, desk-bound, daily work of entering by hand the key statistics from *every* game played by *every* team *every* day on spreadsheets I drew with a ruler. This was a huge data entry job performed before digital recordkeeping eliminated that job. Late each Saturday, I would leave the three-ring binder of stat-heavy pages on the desk of the man assigned to write the Baseball Week column. Sunday afternoon that binder came back to me, and I used it—along with other sources—to confirm whatever statistics and anecdotes the writer used in his column. Neither this stat-keeping job nor my fact-checking of this column got me inside any ballpark, but at SI I was paying my dues in the hope that one day I would be closer to the game.

As I worked my way through the daily box scores, I paid special attention to the Red Sox. I was pretty sure that my mom had watched or listened to the game, so this gave me a way to compare notes on what happened. Back then, not many moms and daughters had baseball as the glue holding them together, as we did. As a child, I'd listened more, talked less, but with my mom's tutelage, I learned enough to start speaking up. Not a whole lot

else other than our love of baseball tugged us together. Our personalities and temperaments clashed, and baseball carried us through some of our rougher times. One day during the off-season, my editor asked me to attend a press conference with Ted Williams. He'd been my mom's favorite player, but I also knew his reputation for rudeness with reporters. So when the event finished, I approached him with trepidation. I told him about my mom being at Fenway Park with her dad when he played there, then I asked him to sign for her the photo of him in our press kit. He smiled and held out his hand for the photo. I also handed him my pen. "To Jean," was all he wrote, then he signed it. I framed it as a gift, which she hung it on her bedroom wall. I knew she loved having it, though not as much as I loved being able to give it to her.

In my junior year in high school, I had a long bout of mononucleosis. Miraculously, my illness coincided with the 1967 World Series, so I watched every inning of every game the Red Sox played against the St. Louis Cardinals. Then, World Series games were played in the afternoon, so if I wasn't sick, I would have missed them. In the seventh game, Bob Gibson, the Cardinals' ace pitcher, pitched against our best, Jim Lonborg, who had only two days of rest, one less than Gibson. Each man had won two games, though not pitching against each other. That afternoon, Gibson pitched nine innings, allowed three Red Sox hits. St. Louis won 7–2.

When those agonizing two hours and twenty-three minutes were over, I understood for the first time what my mother had told me. To be a Red Sox fan was to know grief. The last time my mom's team had won at World Series was in 1918, six years before she was born.

That day I knew what she meant.

* * *

With my dad tutoring me in football, my mom mentoring me in baseball, and me competing on every possible sports team I could, I was the rare girl who talked about sports like the guys did. Competing in sports sustained me through my teens, and although I excelled in school, too, my ability to talk with ease about sports is what got me to New York City and, once there, got me a job at *Sports Illustrated* where my unlikely career as a journalist began.

I'd graduated from Wellesley College as an art history major, but after working in a San Francisco art gallery, I knew art wasn't going to be my career. I had no alternative in mind. That summer I didn't apply for any jobs; instead,

I took education courses at Smith College. I considered teaching but didn't apply for any teaching jobs. By August, I was with my family in Hyannis Port without any plans for the fall. Then one afternoon I walked to the pier, where I found my neighbor, Ethel Kennedy, sailing her Wianno Senior to the dock. As one of her crew climbed out, I held her sailboat. When she wanted to sail to the mooring, I swung her boat away from the dock and as her jib caught the wind, she yelled a dinner invitation to me.

Could I be at her home for dinner that evening?

"Yes," I shouted, as she sailed away.

That serendipitous invitation became my reset button.

At six thirty that night, I walked the short distance from my family's house to hers. When it was time for dinner, she led us into the dining room and gestured toward a seat for me. Across the table from me sat Frank Gifford, an ABC Sports broadcaster, and during dinner we talked sports, as other guests, including our hostess, chimed in. Gifford, a former running back with the NFL's New York Giants, had once been hospitalized for 10 days with a deep concussion after being tackled in a November 1960 football play known as "The Hit." His matinee-idol looks and the glory bestowed on sports heroes who play in New York made him a shoo-in for a broadcasting job. When we met, he was doing play-by-play as a member of the star-studded *Monday Night Football* trio on ABC Sports with folksy "Dandy" Don Meredith and bombastic Howard Cosell. He'd broadcast the Olympics from Munich the prior summer, so our talk that night ranged from football to skiing to the Olympic Games where tragedy had struck[1] and the U.S. swimmer Mark Spitz won seven gold medals.

In 2015, when Gifford died, an autopsy of his brain revealed what his family knew. He'd suffered with chronic traumatic encephalopathy, a debilitating disease resulting from numerous hard hits to the head. At that time, I wrote an essay about the generosity he extended me after we met at dinner. "For a girl, you know a lot about sports," he told me that night as we made our way to the living room for dessert. There, he made me an offer that upended my life. If I was going to be in New York City, he told me to let him know. He said he'd take me to ABC Sports. "I'll show you around," he told me. When I walked to the pier that afternoon, I had no intention of going to New York. When I went to sleep that night, I'd already made plans to drive there. A month later, I did.

"On this day after his passing," I wrote in that essay, "I want to say thank you, Frank, for all you did to open doors for me and most of all for believing in my potential. It's what friends do. It's what you did when it mattered most."

He held that door open, and I walked through. There, I found my life's work.

* * *

In early October, I drove my father's taped-up Pinto wagon from Hyannis Port to Manhattan.

True to his word, Gifford met me at the elevator on the twenty-sixth floor where ABC Sports executives and producers had their offices. Roone Arledge, the president of ABC Sports, was his first friend I met when he walked into the elevator bank just as I arrived. Gifford's effusive introduction bordered on embarrassing. After that, he walked me around, introducing me to vice presidents and producers. As my visit was about to end, we walked by the office of Ellie Riger, who was ABC Sports' only woman producer who was hired in 1971. Gifford had an appointment, so he left me to talk with Riger. We talked for a long time, and before I left, she invited me to join her and her all-female crew at a nearby studio where they were working on *Women in Sports*, a one-hour evening special.

In June 1972, President Richard Nixon had signed Title IX into law, placing the legal weight of the federal government behind securing gender equity at educational institutions. This included sports. Then, a week before my New York visit, tennis star Billie Jean King had given Riger's special a shot of adrenaline when she beat former U.S. men's tennis champion Bobby Riggs in the most widely watched tennis match ever played. ABC Sports had broadcast her tennis match with Riggs by satellite into thirty-six other nations, attracting a global audience of ninety million viewers. Riggs went into their match declaring that a woman's place was "in the bedroom and kitchen, in that order," which had only heightened the viewership for what became known as "The Battle of the Sexes."[2] King had already energized the women's movement by leading the fight for equal prize money for women and men in major tennis tournaments. King's victory was front-page news in the *New York Times*, where the writer, Neil Amdur, called her "Mrs. King," which was still the paper' style for married women. He described the societal dimensions of her win.[3]

Mrs. Billie Jean King struck a proud blow for herself and women around the world with a crushing 6–4, 6–3, 6–3 rout of Bobby Riggs tonight in their $100,000 winner-take-all tennis match at the Astrodome. In an atmosphere more suited for a circus than a sports event, the 29-year-old Mrs. King ended

the bizarre saga of the 55-year-old hustler, who had bolted to national prominence with his blunt putdowns of women's tennis and the role of today's female.... Most important, perhaps for women everywhere, she convinced skeptics that a female athlete can survive pressure-filled situations and men are as susceptible to nerves as women.

King's victory reverberated in school hallways where the girls held bragging rights that day. At workplace water coolers, spirited arguments broke out about whether this tennis match forecast an accelerated pace in the changes happening in men's and women's lives. In retrospect, King's win turned a corner for girls and women; from then on when the words "girls" and "women" were paired with "sports," it wouldn't sound odd to hear them said together.

So when Billie Jean King walked up into Riger's West Fifty-Fifth production studio, I had goose bumps just being in the same room with her. I also knew at that moment that I'd find my place in this exciting media world of sports. Nowhere else did I feel the excitement that I did here. Still, I did not have the experience, skills, talent, or academic credentials to be hired in a production job at ABC Sports, or by any other sports broadcaster. Being a woman would also make my dream job harder to find. Still, my days with Riger's crew convinced me that I wanted this life, even if I had no idea how to make it mine.

Back on Cape Cod, my only questions were how and when I'd move to New York. My plan to become a secretary at ABC Sports, which was the conventional foot-in-the-door strategy that women used to be hired where they wanted to work. From there, I'd work my way up. I bought a book to learn stenography and practiced my typing before I drove back to New York to take ABC's secretarial test. I was accurate and fast on the typewriter, but my stenography was weak. With my results in hand, I went upstairs for a pre-arranged appointment with a vice president at ABC Sports. We chatted for a few minutes before he held in one hand my test scores and in the other my résumé showing no relevant job experience. After turning his head from one piece of paper to the other, he placed them back on his desk.

"I don't think you'd be happy as a secretary," he said. "We won't have a job for you."

My Wellesley College degree turned out to be the game stopper. What I didn't know then was that a few years earlier, women at *Newsweek* had sued their employer, the *Washington Post*, after they had documented a pattern of gender discrimination in their hiring, promotion, and pay. They'd won their case, and in time *Newsweek* changed its practices. Women at other media

organizations, including Time Inc., had followed their lead. ABC knew this. Surely their lawyers had told its personnel not to hire a highly educated woman, such as a graduate of a Seven Sisters' college, as a secretary lest they too be sued.

"You don't want to be a secretary," he told me.

He smiled, but I didn't.

What I'd seen as my point of entry at ABC Sports was blocked. Though disappointed, I was not undaunted. In January 1974, I moved into a two-bedroom, two-bath apartment on East Sixty-Fifth and First Avenue that I shared with Barbara Roche. I'd met her when she was Riger's production assistant. Roche held the keys to this kingdom since she brought home ABC Sports' production schedule at the start of every month. On it were the dates and locations of all of its events. It also showed the dates and times when studio edits and audio overlays would take place with names of the producers, directors, production assistants, and broadcasters assigned to each. She shared this with me, knowing I was eager to learn everything there was to know about the sports TV business. With this as my guide, I signed up for poorly paid gofer jobs at weekend events where I'd be assigned to work with a producer or broadcaster. Essentially, I was his errand girl. I loved everything about this work, and doing it, I met lots of people in sports media. I didn't know what "networking" was, but that's what I did.

On weekday nights I'd go to the editing rooms in the basement studios on West Sixty-Fifth Street. I wasn't paid to be there, but the directors soon grew accustomed to having me around and they'd ask me to run errands, as if I were their gofer. One director sent me to the corner bar on a Sunday night. He told me to get the bartender to let me carry out two martinis made to order for Howard Cosell who was due in the studio. He'd want to sip martinis while he did his audio track for the video. If I learned nothing else, I found out that it's never good to return empty-handed and try to explain to a director why I didn't do what he'd asked. I got the martinis, then I watched Cosell sip them while he nailed his voice-overs on the first try.

I was happiest when I was around ABC Sports. But I couldn't pay my rent on happiness. I needed a paycheck as well to pay for flights I took to weekend sports events where I'd work as a gofer for $25 a day. *Harper's Bazaar* did hire me as a secretary, so that salary subsidized my free labor in sports. One day, this habit of hanging around ABC Sports paid off when a producer, Geoff Mason, told me he knew the man who hired researchers at *Sports Illustrated*. He asked if I'd like an introduction. I'd not thought of covering sports in print before he mentioned this, but I said yes right away. He set up an

interview, and with my résumé in hand, I went to the Time-Life Building, a few blocks from ABC's headquarters, to meet Mervin Hyman. We talked, and I left feeling good about my interview. But a few days later I pulled from my mailbox an envelope containing a typed letter of rejection. Stung, I was not deterred. I taped the letter to my bedroom wall next to my bureau's mirror, so each morning Hyman's note stared back at me. His rejection made me want a job at SI even more than I did a job at ABC Sports, perhaps because it seemed more attainable. I decided not to let Hyman forget me or lose track of what I was doing, so as the summer went by, I mailed postcards to him from weekend sports venues where I was working with ABC Sports. From Mamaroneck, New York in June, I told him on that postcard that I was working in the eighteenth hole broadcast booth with legendary British golfer Henry Longhurst at the U.S. Open. With each postcard I conveyed the same message: I'm working hard, doing lots of events with ABC Sports. I might be getting paid $25 a day, but my postcards inflated the value of my experiences,

Persistence paid off when in late August Hyman invited me in for another interview. This time, he hired me in the entry level job of a reporter, the lowest rung of SI's editorial ladder. Still, I had a job that nearly every collegiate newspaper sports editor and writer wanted. Now, I had to prove myself worthy. On Thursday morning after Labor Day weekend in 1974, I showed up for my first full-time job in sports media. From that day on, I woke up feeling joyful about going to work, even when my workdays stretched to eighteen hours or more.

I'd found my place with the help of friends.

* * *

I was starting way behind my *Sports Illustrated* colleagues. Unlike them, I had no sports writing or editing experience, nor had I taken a journalism class or worked on a school newspaper. My peers at SI had covered sports for college or university newspapers. Thank goodness I'd played sports so at least I could talk a good game, though I knew I had lots of catch-up work to do based on my deficiencies. But I did have one special gift from a friend of my mom's that helped me feel like I belonged in this place I'd landed.

Marge Miller, my mom's college roommate and dear friend, was the boxing writer at *Sports Illustrated* soon after it was launched in 1954. Before that she'd written about boxing for more than a decade starting when she was a student at Wellesley College in the 1940s. One night on TV, my mom and I had watched Miller stump the celebrity panel on *To Tell the Truth*. No one

imagined that she could be a boxing writer. When I was ten, she'd taken my family to the Time-Life Building after we spent the day with her at the Bronx Zoo. Our elevator ride—my first—took us to a high floor where her husband, Sam Welles, worked as the editor of *Life* magazine. They'd met when as a foreign correspondent with Time Inc. he had followed a tip into a boxing scandal. To investigate that story, his editor paired him with Miller, which led to romance and then to marriage, quickly followed by one pregnancy, then another, and eventually the birth of their three children. After her marriage, Miller had left *Sports Illustrated*, as women did in those days. She'd never wrote about boxing again.

The next time I walked into the Time-Life Building, I was twenty-three years old and an elevator took me to the twentieth floor for my first interview at *Sports Illustrated*. That day I thought about Miller, who had died by then. At the age of fifteen, she'd read about the boxer, Joe Louis, then listened to his fights on radio, as my mom did her Red Sox games. Miller's parents took her to her first championship fight in Yankee Stadium when she was eighteen. That was the famous rematch that the press billed as the fight between the American Negro, Louis, and the Aryan German, Max Schmeling, fought at a time when Adolf Hitler ruled Germany and the American Negro was ruled by Jim Crow. During the war, her Wellesley College friends lovingly nicknamed her Cauliflower, a reference to the deformed cartilage on boxers' ears, which spoke to how much time Miller spent with boxers training near Boston, including Louis. She wrote "Joe Louis: American" as her senior thesis, and it was published as a book in 1945, when she was twenty-two.

Long after I left sports journalism, Miller's granddaughter told me how Louis instructed his guards at the arenas where he fought to let Miller into his locker room along with the male reporters. "You tell Miss Miller that if she will call me in advance, I'll be sure to be wearing my terry cloth robe and she can come back any time," Louis told his handlers, according to Roy Peter Clark, who wrote "Cauliflower and the Champ" about Miller and Louis.[4] Clark observed how she "overcame many jeers from unenlightened colleagues about her reporting from the locker room." Miller was the only woman Louis ever allowed in.

When Miller took me on that first elevator ride in the Time-Life building, I couldn't know that one day I'd be on it each day to work at the magazine where she once was its boxing writer.

Chapter Fifteen

Ludtke v. Kuhn was not predestined.

It was a federal court case only because powerful older men in baseball refused to heed wise advice given by younger colleagues on October 11, 1977. That night Kuhn trotted out his no-women-in-the-locker-room policy and banned me from working in any team's clubhouse. Six months later, my lawyer, whom Time Inc. hired after our negotiations with Kuhn broke down, stood in Judge Motley's thirteenth-floor courtroom delineating rights spelled out in the U.S. Constitution pertinent to the discriminatory action Kuhn took against me.

Had Kuhn's right-hand man, Bob Wirz, heeded the counsel of the media directors from the Yankees, Mickey Morabito, and Dodgers, Steve Brenner, then decades later scholars would not be citing _Ludtke v. Kuhn_ in law review articles, nor would book chapters be examining the impact of my case. Journalists wouldn't be referring to my case in stories about women being hired into jobs—on baseball fields, in team management, and by broadcast, digital, and print news organizations. Nor would writers or podcasters ask me to describe how baseball treated me as they talk about how the game treats women today. Nor would students of all ages want to talk with me in writing research papers or ask me to help with their National History Day projects. But they call often, and I always say yes since I want my role in women's fight for equal rights to come alive for those who were not around to experience it.

Had those teams' PR men prevailed on that October night, Judge Motley would not have had to absorb the minutiae of a game she disliked or delve into the financial details of the lease between New York City and the

Yankees. Fritz might have been arguing a different case before a different Southern District Court judge, and Kuhn's attorney would not have endured a cringe-worthy ten-minute debate with Judge Motley about whether baseball players are "compelled" by the powers that be to be naked in locker rooms. If it hadn't been me, another woman would have tripped over Kuhn's edict maybe a year or two later, and perhaps her publication would have taken him to court. But *Ludtke v. Kuhn* was happening, and it happened because Wirz and Kuhn ignored the good guidance that twenty-six-year-old media director Mickey Morabito gave, with an assist from Brenner. Morabito offered his elders an exit ramp that, if taken, likely would have avoided their confrontation with me. But Kuhn and Wirz sped up, skipped the exit ramp, and wound up in a costly collision with me.

* * *

Let cooler heads prevail, Morabito had cautioned Wirz when he and Brenner huddled with him in Yankee Stadium's press box at Game 1 of the 1977 World Series. Brenner had gone to Wirz and Morabito to tell them about the Dodgers telling me I could work in their locker room. Wirz was preparing to keep me out when Morabito cautioned him not to act precipitously.

Don't engage with Melissa about locker room access tonight, he told Wirz. He wanted Wirz to walk, not run, in handling this situation. He worried Kuhn would ignite the combustible issue of female writers in locker rooms by putting it into public sphere on opening night of this World Series. Teams from the two largest media markets were in the series, and Morabito didn't want to divert attention from the games. He thought Wirz ought to hold off acting on my access until the more quiescent off-season. Maybe then Kuhn would devise a Houdini-like escape.

"Don't say no to Melissa tonight," Morabito implored. Work with her, he advised.[1]

Morabito knew me very well, while neither Wirz nor Brenner met me until that October night. Through two seasons of reporting at Yankee Stadium, I'd confided in Morabito, sharing my frustrations about not having equal access to players. After the All-Star Game break of the 1977 season, he'd opened the side door of the clubhouse to let me into the manager's office. Although this wasn't equal to the access the men had, I felt this arrangement put me on a glide path for achieving full clubhouse access in time. I was right. At the end of the season, Morabito left me clubhouse passes for the last two games. By quietly and gradually expanding my access, Morabito and I had

managed to avoid even one story being written about me working in places that no female had worked before. Without causing a confrontation or creating chaos, I had stuck with my gradualist's strategy of patience and persistence, and I'd found success.

Talk with Melissa, Morabito begged Wirz, who in the hierarchy of baseball was his boss. When Wirz told teams' PR people to do something, they assumed the demand had come from Kuhn, so they did what Wirz said to do. In pleading with Wirz to not close out all options for my access, Morabito suggested a compromise position. Don't tell Melissa what she can't do, he said. Present her with a different possibility, one that demonstrates progress, and she'll accept it, he proposed, which wasn't an off-the-cuff notion. Morabito had lots of experience working with me. He'd spoken with Brenner before the three men talked, explaining to him how his alternative strategy wouldn't weaken Kuhn's stand.

Unwisely, Wirz dismissed his proposal from the get-go.

The rest, as they say, is history.

* * *

I knew nothing about Morabito's alternative strategy until 2013 when I saw him quoted in a newspaper story about my legal case. This made me wonder what Morabito remembered about that October night. By then, he was the traveling secretary with the Oakland A's, and when I called to talk with him, the team gave me his cell phone number. When he answered my call, Morabito was in the press box at a spring training game. He'd followed his close friend Billy Martin to Oakland in 1980, when Martin was hired to manage, and thirty-three years later, Martin had died, but Morabito was still with the A's.

We'd barely exchanged greetings when he expressed surprise that I had not reached out sooner. I wondered the same thing. Why in the intervening decades didn't I contact him to find out the backstory of how that evening played out? But until I was researching this book, I didn't think of reliving the events of that evening. In part my reluctance was due to Morabito's testiness that night. But as years went by, I came to understand that Morabito had no choice but to deal with me as he did that evening. He was only doing what his higher-ups ordered him to do when he was the first person to convey to me Kuhn's decision to ban me from the locker rooms.

He seemed genuinely glad that I'd finally reached him. When I told him why I'd called, Morabito replayed the events of that night as clearly as if they'd

happened yesterday. He began by telling me that Brenner had pulled him aside about an hour before the game to tell him about his team's vote. Then, Morabito told Brenner about how he'd worked to gradually expand my access to the Yankees during the season. Based on how well he knew me, he told Brenner that he thought I'd agree to a compromise arrangement for the series which would mean I'd have to give up the full clubhouse access that he and I had worked hard to make happen. But he felt that I'd agree if the alternative I was offered wasn't a full ban. When Brenner learned this, he agreed it would be best if Kuhn avoided a confrontation with me and *Sports Illustrated* at this time. So together, they came up with a compromise they thought I'd accept.

At this point in telling me this story, Morabito assured me that neither of them wanted to battle with Kuhn or Wirz that evening. Both of them realized that if Wirz felt they were pleading my cause, they could be putting their jobs in jeopardy, which was not something either man was willing to risk. I told him I fully understood. I did not know Brenner's history with the Dodgers, but Morabito's job meant everything to him. He'd started with the Yankees as a batboy, then worked his way up to this top position after being assistant PR director in the prior season. He knew how baseball worked. Midway through that 1976 season, Wirz—acting under orders from Kuhn—had rebuked the Yankees when its ballplayers voted to allow female writers in their clubhouse. When Kuhn had heard about that vote, he commanded Wirz to issue a cease-and-desist order through the Yankees' PR staff. That had schooled Morabito to Kuhn's sensitivity on this matter. Also fresh in his mind was our success in the 1977 season in expanding my access without anyone writing a story about it. Kuhn and Wirz had not known about this since Morabito was not inclined to share what we were doing with the commissioner's office. If he found out, I guess Morabito had figured we'd cross that bridge then.

So at the World Series, Morabito found himself in an uncomfortable position. Our gradualist approach had worked, but he feared he could lose his job if he told Wirz about how I'd gained this access. But he also wanted Wirz to consider and ultimately accept his suggestion for how to get through the World Series without the issue of women's equal access to the locker room exploding. He had to tread carefully.

Morabito's idea was to return to our mid-summer arrangement and give me access to the managers during the World Series. The brilliance of his plan—and he didn't know this—was how closely it aligned with the initial request I'd made to Dodgers manager Tommy Lasorda at Monday's World

Series workout. In asking Lasorda for access to him, I was using the playbook that Morabito and I developed with the Yankees. With the Dodgers having no women covering the team, I thought my gradualist approach would work best with them. But when my request stunned Lasorda, he'd refused to engage and tossed me like a hot potato to his team's player representative, Tommy John, who was walking behind us when I'd raised this with Lasorda. Unlike his manager, John talked with me for fifteen minutes in the dugout, listening attentively as I told him about my Yankees experience. He asked lots of questions, which I answered frankly as we touched on some of the thornier issues raised by my access to the locker room. By then, we'd moved my request past the manager and to the entire team. John told me that he'd call a team meeting so the players could discuss my request. He wanted them to share their concerns and views before taking a team vote about whether I'd be admitted to their locker room.

I didn't protest John's suggestion even though I could have. After all, my press pass gave me the right to report in both clubhouses. I could have argued that the decision should not be up to the players to make. I had the right to be there. Still, I said nothing. I thought a team meeting was a good idea. This way, the Dodgers would air their feelings. If it turned out that I went in, they would be forewarned. Being around the Yankees had taught me that to force an issue like this was not going to work well for the players or me. Nor was I naive enough to believe that even if a majority voted in favor of my access that going into the Dodgers locker room would be without its challenges. By being there, I'd disrupt players' customary routines, and that alone would upset a few of them. It was also likely that one or two players would do what they could to embarrass me, perhaps hoping I'd leave and stay away. On nearly every team, a few players seemed to want to put women through the wringer with antics revolving around nudity. They'd shout obscenities and call me names—typical frat-boy hazing. But giving the Dodgers this advance notice would help.

The Dodgers voted in favor of my access before Game 1. When batting practice was over, John met me, as planned, at the backstop behind home plate. There, we'd be apart from the other writers. As his teammates left the field, John gave me news of the vote: "It's a majority vote and that's how we do things. So you can come in."

I thanked him, then started to walk away. He called me back and asked me to tell the team's PR person about the team's decision. I hadn't met Brenner. I didn't even know what he looked like, but I told John that I'd find him and tell him. Although I was under no obligation to do this favor, I felt that the

more prepared everyone was for my presence in the postgame locker room, the smoother my experience would be. After leaving the field, I walked the wide, concrete corridor under Yankee Stadium asking people I knew if they'd seen Brenner. Eventually, I found him and told him about the vote and said that I might go into the Dodgers' locker room after the game. When I told him this, Brenner turned and walked away.

By relaying John's message, I'd sealed my fate.

* * *

Morabito told me more about their conversation with Wirz that October night.

"I told him [Wirz] it would be easy for me to bring you to Billy [Martin], and Steve could do the same with Tommy [Lasorda]," he said.

But before Morabito even had a chance to explain to Wirz why he thought I'd accept this plan, he had nixed the idea. But Morabito decided in that instant that his idea deserved a last-ditch effort, so he took the plunge and courageously told Wirz about escorting me into Martin's office by using the side-door passageway inside the clubhouse. Though he risked his job in telling Wirz this story, Morabito felt that if Wirz understood how well this arrangement had worked—at the same time being told it had drawn no attention from the press—he would agree to a similar plan at the World Series. After all, what he was suggesting would not threaten baseball's ironclad policy against female writers being in the locker room. I wouldn't be in the locker room; I'd be in the managers' offices, and the PR directors would escort me there. As Morabito knew, I had never gone into the locker room from Martin's office even without his supervision.

Once Morabito spilled the beans about our side-door forays, Wirz doubled down. He declared an end to all of the access the Yankees had given me in the second half of the season and at the American League Championship Series. By Morabito adding common sense to this discussion, I lost my ability to go into Martin's office during the series. That was access I had assumed I'd have.

I don't know if Wirz spoke with Kuhn before summoning me to the main press box. But it doesn't matter since the two men had acted in unison in crafting and would do so in enforcing the no-women policy. Wirz knew what action to take if the need arose. With Kuhn in the commissioner's box near the Yankees' dugout—and with no cell phones enabling them to speak—Wirz would have had to take a long walk for a quick talk with Kuhn, only to be told what he already knew.

I doubt he made that walk, but he did act just as Kuhn expected him to do.

* * *

"Melissa Ludtke, please report to the main press box."

Garbled words crackled from a small loudspeaker bolted to a column in Yankee Stadium's grandstand near my seat in the auxiliary press box. I thought I heard my name. It was the fifth inning of the first game of the World Series, and I was concentrating on the game. So I turned to Roger Angell, the *New Yorker* writer seated to my right, to ask what he'd heard.

"Sounds like you, yes," he said.

The disembodied voice saying what sounded like my name had caught me off guard. Usually, this speaker fed us updates like pitching changes or the scorekeeper's call of an error or fielding play. Hearing a person's name was odd, and it was odder still when it was mine. The standard practice was to repeat each message, so I listened for that. This time, I heard my name and the request clearly.

I had to get out from where I was seated. But doing so wasn't going to be easy. I'd have to flatten myself like a pancake and wiggle my body sideways in front of several men. We were squished into tight quarters of a makeshift press box. The main one upstairs had unobstructed views above home plate. Well-spaced seats gave writers plenty of legroom under tabletops for notetaking and typewriters. *Sports Illustrated's* lead writer, Ron Fimrite, was there, while the rest of our reporting team had seats in this auxiliary press box carved out of rows of grandstand seats. We were closer to home plate than first base and far enough back from the field to be under the upper tier's overhang of seats. I'd been assigned seat 9 in the middle of row G. A thin plywood slab jutted out across our row to provide a small writing surface. This obstruction made it tough for the slimmest among us to squeeze by seatmates. To get out meant I'd disrupt each man who sat between me and the aisle. As I wiggled my body down the row, I set in motion a Jack-in-the-box wave. As one man rose, the prior one sat, and so it went. With my mid-inning departure, I was violating a gentlemen's agreement that once seated, we stayed. We were at this game to work, so mid-inning dashes for a beer or pretzels were frowned on. We made sure to visit the restroom before sitting down.

With the score 2–1, the Dodgers led this pitchers' duel, and the Yankees were at bat. I didn't want to draw my seatmates' ire by walking in front of them during a key hit or play, so I moved as quickly as I could. I didn't like

having to accentuate my presence by disrupting them too. A lot of baseball writers weren't accustomed to having a woman among them. Just being there marked me as a stand-in for *all* women, and the men hated the idea of more of us showing up. The longtime PR director of the Red Sox, Bill Crowley, had articulated such fears to Diane K. Shah when she introduced herself to him in Fenway Park's press box late in the 1972 season. Grudgingly, Crowley had agreed to give Shah a pass for the field and a seat in the press box after her male editor and the magazine's male lawyer demanded he do this after he'd refused to give these passes to her. When she got to Fenway Park, he'd ignored her. So a few innings into the first game, Shah approached him.

"See? Nothing terrible has happened," she told him, reassuring Crowley that she could do her job without incident.

"Well, it will," he replied gruffly.

Shah didn't know what he had in mind. "Tomorrow, there will be fifty girls like you here," Crowley declared.

She reminded him that there weren't close to fifty female sportswriters in America.

"Maybe not, but they'll say they are just so they can get at *my* players," he shot back.

* * *

Within every sportswriter, some like to say, resides the soul of a boy who dreamed of playing professional sports but at some agonizing moment realized he wouldn't make the cut. Some of them grew up and found a way to stay close to what they dreamed might have been. When I covered baseball, people asked how I ended up as a sportswriter. As a girl growing up in the '50s and '60s, those dreams could not have been mine.

Leigh Montville posed such questions to me publicly when he created a pop quiz in his well-read Sunday *Boston Globe* sports column. Headlined "But Is She Serious?" it was much more a put-down than it was a hand-up.[2] "I don't ask them [questions] as some sort of chauvinist, though I am sure that could be debated," Montville began. "I ask them because I am serious, and I wonder if the lady is serious." He trotted out dozens of questions to challenge my bona fides in sports. What right did I have to do this job if I hadn't experienced the childhood rites of passage that prepare a person for this job? That was the point he was making with his quiz that surfaced what many men were thinking but had not asked directly. Montville wasn't subtle. In his lineup of snarky questions, I could see an imaginary cartoonist's bubble coming out

of sportswriters' heads containing the words: "You don't belong since you never punched the tickets needed to get in."

"Did she grow up on sports?" Montville wrote as the first of many questions.

> Was her life absolutely dominated by sports when she was a kid? Did she spend hours playing, talking, chewing on sports and then ask for more? Does she have a sense of the history of sports? Does she know how the games are played, know the bits and pieces that go beyond the fact that nine men are on a side and three strikes mean an out?

> Did she collect baseball cards? . . . Does she know that the second baseman covers second when a runner is on first and right-handed batter is at the plate? Does she know that the shortstop covers with a left-handed batter? . . .

> Did she ever spit in a baseball glove? Rub linseed oil in it? . . . Does she know about the physical pain of Mickey Mantle? The psychological pain of Roger Maris? What did she think about the asterisk? Was that fair?

Montville revved his engine for his concluding crescendo. He'd set out to prove that since no girl had the sports life of boys', we were disqualified from sharing the sports beat with men.

> Did she ever feel invincible, surrounded by spotlights, as she walked home along in a uniform, any uniform of any team on any level?

> Has she always had trouble remembering how, exactly, to figure out an earned-run average?

> Does she know how hard it is, absolutely hard, to make it to the big leagues of any sport? . . .

> Is she serious? That's all. Is she serious? . . .

> If the lady, if anyone, has put in the hours and has the interest and can translate it into common-sense English and can find a job then she deserves the right to do that job. If she is there for showtime or cosmetics or a little piece of Eyewitness babble about, "Here I am, sports fans, standing next to Reggie Jackson," then she is as out of place as the average truck driver at a fashion show.

Sarcasm dripped from his closing words, "I have only a few questions."

I didn't want to be pulled into responding to this attack. Fortunately, his *Boston Globe* colleague Lesley Visser responded one week later in a Sunday

column. Her words spoke for me. In the mid-1970s, after she had graduated from Boston College, Visser was the first woman hired in the *Boston Globe*'s sports department. Assigned to report on the New England Patriots, she became the first woman to cover an NFL team. I grew up loving baseball; Lesley's passion was football. Before she was a teen, Visser asked her mom for football shoulder pads for Christmas, and she found them wrapped as her gift under the tree. A bit later, Visser told her mother she dreamed of being a sportswriter. Although her mom could think of no role models for her to follow, she didn't puncture her daughter's dream. Instead, as Visser wrote, her mom "changed my life in an instant" with her words: "Sometimes you have to cross when it says, 'Don't Walk.'"[3] Visser kept crossing barriers. After covering football for the *Boston Globe*, CBS Sports hired her for their NFL broadcast team.

Visser replied to Montville with the headline, "He Asked for It, So He'll Get It—My Answer."[4] Her three-line intro reminded readers of how he'd questioned if "female sportswriters were serious," before she dived into her spirited reply that it was ridiculous for a person's gender to disqualify her from writing about sports:

> We are young, most women sportswriters. That does not mean we can't have perspective. . . . There is nothing genetic that says we cannot do it. I won four gold medals in the National Junior Olympics. Does that mean I am better qualified to write about track? It does not.

> The ability to describe, to write, is sexless. Do you as a writer have the ability to take the readers there with you? Can they feel the wind on their faces? Can you, the writer, sense the mood of the players? Can you paint vivid, clear scenes in the readers' mind? Certainly not all male writers can do it, either. Most cannot. . . .

> The writer asks if we are in the clubhouse for showtime, yet he does not bat an eye when a reporter in this town says, and is quoted, "Why do the women who want to go into the locker room always have to be dogs? What can't it be a good-looking broad?"

> Does that man really deserve to be in there before us?

* * *

When he'd assigned me to cover the 1977 World Series, the baseball editor at *Sports Illustrated* knew I was serious. By then, I'd written several baseball

stories and many TV/radio columns. He had sent me on the road to report with writers such as Roger Kahn, while I still performed fact-checking duties in the office. To report the World Series seemed a life-changing moment for me.

So after moving past those men in row G, I hurried up the aisle steps to the grandstand's walkway, then took the next exit to the inner concourse. I didn't like the field being out of view. I worried I'd miss a key play. In those pre-YouTube days, a controversial call or consequential moment would be shown on local TV news, but I had no way to replay them. It was my job to fact-check the stories about this series, so it mattered that I saw what happened in each inning of every game. When the writer faxed his story to New York late Sunday night, it would be my job to verify that whatever stats and scenes he had in his story happened as he said they did. To do this late at night, I relied mostly on my contemporaneous notes of every game that I purposely kept detailed as well as broadly explanatory. I depended on my meticulous scoring of each play, which is why I was nervous about missing a key hit or controversial play.

I galloped to the press elevator that would take me to the second-level press box. When I got out on the press box level, I heard fans reacting but didn't know why. I kept track of the game with a watchmaker's precision, so not being able to do that now was upsetting. I had good reason to feel anxious since early in my SI career, I'd been reprimanded when I'd let a doozy of an error slip by in a college football story.

That happened in the fall of 1974. SI had not sent a writer or photographer to a Michigan State and Ohio State football game. Everyone assumed Ohio State would win. But Michigan State upset the number one team with a controversial game-ending play. *Sports Illustrated* had to do a story,[5] so the editor assigned one of its finest and funniest writers, Dan Jenkins, to write it. When I left the office on Saturday, I was told I'd fact-check Jenkins' story the next day. SI had hired an artist to paint a picture of the disputed goal-line play and he'd gone to ABC Sports to watch video replays. Sunday afternoon the art department brought me a page-proof of the painting for the story's opening spread. I'd fact-checked the story's words, but I was told to be sure that everything in the painting was accurate too. I cross-checked the jersey numbers of players to be sure each painted number belonged to a player who was on the field for that play. What I failed to notice was that the artist had added an extra player to the pile of bodies near the goal line. It did not occur to me to count the total number of players (or combos of arms and legs standing in for a player) on each team. If I'd done that, I likely would have

noticed the twelfth Ohio State player. If I'd caught that error in the painting, it would have had to be redone, causing havoc with the publishing schedule. But I would have been a hero. I didn't catch it, so I was the villain, even though nobody else who saw the painting had noticed the extra player either.

When the magazine reached readers, hundreds of them counted. Ohio State fans wrote letters to the editor[6] blasting *Sports Illustrated* for rubbing salt in their wounds. This onslaught of letters proved the prescience of that *Time* editor who extolled the happy life of a fact-checker as being the "girl" who assumes *all* the blame. Merv Hyman, who'd hired me, ushered me into his office and, after closing the door, motioned for me to sit in the chair next to his large wooden desk. Somberly, he left no doubt as to the severity of my error. When his scolding ended, I did not know what to say. I was paralyzed by anxiety. I thought I was about to lose this job I loved. I could not hold back tears. As they ran down my cheeks, he handed me tissues. I dabbed my face, trying to compose my thoughts, then offered him apologetic words between heaving sobs. He must have realized that his stern words had their salutary effect as I kept on repeating how sorry I was. Minutes later, I walked out of his office into mine. I hadn't lost my job; I was on probation.

Even though my probation was long over by the fall of 1977, I could not afford to make another error, especially in a high-profile story like the World Series.

That incident had reinforced for me the rigors of fact-checking. It also taught me to rely on detailed notes that I took at sports events. My own eyes and ears were my first pass when checking facts, and I buttressed those with game stories including AP accounts I ripped from the wire service machine just outside my office. So when I lost sight of the field on that October night, I felt panicked in thinking about all that I was missing. By the time I got to the press box entrance, my heart was pounding. Whatever was about to happen inside, I wanted it to happen fast. I needed to get back to the game.

Mickey Morabito was there waiting when I walked in. I didn't know who called me upstairs or why, but I suspected it had to do with the Dodgers' vote. So, I was relieved when Morabito greeted me. We'd worked well through two seasons. To me, he was a miracle worker. But when I stepped into the press box, I saw him step back from me. He offered no handshake, nor welcoming smile. He didn't seem like the person I thought I knew.

In this awkward moment, I wondered if he'd run out of miracles. Maybe I had too.

Chapter Sixteen

Morabito motioned for me to follow him, so I did. He took me as far back in the press box as it seemed possible to be. Once there, I barely heard the crowd, and I couldn't see the game. The ballpark announcer Bob Shepard's voice was muffled when he told the fans who was at the plate. Losing all connection with the game, my anxiety spiked.

After his tepid hello, Morabito stayed standoffish, which intensified my unease. His usual affability was replaced by unrecognizable sternness and a dour expression, telling me that I wasn't going to like what he'd brought me here to say. He stared at the floor, avoiding eye contact. When his long, wavy black hair fell over his eyes, he didn't sweep it back. It was like he was trying to hide from me. On better days, his hands would dance as if conducting his words, but tonight his arms seemed glued to his body. Even in the team's tumultuous times that season, the sparkle hadn't left Morabito's eyes. I saw no twinkle in them tonight. How could I feel so distant from this person I knew so well? We were here together, but I felt utterly alone.

"You can't go into either locker room tonight," he said, in a voice so quiet that I had to strain to hear him. His words stung, but I stayed silent. He shuffled his feet, as if letting me know that he had more to tell me.

"The two managers' offices are off limits to you too."

He was the only person in baseball who'd lent his hand in expanding this access for me. Now the man who'd made this happen was telling me this.

It didn't make sense.

* * *

Baseball writers griped loudly to PR directors when little things about their daily routine didn't work as they thought they should. I didn't have that leeway. First of all, if I griped or got angry and raised my voice to a man, I'd open myself up to unflattering things being thought and said about me. That's why I looked for moments to speak privately with Morabito, then worked quietly with him. I didn't air my grievances when the male writers were around. I knew many watched and judged me as a stand-in for how *all* women would act. This might have been an unfair burden to carry, but it's a familiar one to anyone who works as a tiny minority. If I created a ruckus, there'd be a price to pay. I wanted to stick around baseball, so I wasn't going to burn bridges but try to build them. Morabito knew this about me. On that October night, had someone asked him to bet on whether anger at Kuhn's ban would push me to try to bully my way into a locker room, he'd have bet against me doing that. He'd have been right. In fact, when he learned of my diplomacy with the Dodgers, I'm certain that he'd thought back to the success we had in expanding my access while avoiding chaos.

Why, then, was he closing the doors we'd opened?

I had nothing to say that wasn't spiteful, so I stayed quiet. But Morabito blocked my exit from where he stood, so I felt trapped but not in any threatening way. When neither of us spoke or moved, I'd had time to think, and then I realized why he was treating me so coldly. He must be ashamed to have to tell me what he'd just said. He had not wanted this to happen any more than I did, but he'd been sent to deliver this upsetting news. It wasn't his choice. But if it was the Dodgers that had changed their minds, why wasn't Brenner telling me this news? Whoever had ordered Morabito to do this was someone to whom he could not say no. That person had to be the commissioner, who was also the only person with authority to nullify a team's vote, as he'd done with the Yankees' in 1976.

Morabito had heard Kuhn's dictate, then. Now, I knew he wouldn't forget this one.

* * *

After Time Inc. filed our complaint with the court in December, Kuhn had to turn over all documents related to this case. Among those documents was one he sent to the teams' general managers on April 2, 1975. In his directive, he told them to maintain "a unified stand [in refusing locker room access to female writers] . . . undoubtedly along the lines of total cooperation [with the women] without entrance to the clubhouse—is the best course of

action." Kuhn sent this message not long after the NHL and NBA adapted their media policies to deal with the reality of women routinely covering their games. Kuhn was preparing his teams for the time when a female writer would ask to work in a baseball locker room or when players on a team, like the Yankees or the Dodgers, said they could.

Kuhn settled on his no-women-in-the-clubhouse policy to protect *his* players. He seemed to believe he had the duty to act in loco parentis to uphold his game's integrity. At times, he was explicit in saying that he needed to protect their "sexual privacy." Paramount always, in his mind, was his need to maintain baseball's family-friendly brand as America's pastime. On October 11, 1977, Kuhn must not have believed baseball could survive my intrusion. He also likely calculated that the vast majority of his game's fans would be glad he acted to stop me. He was probably right, and he leveraged my case's shock value to good effect outside of the courtroom.

But once Judge Motley was hearing the case, Fritz would direct her to take a hard look at Kuhn's guiding belief that protecting player privacy justified denying my right to the liberty, as promised in the U.S. Constitution. Kuhn's lawyer had submitted nothing to show that the Dodger or Yankee players had put their "privacy" ahead of what a majority recognized as my right to work in the locker room alongside the men.

Only Kuhn did that.

* * *

In this back room of the Yankees' press box, I saw no upside in arguing with Morabito. He couldn't alter Kuhn's edict. He was only his delivery boy. So I told him that I needed Kuhn to tell me himself why he'd removed the access that the players gave me. I could see that my request caught him off guard. Kuhn didn't frighten me as he did Morabito. I didn't work for him and I felt he owed me an explanation. Morabito assured me this was not going to happen but said I could talk with Bob Wirz if I wanted to know why. That was a name I didn't know, so Morabito told me he handled media for Kuhn.

"Yes, I want to speak with him," I said.

By now, I'd resigned myself to not tracking the game. But as Morabito led me down the steep stairs alongside the four rows of seats in the press box, I saw and heard the game again. In the front row, I saw a man I didn't recognize in the seat next to Morabito's. When we approached, this man stood and Morabito handed me off to him, mumbling something like "Well, here she is," as if Wirz would know. Standing there with Wirz, I saw Morabito swivel

his chair until his back faced us. He'd done the errand he was sent to do. He wanted nothing to do with whatever happened next. By turning his back on us, he told me he hated doing what he'd done as much as I hated what he'd said.

Wirz was easier for me to read than Morabito. He seemed rattled by my presence from the moment we were introduced. Maybe he was worried that he was dealing with a potentially hysterical woman. If I acted out in the press box, then writers and columnists seated just a few feet away would want to know why and he'd need to explain, which he didn't want to do. So he directed me to follow him back upstairs. Up we went, the same stairs I'd just walked down. He took me to the room where I'd been with Morabito, where Wirz appeared relieved to be out of sight and earshot of sportswriters. He wasted little time in telling me that Kuhn had banned me from the World Series locker rooms, but then added that the ban extended past the series, as in forever. After reminding me that Kuhn controlled *all* of baseball, he said it did not matter that my World Series press pass gave me access to the clubhouses or that the Dodgers had voted in favor of my right to work in their locker room. Kuhn was the only person who could grant me permission, and he wouldn't.

His bottom line was that Major League Baseball's locker room policy would be what Kuhn said it would be. Period. "It's not that we're rescinding permission," he told me, sounding like a drill sergeant barking orders at a new recruit. "Permission was never granted."

He seemed to take enormous pleasure in executing Kuhn's order. Until now, the policy he'd brandished had been in a drawer at the commissioner's office. My courtesy call to the Dodgers had given Wirz this first opportunity to apply Kuhn's order against a female sportswriter. He shed not an ounce of empathy in doing so. When this policy was created, Kuhn had engaged Wirz in the process. Then he'd given him the task of staying in touch with the teams about whether any female writer had shown up. If she had, Wirz was to find out how the team responded. No stories had appeared in the press about this policy, so I didn't know one existed. It was just assumed that I didn't have the right to go into locker rooms. I doubted that other sportswriters knew about it. Kuhn's edict was an insurance policy. If a female writer showed up at a clubhouse door, he'd dust it off and respond.

Of baseball's commandments, none rose higher than this one: The commissioner *giveth* permission, and when necessary, he *taketh* it away. On this night in a back room of Yankee stadium's press box, Wirz, speaking with Kuhn's authority, took away the equal access I'd worked hard to secure for

this World Series. His directive was irrevocable, and Wirz assured me there was no one to whom I could go to appeal Kuhn's decision.

It was hard to suppress the rage boiling inside me, and tough, too, to hold back tears ready to spill from my eyes. But here's where the emotional hardiness I'd built up at ballparks helped. I wouldn't let this man see me cry. I refused to give him that pleasure. So, steadying myself with a deep breath, I summoned my reporter's mindset and asked, "Why are you doing this?"

He surprised me by replying. "A woman has no place in a locker room," he said, sounding so sure of his claim that for an instant I accepted what he'd said as fact and not the opinion it was. He kept on talking. Baseball, he told me, was not *ready* for a female writer to be with its players in locker rooms. This seemed his nod to the NBA and NHL that went in a different direction. Clearly, in his mind, baseball had no reason to follow those upstart leagues. Kuhn would set his own course.

By now, he realized I wasn't going to throw a tantrum on hearing his news. Maybe that's why Wirz went on to explain the rationale for this action. "We haven't consulted the players' wives who might object," he said. Perhaps he thought, as a woman, I would empathize with the players' wives. I didn't since I knew from the women who worked in locker rooms that *nothing* about their interactions with players was sexual. If anything, their locker room visits were the antithesis of sexual. Women treated players respectfully by keeping their distance when a player was changing, then approaching to talk later. The women worked as quickly as they could, then left.

We posed no threat to the players' marriages.

At ballparks, I purposely played down any hint of sexuality in how I dressed—no makeup, no jewelry, no high heels, no plunging necklines—and in how I acted. None of us were at these games to find a date. When women covering game in those other leagues went into locker rooms, it was to grab quotes and soak in atmospheric details to tell good stories. So when Wirz told me about not consulting the players' wives, I asked him to tell me what decisions the wives had been consulted on. When he couldn't name one, he gave instead a second reason for Kuhn's decision. If I went in locker rooms, then classmates of players' children would ridicule them in school. This left me speechless. It was ludicrous on so many levels. For starters, how would their classmate find out that I'd been in the locker room? Who would tell them?

It was laughable, but I wasn't in the mood to laugh.

After tumbling down to this level of absurdity, we reached an impasse. But I was not going to leave before he answered my question, "Then, this is because of my sex?"

"Yes," Wirz replied.

He'd admitted that Kuhn did this because of my gender. At that moment I didn't envision us facing off in federal court in a case about gender discrimination. It just felt good to have him on the record with this answer.

With nothing more to say, he motioned me out of the room. This time, when he turned to head downstairs, I turned the other way to exit through the door that I walked in forty-five minutes earlier. I was alone in the press elevator giving me time to compose myself to return to my seat. I decided not to talk about what had gone on upstairs with anyone that night. I wanted time to process what I'd been through. After sidestepping to my seat, I opened my scorebook to this game and asked Angell if he'd let me copy his exceedingly neat scoring. We'd sat with each other so many times that I knew his shortcut codes in his scoring. Generously, he shared his page with me so I could catch up with the game, which the Yankees had tied in the sixth inning.

The ball game was tied but I couldn't get my head back into it even when it went into extra innings. Even when Paul Blair's twelfth inning single scored Willie Randolph from second base to win the game, I couldn't shake how Morabito had treated me or the demeaning tone that Wirz used when talking with me. Men talked down to me all the time, but I was shaken by what these men had put me through. Being around this game had prepared me but I despised the pretense of Kuhn as a chivalrous protector of my feminine virtue. Their attitudes were keeping me from doing a job I loved.

I felt caged by their patronizing attitudes and by the power they had used against me.

* * *

Kuhn led his chorus of chivalrous protectors with paternalistic certitude. I'd never asked Kuhn or anyone else in baseball for *special* treatment or their protection. All I wanted was to be treated like the men when we did our jobs. I'd acquired the skills to do this job. I'd put in long hours to merit my World Series assignment, but to do this job I needed equal access. Instead, Kuhn cast aside the players' vote, then through Wirz, said he needed to protect his players from me, while intimating that they were protecting me from my unladylike urges. After hearing about Kuhn's no, I sent him a letter summarizing my perspective of what Wirz told me: "That the commissioner's office was anticipating problems and protecting the rights of individuals who may not even agree that their rights are endangered."

I was well aware that baseball commissioners did not release their grip on power willingly. Either a commissioner dies or a majority of owners are angry enough to force him out, but usually that took years to happen. At fifty, Kuhn was a relatively youthful commissioner. Doing the math told me that in the foreseeable future I would not be going into locker rooms. This was tantamount to saying that I would not become a baseball writer since he needs to talk easily with his sources. Without access, I couldn't compete with the guys. I wouldn't lose my reporter job over this, so I could continue to put hours of unpaid time into writing my stories when I wasn't fact-checking the writers' stories. If Kuhn's ban stuck, getting promoted at *Sports Illustrated* was incredibly unlikely. It would be a decade or more before Morabito's generation would hold the reins of power in baseball. Even then, the game's conservative bent would stymie any real progress with what had to change.

For now, no one in baseball would quarrel with Kuhn's decision. As the game's commissioner, he personified "the best interests of baseball," which was a somewhat vague concept that emerged in a time of crisis after the 1919 Black Sox game-fixing scandal tarnished baseball's public image. The team owners had turned to Judge Kenisaw Mountain Landis to be their first commissioner. He insisted on having this full authority, if he took the job. He'd need it to burnish the game's reputation. In their 1921 Pledge of Loyalty, owners agreed to "acquiesce in his [the commissioner's] decisions even when we believe them mistaken" and "not [to] discredit the sport by public criticisms of him." Landis ruled autocratically, establishing the model followed by his successors, including Kuhn. The owners have the power to fire the commissioner but only when enough of them disagree with decisions he's made or how he has operated the league. But if a malcontent among them complained, he was on his own in trying to get a court to side with him. His odds of winning were never good. In a 1997 *Columbia Law Review* article, a fellow partner of Fritz's at Cravath, Swain & Moore, Craig F. Arcella, affirmed that "since 1922, Major League Baseball has enjoyed overwhelming favorable treatment from the U.S. judiciary" due to the "vague but broad authority to act in the game's 'best interests.'"[1]

Baseball's good record of success in the courts gave its commissioners a sense of invincibility. Kuhn experienced this when the Oakland A's owner, Charlie Finley, and St. Louis Cardinals' outfielder Curt Flood recently had taken baseball to federal court. Kuhn prevailed both times. So in 1977, Kuhn had not hesitated to act unilaterally in my case, which he made clear in his affidavit: "I concluded that the admission of female reporters to the locker rooms of professional baseball at a time when male athletes were in

a state of undress would not comport with contemporary local standards of decency and would be contrary to the best interests of baseball. . . . I believe that baseball's image would suffer serious damage with a great many of its fans, that those players who do not favor admission of women would suffer embarrassment, and that the families of players would be justly offended."

When Kuhn took his stand against me, his league presidents, the teams' general managers, the ballplayers, and of course, the owners stood with him.

In his affidavit, Kuhn failed to mention that he kept me out of locker rooms *before* and after games. Before games, no ballplayer was in "a state of undress," as he transitions from batting practice to the game wearing the same uniform. Surely, when a player is in his uniform, he wouldn't "suffer embarrassment" due to me being there with him. Kuhn never bothered explaining. He'd also blocked my side-door access to the manager's office in the Yankees' clubhouse where I'd seen Martin take off his shirt. He had never fully undressed when I was in his office, nor was he embarrassed about having me there. So I had to laugh when I read Martin's sworn testimony in his affidavit, which was far more in line with Kuhn's thinking than Martin's reality. Not once had Martin objected when Morabito left me in his office after games, nor had he raised a stink when Morabito gave me clubhouse passes for the last two games of the season. It was obvious Martin's words were not *his* words; someone had written them, and he had been told to sign the affidavit. This only underscored Kuhn's power. Not only had the owners ceded absolute authority to him to rule with impunity, but evidently he also dictated what the managers swore was accurate. While I chuckled at this duplicity, I was also angry since what Martin said could sway the judge when she read this paragraph supposedly from him:

> The openness and informality of the locker room is an integral part of a team's morale, spirit and communication and to infringe upon it in any way would have a serious adverse effect. . . . To inject the presence of women in the locker room would be to completely break down this traditional system of openness among the players and to inhibit their activities. This would be an absolutely unacceptable invasion of their right of privacy and as such should be unacceptable to our society. . . . I know that players' wives would be deeply offended if other women were present in the same room when their husbands were involved in the locker room activities above mentioned. For these reasons I opposed the admission of women to the locker room and support the decision of Commissioner Kuhn in denying such admission.

It didn't even sound like the man I knew.

The Dodgers' manager, Tommy Lasorda, weighed in as well with his affidavit. Down to the level of specific word choices, his objections read remarkably similar to those in Martin's affidavit.

> I believe that the openness of the locker room and the casual informality of the players within it promotes that kind of team spirit and camaraderie that a team needs to hold it together and make it go. . . . The presence of women in the locker room would create inhibitions which would absolutely destroy this atmosphere. . . . The informality would be lost since players would have to clothe themselves at all times and we would have to make, in effect, hiding places for the players in the small cubicles. It just won't work, and far more reasonable alternatives are available and in fact being employed.

However, Lasorda's affidavit went further in saying that although his players had voted to support my right to work in the locker room, they did not really mean to do so. With revisionist history, Lasorda first extolled his ballplayers' religiosity, then picked up on Wirz's notion that the players' wives would be uncomfortable if I was there: "I feel that since I know them [the players] so well I can advise the Court that they are, as a group, deeply religious men of excellent character and high standards of decency. Most of the men are married and many of them have children and they have told me that it would be uncomfortable for them to be undressed in the presence of women other than their wives. I know that their wives would be outraged in the event such a thing should happen." Then he claimed that after his ballplayers voted, they had "reconsidered the question, [and] the overwhelming majority of them now are very much in opposition to the practice." He made this assertion after the Dodgers' player rep, Tommy John, told Howard Cosell on national TV that he believed that I, and other female writers, deserved to have the equal access to do our jobs.

Judge Motley received the two managers' affidavits ten days before our hearing. Along with these, Kuhn's lawyer sent her affidavits from two female TV broadcasters—Ann Carlon, a sportscaster in Tampa, Florida, and Anita Martini, who worked for a local TV station in Houston. Martini was my friend. Both women wrote in opposition to equal access. Neither wanted to work in the locker rooms and they did not want to be pressured to do so. Whenever Climenko sent affidavits or documents to the judge, he sent copies to Fritz, and Fritz did the same with him. With these affidavits, Climenko had submitted his legal brief in which he wrote that my demand for equal

treatment was "unrealistic" and our legal position was "untenable," telling Judge Motley that "the complaint [against baseball] should be dismissed" although he knew she wouldn't do that.

Earlier, Climenko had sent Judge Motley a document with a title nearly as long as the preamble to the U.S. Constitution—"Memorandum of Defendants in Opposition to Plaintiff's Motion for Summary Judgment and in Support of Defendants' Cross-Motion for Summary Judgment." In it, he claimed that "in the overall picture," my lack of equal access was "no more than a minor hindrance in her pursuit of her present goals as a reporter." Fritz had pointed to this "minor hindrance" remark in our final meeting before the hearing, and I told him to "try telling that to a male baseball reporter." If anyone ever did, then he ought to be ready to hear the men's howl from one thousand yards away, and then await the cease-and-desist order sent to Kuhn by the Baseball Writers Association of America. By closing the clubhouses to *all* reporters, Kuhn could have avoided our face-off in court. He would have made my access—or in this case, my lack of access—the equal of the men's. But he never considered doing this since he feared the wrath of the baseball writers. He wouldn't risk the vitriolic blowback he'd get if he dared to shut the men out of their customary workspace.

Far easier to battle one woman than to take on the army of men.

Under the subtitle, "Denial of Access to Female Reporters Does Not Abridge Plaintiffs' First Amendment Rights," Climenko described my case as being "the mission of a new Quixote, tilting at windmills and locker rooms, too." He wrote this in response to a claim Fritz had made in a legal memorandum showing that the Constitution's First Amendment was also relevant to my case. Climenko disparaged Fritz's perspective by contending it was "as myopic as Quixote's way of life," before he'd called the demands we were putting on baseball "unrealistic": "In essence, they claim that a reasonable restriction, grounded in customary tastes, standards, proprieties, and practices must yield to illusory goals of utter uniformity in the treatment of men and women. This claim is not supported by constitution, decision, statute, or common sense."

This wasn't the first time that an iconic figure from the past had been brought into this case. In his January 1978 column, the celebrated *New York Times* sportswriter Red Smith had called me "*Sports Illustrated*'s Joan of Arc,"[2] thus hinting that I was divinely inspired to crusade. Rest assured, no greater power than my desire to do my job carried me into my fight for equal access. However, Smith's notion of me martyring myself for this cause produced better copy. Nor had I pursued this case for self-aggrandizement, as

Kuhn also contended in documents that our judge was reading: "Ms. Ludtke, previously an obscure, fledgling journalist, has appeared on numerous radio and television shows, and both she and *Sports Illustrated* have received broad national attention in the print media. . . . I wish Ms. Ludtke every success in her profession, but I do not believe it is necessary for her to confront naked athletes to distinguish herself as a first-rate sportswriter." Climenko reiterated Kuhn's point in his own words to the judge: "The only real controversy in the case . . . may be fairly stated as baseball's right to protect the personal privacy of its players, its image with the public at large and its fans in particular, and its right to make reasonable rules of self-regulation on the one hand versus Ms. Ludtke's interest in furthering her career by obtaining access to the dressing rooms of male athletes."

But I wasn't a modern-day Joan of Arc, nor was Fritz the "new Quixote." In my mid-twenties, I was a liberal arts college graduate who found her way into an unusual job during changing times for women. Given an opportunity to pursue my dream of reporting on baseball, all I wanted was a fair shot at doing my job as the men did theirs. But when the men felt threatened, they relied on battle-tested ways to defeat me by driving public attention to the location where the men's nudity would intersect with my wandering eyes. In the late 1970s, the male-dominated press was well versed in turning women activists into overly sexualized, ambitious, aggressive, abrasive archetypes. By April, I saw that what was said about me echoed the broader societal threats that men saw happening in their lives. Like women marching in the streets, I was also challenging conventional ways that, when changed, would affect these men's lives. Decades later, when I first heard the word "misogyny" used to describe sexist insult against women, I was grateful that at last I had a word I could use to describe the treatment I'd known. The insults and putdowns in my time were milder versions than those spewed on social media due to lack of anonymity back then. A byline, or even better, a photo of the writer at the top of his column, had a humanizing effect on his words.

In court, Fritz bypassed my treatment to forge in Judge Motley's mind the essential connections between Kuhn's treatment of me and my constitutional protections. As I listened, the ridicule thrown at me flew out of my mind and Fritz's words took root.

Chapter Seventeen

"What about the player privacy argument?" Fritz asked, posing his question more to settle himself than to receive a reply.

Fritz was leaving shapely women in tiny bathing suits behind and inviting the judge to follow him into locker rooms where muscular men wore even less. By dipping his toe into this quicksand, he risked being pulled down by the salacious narrative of a lustful woman threatening the helpless ballplayers trapped there. While this sideshow had titillated Americans, Fritz was playing to an audience of one, Judge Motley, and what she cared most about was how settled law spoke to Kuhn's denial of my access. If Kuhn's attorney wanted to parade his spectacle of lascivious women embarrassing bashful men before the judge, Fritz was happy to leave that lane wide open for him to do so. Were Climenko to argue that the players' "right" to be naked in their locker room weighed heavier than my Fourteenth Amendment rights of due process and equal protection, well, Fritz liked the odds of Judge Motley coming down on our side.

Fritz leaped into the fray. First, he needed to disabuse Kuhn's claim that a professional team's locker room was a private space. With sportswriters and broadcasters moving in, out, and around locker rooms filled with players, before and after games, how was it possible to contend that this was the players' private space? Since he expected Climenko to ground his argument in Kuhn's interest in protecting player privacy, Fritz wanted Judge Motley to see that "player privacy" could be accommodated with equal access, so this did not "justify baseball's absolute barrier to women."

"As I'll show in a moment, any real interest in player privacy can and must under our Constitution, we submit, be accommodated by less restrictive

alternatives than the exclusion of women from equal access," Fritz said. In his legal brief, Fritz hammered hard on the point that legal precedent required judges who ruled for the plaintiff in discrimination cases to order the defendant to apply the least restrictive remedy. Now, to buttress that point, Fritz reminded Judge Motley that this requires "the wise accommodation of conflicting interests" so that the plaintiff is relieved of the discriminatory treatment that would be practiced under a more restrictive remedy. After this nod to legal precedent, Fritz signaled that he'd next address "a couple of preliminary points on the privacy issue."

"First, Commissioner Kuhn's order to the teams [to keep women reporters out of locker rooms] is an order that applies whether or not there is a real player privacy issue," he reminded Judge Motley. In hearing him say this, my mind flashed back to those many times before games when I had waited in dugouts for players to come out of the locker room to talk with me even though not one player in the locker room needed his "privacy" protected from me. Not one of the players was showering or changing his clothes. Dressed in their uniforms, they were in the locker room talking with all of the writers except me. I was kept out. How would I invade *his* players' "privacy" if, as Kuhn contended, it was their nudity that triggered his need to keep me away?

Fritz also wanted Judge Motley to appreciate why Kuhn was fighting equal access with such intensity. Why did he refuse my equal access when other pro sports leagues provided it for women writers covering their games? Kuhn believed equal access threatened his game's popular appeal in ways that the other league leaders didn't. Kuhn said that he feared he risked losing fans if I went into the locker rooms. Although baseball was leading the other leagues in overall attendance and in its TV ratings for postseason championships, the NFL was ascending rapidly. Determined to keep baseball on top, Kuhn worried about experiencing a significant downward financial impact if fans felt that he was not upholding their values. In his affidavit, Kuhn listed this reason first in explaining why he'd banned me from locker rooms. "I believe that baseball's image would suffer serious damage with a great many of its fans, that those players who do not favor admission of women would suffer embarrassment, and that the families of players would be justly offended," Kuhn wrote. Driven by dollars, fortified by his unbridled power, and fueled by his own moral outrage, Kuhn's plea about player privacy became a useful fig leaf for these broader, less sexy concerns. By packaging nudity with implications of my own unladylike immodesty, Kuhn, with an assist from sportswriters, brilliantly marketed his case against me to the public.

"Mr. Kuhn's claim is that baseball's, to use his word, 'image' would suffer if it granted equal access," Fritz said. "And, therefore, his rule applies without regard to any player privacy issue." Feeling the need to reassure Judge Motley, Fritz said, "this is not just an abstraction I thought up for the purpose of this argument." Kuhn had "admitted [this] during the course of discovery in this case," he assured her, referring to his deposition. "Let me give you the reason I say this. First, Commissioner Kuhn admitted that in coming out with his access rule in 1975 that he did not talk to a single player. Baseball heard that hockey and basketball, or at least hockey, at that time, was granting access. They said, 'What should we do?' And without talking to any players, Kuhn said, 'We will keep them out.'"

Not wanting this key point to fade from Judge Motley's view, Fritz drilled down. In presenting his case to the American people, Kuhn championed his heroic rescue of *his* players from me invading their privacy. But if, as Fritz discovered in deposing Kuhn, he came up with his policy without input from any player, and no player had come to him asking for his protection, how could protecting his players be Kuhn's driving force in denying me access to them? Fritz wanted Judge Motley to keep this contradiction in mind, so he shared what Kuhn said under oath in his deposition.

SCHWARZ "Now after the comment which you say Mr. Lasorda made to you [about how the player's vote does not represent how they actually felt], did you talk to any of the Dodger players during the 1977 World Series on this subject?"

KUHN "No, I don't think so."

SCHWARZ "After you were told about the position taken by the Dodger players, that is, the position in favor of permitting Melissa Ludtke to enter their clubhouse, you ruled nonetheless that she would not be permitted to enter their clubhouse, isn't that correct?"

KUHN "That is correct,"

Fritz had pressed him about the Dodgers favoring my access before nullifying their vote at the World Series.

SCHWARZ "You knew during the Series that the Dodger players had concluded in some sort of poll that they were in favor of permitting Ms. Ludtke to come into their locker room?"

KUHN "Yes, I think so."

A simple yes would have sufficed. But Kuhn hesitated before his "I think so" which alerted Fritz that this might be a point of fissure worth exploring. He'd continued to question him and, as the two men went back and forth, Kuhn mentioned talking with Dodgers' manager, Tommy Lasorda, after he'd banned me from the locker room. "Players say, 'yes,' as a matter of routine when they really felt no," Kuhn had explained to Fritz, repeating what Lasorda told him about his team's vote before Game 1. Peer pressure, Lasorda said, herded his players to vote as they did. Kuhn volunteered that Lasorda agreed that it was "undesirable to grant access to the female reporters," and in his affidavit, Lasorda reiterated what he'd told Kuhn. "Last season a majority of the men on my team voted to admit women reporters to their locker room, but I am equally aware that after they reconsidered the question the over-whelming majority of them now are very much in opposition to the practice." Lasorda then reinforced Kuhn's go-to talking point in emphasizing players' nudity. It is, he wrote, "the habit of ballplayers to walk about the clubhouse nude before and after the games on their way to the showers and toilets" as they "take their time dressing and undressing, visiting and talking with one another throughout the clubhouse in various stages of undress." He went on to observe: "The clubhouse is designed on purpose as an open place; the play-ers do not have private rooms within which to dress but rather use open small cubicles along the walls simply to hang their clothes in. This is the way of sports in general and I believe that the openness of the locker room and the casual informality of the players within it promotes that kind of team spirit and camaraderie that a team needs to hold it together and make it go."

Lasorda's words mimicked Kuhn's own in his affidavit: "The custom through living memory is that at the conclusion of a game, baseball players shed their uniforms as rapidly as possible. . . . The players usually going about the place naked or scantily dressed and moving freely through it on their way to and from the adjoining toilet and shower. Player nudity in this area is and always had been commonplace, unremarkable, and part of the post-game locker room scene. This openness and relaxed atmosphere is an integral part in the way baseball teams conducted themselves in the locker room, which is their private quarters," the commissioner wrote.

Hoping for a knockout, Lasorda saved his hardest punch until the end. He illuminated the dire consequences he foresaw if women writers were in the locker room:

> The presence of women in the locker room would create inhibitions which would absolutely destroy this atmosphere. . . . The informality would be lost

since players would have to clothe themselves at all times and we would have to make, in effect, hiding places for the players in the small cubicles. It just won't work, and far more reasonable alternatives are available and in fact being employed. . . . We encourage women in the field of sports journalist and are glad to have them. We want to give them every opportunity to do a good job, but we ask them to please have respect for our personal right to privacy in our clubhouse.

While our argument revolved around Kuhn's voiding of the Dodgers' vote, Fritz felt that he ought to reprise for Judge Motley the circumstances surrounding the 1976 Yankees' vote admitting female writers to the locker room. But as soon as he began this story, Judge Motley telegraphed her unhappiness with him detouring from the legal argument she wanted to hear. The clock was ticking, and she still had to hear baseball's defense. Her stern gaze told Fritz to move along. To press ahead with this story chanced straining her patience. Calculating that risk, Fritz stayed his course.

"More important is what happened in the summer of 1976, and it's a short story," he said, his voice pleading for her forbearance. She didn't stop him, so he proceeded. "The commissioner told his director of information [Wirz] to check up on what the teams were doing about women. Mr. Wirz wrote to all the teams and said, 'What are you doing about women?' The Yankees, the same defendant, wrote back and said, 'Our players by "an overwhelming majority" voted in favor of letting the women in the locker room to do their jobs like the men do and as done in basketball and hockey.'"

With still no interruption from the bench, Fritz kept going. "Did the women get in?" he asked, responding before she could. "No," he told her.

"The commissioner had Mr. Wirz call up the Yankees and he said to them, 'you don't do that. You can't let the players let women in because doing so would be a definite threat to breaking down our overall barrier.'" In Kuhn's correspondence, Fritz learned that these two men agreed that to maintain this "overall barrier" baseball had to keep a "unified stand." So, Wirz had conveyed that message to the teams. As Fritz enthusiastically shared this with Judge Motley, she barely seemed to acknowledge his words. But when he next spoke, he managed to say only "The Yankees dutifully" before she cut him off.

"Overall barrier?" Judge Motley said.

"Those are his words about their policy," Fritz replied.

A rare silence hung between them. I couldn't tell who would speak next.

Fritz did, directing her to his exhibit 5 labeled, "Women Reporters." He'd sent her the memo in which Wirz had updated Kuhn in August 1976 about

how he'd handled the Yankees' vote. After informing his boss that the "overwhelming majority opinion of the Yankee players is that women could be allowed in the clubhouse," he assured Kuhn that he'd delivered a cease-and-desist order to the team: "As I told Marty [Appel, then the Yankees' PR director], action by one team would be a definite threat to breaking down the overall barrier." As Fritz read aloud from this memo, I noticed that Judge Motley had made no effort to find the exhibit and follow along.

"Overall barrier to women playing baseball?" she asked. Apparently, Fritz had lost her at the first mention of "overall barrier."

"Overall barrier to the women going into the locker room to interview players," Fritz told her, hoping he'd made this point more clearly this time. Then he picked up where he'd left off. "In the summer of 1976, the Yankee players said, 'We think they [female sportswriters] should be allowed in.' Now baseball is arguing this is a player privacy issue," Fritz said, circling back to the main flow of his argument. "When the players said let them in, Commissioner Kuhn said, 'I will not let them in. If one team did this, it would be a threat to our overall barrier to women functioning as sports reporters in baseball in the same way as they are able to do in professional basketball and professional hockey.'"

Had he succeeded in bringing Judge Motley along?

"Don't they have any women baseball players? I thought women were playing baseball now," she asked him.

Evidently still confused, she'd swerved far away from where Fritz was trying to take her. His story about the Yankees' vote wasn't working.

"Young ones are, Your Honor," Fritz replied, referring to the few girls playing Little League baseball. "Whether they make the major leagues, I don't know."

I knew that women hadn't played professional baseball since the early 1950s, and Major League Baseball was no more eager to have women play baseball than its men were to have me around their game. Fritz was using congeniality to buy time while he figured out how to steer his ship back on course,

"You will have to educate me," Judge Motley said. "I thought women were playing baseball. They are doing everything else."

His argument had been abruptly derailed, but he wasn't totally surprised. Her friends had prepared for a moment like this, but still Fritz had somehow gotten entangled up in a colloquy on an essentially irrelevant topic. From my back bench seat, I was rooting for Fritz to draw her back in by explaining baseball's "overall barrier" in the context of my case. Instead, he followed down

her path of inquiry about women playing baseball. "They [women baseball players] are at the high school level," Fritz told her. "Whether or not they will be good enough to be in the major leagues, I suspect in time one may know. I hope they are."

Now, he had to come up with a way to draw her attention away from women playing baseball and back to us covering its games. "This case concerns people who are trying to be journalists, and baseball is not letting them do the same thing," Fritz said, affixing a new lead sentence onto his next paragraph of argument. But still his switch was too abrupt.

"When they say, 'overall barrier,' they are not talking about an overall barrier to women in the baseball profession, is that it?" Judge Motley asked, still flummoxed.

"I suspect they have not thought about that yet, to be honest," Fritz replied, trying his best to downplay her misunderstanding without embarrassing her. "I'd be interested to know what the baseball defendants' counsel will say about that," he said, trying again to extricate himself from this spiraling discussion.

"They will get their chance," she replied curtly, signaling it was time for Fritz to return to the legalities of our case.

Storytime was over.

* * *

"What I told you about those two points, Your Honor, is that this privacy argument has a little bit of a question about it," Fritz said, in retracing his prior points. "It's a little bit suspect since they never talked to the players at the outset. They told the Yankees, 'You can't let the women reporters in even if you want to.'"

With his point underscored, Fritz gathered his thoughts to make his next one. It was about a 1975 legal case involving a seventeen-year-old girl who had applied to be a Yankees "batboy." Pertinent to my situation, this case was also a good fit after Judge Motley's unanticipated interest in women being on baseball fields. The Yankees used "batboy" to denote the gender of those whom the team hired to fetch the players' bats, field foul balls and perform other sundry duties, some of them in locker rooms. The Yankees had refused to consider this girl's application, so she had gone to the state's Human Rights Division seeking a judgment against the team. Officials there had issued a finding of "no probable cause" in ruling against her: "The assignment of a female to perform equally as a male batboy would not be in conformity with community standards of morality and propriety," they wrote.

Before this seventeen-year-old girl had applied, the Yankees had fielded similar queries from other girls and responded with the standard no.[1]

Kuhn had introduced this 1975 batgirl case into our legal proceedings. He'd done this at his deposition when Fritz asked him to name the people with whom he discussed my locker room access after the World Series. "I discussed it with George Steinbrenner [the owner] of the Yankees," he'd replied. They'd talked about this at the Major League Baseball executive council meeting in Honolulu that December. "He brought to my attention the Human Rights Division decision of the State of New York regarding batgirls in the Yankee clubhouse," Kuhn told Fritz. "He asked his lawyers to give me a copy of that decision, which I read." He recalled another talk he'd had on this topic, possibly with Steinbrenner, though it might have been with someone else. This man, Kuhn told Fritz, brought to his attention a 1977 *Time* magazine "editorial" on this subject. *Time* had, in Kuhn's words, "styled it as laughable that anybody would carry the cause of women's rights to the point of wanting to have a young woman come into a male clubhouse."

"When you say 'subject,' you mean batgirl?" Fritz asked as a point of clarification.

"Yes," Kuhn replied. "As I recall, there were other examples given in the editorial or essay which they thought were examples of this going too far."

Kuhn's mention of this batgirl case and *Time*'s editorial intrigued Fritz. After finishing Kuhn's March 2 deposition, Fritz asked his associates to get a copy of the essay, "The Sensible Limits of Nondiscrimination," from *Time*'s July 25 issue,[2] along with the legal record of that girl's case. By March 31, when Kuhn signed his affidavit, it was evident that he'd read this essay by Frank Trippett since he'd borrowed liberally from it. As Kuhn noted, *Time* "wrote that many discrimination cases seem to make the implicit demand that 'all customary standards, tastes, proprieties and practices much yield to the whims and oddities of the individual.'" Then Kuhn used Trippett's essay to validate his decision to ban me from locker rooms: "*Time* points out, and I agree wholeheartedly, that some exclusivity and certain groupings exist for 'perfectly decent reasons' and 'decent aims' and calls for 'at least a grain of old-time horse sense . . . to be applied to the situation.'" After listing discrimination cases that Trippett cited in making his broader point, Kuhn borrowed his words: "Too many excursions into absurdity will achieve more than amusement; they could make the whole cause of fair play seem silly." Kuhn then concluded this part of his affidavit with a quote from Trippett describing cases like the batgirl's as being "silly excursions into absurdity."

Kuhn's affection for this essay roared through in his affidavit. Perhaps what he loved most about it was that *Time*, the flagship magazine of the company where I worked, Time Inc., published it. Time Inc. had also filed the legal complaint that launched our court fight. In his affidavit, Kuhn claimed that Time Inc.'s support of *Ludtke v. Kuhn* represented a "complete turnabout from its earlier nation-wide editorial position," hoping Judge Motley would find this juxtaposition curious as well.

With the presumption that Kuhn's favorite essayist would bolster his case in court, his attorney decided to depose Trippett. He was shocked when summoned to discuss my case since he knew nothing about it. Even so, twenty-eight days after Kuhn had mentioned this batgirl case in his deposition, Climenko deposed Trippett.

"Mr. Trippett, you are an editorial writer on the staff of *Time*?" he asked, believing he'd receive from him a quick yes.

"No, sir," Trippett said, his southern drawl elongating "sir." "I am an essay writer."

This wasn't what Climenko expected to hear, and this distinction undercut at the get-go the point that Kuhn's attorney wanted his testimony to support. Trippet's opening testimony indicated that Time Inc. had not voiced its "editorial" view about wacky discrimination suits, then filed its own "silly excursion into absurdity" with mine. Instead, a *Time* writer wrote an essay, not as a mouthpiece for Time Inc. but as an individual expressing an independent point of view.

Climenko regrouped after this disappointing start. As Trippett's deposition moved ahead, Climenko tried to draw out opinions from him like those expressed in the essay. But whenever he tossed out a supposition meant to buttress Kuhn's case, his reluctant witness deflected. Soon it was evident that their back-and-forth was leading nowhere. All the while, Fritz had stayed in his seat, content to watch his opposing attorney tussle with his witness. Climenko tried reading from the essay, and then asking his witness to connect that passage to my situation. He first attempted this by reading about the batgirl case: "Many such cases clearly fall beyond the frontier of ridiculous. It is amazing, if laughable, that a young woman in New York City charged sexist discrimination when the Yankees turned her down for a job—batgirl—that would have required her presence in the men's locker room."

Trippett refused to be backed into a corner. First, he said under oath that he knew nothing about my case except that it was about me wanting access to baseball's locker rooms. Then, he started playing intellectual jujitsu with Kuhn's lawyer.

"Did anyone ever say to you that this case [*Ludtke v. Kuhn*] was one in which the law was being invoked to compel the Yankees to let a girl into the locker room?" Climenko asked.

"No, sir, nobody ever said that to me."

"Nobody ever said that?" he asked again, puzzled by Trippett's definitive response.

"No."

"Do you know whether that is so now?" Climenko asked.

"I don't think the case involved a girl," Trippett replied.

"It doesn't?" Climenko exclaimed, his tone stressing his incredulity.

"Well, I have been misinformed if it does," Trippett retorted.

Oblivious as to where Trippett might take him, Climenko fished for the answer he wanted to hear. "Well, if it doesn't involve a girl, what does it involve?"

"I understand it involves a woman," the essayist replied.

"You are making a distinction?"

"I do make a distinction, yes, sir."

"Glad to have it," Climenko said, regaining his composure to volley back. "When you wrote what you did suggesting that it was ridiculous for a girl to go into the locker room, what were your reasons why you thought it was ridiculous for a girl to be there?"

"Typical Protestant prejudice and ethics," Trippett replied.

"Will you explain that to me?"

"It seems to me that a young girl functioning as a batgirl would become part of a fraternity in which would be unadvisable for her to be exposed to," he surmised.

"And one of the reasons was that players were undressed or perhaps even naked in the locker room?" Climenko asked.

"I certainly think that would be a consideration," his witness agreed.

After a few more back-and-forth volleys about players walking around locker rooms in various state of undress, Trippett informed Climenko that he did not possess "vast experience on this subject."

Hearing this, Climenko pounced. "No, but you have a vast reaction on the basis of Protestant ethics about young girls being in the presence of naked men, don't you? You didn't need a vast experience to have that opinion?"

"No, sir. I did not need a vast experience to have that opinion."

"All right," Climenko continued. "Did anybody ever say to you that there might be some opposition on the part of people in our generation to having

even women, as distinguished from girls, walking into a locker room where there were naked men?"

This question brought Fritz to his feet. "What does 'our generation' mean in that question?" he asked Climenko.

"It means my generation and yours, Mr. Schwarz," he replied.

"Is that the same?" Fritz countered.

As both men knew, Climenko graduated from Harvard Law School in the same class that Fritz's father did.

"Well, no," he admitted. "It is separate but since we live and exist at the same time, we are part of this world. Do you have any other questions about the meaning of the question?"

Fritz did not, so Climenko proceeded.

"Have you heard at any time that people who are alive now feel that women should not be present in a locker room that contains naked men? Have you ever heard that some people think that that is wrong?" Climenko asked Trippett again.

"Frankly, I haven't heard the matter discussed. And I have not reflected on it at all," he replied.

When this tooth-pulling Q and A between lawyer and witness ended, Fritz rose and approached Trippett. "I have a few questions," he said, though his first seemed more comment than query.

"Mr. Climenko didn't ask you why you didn't see any connection between the essay and this lawsuit," Fritz asked this witness.

"The reason is that my essay and its one reference to even a remotely kindred matter relates to a young and inexperienced girl, and as I understand it, the plaintiff in this suit is a seasoned and mature woman reporter," he replied.

It was now Climenko's turn to rise to challenge Trippett's characterization of me. But by this time, his protest came without his usual fiery posturing. His witness had been a huge disappointment. With the deposition heading toward its merciful close, Climenko seemed exhausted. He had pushed and tugged his witness every which way to get him to say something about my case along the lines of what he'd written in his essay, but Trippett had not obliged. Wanting to emerge from this disaster with at least one bit of evidence to use in the hearing, Climenko asked Trippett to "tell me what you know about the lawsuit." He meant mine.

"That the lawsuit involves opening the locker room of the Yankees to a woman reporter. That is about it," he said.

"Do you know any reason why the Yankees and Commissioner Kuhn have said they don't want to do that?" Climenko said to press him again on this point.

"No, sir."

"Do you know that they have said that they didn't want to do it because they felt that a large sector of the population didn't think that was proper? Did you hear that?"

"I have not heard that, sir."

"Would it surprise you that anybody in authority in connection with baseball entertained that view of the matter?" Climenko asked.

After pausing as if to collect his thoughts, Trippett replied, "Nothing would surprise me on this Earth."

Determined to not leave empty handed, Climenko rephrased his query: "Do you think it is ridiculous that some people might not like to have a woman in the men's locker room even if she is a seasoned reporter? Do you think that is ridiculous?"

"Not necessarily."

Climenko had heard enough from his uncooperative witness. "That is all we want of this witness," he said.

Lawyers say this after they finish questioning a witness. This time Climenko meant it.

Chapter Eighteen

Fritz moved on, sticking with the law. If this was what Judge Motley wanted to hear, he would comply.

"We make before you, Your Honor, the same points that the ACLU made in its excellent amicus brief," he said, pivoting away from their women-playing-baseball conversation. "The question is whether the claim of player privacy justifies baseball policy of refusing to let the women reporters do the same thing as the males traditionally have done and which the male reporters have said is essential to getting their job done?"

Speaking slowly and deliberately, Fritz answered his own question about player privacy versus my right to do my job. "We say that it does not because of a simple constitutional principle, which has been repeatedly voiced by the Supreme Court in both sex discrimination cases. We rely on those cases and the First Amendment cases," he told Judge Motley. To frame this part of his argument, Fritz had cited the U.S. Supreme Court's 1975 ruling in *Cleveland Board of Ed. v. LaFleur*. Earlier, he'd noted the significance of the ruling in *Frontiero v. Richardson*, which was Ginsburg's 1973 case in which justices raised the judicial scrutiny in sex discrimination cases. At that time, he'd also mentioned *LaFleur*, which now became his focus.

In *LaFleur*, the justices decided that by imposing mandatory pregnancy leave, Cleveland's superintendent had violated the teachers' right to due process guaranteed by the Fourteenth Amendment. Although Fritz knew Motley was well versed in the "less restrictive alternative" precedent set by this case, he thought it possible that she did not recall the argument the superintendent's lawyer presented in district court. There, he had rationalized the mandatory pregnancy leave policy—starting at the end of the fourth month

of pregnancy and lasting through the mother's third month after birth—by saying his client was preventing the humiliation that pregnant teachers would receive when students giggled at their condition. This justification had an eerily familiar ring to what Wirz had said about the players' children being ridiculed by their classmates if Kuhn let me go into locker rooms. But the Cleveland district court judge must have shared this lawyer's implication that pregnancy was emblematic of a woman's sexuality when he accepted this rationale as justifying his policy. At the U.S. Supreme Court, Justice Potter Stewart, writing for the court, held that "the Fourteenth Amendment requires the school boards to employ alternative administrative means, which do not so broadly infringe on basic constitutional liberty."[1]

Similarly Kuhn had done what he could to sexualize me in the court of public opinion. Then, he tried to do this in his documents sent to the judge, despite not one female writer saying that she'd experienced anything remotely sexual in her locker room experiences. Universally, the women found their work there unappealing, at times degrading. Still, this time with the players was essential to their job, so they put up with all the rest.

Fritz pushed ahead with *LaFleur*. "As the Supreme Court said in the *LaFleur* case, the rule in sex discrimination cases is that even if you assume the legitimacy of an excuse put forward by the discriminator, the action you take in the name of that excuse cannot be applied in a way—to use the language of the Supreme Court—that 'sweeps too broadly.' Here, baseball's policy of exclusion sweeps *much* too broadly," Fritz asserted, connecting my case to that one. "To use another expression of the Supreme Court, the [media] policy of baseball is not 'the less restrictive alternative.'"

When Fritz dipped quickly into precedent cases, I tried to follow along, but on occasion he lost me. By reiterating his points, as he'd just done, he gave me a handhold to grasp. Even if Kuhn saw his rationale for keeping me out as "legitimate," the nation's top court said that he would need to come up with a less restrictive alternative one so as to not unduly burden me, if he lost this case. In our negotiations, Kuhn had refused to broker any alternative to his "separate accommodation" policy. Kuhn evidently believed that this arrangement, which was more a figment of his PR machine than a reality, was lawful. But in Fritz's "reply" memorandum that went to Judge Motley two days before this hearing, he had postulated that "the possible inconvenience of wearing a towel or bathrobe is not a sufficient justification for the deprivation of plaintiff's constitutional right to equal protection."

"Your Honor is familiar with those cases," he declared, now standing before her. Hearing nothing to the contrary, he proceeded. "There are plenty of alternatives, simple alternatives—"

"Do we have to hear that?" Judge Motley interrupted.

"I want to describe it because you know the cases," Fritz replied.

Evidently, the two of them weren't communicating well. Judge Motley clarified why she'd stopped him. "I was asking whether we have to have a hearing on what the alternatives would be," she said, sounding exasperated. She was concerned that Fritz was pointing her to a disagreement in the facts in our case. If he did this, she would have to hold a separate hearing to resolve the dispute. Clearly, she did not want to do this.

"I understand your question," Fritz replied, "and no, Your Honor, we do not have to have a hearing on that. We have no disagreement with the fact that there are alternatives. Baseball asserts they should not have to adopt those alternatives, but that is an issue of law and not facts."

After relieving her concern, he proceeded. "The alternatives are many. The ballplayers can dress in another room. The ballplayers can wear a towel around their waists. They can wear a bathrobe. That's what is done in soccer, basketball, and hockey. Players who feel embarrassed by the presence of a woman have all of these alternatives."

After she'd heard his list of alternatives, Judge Motley ignored the particulars and called his attention to a case heard at the Second Circuit Appellate Court. "Are you familiar with the Second Circuit's opinion in *Forts v. Ward* involving male prison guards in the women's bathroom area, I guess it was?" she asked him.

"I am, Your Honor, and I think the case supports our position," he replied.

In that case, women inmates claimed to be "involuntarily exposed" when male prison guards patrolled their cellblocks when they were changing their clothes. So, the guards could see the women naked or partially undressed. This led their lawyer to contend that the women were denied their "constitutional right to privacy" due to their "involuntary" exposure to male guards.

"I think it does," Judge Motley said, indicating her agreement with Fritz. I was surprised to hear her say this, and her words must have surprised her since immediately she qualified them. She was referring, she told Fritz, only to "the required evidentiary hearing with respect to possible alternatives" that district court judge Richard Owen had called for in *Forts v. Ward*. When she'd heard Fritz listing alternatives, her fellow judge's case came to mind, making her think she'd also need to schedule an evidentiary in which witnesses would testify on that one aspect of our case.[2]

Fortunately, Fritz was familiar with the proceedings in *Forts v. Ward*. "As I read the case last night," he began, "I think the issue of whether or not those [defendants'] alternatives were practical was more complicated in the prison setting than here." Fritz then explained how he distinguished the two cases: "Here, they [these alternatives] have been used in other sports and wearing a bathrobe is part of one's ordinary experience." Having said this, Fritz believed it was the right time to show Judge Motley a photo of a man seated in a club-house cubicle taken when his legal team visited the Yankees' locker room. "As I told you, I would come back to picture #2 in our exhibit of pictures," Fritz said, giving her time to turn to this exhibit in her binder.

When she was looking at it, he resumed. "That shows the cubicle [in the Yankees' locker room]."

"Is that you, sitting in the cubicle?" she asked him.

"It's not me. It's Mr. House," he said, turning to point to his associate attorney, Calvin House, seated the plaintiff's table. "I am six feet two inches and Mr. House is recorded as being six feet. We're a little different, but he is a big fellow, too. He's not very heavy, though." Perhaps he was sharing those trivial details to buy time for her to study this photo. She turned to look at House, then back at Fritz, until she seemed content House was in the cubicle.

Fritz resumed. "At Mr. Kuhn's deposition I asked him two questions on this subject of alternatives," he said, guiding her to where he planned to go next. "I got the admission [from Kuhn] that seems to me, Your Honor, self-evident," he said, referring to answers he gave in his deposition about alternatives. This said, he asked her to turn to specific pages of his deposition to follow along as he read the questions he'd posed and Kuhn's nearly monosyllabic responses.

QUESTION [FRITZ] "If the player wants to, he can change in the cubicle?"
ANSWER [KUHN] "He could."
QUESTION "You could put a curtain in front of the cubicle?"
ANSWER "Yes, you could."

Fritz allowed Kuhn's answers to linger in the silent courtroom before moving on. "That's a flat admission of what is self-evident about the cubicle, and the towel and the bathrobe points are a matter of common experience," Fritz said. "Therefore, in our situation, Your Honor, there are many less restrictive alternatives that can accommodate both the interests of player privacy and the concept of equal opportunity for women."

If Judge Motley was able to see these less restrictive possibilities as real alternatives to Kuhn's ban, then the odds of her ruling in our favor would improve. "That being so, baseball's 'overall barrier' is unlawful sex discrimination under both state and federal law," Fritz said, in concluding this part of his argument.

* * *

Kuhn claimed that his teams did provide "alternative accommodations" for female writers. But the facts belied this. When he'd boasted to broadcasters and writers about baseball teams taking care of our needs with his policy, sportswriters had parroted him without verifying that these places and procedures existed. No sportswriter ever asked me if they did. But what Kuhn was selling, writers bought because they wanted it to be true. I was never offered *any* accommodation for interviewing players at any ballpark where I'd worked. The only person who had ever given me assistance was Morabito with the Yankees.

When Stephanie Salter, my former *Sports Illustrated* colleague, had left the magazine and moved to San Francisco, the *Examiner* hired her to write about its baseball and pro basketball teams. In 1976, I took her spot on SI's baseball beat. A year later, in the *Examiner*, Salter wrote about Kuhn banning me from locker rooms and broke the news that Time Inc. was contemplating taking legal action against him. "Bowie Kuhn finally may have gone too far," she wrote at the start of her November 7, 1977, story.[3] A few paragraphs later, she placed this possibility in a broader context: "Bowie Kuhn has thrown down the official gauntlet, challenging journalism and civil rights. He has managed to do what the rest of professional sports has been avoiding like the plague—drag the issue of women writers in the clubhouse into a national, legal arena."

In the next day's paper, Salter described her experiences in bringing readers coverage of baseball games. As usual, she didn't mince words, just as she had not done when baseball writers evicted her from their 1973 winter gala because of her gender.

> When it comes to The Woman Question, fairness has dissolved. . . . Many
> times this past summer I amused myself outside of the Oakland A's and San
> Francisco Giants' dressing rooms by rereading the rules on my pocket creden-
> tial, the one that promised the bearer access to press box, playing field and
> clubhouse. I met all the qualifications save the unwritten one: No Girls

Allowed. I specifically use the phrase 'No Girls Allowed' because it is the overwhelming sentiment of those persons who are most vehement in their denial of equal access to women. The only thing that separates them from the eight-year-old boys who nail such a sign to their tree house is about 20 years.

At the Oakland A's, Kuhn's so-called "separate accommodation" was little more than a storage closet emptied of its cleaning supplies. It wasn't a place where any writer would want to conduct interviews. Years later, Salter told me she'd fiercely resisted her editor's request that she write this first-person account as a companion to her story about my entanglement with Kuhn. Like me, she avoided sharing publicly what she endured on a daily basis to deliver the stories she did. She did not like bringing herself into the story, but when her editor insisted she write about her exclusion from the A's and Giants' locker rooms, she vividly detailed her on-the-job treatment. "While trying to cover my beat I have been screamed at, called a bitch (not far enough behind my back), addressed as 'little girl' and advised to find a new line of work because 'You're trying to do a woman's job in a man's world.' Whatever that means. I have explained to a black ballplayer that his vote to bar me from the clubhouse was discrimination and watched as he smiled and said, 'You bet it is.' I have been asked by a major league manager if I was still a virgin."

Salter's stories surprised readers who rarely were told how a writer did her job. Leonard Koppett, who was the *New York Times* sports correspondent in San Francisco, was also shocked by her story about me. He'd focused on her news that a woman reporter might be taking Major League Baseball to court over her lack of access to the players. He immediately called Wirz in New York to talk about this development.

In the memo that Wirz wrote to Kuhn summing up the developments in my case that November week, Wirz led off with an encouraging message about a female broadcaster in Houston who did not support my call for equal access before informing Kuhn about Salter's story. It's likely he made that broadcaster, Anita Martini, his first memo item to soften his later news about potential legal action from Time Inc. That week the Houston Astros president Tal Smith had called to tell him that Martini had received a phone call from my lawyers "who asked if she would give an affidavit of her experiences in trying to cover baseball." Martini, Smith told Wirz, had refused to cooperate with my lawyers because "she said it had never been, nor was it now, her intention of going into the clubhouse." Smith also had shared this news with Kuhn's in-house lawyer, Sandy Hadden. Wirz had spoken with Martini and reported this call to the two men. "I did that yesterday, and she ended up by

offering us help regarding Melissa, if we need and desire that help," Wirz wrote.

Martini and I had gotten to know each other when I was in Houston for a series of games with the San Diego Padres. An editor had assigned me to write a story about Dave Winfield, an outfielder for the Padres who would soon be a free agent. After Martini and I talked on the field, we sat together in the press box. I relished the rare pleasure of being at a ballpark with another woman journalist. The next day, we'd had lunch at a restaurant of her choosing. I enjoyed getting to know her on that trip, and when I was back in Houston on another assignment, Martini and I had picked up where we'd left off, strengthening our friendship.

I wasn't surprised to hear she'd taken baseball's side. She was the only woman covering the Astros and the team's PR man helped her by getting the players she needed to talk with soon after each game. Of course, TV game coverage was very different than my job; one, or on some occasions, two players were all she needed to recap the game. They'd meet her outside the clubhouse for a brief on-camera interview. When their remarks were readied for the late newscast, Martini had her story. Working for a magazine, I needed to move freely among the entire team, just like the male writers did. Our work needs differed, but I knew from talking with her that we had both experienced slights and challenges due to our gender. In 1973, she'd been given tickets to the All-Star Game's wives' luncheon instead of the press pass for the game, as she requested. Only the next year did Martini finally get a seat in the Astros press box. Before then, she worked from a seat in the grandstand. It has upset her when the Astros made her eat her pregame meal separate from where the rest of the press ate at the ballpark.

When the *Los Angeles Herald-Examiner*'s columnist Mel Durslag wrote about women covering baseball, he cited Martini's meal service, including what an Astros staffer had told her when she asked to eat with the men: "Savor this exquisite room service. At the Ritz in Paris, it would cost you 50 bucks."

"She accepted it, instead, as a form of Jim Crowism," Durslag opined.

In 1978, before my hearing, Kay Holmquist of the *Fort Worth Star Telegram* wrote about women in sports media, quoting Martini about my case.[4] "Melissa will probably win," she'd said. "It upsets me to think of the animosity that I feel I've overcome and that now there will be people who think that women sportscasters are just going to be sports groupies." Oddly, at other times, Martini had seemed proud of having been the first woman to report inside a baseball clubhouse, which happened when the Dodgers invited her into their clubhouse at the end of the 1974 National League

Championship. Manager Walter Alston would be delivering his victory speech there, and since she was a member of the press, he told her to come in to hear it. In her 1987 book manuscript, Martini wrote that "in some circles, I will always get credit for being the one who broke the locker room barrier for women, and in part that is true. But in reality, all I've ever done is try to survive in a world that attempts to keep women in their place."[5]

When Martini's affidavit was sent to Judge Motley, my lawyers received a copy. They knew her views about my case but Fritz was shocked to learn that she'd testified that my legal team had approached her about being a plaintiff in our lawsuit. "I declined to be party to such a lawsuit, for I disagree wholeheartedly with the goal which they hope to achieve," she wrote. Fritz alerted Judge Motley to this key factual error in Martini's sworn affidavit, informing her that the "commissioner and his counsel had a document in their possession which showed statement to be false and irresponsible." Fritz referred Judge Motley to the memo Wirz had written in November 1977 telling Kuhn that my lawyers had contacted Martini to "ask for information and asked whether she would be willing to supply an affidavit." He assured the judge that he'd asked only "if she would give an affidavit of her experiences in trying to cover baseball."

Even though Martini opposed my plea for equal access in 1978, by the mid-1980s she was working in the locker room of the Houston Gamblers, a United States Football League team. Not only was she reporting there, but she was speaking out in favor of women having the same access that men did albeit without mentioning her prior opposition. In a 1985 *Houston Chronicle* story, "Men's Locker Rooms Still Bane of Women Writers,"[6] Tim Panaccio wrote about twenty-two-year-old Hannah Storm, who was working at a Houston radio station. When Storm said she did not want to report in men's locker rooms, Panaccio contrasted her decision with that of then-forty-six-year-old Martini, describing her as a nineteen-year broadcast veteran "who believes women reporters need access to enter the dressing room." Storm told him, "I don't want to work in a room with 50 naked guys. I think I get more respect by not going inside. It's a problem at times, but I won't compromise. I feel I can do my job effectively without going in. I think they [athletes] have a right to privacy." She hoped teams would create "a neutral interview room" for the players and the press. But Martini, then working at ESPN, told Panaccio, "I'm here to finish the job I started. It's not a one-on-one sexual encounter between a man and a woman. It's a bunch of people talking to each other, trying to do their jobs."

Storm's words uncannily echoed Martini's in the affidavit she'd written seven years earlier. By 1985, Martini believed that Storm's young age made her feel "more vulnerable," which led her to not want to work in the locker room. "This can become an emotional issue for me," said Martini. "Bum Phillips [the Houston Gamblers' coach] opened the locker room for us here because players wouldn't respond if we waited around so long. Maybe the only nice thing Ken Stabler did for me was get Bum to open those doors." She insisted that male athletes should not feel embarrassed when female journalists work in the locker room.

"How smart do you have to be to put on a towel?" Martini said.

In 1993, Martini died of brain cancer. Our paths had last crossed before she wrote her affidavit. Her Associated Press obituary[7] read, in part, "Anita Martini, a Houston sports broadcaster who was the first female journalist admitted to a major league baseball team's locker room, died Saturday. She was 54.... In 1974, Ms. Martini won a major victory in female reporters' fight for equal access to professional sports facilities when Los Angeles Dodgers manager Walter Alston admitted her to his team's clubhouse after a game at the Houston Astrodome."

Martini had not shared her locker room experience with me. I wish she had.

Rest in peace, my friend.

Chapter Nineteen

Judge Motley's impatience was palpable. Fritz was running short on time. Ours was her last hearing of the week, and she seemed determined to not let the sun set while lawyers made unnecessary detours. Already diminishing shafts of sunlight were coming in through the courtroom's windows, and Kuhn's lawyer had not started presenting his defense. But as long as Fritz held the floor, he'd use his time to respond to the arguments that he knew baseball would make against us., Fritz wanted his counterpoints embedded in Judge Motley's mind when the defense had its chance to speak.

"Let me come back briefly to the jurisdiction issue," he told her.

No plaintiff's lawyer squanders the opportunity to reinforce his main points—and counter the opponent's. Once back at the plaintiff's table, Fritz would stay silent unless the judge invited him to speak. With each side reading the other's legal brief, lawyers are rarely surprised by what an opposing lawyer says or does in the courtroom. However, Fritz had surprised everyone with his buildup to reveal that sexist swimsuit letter. But that was an exception to the normal tactical duel that tests each lawyer's ability to ground his case in legal principles supporting his argument while sustaining the judge's attention.

* * *

"Baseball makes two arguments," Fritz reiterated for the judge. "First, it says the state action doctrine does not apply [to our case]. Second, it contends, particularly in a paper they have just filed this week, that baseball, believe it or not, is immune—absolutely immune—from challenge in the courts

concerning *any* policy which the commissioner of Major League Baseball, Mr. Bowie Kuhn, deems to be 'in the best interests of baseball,'"[1] Fritz wasn't shy in declaring this with a mocking sense of astonishment.

Fritz trusted that she was conversant with that clause despite not knowing much about the game. Kuhn had told the judge about his recent cases in which that defense succeeded, as it had when his predecessors depended on it for relief by the courts. She'd likely familiarized herself with its legal usage, so Fritz turned first to the essential part of our case that he thought turned in our favor.

"The first argument of state action falls under the cases" he said, leaving unsaid that he was referring to those cited in his legal brief, especially how the legal threads of the *Burton* case closely matched ours. "The second argument ['best interests of baseball'] is so clearly unacceptable that it tends to suggest to me a certain lack of confidence in the first argument."

Most critical to his argument's success was whether Judge Motley would apply the justices' reasoning in *Burton*. "We rely principally upon *Burton*," he said, though he'd also highlighted the state actor role in several other cases. In a footnote, Fritz had written about *Fortin v. Darlington Little League Inc.*, a 1975 case involving girls who were denied the opportunity to play Little League baseball. In court, the girls' attorney said the judge should grant them the right to play on a Little League team if their skills on the field were equal to those of the boys. Until then, only boys had been eligible to play on this team. This case knotted together baseball, gender discrimination, and *Burton*. In relying on the state action precedent in *Burton*, that lawyer had convinced the judge to rule that the Little League's refusal to let the girls play amounted to unconstitutional discriminatory treatment. Fritz summarized this ruling: "In holding that girls could not be excluded from a previously all-boys Little League, state action was similarly found where the League was allowed to use the City's baseball diamonds at night and on Saturdays during the baseball season because such use was a 'rationing of a public resource.'" Fritz also reminded the judge of the U.S. Supreme Court's 1974 decision in *Gilmore v. City of Montgomery*, which rested on the state action precedent in *Burton*. In *Gilmore*, the justices "found state participation where *a private group* has been granted *extensive control* over a *public facility*." From this ruling, Fritz drew comparisons with our case, even bolding words he wanted to stand out.

This case [*Ludtke v. Kuhn*] is controlled by the results of *Burton* and *Gilmore* for here the contacts between the **private entity** and the City arising out of the leasing of public property are even more extensive. Yankee Stadium and the

land surrounding it were acquired by the City in the exercise of its power of eminent domain upon a factual showing, approved by the Supreme Court of the State of New York, Bronx County, and the purchase of the Stadium was required for a "public use." . . . It was just such "benefits mutually conferred" that led the Supreme Court in *Burton* to find state action in discrimination by a restaurant that leased a small part of a public structure. In this case not only are the mutual benefits greater, but the allegedly private entity has a 30-year lease to the entire public structure, and it was such *extensive control* amounting to rationing of a public resource over a *public facility* which led the *Gilmore* court to find state participation.

Fritz had little doubt that Judge Motley would grasp right away the stark parallels between the *Gilmore* decision and our case. Bolding those words, Fritz reminded her that like the *Gilmore* defendants, the Yankees are "a private entity" maintaining "extensive control" over a "public facility." At the hearing, Fritz told her that "the Yankees, in turn, have delegated control over access to their clubhouse to the commissioner and the president of the American League, who was also a named defendant in *Ludtke v. Kuhn*."

Fritz paused to take a temperature reading of Judge Motley's patience. "Unless Your Honor wants me to expand that, I would rest on my reply brief which shows on pages six through sixteen why in our judgment this is a stronger case than *Burton*." When she was silent, Fritz proposed his own time limit. "I can take five minutes on that, Your Honor, if you want me to."

"All right," she told him. "I will let you have five more minutes, and then I will have to hear from the defendants."

Fritz took a few seconds to compose his thoughts before heading into the home stretch. "*Burton*, as you know, calls for an analysis of the complex involvement between the discriminator and the government. In this case, the defendants try to pick apart the elements," he told her, again counterpunching before his opponent was in the ring. "We make two points in response to that. First, even if you pick the elements apart, our case is stronger," he said. "Second, in the aggregate this case is certainly as strong or stronger than *Burton*." Next, he explained why. "First, much more money is involved," he said. "New York City spent over $50 million as a favor to the Yankees to refurbish the entire Yankee Stadium because the state legislature passed a statute saying, 'We want to keep the Yankees in New York City, and we will let you spend $50 million.' This is infinitely more than what was spent in the Wilmington case."

Fritz didn't stop there. "Under *Burton*, we have a tie between the challenged act of discrimination and the government," he asserted. He stressed

this point because he believed that Climenko, in his April 4 cross-motion for summary judgment, shaded the truth about the Yankees' legally binding relationship with New York City. In that cross-motion, Climenko told Judge Motley that "the Yankees happen to rent a stadium that is owned by the City of New York." By using the word "happen," Climenko intimated that the relationship between New York City and the team was distant and accidental, though the lease made clear that their working connection was close and contractual. When he had responded to baseball's cross-motion, Fritz let the lease's actual words speak for themselves so the judge could decide if Climenko had accurately described their arrangement. He'd also led Judge Motley to believe that "all of the baseball activities at the stadium are managed totally by the New York Yankees and there is not even the remotest public pretext of official involvement." By showing her contrary evidence in the lease, Fritz challenged that claim too.

"Certainly, the mere fact of municipal ownership of one of baseball's playing fields does not elevate the sport to the status of a government activity within the meaning of the Fourteenth Amendment to the United States Constitution," Climenko had written in his motion. Yet with Yankee Stadium it wasn't a "mere fact of municipal ownership"; it was the lease requiring them to pay handsomely into the city's coffers annually. Again, in rebuttal, Fritz turned to the primary source—the lease—to remind Judge Motley that in both 1976 and 1977, the Yankees paid roughly $1 million to the city, an impressive sum in those lean years. With his written rebuttals on the record, Fritz said now that "the baseball defendants [were] pretty vague about the lease between New York City and the Yankees." If Fritz's advance warnings punctured her faith in Climenko's "truth" telling, then he'd start off having a steeper hill to climb in making his client's case. First, he would need to regain her trust.

"It's a 198-page detailed lease," Fritz said. "And it's before Your Honor."

When Judge Motley offered Fritz no reaction and didn't reach for a binder to look at the lease while he was speaking, he simply pushed on, cognizant of the clock. "The key provision, or one of the key provisions, is that the Yankees have to pay rent under a sliding scale, where the rent goes up when the attendance goes up," he said, simplifying the lease's complex fee payment formula that he'd acquainted himself with before the hearing. "The baseball defendants are pretty vague about that when they say, 'The Yankees are required to pay rent under a varying formula.' The formula varies with attendance," he said, guessing that details like this likely had escaped her attention. He doubted that she'd dug into such specifics in the lease. If he didn't

do this, it's possible Judge Motley might overlook the critical connection between the Yankees' lease fees and Kuhn's primary motivation for denying my access.

"According to their argument which Mr. Kuhn has put before this Court [in his affidavit and deposition], the Yankees' attendance depends on keeping women out of the locker room," he explained to Judge Motley. "He says that baseball's image would grievously suffer, and their attendance would go down, and the Yankees income would go down, and the New York City income would go down." He'd alluded to this domino effect earlier, but he knew he needed to solidify these connections. Kuhn admitted in his deposition that burnishing his game's family-friendly image was vital to baseball's growth. Maintaining this image brought more fans into ballparks, which included more paying customers at Yankee Stadium. When those ticket sales increased, the revenue going to New York City rose due to the lease's formula. By connecting these dots, Fritz underscored the strength of his state action argument. If Judge Motley also saw these revenue-generating activities as integrated gears, one moving the other, then she'd see how Kuhn merged his financial motivation with his moralistic authority to keep a woman out of his locker rooms.

"Here we are on all fours with *Burton* but stronger because in *Burton* it was a flat fee and here it is a sliding scale," Fritz explained. Whereas the Eagle Coffee Shoppe in *Burton* had paid a steady rent to the city of Wilmington, the Yankees' payments varied. They were based on numerous factors, including ticket sales.

Knowing his time would expire soon, Fritz sped on. "They make a big deal that the maintenance is done by the Yankees," he said. "They don't tell the Court that New York City reimburses the Yankees for every single penny of the maintenance each year. Whoever cleans up or paints or takes care of any other part of Yankee Stadium is paid by New York City." Drip by drip, Fritz was delivering facts found in the lease that eroded Climenko's "vague" claims. "New York City has the power under the lease to stop what is going on in Yankee Stadium," Fritz declared. "That is an important fact on state action. The city has the power to do something about it."

Fritz had hoped Judge Motley would hear from the city's lawyer, but at the start of the hearing she'd dismissed the city employees named as defendants. So, with New York City's mayor and its directors of parks and recreation and economic development released from our case, Fritz read from a letter that the New York City Corporation Counsel wrote Judge Motley to say that the city officials "were not a necessary party to the litigation." Judge Motley

agreed with him over Fritz's objection, but Fritz wanted to remind her of a pertinent part of his letter. In seeking their removal, he had also told the judge that he "recognized that by writing the letter the City acknowledges that what is going on [with Kuhn banning me from locker rooms] is not proper under the least restrictive alternative doctrine." This counsel's assertion harkened back to the case Fritz spotlighted earlier—*Cleveland Board of Education v. LaFleur*. Climenko had ignored that precedent when he submitted Kuhn's supplemental affidavit. Instead, he'd written: "The City claims not to be 'a necessary party to the litigation for it plays no part in management of the stadium or formulation of baseball policy.' The City of New York has correctly assessed its role, and this fact establishes conclusively plaintiffs' failure to state a cause of action under applicable law." Climenko had claimed that because the city played "no part in management of the stadium or formulation of baseball policy" this nullified our "state actor" argument.

Fritz had established disagreement on that point, and with the clock running he had to quickly address the other constitutional amendment involved in our case. "Just one point on the First Amendment," he said. "Baseball contends that the rights of plaintiff, Time Inc., as opposed to Melissa Ludtke, have not been abridged by their [no access to locker rooms] policy." Even though the Fourteenth Amendment was the engine driving Fritz's argument, he felt obligated to respond to Climenko's First Amendment charge. "Let's think about that for a minute. There are two reasons why the defendant's argument is wrong," he said. "First, today in this changing world, my client [Time Inc.] is hiring more and more women. In fact, more than half of the reporters at *Sports Illustrated* are women, and more than half of the people graduating from schools of journalism are women."

He'd anticipating Climenko's defensive posture with the First Amendment, so Fritz had asked Elie Abel, the dean of the Graduate School of Journalism at Columbia University, to submit an affidavit in our case. He'd attested to the rising percentage of women among his students. Abel wrote that more than half of Columbia's students were women before he gave his opinion about what this signified: "It seems to me a matter of simple equity that all major fields of journalism should be open to qualified women," he wrote. "The day is long past when women can be enclosed in such professional ghettos as fashion, style and society sections." Abel described sports as "a major field of journalism that is now beginning to open up for women," and told Judge Motley that several women graduates recently had been hired to write at sports sections at major newspapers and magazines. Next,

he addressed challenges that even the best of these women confronted in doing their jobs.

> Getting hired is, however, only half the battle. If women reporters are not allowed to do their job fully, on the same basis as men, the encouraging trend towards employing women as sports reporters will soon wither. It seems to me elementary that women reporters must have the same degree of access to the athletes as their fellow reporters who happen to be males; this includes being permitted to enter the locker rooms after the game in order to interview the players. . . . I cannot conceive of this job being done adequately so long as women are barred from direct access to the athletes in the locker rooms.

In his legal brief, Fritz echoed this when he wrote: "baseball's discriminatory policy toward female reports has interfered significantly with the news-gathering functions" of reporters and their publications. Then, in a later motion he filed with the court, he argued that Kuhn's denial of equal access had infringed on our First Amendment rights and told Judge Motley that "*Sports Illustrated* has the right to expect that its female reporters will have the same access to sports news that their male colleagues and competitors enjoy." Citing legal precedent to back this claim, Fritz noted that when the Supreme Court ruled in *Branzburg v. Hayes* in 1972, the justices acknowledged that "freedom of the press" includes the right to gather news.

Since Time Inc.'s corporate group vice president and secretary Charles B. Bear had authorized filing my complaint with the Southern District Court, Fritz asked him to rebuff Climenko's charge that Time Inc. had acted in "bad faith in bringing this lawsuit." In his affidavit, Bear affirmed that *Sports Illustrated* "cannot refuse to assign a woman reporter to baseball in order to accommodate baseball's discriminatory policy." The company's 1971 conciliation agreement required Time Inc. to "treat male and female employees equally." Bear explained that this agreement made SI's editorial management policy be 'that there will be no discrimination on the basis of sex in connection with the giving of assignments to reporters . . . [and] to protest and combat the denial of any reasonable press facility to any member of its staff.' Thus, the law, fairness and practicality required that *Sports Illustrated* assign its reporters without regard to their sex and that it 'protest and combat' baseball's discriminatory policy."

Abel's and Bear's affidavits about our First Amendment claim were with the judge, so Fritz used his waning moments before Judge Motley to

dramatize its practical implications. "Are we to be told that we can't use women on sports?" he asked, before letting out an even more plaintive plea. "*Sports Illustrated* can't use women on sports. We want to be able to use them in the future." Fritz implored, including himself in the "we" that felt this frustration.

How could he leave the stage without some encore of that dramatic moment with SI's swimsuit issue? "It may be hard for Time Inc. to rely on exhibits, as the baseball people do, that suggest that women are only here for a display in bathing suits," Fritz said. Only when he'd drawn the judge's attention back to my magazine did he invite her to consider how an editor at *Sports Illustrated* would have to act if she ruled in baseball's favor.

"Our position is that the best choice for a baseball reporter may be a woman. What are we to do under baseball's theory? Should we assign the women, the best choice, and lose access which male reporters say is an important part of their function? Or should we assign a man who will get the access but is not the best choice?" Fritz postulated. "We say that under the Constitution we shouldn't be confronted with that untenable dilemma."

"Thank you"

Turning his back to the judge Fritz walked the short distance to the plaintiff's table.

"Thank you," Judge Motley replied.

As Fritz sat, Climenko rose from the defendant's table and walked to a spot in the courtroom close to where Fritz had stood. "If the Court please, I represent the defendants, and on their behalf, we move for summary judgment," he began. with his opening words the similar to Fritz's. Both sides agreed on the facts in our case. Now, Climenko was going to show how he disagreed on how Judge Motley ought to apply the law.

I had no doubt that the longer he spoke the wider the gap between us would be.

Chapter Twenty

In the late 1970s, an infinitesimal number of women were sportswriters. Fewer were sports columnists, and only one woman, Phyllis George, broadcast sports on network television. She had been crowned Miss America and, when hired, admitted that she knew little about sports. Still, her likability and appeal to the male gaze worked for TV, and CBS Sports featured her in its safe zone of feature stories about athletes. She stayed a few years at CBS Sports and, in this time, solidified in executives' minds the idea that women in sports TV ought to be hired for their beauty rather than for their knowledge of games men played. In fact, the less the woman knew, the better things would work out.

Before George proved this a winning formula, CBS Sports had put Jane Chastain in its sports spotlight. In Florida, she'd been successful as a local TV sportscaster, but all she knew about sports didn't benefit her at the network. After her first game in the booth with two male football broadcasters, *TV Guide* critiqued her performance. That story's title, "Get That Broad Out of the Booth,"[1] summed up the gist of the disparaging letters and crude phone calls the came to the network after her debut. A woman in the booth ruined their game, men said, raising a complaint that is frequently on social media today. Chastain was not put in the booth again as she was delegated to sideline roles that never let her use all that she knew about football. CBS did not renew her one-year contract, and then hired George.[2]

Her legacy influences sports broadcast media to this day.

With women marginally present in sports media in the 1970s, men controlled the mics, the cameras and the pen. Therefore, women's views were largely absent in coverage of my legal case. But the women who did write and speak about it mostly favored equal access. Even the women who said they

didn't want to work in locker rooms wrote more about the issue of equal access. If someone had handed me a story or column about my case with its byline crossed out, I could have guessed the gender of its writer. If the story or commentary had phrases like "equal rights" or "women's rights," and men's nakedness wasn't positioned front and center, I'd know that a woman wrote it.

In the *Ann Arbor News*, Jane Myers contrasted two postgame locker rooms with female writers working in them. In her column, "Let Them Keep Their Pants On,"[3] she wanted to show the competing narratives that Judge Motley would encounter when my lawyer and baseball's attorney told her differing stories about what happened in this space.

> Picture a bunch of nude men in a locker room. Picture a woman reporter in there with her clothes on. LOOKING. Picture Sodom. Picture Gomorrah. Picture a locker room in Sodom and Gomorrah. Picture an end to "common sense" and the right to privacy.

> OK. Stop salivating and start over.

> Picture a bunch of baseball players (male) after a game in a locker room. They all have towels wrapped around their middles. Picture a giant horde of male reporters, all with their clothes on. Picture one or two female reporters in there, too. With their clothes on. Picture all the reporters, male and female, racing like mad to interview the players, so they can rush out and write stories and transmit them to their papers within an hour. Picture a few nude players heading for the showers. Picture the reporters paying no attention. Picture them scribbling as fast as they can. Cut.

Myers then carried her readers into Judge Motley's courtroom, where concisely and accurately she laid out the essence of my case. People reading her story could appreciate what was at stake: "Judge Constance Baker Motley of the United States District Court, Southern District of New York, has to decide which of these two versions of what happens when a woman reporter goes into a men's locker room is true. . . . Bowie Kuhn has taken the basic Sodom and Gomorrah position, while Time Inc. has taken the 'every-reporter-deserves-an-equal-chance-to-get-the-story-and-get-the-hell-out-of–there-dammit' position.'"

Meanwhile, the men's media hurricane swirled around me and my case.

* * *

When the press assault began, I was young, blond and slim, and unmarried. I was also a person about whom the media had never paid any attention. I'd never read a story about myself in a newspaper or magazine, nor had I seen myself on TV or heard a radio host talk about me. I was as far from a celebrity as a person could be, nor was I even well known as a writer when I surfaced as the "girl" plaintiff in a highly publicized court case. Notoriety was as new to me and it was frightening. I didn't have the slightest idea how to protect myself from the blasts of negative attention. I'd tumbled headfirst into this media maelstrom that naively I didn't expect. When Time Inc. asked if I'd be the plaintiff in this case, I said yes right away without thinking there might be a downside. That's how much I wanted to do my job. I gave no thought to the possibility that things said about me would be twisted in the ways they were.

When the onslaught started, I realized right away how little control I had over how all of this would unfurl. I also didn't know where to turn for solace so I internalized the emotional pain. This, in part, contributed to my hasty, ill-advised decision to marry a man whom I barely knew and whom my friends and family warned me not to wed. To me, I saw becoming a wife as the safe harbor I needed to have as this media storm raged. The more that people harped on my poor judgment in saying I'd marry him, the tighter I clung to my cockamamie belief that by doing this I'd rescue myself. This illusion sustained me at a time the press misconstrued my intent, mischaracterized who I was, and misled Americans about me and my case. I didn't know how to respond to these falsehoods. Some mornings, I woke up feeling bruised like I'd been a sparring partner to writers whose punches I absorbed. As weeks went by, the constancy of these attacks took a toll on my well-being, though I hid my internal bruises.

* * *

Just a few hours after the Associated Press put on its wire service the news of Time Inc. filing our complaint, my parents and I took our seats in the mezzanine for a Broadway show. They'd arrived late that afternoon by car for a long-planned holiday visit as the New Year approached. I'd bought tickets for us to see *The Gin Game*, and when we got to our seats with fifteen minutes to spare, I wanted to catch up on family news. But soon after we'd started to talk, a conversation behind us derailed our own.

"She wants to go into baseball locker rooms when the players are changing their clothes," I heard a woman say. It sounded like she was recounting a

radio story she heard driving into the city. I didn't turn around to look but guessed she was sharing this news with her husband. Soon, another man joined in, and these two couples began a vigorous discussion of the merits—mostly the demerits—of this girl going to court so she could go into a baseball locker room. The theater lights blinked, then dimmed, to signal the play's imminent start, but the four of them kept talking in whispered voices, which made it harder, though possible, to hear them. By the time the curtain rose, they'd settled on two points of agreement: (1) the judge should—and surely would—tell this girl no, and (2) she must be a women's libber. My dad whispered his astonishment at what had gone on. I looked to my mom sitting on my other side. She said nothing.

It was weird hearing strangers talk about me. I'd squirmed in my seat when I heard the woman say the news about me. For an instant, I'd considered turning to introduce myself as "that girl," but I'd let the impulse pass. I wanted to appear cool in front of my parents, though I doubt I succeeded. With little time to talk on our way to the theater, and not knowing when the AP story would be published, I hadn't updated them on my case by the time we'd sat down. The chatter behind us was my first inkling that the AP story went out. When the play began, it took a while for me to refocus my mind on what Hume Cronyn and Jessica Tandy said to each other as they talked across a card table on a porch.

* * *

My court case hit the third rail in America's gender wars. Stories about it moved with a space-age velocity I hadn't contemplated, though slower than had there been digital media. Even as thousands of words poured out about me being with undressed men, the letters that women and girls sent me at *Sports Illustrated* comforted me.[4] They wrote of their joy in watching and playing sports and expressed heartfelt gratitude to me for proving that when girls grow up they can still love sports and write about them. Several told me they wanted to be sportswriters, while others hoped to play competitive sports, even though at many schools, girls had no sports teams. Nor were there professional teams for them to play on. When they competed in sports or sat in the stands watching the boys play, some people made them feel they didn't belong there. In writing to me, they connected with someone who showed them their dreams could come true.

Julia Lagonia was in her forties and unmarried when she wrote to me. In writing her second letter on January 16, 1978, she filled three notebook pages

with flawless handwriting. She thanked me for replying to her first letter, then closed her second expressing with a similar sentiment to her first: "Thanks again and the best of luck in your future with the baseball case. I'm behind you, 100 percent." Fifteen-year-old Terri Lynn Bottjer handwrote a five-page letter on adorable stationery with her name imprinted on it. It took all those pages for her to tell me about her recent run-in with the Yankees after she and her friend wrote the stadium manager, Mr. Patrick Kelly, to apply "for positions as batboys, or, in our case, batgirls." She then told me what happened next: "We were very promptly and, I might add, rather rudely turned down for applications by Mr. Kelly for the simple reason that we were female. He said, in essence, that the players would be in various stages of undress, and that the locker room language was not suitable for an 'impressionable teenager's ear,'" she told me. Then, as an aside, Bottjer confided: "I can assure him that between all the books I read on baseball and my friends, the players' language is nothing I haven't used or heard."

Kelly's response upset the girls, so Bottjer's mom suggested they write to New York City mayor Abe Beame and former congresswoman Bella Abzug and "other important people in New York." They did, and a deputy mayor replied. He'd referred their issue to the New York City Human Rights Commission. Soon, a commission official asked them to come to its office to file a "formal sex-discrimination suit against the Yankees." He also arranged a meeting for them with representatives from the Yankees. However, just before this meeting was to happen, the Yankees told the commission that another teenager, Virginia Savage, had filed a similar case, and hers was being heard. When Bottjer wrote me on January 9, they were waiting to hear from the commission about its decision in Savage's case.[5] "In the interim," Bottjer assured me, "I've applied again for the job of 'batgirl' to see if we get the same reply from Mr. Kelly." Bottjer dreamed of becoming a sports journalist or TV broadcaster, so she'd also corresponded with Robin Herman at the *New York Times* and Lawrie Mifflin at the *Daily News* to ask about their locker room experiences in the NHL. "Robin says she has no real trouble with the guys and Lawrie doesn't appear to have any either," she told me.

I wrote back to Bottjer, as I did everyone who wrote me a letter that wasn't gratuitously mean. Her gumption and grit impressed me, and what she told me about Savage's court case I told Fritz so he'd have her firsthand testimony about what it was like for girls to apply to be batboys with the Yankees. Bottjer closed her letter with these words: "Well, this whole story was just to tell you that, in a way, I know how you feel, and to let you know that I'm

behind you and your beliefs <u>all the way</u>. I love the Yankees very, very much, and would hate to see my image of them ruined by this one incident. I also hope that if this problem is solved now, I won't have to face it when I'm a sportswriter. So Good luck! And thank you, Terri Bottjer."

* * *

Her letter reached my inbox at *Sports Illustrated* about a week after I'd done a live interview on America's most popular morning TV program, the *Today Show*. Maybe she was watching on that Wednesday morning before leaving for school, or perhaps she'd heard a radio story while her mom drove her home from sports practice. She didn't tell me how she found out about my case, but she did a terrific job expressing what it meant to her. And her letter meant a lot to me, too.

Being interviewed live for six minutes on the *Today Show* was terrifying. Nothing I'd done in life prepared me to sit in front of TV cameras and respond instantly and coherently to Jane Pauley's questions about naked ballplayers when I knew that millions of Americans were watching. In defending my case, I was scared that if I said something wrong on national TV, I'd jeopardize the case Fritz was building. I knew viewers would scrutinize what I said but also how I looked.[6] Even though my appearance had nothing to do with the merits of my case, I knew I had to be likable. Americans didn't like uppity women, which I thought a lot of them believed I was. Be yourself, my friends advised, but frankly I wasn't sure I even knew at this point in time who I was. In media portrayals, I was the poster child of a controversial and salacious cause, while I saw myself simply as a reporter wanting to do her job. Add to this my morning sickness due to my unintended pregnancy, and I was experiencing emotional tumult. But I had to summon whatever strength I could find to speak as clearly as I could about the job that I did each day and explain why I needed equal access to do it—and do this with a smile.

I had a only few days to prepare for the *Today Show* after a PR person from Time Inc. called me on Monday, January 2 about appearing two days later. I was encouraged to do this, but no one stepped forward to coach me. On my own, I practiced for the probability that Pauley would want to travel through the more salacious territory of my case. That's where her viewers expected her to go. I thought I was ready, but on my way to the Rockefeller Center studio I worried about my ability to handle this live TV interview. Other than my grab-a-quote phone call with the Associated Press for its December 30 story, I'd spoken with only one other reporter, Diane K. Shah, who

was writing a story for *Newsweek*,[7] and she'd also interviewed me by phone. Given Shah's own gender run-ins with baseball's men, talking with her felt like confiding to a friend. Neither interview was a live national TV show, and in neither had my interrogator's goal been to get me to emote, as Pauley would want me to do. To say I was nervous vastly understates the stress I felt in the green room waiting to go onto the *Today Show* set. A lot could go wrong, and I had no idea how to ensure that things went right.

Still, I was there to do this interview, so I would.

Just as no one at *Sports Illustrated* prepped me for my Q and A on the *Today Show*, nobody from Time Inc. met me at NBC. For *Sports Illustrated*, Wednesday was our day off. So I was overjoyed when my apartment roommate, Barbara Roche, came in the taxi with me, offering emotional ballast and practical support. From her years as a production assistant at ABC Sports, she could settle my nerves by offering helpful pointers. Most valuable was her reminder to "listen well." Always wait for Pauley to finish asking her question before jumping in with my reply, even if she said something I knew was wrong. Don't respond until she finished speaking. Use that time, she told me, to formulate my response.

Roche stayed in the green room when I went to have my makeup applied in a mirrored room. There, I watched the show on the monitor, then returned to the green room where I waited with trepidation for someone to fetch me to go on the set.

Pauley was only a year older than I was, but when I watched her on TV, I did not think of us as contemporaries. She was so poised that she seemed older. Although still a rookie on network television, the viewers quickly had grown to like her as Tom Brokaw's cohost. I'd watched her put guests at ease with her cheerful, easygoing ways and, to some extent, this had quelled my fears. Maybe I'd be at ease around her too. Still, I should have remembered that the reason so many Americans liked her stemmed from her sensible Indiana roots and wholesome midwestern friendliness. Pauley's fans would expect her to grill me about my "libber" ways and scold me about wanting to intrude on naked men. But I didn't fully appreciate this duality when I arrived on the set. Naively, I didn't think she'd turn this interview into an attack on me.

I was wrong. Even in the early going, her incredulity about my case was apparent.[8] As time went on, my guard went up even as I tried to articulate a strong argument to convince her and viewers of the merit of my case. But just as I hit my stride, she asked a question that made me squirm. She kept her poise, while I lost mine. Her query came from a throwaway line I'd said soon

after we'd met on the set designed for our interview. After Pauley walked over from the anchor desk, we'd shaken hands before sitting in the two swivel chairs on a raised platform. On the fake wall behind us there was a huge black-and-white photograph of Reggie Jackson in the Yankees' locker room after the sixth game of the 1977 World Series. While she reviewed her notes, I looked at the photo. Then, in an attempt to soothe my nerves, I mentioned the photo to Pauley. The photographer's upward angle had made Jackson's bare chest puff out so much that it consumed most of the image. So I'd said something flippant about Jackson's chest that related to me not being allowed in the locker room that night to see him. Without looking up, she mumbled something back, which made me think she hadn't heard what I said. I said nothing else, then a few seconds later the red lights on both cameras lit up. A stage manager sliced the air with his arm, and we were underway.

Pauley asked me about that last game of the World Series, and I started telling her about why I wasn't able to talk with Jackson after he'd hit three home runs to bring the championship back to the Bronx after a fourteen-year drought. That evening, Jackson was *the player* who every sportswriter wanted to be around in the locker room, hoping for memorable quotes while chronicling his interactions with teammates, the manager, and the team's owner. That season, his outsized ego and tempestuous relationships with teammates had led to the kind of drama found on soap operas. On this night—the capstone of his career—Jackson was writing another chapter in his remarkable career, and how he handled these interpersonal struggles while celebrating this victory was vital for any writer to observe.

But before I managed to say much of anything, Pauley interrupted to assure her viewers that when the men encircled Jackson, I was waiting "in the room adjacent to the locker room," presumably about to talk with him. This wasn't true, but heeding my friend's advice, I did not interrupt her even as she parroted Kuhn's claim about my "separate accommodation." What a great coup for Kuhn, I thought, when a trusted media person like Pauley tells Americans how well he treated me. As she spoke, I was figuring out how to respond. When she finished, I leaped in with what I hoped would come across to viewers as a measured response, delivered calmly.

"I was not in some adjacent room. I was standing outside of the clubhouse, crushed against the wall," I told her. As controlled as I'd set out to be, I realized I was displaying a hint of the anger I harbored at how I'd been treated that night. I tried to tone that down. "I was watching people go in and out of the locker room with no credentials. I had a credential that said I could go into the clubhouse. I was standing out there, and the guard at the door told

me, 'You can't go into the clubhouse. I have orders from the commissioner's office. You're not allowed.'"

When I was finished, she said nothing about what I'd said. She had no reaction to what my real circumstance were. On we went, and with our interview nearing its end, Pauley tossed me her question that threw me off stride. She'd pieced it together from that *off*-camera remark I'd made about Jackson's chest. As her question oozed out, I realized she'd scribbled notes from my remark with the plan of asking me about the female gaze of the male anatomy.

"When you first came out here and you looked at this picture and you said, 'Who is that?' And I said, 'That's Reggie Jackson,' and you said, 'That's Reggie's chest!'" she said, ambushing me with her accusatory tone. She'd twisted what I'd said into utter nonsense. How could I not recognize Jackson? I'd been around him almost daily for two seasons. In the summer of 1977, I rode with him in his Rolls Royce to many games after meeting him at the car ramp under his Fifth Avenue apartment building. With me in the passenger seat, he'd driven us to the stadium. On these trips, we talked at length, an opportunity I didn't have at the stadium. I would never have asked Pauley to identify Reggie Jackson for me.

When she mimicked me saying "That's Reggie's chest!" Pauley accentuated her words. I giggled nervously, but I was actually thinking fast about how to respond. "Now, why did you say that lest we create the impression that you are after all leering at athletic bodies?" she concluded.

Live on national TV, my folksy host was accusing me of filing this lawsuit so I could go into a locker room to gawk at naked men. She'd waited until the end and pushed me into the same corner favored by so many men. Her blindsided accusation shocked me to the point that I felt my brain freezing. With the camera's red light pointing at me, I felt miserable and alone, vulnerable and unjustly charged. I tried to kick-start my mind looking for a hook on which to hang an answer. After summoning every ounce of clearheadedness I could muster, a scrabble board of words tumbled out until I found the semblance of a coherent response.

"No, I was just trying to get loose," I said. "I was sitting here thinking, what am I going to say? And I was just trying to get loose." I was so nervous that I was sort of chuckling as my words came out. I was treading water, trying to stay afloat until a solid thought clicked in. I had to finish strong. Then, miraculously, the words I needed showed up, enabling me to regain a modicum of the dignity I knew I'd lost.

"Well, it was a situation that when I walked in here, I thought, I missed that," I said to Pauley. I felt my confidence returning, so I swiveled my chair

to look directly at Jackson's photo. "I never saw that part of Reggie's evening or saw Gabe Paul [the Yankees' general manager] pouring champagne over his head or watched Reggie Jackson drink that champagne." I wanted these words to end this interview by reminding viewers why I'd filed this lawsuit.

But Pauley cut me off again with a closing soliloquy. "If I could ask a rhetorical question," she said, smiling into the camera, oblivious to me being there with her. "I'd like to know the sex of the camera that was allowed into the locker room to take that photograph while you weren't allowed there. And I don't know that anybody can answer that question."

She didn't even look my way when she said, "Melissa Ludtke, thank you for being with us and we'll be following your case."

With that, she tossed the show back to Brokaw. When the red lights were off, Pauley swiveled her chair back toward me, then rose from her seat. I did too. She reached her hand out to shake mine, then without saying a word to me, she walked away.

Back in the green room, Roche gave me a reassuring hug, then handed me my winter garments. We left the building without exchanging a word. She knew I was upset. Back on Fiftieth Street, she said she was going to her office at ABC Sports, which was a few blocks north on the Avenue of the Americas. I'd done well, she told me, while urging me to let go of those final awkward moments. "Stay focused on how well the rest of the interview went," she said before she walked away.

I blamed myself for that final question. If I'd been Pauley, I think I would have grabbed hold of my remark about Jackson's chest and done, as she did, by putting me on the spot with a query about us looking at naked men. That morning taught me a valuable lesson. From now on, I'd guard my words and scrutinize my actions whenever a writer or TV reporter was nearby. I'd do no more throat-clearing remarks like whatever I'd muttered in front of Pauley before cameras were on us. Things I said or did could—and would—be used against me in juicy headlines or salacious stories. I was no longer just me. I was the plaintiff in a notorious case that was upsetting lots of Americans, and they'd ridicule me for waging this fight.

I couldn't afford to make any more mistakes.

That morning, I told myself I wouldn't.

Chapter Twenty-One

Kuhn's lawyer seemed slighter and more stooped than I remembered him from my deposition in March when he'd hovered near me as I answered his questions. Maybe that's why he loomed large in my memory. I'd been told to sit in a straight-backed wood chair in the corner of his law firm's small conference room, and whenever I looked up, it seemed he was leaning in. I took this as his attempt to rattle me. While his closeness annoyed me, I tried to ignore it by executing the game plan that Fritz had drilled into my head on our fifteen-minute walk to Climenko's firm. I hadn't been deposed before, so every hint that Fritz had to offer, I was eager to hear. Stay focused, listen hard, he told me, from the instant Climenko started his question until he finished. Then, after a micro-pause to organize my thoughts, answer succinctly, resisting the impulse to elaborate. In baseball terms, he was saying not to swing for the fences even if Climenko tossed me an easy pitch in my strike zone.

Make solid contact, but swing for a single.

Occasionally, I glanced at Fritz to see if I was on track. His expression was my reply, and I never saw any look that made me worry. Mostly, he left me to fend for myself, entering the fray if he felt a question was convoluted enough to possibly mislead me. Then he'd ask Climenko to reword it to remove any doubt of what he was asking. Fritz didn't need to say much for Climenko to shoot him a caustic retort. "I will have to operate with my mentality unsupervised or unaided by Mr. Schwarz," he said once after Fritz spoke up. But after these excursions, he'd turn to me and say politely, "Let me ask you a question."

* * *

To warn Americans about the threat I posed to *his* game, Kuhn had harped on *his* players' state of undress while pointing an accusatory finger at my unfeminine ways. To argue this case before Judge Motley, Climenko had the unenviable job of defending Kuhn's patriarchal attitudes at a time when equal rights cases were ending in judicial victories for women. Court orders were depriving men of the impunity that for decades had allowed them to dominate nearly all spheres of life. Kuhn's and his attorney's patriarchal views stemmed from their privileged upbringings during a time when white men assumed positions of authority and advantage. Kuhn's buttoned-up manner and self-assured rectitude meshed well with Climenko's haughty comportment. Both men traveled in Manhattan's elite legal circles in which their powerbroker status was regarded as their rightful inheritance. Kuhn later wrote about his comfort with the regal trappings of his office in a *New York Times* op-ed in which he gave advice to the man who would succeed him. The next commissioner, he asserted, "should use his powers fearlessly to protect the integrity of the game [even though] the critics will call him self-righteous and moralistic." Then, he'd added, "Have courage. Ignore them."

Climenko was born in Manhattan in April 1904 as the son of a celebrated physician who directed the neurology department at the Montefiore Hospital. He attended private school with other white boys who, like him, trusted that a lucrative, prestigious position would be his for the taking when his studies ended. Twenty-two years later, Kuhn was born in Washington, D.C. into similar circumstances, though he lacked his attorney's Manhattan pedigree. Kuhn attended the then-segregated D.C. public schools. His father was an executive with a fuel company, so it was his mother who secured his family's influential social standing through her descendants that included five Maryland governors and two U.S. senators. As a teenager, Kuhn earned one dollar per game working the scoreboard at Griffith Stadium, the home field of the Washington Senators, but his bigger payoff came in seeding his connections with the game. In 1947, Kuhn graduated from then-all-male Princeton University before enrolling in the University of Virginia Law School where a mother-daughter pair, Ruth and Elizabeth Taliaferro, were a curiosity as women in his class. Virginia's first Black law student arrived in the fall of 1950, just after Kuhn graduated. In Climenko's seven years at Harvard—first, at the college, then the law school—he also had little, if any, exposure to female or Black students.

Climenko had entered Harvard University in 1920 just after a decades-long campaign had won women the right to vote with ratification of the Nineteenth Amendment. Yet, America's insidious color line still held firm. More

marches and protests, jailings and deaths of advocates, and more court cases would be needed before Black Americans, men or women, could cast votes in the Jim Crow South. Judge Motley was part of this fight with her courtroom battles. In 1927, Climenko, his law degree in hand, joined one of Manhattan's top law firms at a time when such firms didn't hire highly qualified female law school graduates like future Supreme Court justices Sandra Day O'Connor and Ruth Bader Ginsburg. (Graduates of color, especially women, were rarely hired as well. Motley didn't bother to apply to a private law firm and went to work for the Inc. Fund.) After Kuhn's law school graduation, Willkie Farr & Gallagher—with Major League Baseball as its client—didn't hesitate to hire him. Soon, Kuhn was that firm's counsel for the National League, which made it inevitable that he'd intersect with Climenko, whose firm, Shea Gould Climenko & Casey represented the Yankees and Mets.

At these men's law firms, women served the men in their subservient roles. Accustomed to wielding power, professional men of that time weren't about to carve out space for women like me. Fear of change accounted, in part, for their hesitancy, but as commissioner, Kuhn also clung to baseball's storied traditions that he cherished for their constancy. "I believe in the Rip Van Winkle Theory," Kuhn liked to say. "That a man from 1910 must be able to wake up after being asleep for 70 years, walk into a ballpark and understand baseball perfectly."[1]

Elite men's eating clubs had been staple of campus life for these two men. In midtown Manhattan, the Century Association was among the city's more exclusive men's clubs. On its second floor, the Southern District Court judges held monthly dinners. Although members' guests were permitted on the first floor, they were forbidden on its second. So when Motley became this court's first woman judge, its chief judge concocted a story so that she could eat with the rest of the judges. Years later, Motley found out, as she wrote, that he had told "a little white lie to the powers that be" by telling the concierge that's he'd be bringing a secretary, aka Judge Motley, to their dinners to take notes. After her first dinner (around what she said "must have been the largest round table in New York"), Motley made it her habit to bring a floral centerpiece at every meal. As this gathering's only woman, she wanted "to brighten" the room.[2]

Not until a decade after Judge Motley ruled in my case were women allowed to be members of the Century Association. It was Fritz who made that happen.

In 1982, Fritz had resigned from the Century Association after being hired as New York City's corporation counsel. In that role, he set out to eliminate New York City's male-only clubs, partnering in that effort with Jack

Greenberg, who'd succeeded Thurgood Marshall at the Inc. Fund. In 1984, these two men convinced New York's city council to pass a law that barred clubs not "distinctly private" from discriminating in their membership due to gender, race, or creed. But the Century Association didn't comply. After several years of legal wrangling, Fritz's case reached the U.S. Supreme Court, and in 1988 the justices ruled that the city's law was constitutional. This meant that Judge Motley could dine on the second floor without subterfuge, but by then, the judges were no longer dining there. Their salaries had not kept pace with the cost of the Century Association's meals.

New York City was also where in the early 1970s women had challenged their exclusion from Lower Manhattan's McSorley's Old Ale House, which in 115 years of business had served only men. Judge Walter Roe Mansfield, whom President Johnson also had nominated in the same year to sit on the same district court as Motley, wrote this in his ruling when he also found state action under the *Burton* precedent:[3] "The state's involvement in the operation of defendant's business, and hence by implication in the exclusionary practice under attack, rises to the level of significance within the meaning of *Burton*, and requires McSorley's to comply with the proscriptions of the Fourteenth Amendment 'as certainly as though they were binding covenants written into the [license] itself.'" Mansfield had used the Equal Protection Clause to rule in favor of the McSorley plaintiffs, writing, "Without suggesting that chivalry is dead, we no longer hold to Shakespeare's immortal phrase 'Frailty, thy name is woman.' Outdated images of bars as dens of coarseness and iniquity and of women as peculiarly delicate and impressionable creatures in need of protection from the rough and tumble of unvarnished humanity will no longer justify sexual separatism. At least to this extent woman's 'emancipation' is recognized."

* * *

"I shall refer to the facts as they actually exist rather than how they are suggested by Mr. Schwarz to indicate to Your Honor that there is not here any discrimination against women reporters," Climenko said in rolling out his argument. I found it hard to see how he'd convince this judge that Kuhn did not discriminate against me given his policies and practices. That he'd kept me out while letting the men inside was not in dispute. But as I tried making sense of his opening gambit, Climenko doubled down: "On the contrary, there is a great effort on the part of the defendants to assist them [women] in every possible way."

That was a demonstrable falsehood, so when I heard it I tapped Eric's ribs with my elbow, then I rolled my eyes when he looked at me—my way of saying Kuhn's lawyer could not be serious! How would he explain what happened after Game 6 when Kuhn's "assistance" had forced me to stand outside the locker room door amid ear-splitting screams of exuberant fans while the man assigned to bring me players had failed to bring them to me? While standing there, I'd amused myself, if I could call it that, by watching uncredentialed men be waved into the locker room by guards whom Kuhn told to keep me out.

Not discrimination? Was I not in a courtroom, I'd have laughed out loud.

What evidence would Climenko use to back up his claim that baseball assisted women writers "in every possible way"? More evidence existed of the opposite. Nevertheless, *Today Show* cohost Jane Pauley had taken Kuhn's bait twice in our six-minute interview in referring to Kuhn's separate rooms as if they were real. In introducing our segment, she'd told viewers that Kuhn gave female writers "interview facilities adjacent to the team's dressing quarters, appropriate and in the best interests of all concerned." Then, later on, she'd interrupted me to remind them that I was "in the room adjacent to the locker room" after Game 6.[4] Of course, I wasn't, but she had transmitted Kuhn's *fake news* to millions of Americans, who believed her.

It also had worked for Kuhn to spoon-feed his falsehood to sportswriters. They'd eagerly regurgitated this misinformation to serve their interests. But if Climenko parroted this lie in court, he'd dig himself into a legal hole. Even if Kuhn had given us in a room of our own, we'd still not have access equal to our male peers. One-on-one interviews, though vital, do not equate to reporting in the aftermath of a game played by a team. When Fritz had deposed Wirz, he had pressed him about this key point made by the president and the president-elect of the Baseball Writers' Association of America. After several attempts, he'd gotten Wirz to acknowledge that those writers believed that locker room access was "important in carrying out the function of the baseball reporter." Wirz also reluctantly confirmed that these veteran writers were not willing to trade being in the locker room for time with players in Kuhn's "separate accommodation."

"I will also indicate to Your Honor the deficiencies in Mr. Schwarz's case," Climenko assured her. "He [Schwarz] attempts to obliterate by a contrived attack on us by saying we have been guilty of some obscene comments on women. This is nonsense," he insisted. That he spoke specifically to Fritz's courtroom surprise only demonstrated its power. "This is Mr. Schwarz's technique for the failure of his case," he said.

He'd rushed through his introduction, but now Climenko slowed his pace. "If Your Honor please, let's get the facts so we know what we are talking about," he said. This seemed an odd approach to take since we'd already agreed to a long list of "controlling" and "supporting" facts in our case. Our hearing wasn't to debate facts, but to argue the case based on the law. Fritz had stayed largely in that lane while spending little time reviewing our case facts, nor had Judge Motley signaled her desire to revisit them.

Climenko's approach seemed different.

"We are not talking about restricting women from being reporters," he declared. In offering this semantic distinction, Climenko tried to distance his client, as much as he could, from one of our core claims. In our complaint, we had not accused Kuhn of restricting me from *being* a reporter since he did not hold such power over me. We did charge him with denying me the ability to fully report by restricting my access to sources.

"There is obviously only one question involved here," Climenko said. "There is no question about keeping women away from baseball."

But quickly he left that notion behind in pivoting to a history of female writers' access to men's locker rooms in professional sports. "All that has happened here is that in 1975 Mr. Kuhn learned in his capacity as baseball commissioner that women or several women had attempted to obtain access to what is called 'the locker room,'" he told Judge Motley, referring to the female writers covering the NHL and NBA. "If Your Honor please, you have been requested to look at pictures or designs of parts of the Yankee locker room. Let me suggest to Your Honor that there is one thing that is not in dispute here: a locker room is an area used by players immediately after a game to get undressed, to proceed to take care of their hygienic needs, to shower, etc., etc."

She stopped him there: "Are they required to get undressed?"

Barely two minutes into his defense, and Climenko seemed shaken by her quizzing him about whether ballplayers *must* get undressed in the locker room.

"They are not required to, but that is what they do," he told her.

"While the reporters are there?" she inquired.

"No," he said, which confused me. Of course, reporters were in locker rooms when some players undressed to shower and when others were dressing after taking one. Also, I wondered why he'd said this when it undercut Kuhn's key contention that players would be undressed when I was in the locker room. But then Climenko regrouped to provide a hybrid reply to her questions. "This is their practice," he reiterated. "There is no requirement of anything, Your Honor. We are talking about the way in which

things happen. We're talking about the fact that after a game men habitually use the locker room, and a locker room is a place where they do undress preparatory to taking a shower."

Of course, this explanation pertained only to the time *after* games. Overlooked, as it always had been in news coverage of my case, was the recognition that we were kept out *before* games too, when the writers were with fully dressed players. This was a less chaotic time, when writers could talk at length with an individual player while picking up team gossip and gathering quotes and anecdotes for future stories or columns. Roger Angell, in his affidavit, had told Judge Motley what a writer missed by not being in the locker room before *and* after games: "It is in the clubhouse that the ballplayer prepares himself before the game and winds down after it is over. He reads his fan mail, drinks beer, jokes with his teammates, exults, or rages or despairs (according to the outcome of the game), talks to sportswriters, and discusses strategy and rumors and trades and girls. Access to all of this is absolutely essential to the sportswriter. . . . Reporters want more (than the basic information)—especially reporters for magazines."

* * *

With her astute questioning, Judge Motley was pressing Climenko to go beyond Kuhn's fixation on player nudity as the core rationale for excluding me. Baseball had a long-standing habit of blocking women's access, but this wasn't a history that Kuhn wanted the judge to hear. The big difference this time was that baseball's men had an assist from a commissioner who blamed this exclusion on the players' nudity.

"I know what a locker room is generally by common knowledge," Judge Motley said in a scolding voice. "I am asking you whether the players, when the reporters are there after a game, are required by anyone to start undressing?"

"Certainly not, but they do," he replied curtly.

No attorney wants to be in an unwinnable argument with a judge, especially when his time to argue his case is short. Motley's interruption had derailed him from fully framing his argument up front, but he had no choice but to engage with her as best he could. After he'd responded, she was silent, although she was glaring at him, as if saying she needed more of an explanation.

"It's common knowledge that they do," Climenko said, borrowing her phrase.

When she stayed quiet, he spoke: "Under those circumstances, Mr. Kuhn attempted to find out what was appropriate in relation to access of women to the locker room. We are not talking about anything else about the activities of women reporters in relation to baseball. As I will show you, he [Kuhn] concluded that he thought it was not in the interests of baseball to permit women in the locker room when men were undressed. That's all he decided."

So there it was, a baseball commissioner's favorite phrase—"in the [best] interests of baseball." It was bound to be introduced into the hearing, and here it was early in his defense. Every lawyer representing a baseball commissioner speaks those words in a courtroom since this clause bestows on this man the decision-making power to act on behalf of the entire league. If he believes something is injurious has happened to baseball, he uses his power to try to stop it, even knowing he might end up in court. This was Climenko's first time invoking this clause, but I knew it would not be his last. "When he decided [to exclude women], [Kuhn] said, 'Whatever we do in this situation, we will be criticized, but let's attempt to cooperate with women in every possible way short of access to the locker room," he told Judge Motley, who responded with another question.

"In that connection, why can't they have a lounge area in the locker room immediately after the game where all the reporters have access to the players, then excuse all reporters, and then [they] go and take a shower? Is there anything wrong with that?"

"There is nothing wrong with that," he replied.

"Can that be done?"

"It could be done," Climenko said.

"Could they set up a lounge area?" she asked again, pressing for a fuller response.

After I'd witnessed his earlier flashes of anger when Fritz had challenged him, I sensed that her questions were irritating him. But with judicial deference in mind, he wasn't about to show the ferocity he had with Fritz.

"If Your Honor please," he said, calming himself with the court's verbiage. "If Your Honor will read Mr. Red Smith's editorial on the subject of this case."[5]

"Mr. who?" she replied, confirming what Fritz knew before the hearing began: she didn't read the sports pages.

"Mr. Red Smith," he responded. "He is a well-known reporter who commands the respect of these people who read these pages. In a newspaper report about this case, he indicated that Miss Ludtke could have learned everything

she wanted to immediately after the last game of the World Series if she had gone where 250 other reporters went to interview the players." If this were true, then why had the men charged out of that interview room to go to the locker rooms where they worked for the next hour and more? I'd been in that interview room, but its brief Q and A with a few players was hardly sufficient. That is why the male writers left there to be with the players while I stood outside the locker room.

"Where is that?" she asked, referring to this interview room.

"It's an adjacent area to the locker room inside the stadium," he told her, leaving aside the fact that this "adjacent area" existed only during postseason series. "It's a facility created for the purpose of accommodating all of the reporters."

"That is what I had in mind," she told him. "I am glad you mentioned that because I am trying to understand the facts of the case, and in so doing I wondered whether there was a kind of lounge or reception area where people could gather after a game and talk to the reporters and have the players retire to take a shower. You say that is, in fact, done?"

Here, Climenko must have felt the need to clarify this fact for the judge. "That was, in fact, done on the occasion of the precipitating event for starting this lawsuit, on occasion of the last game of the last World Series," he added, clearly squirming his way through her Q and A. He was trying hard to not share any *real* information about this temporary "adjacent room," thus shading the truth and hoping the myth of "separate accommodation" held up. Apparently, he'd sized her up as enough of a baseball rookie to believe what he told her about the game's inner workings. "Miss Ludtke was informed in advance of the game that she would not be permitted to enter the locker room," Climenko concluded.

But if he believed that response satisfied her, he was wrong. She wanted him to say more.

"Were men permitted to enter the locker room?" she asked him.

"Yes," he said. Then, he said only "*Sports Illustrated*," before switching topics.

"Let's answer this with respect to information gathering and the First Amendment—*Sports Illustrated* knew that they'd have at least two male reporters in the locker room. There is no question of them [the magazine] being refused an opportunity to report, but they sent—"

She interrupted, and I thought I knew why. She appeared to sense that he was trying to sneak not-quite-true representations of this experience by her. Now for the first time, she raised her voice to emphasize her word choice: "Are

you suggesting that those male reporters were as good as the female reporter here?"

Hearing *that* question, Climenko's response had my utmost attention.

"I don't want to compare them, Your Honor," he began. "The man who wrote the story [of the series] was an editor. He was the boss of that group at *Sports Illustrated*. He had an assistant [Jim Kaplan] who apparently was at the same level as Miss Ludtke. In any event, the fact is that they did report the game. They knew in advance [of the sixth game] that the commissioner had said that he did not think that she should be permitted to go in, and I want you to hear another part of this. In addition to that she was told in advance, she would be assigned to an official of baseball who would accompany her and arrange for her to interview any particular players she wanted to interview."

"Later, after everyone else had entered?" Judge Motley asked.

At this point, I thought she might remember reading the letter I'd written Kuhn after the sixth game that Fritz included it in our evidence. In it, I'd told how I'd agreed to work with baseball's "male escort" whom Kuhn arranged for me to be with after that game but I'd done so only under protest. In no way would Kuhn's "separate accommodation" measure up to the access that the teams had promised me before Kuhn overrode them. In that letter, I had documented my frustrating experience, and I suspected the judge had read it.

Yet Climenko said nothing about Kuhn's arrangement for me as he confirmed for the judge that my interviews took place after the men were inside, and I was forced to stay outside.

"Let me ask you this, Mr. Climenko. Why isn't this case resolved by having the lounge area, which you say exists here?" she asked. "Is it on this diagram?" she added, referring to the "pictures or designs of parts of the Yankee locker room."

"I don't know if that is the lounge area I have in mind, Your Honor," he replied. "There is another room, a large room, probably not depicted in the photographs you have before you."

Climenko knew his room existed only for the American League Championships Series and World Series. That was when the Yankees transformed a storage room near their locker room into an extra-large interview space. Unless she cornered him on this point, I knew he'd never volunteer that Kuhns's "separate accommodations" didn't exist. He'd play a cat-and-mouse game with her for as long as he could. But with each step he tried to take forward, Judge Motley was pulling him back with inquiries. At best, from his

perspective, her interruptions disturbed his flow; at worst, he was losing ground with her.

Largely, Fritz had been left alone to make his case, except when he had confused or surprised her. Not so with Climenko. Her questions struck at the heart of his defense, raising topics he would have preferred not to address. I admit that I was enjoying watching him try to wiggle out of this bind by obfuscating before our no-nonsense judge. All they'd done was cost him valuable time and pulled his own argument off course.

Chapter Twenty-Two

"Before Your Honor suggests that this interview room is the ultimate conclusion, I think you ought to give me the opportunity to tell you the legal questions involved here," Climenko told Judge Motley.

If the judge came away from our hearing with the view that my situation could "be resolved by having a lounge area" for the press, then Kuhn would be living out his worst nightmare. The male writers had warned Kuhn that they'd never accept him mollifying me by depriving them of their customary locker room access. Back then, their stories supplied baseball's oxygen by bringing fans into ballparks, so theirs was not an idle threat. They didn't control what the commissioner did, but they wielded considerable power.

"I will give you an opportunity," Judge Motley replied, "but I would like an answer to my question." She would control this hearing, including telling the defense attorney the topics he'd cover, along with when and how he'd do it. "Is there something wrong with setting a portion of this Yankee locker room aside as a lounge where everyone gathers as an opportunity to talk to the reporters, and then the players retire to take their showers?" she asked. When he'd evaded her earlier query, she reframed it and now was shooting it back at him.

"It can't be done," he replied. "It's a large area where men immediately after having played a game have the right to undress and get ready to take a shower. They move about that area without their clothes. Mr. Kuhn thinks that—"

Judge Motley stopped him mid-sentence. "You are suggesting that this ought to be done after everybody has showered, then, after the players have had their showers and are cleaned up," she said, prodding him toward a workable idea. "Then the team members should go into a lounge where all reporters have equal access to them." She was pushing him to arrive at a solution.

"Is that what you are suggesting?"

"I am not suggesting anything of the sort," he said defiantly. "Your Honor is suggesting that." Then, as if waging his own filibuster, Climenko led the judge down his road of telling her how things *were done* in baseball. He'd tried this before, but by now she'd run out of patience. It was time for him to help her in figuring out how things *could be* done to resolve this matter. I wondered how much longer she'd permit their tug-of-war to go on. Climenko would tug on his end of the rope for as long as she pulled on hers. He'd all but said this in his memorandum to her when he'd underscored his client's adamant refusal to yield to any change that would alter anything about his players' usual locker room routines:

> There is no other less sweeping means of preserving the players' privacy. To argue that the use of curtains or the wearing of bathrobes is less intrusive is no answer. For to impose such restrictions and regulations upon the Yankees is to intrude more pervasively upon their rights. The use of curtains, swinging doors, compelling the wearing of bathrobes would impair the traditional freedom, openness, and uninhibited style of a professional athletes' locker room. To say that a ballplayer must wear a bathrobe, by virtue of constitutional command, is an absurdity and does violence to the foundation of constitutional rights itself.

Judge Motley could propose every less restrictive fix she could imagine, but Climenko—on his client's behalf—would refuse each one. He wasn't going to leave this courtroom having to tell Kuhn that he'd agreed to an approach that had me working in the locker rooms or that he had settled on a plan that kept the men out. So all he could do was keep telling her why things were as they were in baseball while avoiding the slightest hint that he was open to her suggestions.

"Up to now male reporters have been admitted and women have not been," he affirmed. Surely, she knew this, so he was buying time while he figured out how to dig himself out of this hole. "The only reason women have not been admitted to the locker rooms but are given every other kind of access is simply because the baseball commissioner has investigated this matter and believes that at this particular moment of our history a large part of our population does not want that to happen," he told her.

From my seat, I wanted to shout to Judge Motley, "Ask him to tell you how Kuhn 'investigated this matter.'"

By then, we knew—as Fritz told her—that Kuhn had relied on no players or managers in crafting his ban-the-ladies policy. Did this qualify as him *investigating* this matter? But Judge Motley stayed quiet, while Climenko pushed on. "Now, the next question is, if he believes that women should not go into locker rooms, then what is the basis of him saying it can't happen?" Climenko asked rhetorically. "That takes Your Honor into the question of law in this case. We started with the proposition that there is no state action in this case, and we cite any number of cases," he told her, referring to his brief.

"How do you distinguish this case from *Burton*?" she asked him.

Late on this Friday afternoon, she wasn't going to indulge in talk about any case other than *Burton*.

"It's entirely different from *Burton*," he assured her. "Because, if Your Honor please, you have decisions by a district court and a circuit court that we've cited to you which show that the mere ownership of a stadium does not, in itself, constitute state action."

"By the state?" she asked, puzzled by his response.

"By the state," he responded, though he didn't elaborate. "In this case, they want New York City's ownership to be tantamount of state action. I don't quarrel about that. [But] there is no state or city action for this reason: There is no intertwining for the city with the commissioner's action in deciding who goes into a locker room and who doesn't. That is a private place and has nothing to do with the City of New York. You can read the lease backward and forward and you won't find any right on the part of the City to participate with baseball in the character of who goes in and who does not go into the locker room. This is a private place."

* * *

The judge also had read the memorandum that Fritz had submitted on March 13, a month before the hearing, in which he'd written that his state action argument would rely on two U.S. Supreme Court decisions. The first was its 1961 decision in *Burton v. Wilmington Parking Authority* about which Fritz had spoken at length. The other, *Gilmore v. City of Montgomery*, was a 1974 decision on which he'd lingered in his writing but spoke relatively little about in the hearing. In *Gilmore*, the justices had ruled that the city of Montgomery, Alabama could not continue to serve white-only schools in the city's publicly owned recreational park facilities. In writing about *Gilmore*, Fritz had footnoted a 1975 case, *Fortin v. Darlington Little*

League, Inc.,[1] in part because of its baseball connection but mostly because of its relevancy to our state action argument. Fritz wrote: "In holding that girls could not be excluded from a previously all-boys Little League, state action was similarly found where the League was allowed to use the City's baseball diamonds at night and on Saturdays during the baseball season because such use is a 'rationing of a public resource.'"

Fritz argued before Judge Motley that he saw our case as "controlled by the results of *Burton* and *Gilmore.*" But in his brief, he had observed that "the contacts between the private entity and the City, arising out of the leasing of public property, are even more extensive." To support his point, Fritz showed how New York City acquired Yankee Stadium and the land surrounding it "in the exercise of its power of eminent domain upon a factual showing, approved by the Supreme Court of the State of New York, Bronx County, and the purchase of the Stadium was required for a 'public use.'" Such "benefits mutually conferred," Fritz said, "had led the U.S. Supreme Court in *Burton* to find state action in discrimination by a restaurant which leased a small part of a public structure."

Not until early April did Climenko submit the defendant's memorandum. In it, he told Judge Motley that he would argue against state action existing in our case. In his memorandum, he downplayed New York City's "ownership" of the stadium by writing that "the Yankees happen to rent a stadium that is owned by the City of New York," then added that "all of baseball activities at the Stadium are managed totally by the New York Yankees and there is not even the remotest public pretext of official involvement." He also invited a Yankee executive to file an affidavit supporting his claim of the team's fully independent management. "Certainly, the mere fact of municipal ownership of one of baseball's playing fields does not elevate the sport to the status of a government activity within the meaning of the Fourteenth Amendment to the United States Constitution," Climenko wrote in this memorandum. Still, he acknowledged that Judge Motley's finding on state action's relevance would be key in determining how she ruled in this case, when he wrote: "In the absence of state action, there can be no violation of Fourteenth Amendment rights."

On this point, both sides agreed.

But Climenko disagreed with Fritz's belief that *Burton* and *Gilmore* "control this case." Starting with *Burton,* Climenko showed the judge his legal reasoning. "The lease of public lands and the payment of rent does not in and of itself mean that state action is present." In separating from *Gilmore,* Climenko wrote, "The clubhouse, the site of alleged discriminatory action, is

not a public place" as Montgomery's facilities were. To sum up his argument, Climenko switched to the vernacular: "The plain fact is that New York City is not involved with the Yankees clubhouse. Thus, the City's involvement cannot signify approval."

While his legal argument dominated the defendant's memorandum, in his own affidavit, Climenko struck a less lofty tone. In it, he echoed Kuhn's charge that I was the plaintiff in this case to advance my career. "Ms. Ludtke, previously an obscure, fledgling journalist, has appeared on numerous national radio and television shows, and both she and *Sports Illustrated* have received broad national attention in the print media," Kuhn had written, before he wished me "every success in her [my] profession." Kuhn had taken one more shot at me in his affidavit, writing that he did not "believe it necessary for her to confront naked athletes to distinguish herself as a first-rate sportswriter." When it was his turn, Climenko opined that being banned from the locker rooms was "no more than a minor hindrance" in the pursuit of my goals as a reporter.

To them, a reporter not being with her sources was a trivial matter, neither hindering my work nor stymying my career. But, as Fritz forced each man to admit in his deposition, no male writer would willingly trade places with me. Judge Motley would assess if Kuhn's edict was a "minor hindrance" or unequal treatment worthy of a court finding. To improve our odds, Fritz had asked women sportswriters to write affidavits about working with and without full access.

Washington Post sportswriter Betty Cuniberti told the judge about an NFL game in Los Angeles. "The Rams stationed me outside of their locker room but were unable to produce either of the just two players I requested," she wrote, mirroring my Game 6 experience. "The Vikings, by contrast, allowed me into their locker room and I was thus able to interview several of the players quickly and efficiently." When Cuniberti covered an Oakland A's, the PR director "stuck her away in a tunnel outside the locker room in Oakland Stadium" and told her to stay put. While she was there, an A's player "announced inside the locker room that he would never play for Charlie Finley, the team's owner, again," she told Motley, explaining why she had to be in that locker room that day. "Naturally, since I was not in the locker room, I did not hear the announcement. None of the male reporters who did hear it told me about it because I was from the *Chronicle*, their biggest competitor. As a result, that story did not appear in the next morning's *Chronicle*. However, all the evening papers, having had male reporters in the locker room, carried it. That was professionally embarrassing to me and harmful to my paper."

In 1976, when *Newsday* sent Jane Gross to cover a New York Mets' game, her editor phoned the Mets' PR person to let him know he was sending her. Even so, the Mets told her to "wait in either the manager's office or another room no bigger than a supply closet," Gross wrote in her affidavit. The PR man said he'd bring players out to talk with her, but as she told for Judge Motley, her "arrangements were completely unsatisfactory."

> I had to wait up to an hour for the most important players, and some of the players would not come out to speak with me at all. The players who did come out were so tired of answering the same questions over and over again. More-over, I could not ask other players follow-up questions. Most important, I was unable to see what went on inside the locker room. If one player yelled at another or threw a deodorant can at him. I was dependent upon my competi-tors to tell me about it. Even if they did tell me about it, I was unable to catch the general ambiance.

In her affidavit, Robin Herman wrote about a Rangers' loss to Atlanta in 1977. After that game, one of the Rangers, Nick Fotiu, turned over a table and threw an ice bucket against the wall in the locker room. "Reporters who were given access to the locker room saw the mess and related the incident to their readers," she told Judge Motley. "An excluded reporter would have missed the story." By then, Herman was inside this NHL locker room chron-icling this event for *New York Times* readers.

* * *

One by one, Climenko rejected Judge Motley's suggestions for equal access. He also ignored the women's affidavits, perhaps hoping that she did too. But I trusted that she'd read them, and what those women told her was helping to guide her line of questioning with him.

"If Your Honor, please. Reference has been made here to male guardians or women guardians in a jail," Climenko said, referring to the *Forts v. Ward* case filed by women prisoners. Judge Motley had asked Fritz to talk about the male prison guards patrolling the bathrooms of female inmates who claimed to be "involuntarily exposed" due to this practice. The inmates' lawyer argued that the women were denied their "constitutional right to privacy" since the male guards saw them in stages of undress. Picking up on that case and his privacy issue, Climenko drew a parallel with a distinction. "These

ballplayers are not yet in jail, Your Honor. They are playing baseball. They have a right to privacy," he told her.

"That is what I was getting at," she replied. "If you have a privacy argument then—"

Chomping at the bit, Climenko broke in. "I sure do."

Before hearing more, she asked a question: "Isn't the issue whether your restriction is too broad and could not be adjusted by some less restrictive alternative?" In the inmates' case, there was lengthy discussion about various less restrictive alternatives to removing the male guards. In pursuing this line of questioning, Judge Motley was assuring him that she'd be exploring similar less restrictive alternatives, such as installing curtains across the players' cubicles or creating lounge areas where interviews would take place.

"Let me speak on that for a minute, Your Honor," Climenko replied.

Before he did, she spoke: "That is why I was asking you about the locker room. That is a simple issue, I gather, if you are on the privacy question. That is what the jail case is about, I think, and that is the Second Circuit case which we would have to consider in deciding this."

Climenko ignored the women inmates' case and moved in a new direction, telling the judge about a last-ditch effort that Kuhn made to try to keep us from ending up in court. "Your Honor, at the end of December last year, Mr. Kuhn, acting out of respect to the size of *Sports Illustrated*, if for no other reason, but certainly acting defensively, got in touch with *Sports Illustrated* and said, 'Let's do something about this; let's see whether we can solve this,'" he told her.[2] "*Sports Illustrated* told him there is no point, no discussion, 'we have already decided to start this lawsuit.' Something could have been worked out," Climenko insisted, but offered no solution to back up this claim. Gesturing toward Fritz, he continued, "But my learned friend here with all of his assurance that what we are doing is coming into court to humiliate women, which we are not, decided they wanted what you see here. They wanted to exploit the publicity value of this lawsuit. This is what they did, and they would not talk about it."

He seemed surprised that Judge Motley had refrained from breaking in so he pressed on. "Your Honor has suggested that something should be understood about baseball, and I respectfully submit to Your Honor, an opinion in a case that the Court of Appeals of the Seventh Circuit decided a couple of days ago, which I respectfully submit would be informative to Your Honor of the character and quality of baseball."

Still, she stayed silent. Had she decided to let him speak at length as she'd let Fritz do? Or was she biding her time?

"Baseball is a specialized business," Climenko declared. "What we are talking about here is not state action. What we are talking about is whether or not baseball has a right in the exercise of whatever intelligence it can muster to find out what the public wants. There is nothing in the constitution that I have ever heard about that says it's impossible for somebody running a business to decide whether a woman should be permitted access to naked men or vice-versa. That is all that there is in this case."

This was his lengthiest statement of this hearing.

Judge Motley wasn't impressed. "Let's get back to the legal issues now," she told him, admonishing him for straying off course. "The first issue is whether the plaintiff has been denied any constitutional right," she said. It felt like she was tutoring him for a test. "We have to first define state action. If you want to get back to the legal issues, let's get back to them and find out, first, whether we have state action. If we get through that, then we will move to what the constitutional claim is. Then, we will move to any other legal questions there are after that."

There it was, her path for the rest of this hearing. Drawn with explicit detail, she was showing him how she expected him to present his case to her. Would he follow?

"Let's get back to *Burton*," she coaxed him. "How did you say you distinguished *Burton* from the instant case?"

"In *Burton*, if Your Honor please, there is a question as to the interrelationship of the maintenance of a restaurant with a parking place," he said, sounding tentative and nervous in calling that city's parking authority a "parking place." "There is a showing of interdependence of those two operations. In this case, all you have is the ownership of the Stadium by the city. There are a number of cases, and we've submitted them to Your Honor," he said, referring her again to his memorandum. "They are there and can be distinguished and [they] govern this case."

Again indicating no interest in those other cases, she quizzed him about *Burton*. "In *Burton*, did the state or city own the parking lot which was adjacent to this restaurant?"

"I believe it did, yes," he replied.

"We have similarly a city-owned facility. Is that it?" she asked.

"Right."

"Being leased to a private enterprise, is that right?" she said, pressing him to go further.

"Yes."

"In addition, what did we have in *Burton* which you say is different in this case?" she asked, pleading for him to finally tell her why *Burton* didn't apply to our case.

"I saw that *Burton* is different from this case, if Your Honor please, because in *Burton* the City could have said 'we will not tolerate racial discrimination in the restaurant, which is part of the overall operation.' In this case, the city comes in and says, 'We have nothing to do with the operation of the Stadium,'" he said. "That is in the affidavit here," he said, gesturing to the defendant's table. "Your Honor has dismissed them [the city of New York] from the case. They have nothing to do with the operation of the Stadium," he reminded her. "They [the New York City defendants named in the lawsuit originally] have no right to tell the Yankees or the baseball commissioner who goes into the locker room."

"Let's take the opposite of that," the judge suggested. "Did they tell the Yankee baseball owners that they could not have women?" Either her exhaustion was showing or she thought it no longer necessary to say "in the locker room" at the end of her queries.

"I beg your pardon?" Climenko replied, startled by her question.

"Taking the opposite of that, did they tell the Yankee baseball owners they could not have women in the locker room? Has the City done that?" she asked again.

"No. All the City has said is 'We are sorry this case has arisen. Can't you find an alternative? We would have been glad to find an alternative, but we were forced into a lawsuit.'"

Without a moment's pause, she explained her dismissal of the city's defendants from this case. "Since the City has not excluded women from this area, I didn't see any basis for keeping the city defendants in here. You admit that they did not direct the exclusion, is that it?"

"No," Climenko replied. "I did not say they did."

Deciding to return to *Burton*, Climenko addressed the differences between that case and ours. "The essential difference is that the restaurant was a public place. The place where these fellows undress is not a public place," he told her. "This is a distinction which is controlling."

Since she'd heard him say this earlier, she was prepared to respond. "Can any male sports reporter go in there or do they discriminate among various men?" she asked, moving him closer to our issue at hand—gender discrimination.

"They do," he said, "Your Honor, we—"

She cut him off. "What male reporters are excluded? Maybe that will help," she said.

"Only accredited male baseball reporters are admitted in. You have to have a badge."

"Among accredited reporters, is there any discrimination against reporters?" she asked, step-by-step drilling toward the nub of our dispute. "Can all accredited reporters come in?"

This reminded me of a pitcher dueling a tough batter at the plate. With each query, she'd brushed him back, leaving him wary of what question she'd throw next. "I think there are occasions when you can't let all accredited reporters in because the space is too small. That happens when at a World Series when you have 250 or 450 reporters coming in," he told her, even though it wasn't true. At the World Series, every accredited writer had locker room access; even I was given access at the 1977 series until Kuhn took mine away. So, it didn't take long for him to abandon this train of argument and turn to offering another baseball history lesson.

"The origin of why it is a private place goes back to the history of baseball. If Your Honor is going to do minimum recognition to baseball and its special place in our jurisprudence, and it has one, I have to ask you to read the opinion of Judge McGarr in *Finley v. Kuhn*, which was affirmed by the Seventh Circuit a few days ago," he implored. "It goes to the question of why there is a Major League Baseball Commissioner and what his powers are." Our case was not an internecine baseball fight like *Finley v. Kuhn*. Nevertheless, Climenko wanted to insert the "best interests of baseball" defense into his argument even though I was not governed by Kuhn. His game did not pay my salary. So what transpired between the Oakland A's owner and Kuhn wasn't relevant to this case. Even so, Climenko started to give the judge another history lesson. "Fifty-five years ago, baseball was almost ruined by a scandal in Chicago concerning the lack of integrity, the dishonesty of the World Series," he told her.

She stopped him. cold. "Did this involve women?" If it didn't, she was telling him, don't tell her the rest of his story.

"No," he replied.

"What is the relevance?"

"If Your Honor, please, obviously it had nothing to do with women. I suggest to Your Honor that nothing I said suggested it," he responded timidly.

Judge Motley was flummoxed. She was trying but failing to keep Climenko on track. "I would like to get to the legal arguments, but I don't know that that case is relevant at all," she told him, referring to *Finley v. Kuhn*.[3] "The

right on which they challenged the commissioner, is that a disputed issue here?"

Climenko said nothing, but Fritz did.

"No," he said, rising to address the judge for the first time from the plaintiff's table.

After Fritz weighed in, Climenko did too, before he left his history lesson to return to state action. "Baseball is a private pursuit. I suggest that there is no state action, and Your Honor cannot find otherwise. That being so, the next question is why are women kept out of the locker room?" Although he'd asked this core question, he didn't answer it. Instead, he circled back to Kuhn's sweeping powers. "That brings you to the question of not whether women were involved in a 1920 [Black Sox scandal] problem about baseball but why there is a commissioner and what his authority is," he explained. "Based on that 1920 situation, he has complete authority over every locker room in organized baseball. The Yankees have no authority whatsoever to do with anything except to comply with his rules based on what he thinks is good health for baseball."

In merging baseball history with our contemporary case, Climenko was on a roll again. For some reason, Judge Motley had let him meander again, but I doubted she'd wait long before reasserting her control. It was anybody's guess as to what Climenko would put forward to cause her to steer him back to the legal issues at hand.

Soon we'd find out.

Chapter Twenty-Three

I relished baseball history, but even I had a hard time following the twists and turns of Climenko's stories. I wondered how Judge Motley was doing with his disjointed monologue.

"Mr. Kuhn went about his investigation in a completely intellectually honest way," Climenko said, picking up his earlier thread. "He asked what the rules were in various sports. He asked what the responses were," he told the judge, sidestepping the fact that Kuhn didn't speak with a single ballplayer or manager before creating this policy. In writing to the teams about his new media policy in April 1975, Kuhn mentioned speaking with "the public relations men" who would enforce his rule. Adopting the imperial "we," Kuhn told them that "we feel the proper course to take is to assist accredited women reporters in every way possibly short of allowing them entrance to the clubhouses." He'd found no reason to issue "any formal directive," he said, but asked the general managers "to be alert to any possible problems." See something, say something by reporting any rumblings to Wirz.

"If Your Honor please," Climenko began anew. It was impossible not to notice how often he included, "Your Honor," in his intro sentences. Fritz hadn't done this. Did this honorific lose its meaning by his repetition, I wondered?

"These suggestions of improper comments on women come not from the baseball commissioner. They come from the responses of *Sports Illustrated*'s subscribers who said, 'We don't want to have your magazine any more now that you have instituted this lawsuit because we think it is an affront,'"

Climenko said, without mentioning the disgruntled subscriber whose letter Fritz featured. After extolling Kuhn's exemplary policymaking process, he'd now put us hip deep in the muck of that subscriber's disparagement of women. This disjuncture was so jarring that I now knew that Fritz's suspenseful *sad* surprise had rattled Climenko. He was retooling his argument on the fly, which was never a good idea. "It's not a question as to whether you think it's an affront or whether I think it's an affront," he posited. "The question is whether Kuhn, in a responsible way, went about the process of finding out what the reaction was to the spectacle of women being given access to the locker room. Based on what he was told, he decided a large fraction of the citizens of this country were against it."

So public opinion had framed Kuhn's policy. But as soon as he'd said this, Climenko must have realized the legal hole into which he'd tumbled. In hearing him cite Kuhn's reliance on public opinion as his policy's legal justification, Judge Motley might have heard the echoes of southerners defending Jim Crow by touting its popularity, and using this as a rationale for its discriminatory treatment. Quickly, Climenko qualified his words to make clear his regret for what his words implied. "This is not a question of deciding constitutional questions by polls," he assured her. "This is a question as to whether or not, as part of his authority, he was within his province in deciding that having women in locker rooms was not consistent with the interests of baseball." He'd retreated to the comfort of baseball's "best interests" argument even if the judge wasn't impressed when he'd gone there before. "This is not for you, Your Honor, and it's not for me, and it's not for the Constitution [to decide]. There is no state action in this case," he said. "That being so, if Your Honor please, the only questions that remain are the questions of the so-called First Amendment problems."

"If Your Honor please, there is no First Amendment problem here," Climenko asserted. "There is enough access to the information. *Sports Illustrated* covered the stories at the World Series. The women reporters [at SI] are not being discriminated against in any way except that they are not permitted in the presence of naked baseball players."

After again pairing me with those naked men, Climenko stopped talking. He seemed to anticipate that Judge Motley would speak. When she didn't, he did, retreating to the Fourteenth Amendment on which Judge Motley was likely to base her ruling if she agreed with Fritz on state action. "If anybody can convert men's nudity into a Fourteenth Amendment problem on private property," Climenko said forcefully before he stopped talking. I waited for him to finish his thought. Then, shaking his head as if to underscore his

incredulity at such a conversion, he told Judge Motley, "I don't know how it can be done."

With that performance, he corralled her attention. "Let me see if I understand your argument and that is that the locker room is private. Is that it?"

"Yes," he replied, relieved that she finally understood.

But she hadn't finished her thought. "It's private, although any male reporter who is accredited can enter, if there is room, and interview the players. Is that it?"

I expected his cautious response.

"By invitation, by authorization. No one comes in there except with a badge," he told her. "Kuhn will not give a badge to the women reporters." Of course, I was given an entry badge at the 1977 World Series, which he didn't mention. "He says to the women, 'to the extent you want to carry out your reporter function, I will give you, as best I can, equivalent facilities, but not in the presence of naked ballplayers. Your Honor may not like this. The people back there may not like it," he said, turning to look in my direction. "But it's within his province [of authority]. That is what we are talking about in this case."

She didn't respond, so he continued to speak.

"It's also suggested by the American Civil Liberties Union that there is discrimination in employment involved here," Climenko said, referring to its amicus brief in support of my case. "There is no discrimination in employment. As Mr. Schwarz says, 'if you look at the first page of *Sports Illustrated*, you will find there are more female reporters than there are men.'" By "first page," he meant SI's masthead listing staffers, by name, in job categories. The reporter job was on a low rung on its editorial ladder and top heavy with women who fact-checked stories written mostly by men. Climenko should not have been surprised that women far outnumbered men in this role. To cite this high number of women as proof of a lack of employment discrimination was absurd. We'd need to rely on Judge Motley's recall of what Fritz sent her about Time Inc.'s long-standing challenges with treating its women fairly. In reading this history, she'd appreciate why Climenko's boast about there being so many women at SI proved to her the opposite of his claim. I chalked this up to his fondness for shading the truth by ignoring inconvenient truths. "There is no question about this particular plaintiff being discriminated against with respect to her right to a salary or to promotion or anything of the sort," he told the judge. This was patently false. "That, too, is a feigned issue," he claimed. "The only question ultimately you come down to is whether or not someone can somehow convert, distort, or depart from the cases and say

there is state action and, therefore, we will find something in the Fourteenth Amendment that says that if a male reporter is permitted in a locker room with naked players, then women reporters must be given the same access."

Modulating his tone, Climenko told her, "I dispute it."

After briefly pausing, he spoke again. This time he shocked me. "That is our case."

* * *

Not so fast, Judge Motley told him. Climenko, who was heading to the defense team's table, stopped, turned, and looked up at her. Apparently, she wasn't going let him quit until she got him to agree to a solution. He'd been a reluctant sparring partner, but she was keeping him in ring.

"You will recall I asked a while ago whether the men were compelled to be naked on this occasion when the reporters are interviewing them," she reminded him. "I understood you to say they are not compelled to undress."

"They are not compelled to undress. They have a right to undress," he replied hesitantly. Essentially, he was repeating that the players' *right* to be naked merited the same legal deference as did my *right* to be treated the same by baseball as the men. "They are playing baseball. These are the quarters for them to undress in. I can't argue with Your Honor on that. That's either acceptable to Your Honor or it isn't," he said. "Nobody says when you get through playing you have to undress."

Again, his answer left her perplexed.

"I am trying to get at why this is being injected into the case if the men do not have to get undressed at this point. There is no requirement. They could protect their privacy some other way," she said, driving home her interest in finding a less restrictive remedy to what he was telling her was an insurmountable problem. Would he play along?

"I am not injecting anything into this matter," he responded testily. "I'm telling Your Honor the way the things go is when a player gets finished with a game, he undresses. Nobody tells him he must undress. I don't think Your Honor can change the natural events we're talking about. The problem of the case cannot be distorted by suggesting that somebody tells them they must undress. I reject that suggestion, Your Honor."

She was not deterred. "I am trying to get in this record whether there is, as a matter of fact, a nakedness issue," she said.

"What?" he exclaimed.

"You said the men are nude, and so forth," she said, before he leapt in.

"There categorically is," Climenko bellowed. "You can't change that any more than you can change what happens in a men's locker room at a golf club. Men undress after they play golf. Men will undress to shower after they play baseball. They are not directed to. That is what happens. I don't see how Your Honor can let the fact roll out any other way."

She said nothing, so Climenko spoke, falling back to the *Finley* decision, which hadn't interested her when he mentioned it earlier. "Your Honor will find in the *Finley* case the first question Judge McGarr decided was that there was no state action there. We have given Your Honor a copy of his memorandum on that subject. Other cases say the same. All you have here is municipal ownership of a stadium. You can't make it into state action, and if you don't have state action, everything else that is contended here falls."

When I woke up on this April morning, I'd never heard the words "state action." By now I'd heard them enough to know that what Climenko had just said was correct. If Judge Motley didn't agree with Fritz's argument on state action, we'd lose. But nothing Climenko had said seemed convincing enough to counter Fritz's presentation.

"Let's assume that I find that this case is not distinguishable from *Burton*," Judge Motley told him. Was she tipping her hand in saying she would apply the *Burton* precedent in our case? Or was she testing the waters to elicit a helpful response from him? "Would you proceed then to discuss the plaintiff's claims of denial of equal protection because she is a woman reporter?" she demanded of him.

"Not at all," he said. "What we have been perfectly willing, in response to a public sense of propriety, to say is she can't be there in the presence of naked men. Because we think the public doesn't want that, we will give her the best alternative we can. That is what we did. It was turned down. This lawsuit was instituted. Before that, Your Honor, we went to every length that we could to give this lady an opportunity."

While she had invited him to speak to the constitutional issues on which she might rule, he'd refused to engage on that level. In proffering him this second chance, she'd counseled him to listen hard to her questions and respond to what she asked. Now she tried again.

"I would like to get back to the proposition I just put to you," she told him. "Assume for the purposes of this argument the Court finds that the relationship between the city and the baseball interest at Yankee Stadium is indistinguishable from the situation in *Burton* and that therefore we have state action. The next question is whether, having found state involvement in

the Yankee Stadium situation, the plaintiff has any valid Constitutional right, such as she claims here, such as would meet the requirements afforded?"

"I will answer both parts of your question," Climenko said courteously, without the "but" that we knew was coming. "I cannot indulge in your assumption because I don't think you can do it," he replied. "Assuming you did find it, you can't reach a proposition of discrimination which assumes a constitutional level of importance. I do not think that the Court can say that barring a woman from access to the presence of naked men at the same time you give her other opportunities to interview them is the kind of discrimination proscribed by any constitution," he said. He'd raised his voice and harshened his tone in working his way through that reply. "That is where we stand in this matter. We want—"

She interrupted him. "Am I correct in—"

Then he interrupted her. Climenko had started doing this with some regularity, although for a lawyer to do this was highly irregular. "We want these ladies to be reporters. We want them to have every opportunity that they need to develop their careers, but we say it's not necessary for them to have access to a locker room to do that," he argued. "We submit to Your Honor, as part of this record, affidavits of a couple of lady reporters who say, 'we do our job, and we don't have to go into the locker room.'"

I was sure she'd read them, but she didn't ask him to elaborate. Instead, she pressed him on a point that Fritz made earlier. "Is Mr. Schwarz correct when he asserts that the players were polled and said that they had no objection to women being there?"

"Some of them did and some of them did not. You have it both ways, Your Honor," he replied, again shading the truth, which I believe she knew. Certainly, he knew the World Series teams affirmed my right to work in their locker rooms *and* I had that press badge that he'd told the judge made it okay for me to work in the locker rooms.

"I thought you said all of them," she said, glaring at Fritz.

Fritz stood to respond. "The word in their document was 'overwhelming' 1976, summer," he said, referencing the Yankees favorable vote.

When Climenko spoke, Fritz sat. "Obviously Your Honor has not had the opportunity to read the record," he said, this time challenging her diligence in preparing for the hearing. "We've submitted to Your Honor affidavits by players, by managers, by other officials who say that they do not want women to have access to the locker room when the players are undressed."

"Because it's an invasion of their privacy?"

"That is right," he responded.

"Then, the question is whether there is some other less restrictive alternative, isn't that so?" she asked, prodding him to come up with a remedy that didn't treat me differently than it did men. After all, when Fritz cited the case *Cleveland Board of Education v. LaFleur*, he reminded the court that Kuhn couldn't justify his "ban upon access to the locker room by female reporters . . . because the ban is not the less restrictive means of serving the interest which the defendants claim to rely on."

"Yes, we offered a *less* restrictive alternative," Climenko said, essentially telling her that she should accept Kuhn's separate accommodations as being as good as he could do for me. To do this, meant her accepting a solution in which separate stood in for equal. I doubted she would.

"If there is a constitutional right here and it's being infringed—" Judge Motley said.

She couldn't finish her thought when Climenko interrupted and spoke over her. "We offered it, and it was turned down," he insisted, without saying what "it" was. "This lawsuit was instituted because arbitrarily the plaintiff decided that they prefer the lawsuit."

"Your suggested alternative was what?" she inquired.

"That for each woman reporter who was not given access to the locker room, we would provide every possible interviewing facility to that lady," he replied. "We would arrange for any player who wanted to be interviewed to be interviewed. We would do it as quickly as possible. We would resort to any arrangements that we could possibly conceive of that would make up for the lady reporter not being permitted into the locker room right after the game. We tried to do it, and it was turned down."

* * *

He had lied again.

I did not turn down baseball's separate arrangement after Game 6 of the World Series. I did protest doing it, but still I worked under Kuhn's policy by relying on Larry Shenk to be my designated runner. To anyone watching Kuhn's policy at work, it was an unmitigated disaster—even when I was the only woman whom baseball had to deal with that night. I'd documented why things fell apart in my October 20 memo to Kuhn, which was among the documents Fritz sent to the judge. I'd concluded that Kuhn's special "arrangement" was impractical, insulting, and incapable of working for any woman, ever. It was impossible for me to report on either team after that sixth game.

"We are still willing to try to do it," he said. "I don't think as a practical matter—"

Here, the judge broke in. "Your suggestion is that there is still a possibility that the case can be settled?" she asked, clinging to a thin thread of hope. If she could broker an agreement in the courtroom, she'd never have to hear about baseball or locker rooms again.

Sensing a trap, Climenko backtracked. He preferred to dwell in the past to avoid letting her drag him into an uncertain future.

"We tried to settle the case, and we were frustrated. Your Honor, on the 29th of December, Mr. Kuhn called up Mr. Meyers, who is the publisher of the magazine. This is the fourth largest money-producing magazine in the country."

"*Sports Illustrated*?" she asked. Judge Motley was incredulous that Kuhn had tried to broker an end-around settlement on the day before Time Inc. filed its complaint with the court.

"Yes, we went to them and said, 'Please sit down and try to work this out.' Meyers said, 'It's too late.'" Climenko proceeded. "If Your Honor please, the action of *Sports Illustrated* is the action of a plaintiff intent on instituting an action that has marginal questions unnecessarily embarrassing all of us—the law, baseball, and everybody else. And for no purpose whatsoever except, by my standards, exploiting the titillating value of this case."

How precious it was to hear Kuhn's lawyer charging us with "exploiting the *titillation value* of this case." It was an outrageous accusation. Nudity was never an issue I raised, and I was the person insisting that baseball's "titillating" characterizations of my case should not be framing the public debate. But baseball kept on inserting nakedness into news coverage—just as Climenko was doing in this hearing, even after he admitted that no player had to be undressed when reporters were with them. Shower and toilet facilities were walled off—no writer could go there—and a player could return to the locker room wearing any piece of clothing or with a towel wrapped around him. This was hardly a huge imposition.

"If Your Honor please, reporters will continue to report. Journalism will continue. The First Amendment will be protected. Everybody will be all right, even if women reporters aren't permitted to enter the Yankees' locker room," Climenko beseeched.

How cavalier of him! Surely, I and other women sportswriters ought to be counted in his "everybody." Yet he'd told Judge Motley that I'd "be all right" if she did not grant equal access. Why be surprised? Climenko had

said that me working under Kuhn's separate accommodations policy was "no more than a minor hindrance" in pursuit of my "present goals as a reporter."

Had Judge Motley heard his dismissal of women as I had?

I presumed she'd read the April 12 memo in which my lawyer responded to that "minor hindrance" comment. In doing so, he distinguished my situation from what would be baseball's minor inconveniences in turning to less restrictive alternatives. In his strong reply, Fritz wrote that "the possible inconvenience of wearing a towel or bathrobe is not a sufficient justification for the deprivation of plaintiff's constitutional right to equal protection."

Perhaps with his point in mind, she asked Climenko: "With respect to the assertion of privacy, at least by some of the players, isn't it possible for them to use curtains in front of this cubicle?" At this point, she referred him to tab #2 in our exhibits, which was that photo of our associate lawyer, Calvin House, sitting in a Yankees' cubicle. "Couldn't he put up a curtain if he wanted to undress and hide himself from these women?" she asked, provoking muted laughter from our side of the courtroom.

"There is humor value as soon as you put the question," Climenko observed. "We get into the sex value of this awful case. These people cannot restrain themselves when they hear Your Honor's question."

Resolute in her quest to find a less restrictive alternative, she advised Climenko, "Let's try not to pay attention to the people in the audience. I will direct them to refrain from laughing, otherwise we will have to clear the courtroom."

By then, the laughter was gone, not to return. The courtroom returned to its prior silence with the judge fully in command.

"Isn't it possible for the player to erect a curtain of some kind?"

"It's possible, Your Honor."

"Or put swinging doors so if he wants to get behind the door when a woman comes in, he can do that?" she asked.

"It's possible," he said. "It's possible to do what the plaintiff in this case says, 'wear towels.'"

* * *

In January, as the guest on Howard Cosell's *ABC Sports Magazine* TV show, I'd posited that a well-placed towel would be a solution to baseball's nudity concerns.[1]

Early in my interview, Cosell had questioned me about male writers working in women's locker rooms. "What about women's college basketball?" he'd asked.[2] I had shared my recent experience at Madison Square Garden after a women's college basketball was played there two weeks earlier. "Men were in the locker room. Now, the women solved that problem by putting their sweatsuits on and leaving the Garden in sweats," I'd told him. "But the situation was such that maybe they'll just have to get a bigger towel."

Cosell laughed.

"I mean it. Seems as simple as that. If one has access, the other one needs it," I'd said.

"Isn't nudity a problem?" he wanted to know.

"Howard, there are 11 people on a basketball team, 25 on a baseball team. It's not like high school where the bell rings and everyone changes at the same pace. You can go to one person who is surrounded by people and who has not yet gone to take a shower, talk with him. When another person returns from the shower area and is dressed, you can talk to him. It's all in how you handle yourself. And if you handle yourself in a job like you do in any other job, it will work," I'd replied.

At this point he'd paused our conversation to show clips from interviews he'd done with Kuhn and the Dodgers' player rep, Tommy John. Then, he asked me to respond. I'd heard Kuhn say that when ballplayers were asked privately about women in the locker room, they don't want us there. John had said that although he might feel embarrassed with me in the locker room, I had every right to work there.

I reacted to what the men said.

Howard, it's a two-sided coin for me also. It's not something that I enjoy putting a player ill at ease. I'm obviously not going to get a good story or a good reaction from someone if he's ill at ease I don't mean to do that. As for the privacy question, if you can call a locker room where you have 30 men who didn't have anything to do with the game walking around and talking to you and still maintain that that's a private situation, I don't buy that.

It's a situation where they're a public figure at that point. They're not a private individual in their home. And as many people have said, "it's a question that nothing short of a towel won't solve." Cannot these players who make these incredible salaries afford to buy a towel? And it would make a terrific concession stand item to get these towels with the team logos on them, and say, "This is the kind of towel that so and so puts on after the game in the locker room." I mean, the teams could stand to make a terrific profit from this.

But to be serious, it's a situation where I don't mean to embarrass anyone. I don't want to embarrass anyone. I would go out of my way, and I have in NBA locker rooms, to not embarrass players. . . . It's a situation of working with people's mutual respect for each other's profession.

"You talk very well," Cosell said. "Now we'll see what happens in court."

With the taping over, I started to leave. But then Cosell asked if we could continue the conversation at a nearby hotel bar. I agreed, and once there, sipped white wine while he drank martinis, the drink I'd fetched for him at his voice-overs at ABC Sports. Back then, I could not have fathomed that I'd be a guest on his TV show that we'd tape on the stage where the Beatles performed on the *Ed Sullivan Show*. I'd watched that performance on my family's black-and-white TV, squealing as twelve-year-old girls did.

On Super Bowl Sunday, I tuned in to watch his show. I was surprised by how quickly it went by and pleased by how it turned out.

Of course, many disagreed with my assessment, as I realized when a second wave of letters reached me at *Sports Illustrated*. From Pepper Pike, Ohio, Bill Woerner summed up in one sentence his whimsical view, which I enjoyed more than the notes from my many angry detractors: "Sir: Seeing Melissa Ludtke in a man's locker room would be as nifty as Howard in a woman's." In a single paragraph, eighteen-year-old Beth Buckley raised my spirits. "Dear Ms. Ludtke," she began, before writing she was "seriously considering going into some form of sports journalism": "I was very impressed with your arguments and totally agree with what you said. . . . I really hope that this controversy will be cleared up soon so women now, and in the years to come, will have a much easier time doing their jobs. . . . Even though the field is quickly filling with women, you and other women in sports give hope to girls that are just starting out. Good luck!!!"

* * *

Kuhn's attorney admitted that the judge's ideas were doable, but that didn't mean he was going to allow any of them to happen. "It's not the way baseball people are accustomed to having freedom of access after their own game," he told her. "I don't think it's the province of the Court to inject its authority into that situation. That is the problem. You can tell them they can't get undressed. Is that the function of this Court?"

"No," Judge Motley replied. She couldn't, and wouldn't, do that. "I was suggesting that there was a less sweeping alternative to the one that baseball

proposed here with respect to privacy. That is, the men whose privacy may be invaded by them can protect themselves by use of curtains. First, you said they are not required to undress."

"They are not required to take a shower, for that matter," Climenko replied with sarcasm.

"I am talking about when the reporters are present after a game for the purpose of interviews," she reminded him. "I assume they don't stay there forever, that they go home eventually."

"As soon as they can," he replied.

"The reporters must get tired. But we, lawyers and judges, do not end at five and we started at nine o'clock this morning," she said, reminding him she had her eye on the clock. "I gather other people go home, Mr. Climenko. I am talking now only about that situation where the reporters are present for the purpose of interviewing players immediately after a game when they are still fresh with respect to their recollection on what occurred on the field, and that kind of thing, and still are talking about it as they emerge from the field."

"Right," he replied.

"In that connection, as I said, there seems to be some other less restrictive alternative to what we have here and that is the erection of curtains or players to use towels around themselves or some such thing," she told him. Her weariness was evident in the impreciseness of her words.

"May I speak to that, Your Honor?"

"Yes."

"I have talked to Mr. Kuhn about this, and I've talked to other people who have executive responsibilities in connection with baseball. They think that these suggestions just don't work or wouldn't work," he told her. "Mr. Kuhn has really given serious thought to that. If Your Honor will read Kuhn's deposition, I hope you'll see that this is not a man 27 miles to the right of Queen Victoria." That wasn't a comparison I'd heard used before to describe a man who held conservative values. "He is a man of his time. He has thought about these problems. He knows more about it than you do, or I do, and I say that with the greatest respect. He has been at the top of this game for at least 10 years. He thinks it wouldn't work. This is his job. He is an expert." He concluded with another nod to Kuhn's omnificence. "He thinks the only alternative that is available, that is feasible, is the alternative of giving the lady reporter separate, substitute, interviewing facilities."

When Judge Motley said nothing, Climenko pushed on. "If Your Honor please, I put it to Your Honor out of respect for Your Honor's function that

this case can't be disposed of on the basis of directing towels, bathrobes, or a screen in front of these cubicles," he insisted. "If it can't be, and if we are confronted ultimately with the question that no other alternative will be accepted by the plaintiff, then we have the horrible moment in our lives of saying that we have a constitutional question as to whether this district court must tell organized baseball that female reporters must be permitted in the locker room when men are not dressed."

Again, when Judge Motley didn't react, he kept going. "I don't think we have reached that point. I don't think it is within the competence of the Court. That is why I start with the proposition that there is no state action here. Whatever way Your Honor may feel about an intent to find it, you can't because the cases are otherwise. That being so, that ends the entire problem."

By retreating to that state action question, Climenko had finally returned to common ground with the judge.

"I agree with you the problem is ended if the Court finds no state action," she told him. "But I suggest to you, Mr. Climenko, that is a difficult question. That is not easily dismissed because of the ownership of these premises by the City and the City's involvement in this activity. As suggested by plaintiff's counsel, they get a share of the revenues depending upon attendance and so forth. That is not an easily disposed of question, as you suggest, that there just is not any state action here." Still, she tossed him a lifeline with a cautionary warning. "I suggest to you that we ought to seriously consider this constitutional claim of the plaintiff and whether there is some resolution of this problem short of the Court's involvement if the parties cannot reach a reasonable accommodation. It's not an easy question to say there is no state action here."

She'd signaled to him, in every way she could short of telling him that she'd likely rule with a finding of state action. Still, he refused to budge from his usual rhetoric.

"If Your Honor will permit me to speak for a moment out of respect for Your Honor's office and your person, and you know I have respect for both," he said, searching for his best response. "It's one thing to say it's not an easy question to deny that there is state action. I suggest to Your Honor it would be much more difficult proposition to find that there is. We have submitted to Your Honor cases which hold that there isn't. These cases can be overruled, perhaps," he told her, before offering her a concluding thought: "I doubt it."

Chapter Twenty-Four

Fritz had built our case on the legal foundation of *Burton v. Wilmington Parking Authority*. This left Climenko two tasks: He had to show why the *Burton* precedent on state action didn't apply in our case; then he had to present his legal reasons why the judge should rule for Kuhn.

At this last stage, neither was going well.

"Can you tell me specifically?" Judge Motley said, pushing him to get into the details of why he didn't believe state action applied in our case. To do this, he'd need to refute what Fritz had said. Persuade me, she was telling him, why she should disregard the evidence that Fritz had presented about the various financial linkages in the stadium lease. When she asked before, he had not given her the details she was seeking.

This time, would he comply?

"Yes, let me tell you about one specific case, *Finley v. Kuhn*, we submitted to Your Honor only yesterday," Climenko said. I felt like someone had put money in a juke box and hit the same buttons again. "The simple question ultimately was whether Kuhn had the authority to tell the owner of a big-league team that he couldn't sell three players and get $5 million. Judge McGarr decided he had that authority." Finley's lawyer had argued in his motion that "there was state action here because the stadium is owned by the city." But, as Climenko told her, "McGarr immediately said there isn't state action. That is a ruling made in that case and we've submitted the decision to Your Honor. It isn't Judge McGarr on his own, but he cites the Supreme Court of the State of New York and a case in the Seventh Circuit. We respectfully invite your attention to it."

"Is that a Court of Appeals decision? Is Judge McGarr in the Court of Appeals in the Seventh Circuit?" Judge Motley asked.

"Let me be very accurate with Your Honor about that," he began. "By the time the case goes to the Court of Appeals that [state action] question has been eliminated from the case. This is McGarr on that question. He is at least a district judge," he said, confirming that the circuit court's ruling did not involve this question. "Let's give him [McGarr] credit for that," Climenko chimed in, telling Judge Motley that McGarr citied the U.S. Supreme Court decision in *Jackson v. Metropolitan Edison Co*. "you will find it at the end of the memorandum we submitted to Your Honor yesterday. There are other cases which say the same thing cited in our brief. If Your Honor says to me, what is the authority? There is the authority. Your Honor may not like it."

"Are there other cases in your brief?"

"Yes."

"Similar to that?"

"Yes. We think they are similar," he replied.

Fritz vigorously shook his head conveying his strong disagreement with Climenko's characterization of those cases as similar to ours. When she looked at Fritz, Climenko did too. "Mr. Schwarz can shake his head, but we think they are similar. We think it is an established proposition that there is no sufficient nexus between the activity of the state or city, only mere owner-ship of the facility. It's on that that we rest this proposition," he said.

He might have stopped with his unswerving belief that New York's owner-ship of this stadium did not, by itself, constitute state action. But he didn't. Instead, he went on to reiterate words that by now everyone in the courtroom knew by heart: "I go back to what I said 30 minutes ago that the City of New York has nothing to do with the way in which the Yankees operate the locker room. Mr. Kuhn has everything to do it. The Yankees, whom I dearly love, have no opposition [to Kuhn] here. They must abide by what he decides because that is in the compact that governs baseball," he reminded her.

Climenko looked at his watch.

"Since it is 5:35 I don't want to take Your Honor's time to go into the his-tory of this. We've given it to you in a memorandum, and, if Your Honor please, the Seventh Circuit case of *Finley* is the starting point. All instances of prejudice against baseball, such as a suggestion that a type of sex discrimi-nation exists here, are not the controlling questions of law. Let me again say, don't let Mr. Schwarz suggest to you that we make any slurring suggestion about women reporters. We never did. When they started this case all we did was to say to *Sports Illustrated* show us your papers in the case. They came up

with 60 pages or more of rejections by their own subscribers saying we want to have no more of you because of what you have done in starting the lawsuit. We think it's ridiculous. We did not write those letters. It's their readers who did."

He'd just shown me how gravely Fritz's surprise[1] had affected him.

"I think you are right," she consoled him. "This case certainly can't be decided by someone writing a letter criticizing anybody."

"Of course, it can't be," he said with a surge of confidence. This was the first time they'd agreed today. "It has nothing to do with it. It's not a popularity question. It's a question of whether baseball has a right in its proprietary interests to say it won't have women in the same room with naked players. I am telling you that there is no Constitutional problem created. That I think is the beginning and end of this story."

Was he resting his case a second time? It seemed so when I saw him walk to the defense table to rejoin his team of lawyers. But he'd barely sat when he was on his feet again, apparently prompted by another attorney. "If Your Honor please, I thought that this had been submitted and I am caught short by my learned friends on my left and right," he told her. "There is a five-page supplemental memorandum on why there should be no state action, which we would like to submit to the Court. We gave a copy to Mr. Schwarz."

"While you are on your feet, Mr. Climenko, let me ask you about the Chicago case [*Charles O. Finley & Co. v. Kuhn*]. In that case didn't they simply hold that the question of trading players did not involve state action?" she asked him. In her questioning about *Finley*, I suspected she'd read its entire record since she expected Climenko to rely on it.

"No," he replied. "On the question of trading players, this had nothing to do with state action."

"That is what I am saying, isn't that the holding in that case?"

"The holding is that the commissioner's powers are omnibus powers; he may do anything he thinks is necessary in the interest of baseball," he said, evading her specific query again. "One of the things he can do is to rescind a trade of players. Another thing he can do here is to decide who has access to the locker room."

"I think I have your argument now," she told him.

Either she had his argument, or she realized it made no sense to keep quizzing him on a topic he was doing his best to avoid. So she swiveled to ask him "one final question," as she put it. "Are TV cameras permitted in the locker room at this juncture that we are talking about immediately after the game when the players are fresh off the field? Are TV cameras in there?"

Baseball fans knew a TV camera is always in the World Series team's winning locker room for the trophy presentation. In 1977 Billy Martin, George Steinbrenner, and Reggie Jackson were interviewed in front of it.

"No," Climenko replied. Once again, his response was wrong, so his pattern of qualifying his answers resumed. "Let's be precise about it, Your Honor. At the end of the last World Series game, there were TV cameras in the locker room. There were no naked players within the scope of the camera." By saying this, he opened a huge hole in his argument, and Judge Motley leaped in. "That is what I was talking about. This nakedness is not necessary at this juncture. That is precisely where I started, Mr. Climenko," she told him. "This nakedness has been injected in this case, and you've just answered the question that it's not really here."

"I must disagree with Your Honor," he replied rapidly. "What happens at the very end of the World Series in connection with a TV report lasts a few minutes and has nothing to do with what normally happens during the season as to how players finish a game and get ready to take a shower. I just can't agree with the implication of Your Honor's question," he insisted. "It just isn't so."

"I don't think that just miscellaneous women ought to be looking at naked men either," she replied, revealing for the first time her perspective that aligned with her prudishness that her friends told Fritz about. "But I don't think it's here. I don't see that there is any nakedness at all involved here. It's being injected as a reason for excluding women. If TV cameras were there, why couldn't women be there?" Hearing her words, my mind raced back to Pauley's interview with me when she ended it by wondering aloud about the sex of the TV camera in the locker room when I wasn't allowed inside.[2] Judge Motley knew that Kuhn had forced me to stand outside the locker room, when in homes across America, female viewers watched scenes inside that were off limits for me.

"It shows there is no necessity for anybody to see anybody naked," she told Climenko.

By now, she'd rattled him to the point where he found no words with which to respond.

"Will you let Mr. Andrews address Your Honor's comments?" he asked, referring to his cocounsel.

Judge Motley nodded, and soon Thomas A. Andrews was standing where Climenko had stood to speak in support of Kuhn. Slumped in his chair, Climenko looked exhausted.

* * *

"I happen to know exactly how that was set up, and I think I can assist Your Honor," Andrews said. "There was a very small backdrop set up in the locker room and players were brought before it so that the camera did not scan the entire locker room so the public, coast to coast, did not see the entire locker room. All they saw was a player in front of a backdrop. There was nakedness generally about the locker room, but the TV—"

Judge Motley broke in. "Precautions were taken to screen the nakedness. That is what I am saying." She seemed satisfied that she'd heard enough to reach this conclusion, but Andrews would not let the matter end there. "This is a precaution you can take for the one eye of the TV camera that you can control directly forward. You can't take it for the roving eye of a human being who has the entire field of the locker room before her," he told her, trying to finesse his way out of the corner she'd put him in. One phrase I heard distinctly was "the roving eye of a human being," which he'd lifted from the sportswriters' supposition that with my "roving eye" I'd leer at naked men. However, judging from our judge's reactions, the defense team was going a bit overboard in its emphasis on the comingling of the naked players with my indecent intentions. While they focused on this, Judge Motley was telling them that nakedness wasn't an issue.

"Can't the player just protect himself by a curtain?" she asked Andrews, posing to him a question she'd put to Climenko. "Put a curtain on front of his cubicle if he doesn't want anybody to see him or a towel or something like that while he is naked. I don't suggest that he ought to be in front of anybody naked. It seems to me he doesn't have to be. This is just being injected in here. He doesn't have to be naked."

"It's the women being injected into the locker room," he said with a brash certainty that Climenko hadn't possessed. He'd seemed to be back on his heels, while this younger lawyer was faster on his feet and more adroit with words. "Nakedness is indigenous to the locker room and women are not," Andrews added, again with his sharp-edged reply. I sat upright, more attentive to his words than I'd been with Climenko's. "There are many affidavits, which you will have an opportunity to read, which establish that nakedness and openness are part of the entire spirit and atmosphere of the locker room. These cubicles are tiny. To put these men who are star players behind a curtain and in bathrobes to go to shower would cut down on their access," he explained.

Andrews was using our word—access—against us. When on TV I'd seen Muhammad Ali wear a bathrobe as the writers surrounded him to talk after a fight, it had never crossed my mind that in doing so he had "cut down on

his access." Access to what? I didn't know what he'd meant by "access," and evidently Judge Motley didn't either.

"Cut down on their access to one another?" she said, asking him to clarify this point.

"When a fellow comes off the field, he takes his clothes off and casually walks about talking with his friends while he undoes his shirt," Andrews explained. His descriptive details brought the locker room scene to life in ways that Climenko never managed to do. "They talk to one another in and out of the shower room."

"Yes, they talk to each other," she said. In repeating what he'd said, she seemed skeptical about what this had to do with what players wore or didn't wear while they talked.

"They visit one another at the cubicle," he told her again. "They don't go behind cubicles and hide from one another."

"They could if they didn't want anybody to see them naked," she countered, appearing a bit bewildered about where Andrews was leading her.

"It would change baseball, the locker room, and the way teammates have related to one another for one hundred years," he declared.

So baseball's argument did land on tradition triumphing over equality.

Judge Motley seemed uncertain about what to ask next, so she called on Fritz, asking him to approach her bench. When he was at his usual spot, he spoke without a further prompt.

"I want to reply—I know it's late—to the one legal point, and that is the *Finley v. Kuhn* case in Chicago that involved the question of trading players," he said. Hearing no resistance, he continued. "In *Finley v. Kuhn*, it was held that Mr. Finley, who owns the team in Oakland, had agreed, as all other owners had, not to seek recourse in the courts with respect to disputes with the commissioner. Obviously, neither Ludtke nor Time have made any such agreement. Indeed, the contrary exists here," he said. "At page 167 of the lease, the New York Yankees have agreed with the City of New York to comply with federal law and state law, as well as city law, so on the subject of state action this is the first distinction."

He'd put me at ease in returning Judge Motley to the core of our case.

"As I have indicated, that is a substantial problem here, one which I would like to address to you that Mr. Climenko has raised," she said when Fritz had finished. "His contention is that the locker room is a private area. It's not really a public area, although the rest of the Stadium might be. Because it is private, the baseball commissioner can regulate what occurs there."

"Your Honor," Fritz replied, adopting his opponent's use of this honorific greeting, "it is part of the facility which New York City owns and paid to renovate. New York City, in the lease, moreover—"

She cut him off, not needing to hear what he'd already said about the lease.

"How big is this area? Do you have any idea?" she asked, referring to the locker room. "The picture doesn't state the dimensions."

Fritz immediately directed her to tab #1 of the exhibits he'd submitted, then spoke. "The locker room itself is 40 feet by 44 feet. If you extrapolate that to the rest of the chart, I'd say the whole clubhouse is about 100 feet by 44 feet," he said. He'd answered her question, but since she'd given him this opportunity to speak, he wasn't about to pass up a chance to respond to her dialogue with the defense attorneys.

"As Your Honor pointed out, we are not talking about a nakedness issue here. We are not trying to get into the toilet room or the showers. No reporters get in there. Commissioner Kuhn has never been in there. Those are private places left for the players. They are left to them and them alone," he told her. "We are talking just about the locker room. In that locker room it's perfectly possible to wear a towel. It's perfectly possible to dress somewhere else. That is what some people do in basketball. There is no nakedness issue," he assured her, echoing her words. "No one has to be naked in that room." Then, returning to *Finley v. Kuhn*, Fritz directed his comments to what Climenko had argued in his recent memorandum. "They try to say in one of their papers submitted this week that baseball is completely immune from the jurisdiction of the courts on any subject because it has been held that the antitrust laws don't apply to baseball," he said. "The Supreme Court has repeatedly indicated that that ruling does not have anything to do with anything other than antitrust. The Supreme Court called that case an anomaly."

Fritz lost me again with his dip into antitrust rulings. I hoped he'd explain. "Baseball is not, I venture to say, immune from the constitution," he reminded the judge. "It's not immune from the laws that prohibit discrimination. As to those matters, Your Honor, the courts and not the commissioner of baseball is the final umpire." With that explanation, I understood.

Fritz's exchanges with the judge also revived Climenko, who rose to speak.

"I represent baseball," he stated tersely, as if feeling he had to reassert his lead role on his team. "We don't take the position that we are immune from the government of this country or immune from submission of the activities of the federal courts. We are here. We've not been cavalier about this case," he assured Judge Motley. "We do say, if Your Honor please, that you don't

reach the kind of constitutional question in this case that would prompt a judge to tell players when they can undress after a game, and that is all there is. No one is injecting nakedness. Nakedness occurs because people undress after a game. I didn't inject it."

With Climenko reengaged, Judge Motley had a few more questions for him. "In that respect, let me read to you in *Forts v. Ward*, the case of the prisoners, this statement that the Second Circuit said in a footnote. That case involved female inmates complaining about male guards in the ladies' room," she said, reintroducing it to him. "The Second Circuit said: 'If the female inmates are responsible for their own exposure, arguably the conduct of the guards could not be characterized as invading privacy rights.' What do you say to that?"

Throughout this hearing, Judge Motley's thorough preparation had been evident. Her deep dive into *Forts v. Ward* signaled her belief that the case held relevance to ours. Late in our hearing, she was using it again to elicit a response from Climenko, but he remained reluctant to follow her there. "I dispute the suggestion in Your Honor's questions that there is any reason, justification, or excuse for suggesting that something said in a prisoner's case applies to baseball players and their right of privacy," he shot back. "That is my answer to Your Honor."

But back she came to offer greater insight into her thinking: "I think the reason is that the case involved state action and that is why I was asking you to assume, for the purpose of argument, that state action has been found, and therefore the Fourteenth Amendment has been found." He'd dodged her earlier invitations, but this might be his last chance to engage. This time, she'd put even more hints on the table showing him how she might rule. "Therefore, we ought to discuss the privacy issue, whether there was anything to this claim, and if so, what it is," she told him. The judge was all but warning him that if he didn't give her a persuasive rebuttal, she was likely to rule against his client. "If there is a valid privacy claim, whether the restriction is too broad and there ought to be found some less sweeping restriction," she said, putting before him issues she'd consider in deciding this case.

Would he ignore her final offer?

"The purpose of a locker room, if Your Honor please, is to give a ballplayer the opportunity to undress. I don't think there is anything in this case that would justify Your Honor trying to change the function of the locker room," he told her. "So far as state action is concerned, I suggest to Your Honor with

the greatest respect that you can't find it. If you can't find it, that is the end of the case."

Climenko paused momentarily, then said, "I renew my motion for summary judgment."

* * *

This time, he had ended his presentation. With both lawyers done speaking, hers was the only voice left to speak.

"The court is going to, of course, reserve decision on this motion," she said, indicating there would be no ruling now. "As I indicated, if there is some inclination here to settle this case, I wish you would let me know before we proceed to write an opinion," she said, looking first toward Climenko, from whom she'd tried hard to find a settlement, then at Fritz. "There was indication that the baseball commissioner was ready to make some accommodation," she observed, but whatever tiny opening she'd seen had dissolved in her dialogue with Climenko. "I think that if the parties sat down, they might be able to come up with some solution agreeable to everyone, such as having this thing take place only when all the people are able to be there rather than when the players are undressing or whatever."

When she'd jousted with Climenko about alternatives, there was always a lingering hint that she wanted us to settle this dispute. Then, she would not have to write an opinion. "It just seems reasonable that the baseball interests would provide a place for everyone to have equal access to everyone at the same time and not at different times," she said. "That is what this really boils down to. Simple justice would seem to dictate that everyone who aspires to be a reporter in the sports world has an equal opportunity to do that. The solution seems too simple that I don't know why we spent three hours here. It seems to me the parties could work this out themselves without involving the Court," she said. She was having a hard time concealing her exasperation at the time and attention being paid to a situation that she felt should be easy to solve.

Climenko responded first. "You are spending three hours because *Sports Illustrated* with all of its money and all of its power decided to terminate discussions and come here."

With that comment, he'd given her the excuse she'd wanted to order the two sides to find a way to solve this. "They are directed now to try to settle it, if that is their position," Judge Motley proclaimed. "It seems to me the Court

ought to be spared the time that it would take to write this decision and to work out these problems, if it could be readily settled."

Without asking Fritz for his view, Judge Motley declared, "Pending the Court's decision, the parties are directed to try to settle it. Thank you, gentleman."

Upon issuing this order, Judge Motley swung her gavel down, then rose to depart, as the rest of us in her courtroom stood in place. I couldn't see her as she walked down the steps of her raised bench. I knew she'd left the courtroom when the door in the back wall opened, then shut behind her.

Our hearing was over.

Chapter Twenty-Five

When I'd walked into Judge Motley's courtroom, I expected I'd leave without knowing her decision. But I hadn't foreseen her commanding us to talk again. Fritz seemed to be surprised too. How could she think that by forcing us to reengage we'd resolve this matter? We'd ended up in court only when we'd reached an impasse. With the media amplifying our animus, how could we now negotiate a resolution from our fortified positions? Kuhn still refused to treat me like my male peers, and Climenko had shown no appetite for backing away from the precipitating edict.

Would either of us back away from its position to avoid Judge Motley deciding our fate?

I was certain we would not.

Kuhn had told reporters in December that he'd change his policy only if "they [the courts] could satisfy me that we have violated any law."[1] Baseball's men had rallied around him. In a December 30 *Newsday* story,[2] American League president Lee MacPhail told Jane Gross, "I don't think we have violated any law. . . . The dressing room portion of the clubhouse is a private domain of the players and the club." Then he added, "The personal dressing quarters of players cannot reasonably be regarded as a place of public accommodation." Whenever Judge Motley had offered suggestions to accommodate women working alongside men in the locker room, Climenko had retreated to his bedrock belief that the men's *right* to walk around naked should triumph over my *right* for equal protection. Wirz had summed up his legal defense in Gross's *Newsday* story: "We don't consider it [women's access to the locker room] to be a right."

Work it out, Judge Motley told us. She was exasperated by then. Clearly, she was not going to spend more of her precious time on a silly situation that was simple to solve. She must have wondered how a case about a baseball-loving woman and naked ballplayers ended up on her docket or, for that matter, on the docket of any federal judge. Maybe we'd produce a miracle, sparing her the task of writing a decision. But I had the feeling she'd have my case back soon. But on this Friday afternoon, perhaps all she'd hoped for was a break to restore her equanimity. No case in her dozen years as a judge had reached her with the rancorous press attention that mine had, nor had any made her deal with issues so far afield from her lived experience. Her respite might be short lived, but at least she'd have a restful April weekend with family at her rural Connecticut home. And since the Yankees had a rare Friday night off, she'd be spared having to listen to a Yankees radio broadcast on her drive from Manhattan.

All of us took the weekend off. Then, midway into the next week, Fritz wrote Climenko to reopen negotiations. Unlike the talks after the World Series, Fritz's legal team and Climenko's would sort this out without attorneys from Major League Baseball or Time Inc. in the mix. There would be no face-to-face meetings this time; lawyers would negotiate by letter, sending copies of their letters, with enclosures, to Judge Motley who still presided over our active case.

Climenko responded a week later, then Fritz replied quickly to him. In that letter which he knew Judge Motley would read, Fritz wrote that Climenko was not abiding by her order that asked both sides to work toward reaching an out-of-court solution. "Instead of addressing the subject of finding a way, as Judge Motley put it, of 'provid[ing] a place for everyone to have equal access to everyone at the same time and not at different times,' you continue to defend baseball's current discriminatory policy, and you offer only the status quo," Fritz wrote him. In his reply, Climenko had sung his same old tune about how Time Inc. relished litigation so much that had broken off negotiations in 1977 just before Kuhn could propose a solution. Fritz rebuked that charge: "You repeatedly have suggested that my clients want litigation. They don't. You don't find Time Incorporated as a plaintiff very often. And Melissa Ludtke has been subjected to the sort of abuse that plaintiffs seeking equal rights usually get. It would have been appreciated by my clients if we could have resolved this matter as it should be resolved, fairly and justly, before or during this litigation. My clients want something very simple—equal access to baseball

newsmakers at the same time and place and not at different times and places."

* * *

Thirty-five years later, in March 2013, I spoke by phone with Wirz. In the 1970s, he'd shaped the public narrative of me as a bothersome "girl" victimizing Kuhn's players. This was the typical blame-the-girl strategy that powerful men turned to with disruptive women, and the sportswriters played along by portraying me as an ambitious, aggressive, brash, girl-lib invader of America's most family-friendly sport. Such adjectives were not compliments then, and men weaponize these words still against troublemaking women. By labeling me the invader, they practiced "the sort of abuse that plaintiffs seeking equal rights usually get," Fritz observed. The *New Yorker*'s Roger Angell wrote that my mere presence in baseball "brought out the worst in his sports journalism colleagues."[3] In "Sharing the Beat," Angell revealed what baseball writers said when they were together talking about my case and me: "I often heard Ludtke defamed by people in her own profession. Her reportorial abilities, her seriousness, her motives for bringing the suit, her appearance, and her private life were snickered at and vilified. . . . I was startled by the slanders, not just because I know Miss Ludtke but because the worst of them were delivered with a perceptible, barely concealed rage—verbal hate mail."[4]

When I spoke with Wirz in 2013, he reverted to using the same evasive tactics that he and Kuhn used against me in the 1970s. He repeated his theme about Time Inc. lusting for litigation and how we'd left the negotiations just as Kuhn was on the cusp of offering us a solution. This wasn't true, but now he embellished his account by intimating that people at Time Inc. actually had orchestrated the actions I took at Yankee Stadium to garner publicity for *Sports Illustrated*.[5]

"The very first thing I recall is you approaching me in the press box and telling me that you intended to go into the locker rooms," he said in our phone call. "What you were saying virtually hit me cold. I was dumbfounded by it. In my mind, *Sports Illustrated* and you had chosen this dramatic time to try to take this step."[6] In saying this, he pegged me as a marionette dangling from strings being manipulated by men at Time Inc. This was utter fantasy. No one at Time Inc. had paid the least attention to any challenges I had encountered at ballparks. In part, this was my fault since I didn't tell anyone at *Sports Illustrated* about reporting difficulties. I also hadn't shared with them

successes like my side-door entry into Martin's office or those end-of-season clubhouse passes the Yankees gave me. Nor did I tell anyone about my conversations with the Dodgers' manager or player rep when the team voted favorably about my locker room access. As always, I had figured things out as I went along, and as long as I was making progress that was good enough for me. I saw nothing to be gained by complaining or explaining.

The intervening decades had not altered Wirz's way of evading the truth. Saying I had "virtually hit him cold" wasn't true since he'd dispatched Morabito to tell me about Kuhn's ban before Morabito introduced me to him. His claim that my words "hit him cold" was laughable. Nothing I told him that night should have surprised him since the teams' PR man had discussed my locker room situation with him before I'd been called to the press box. He knew the Dodgers voted to let me into their locker room and Morabito had even told him about our arrangements during the regular season. Had Wirz not known these things, there would have been no reason for him to summon me to the main press box that night.

It upset me to hear him bending the truth again.

* * *

When we'd left Motley's courtroom, Fritz had assured me that he wouldn't allow this new round of negotiations to drag out. His promise settled my emotions. When we said goodbye, I trusted that he'd move us swiftly past this unexpected bump in the road.

As April was ending, Fritz enclosed a letter to Judge Motley along with a reply he'd sent Climenko. "It is clear," he wrote her, "that baseball offers as 'settlement' nothing but the status quo." He then told her that soon she'd need to take back the reins of this case. "Given baseball's continuing refusal to change its policy so as to grant equal access to women reporters it appears that the legality of its policy will have to be decided by the Court." Repeating the argument he made at the hearing, he reminded her that baseball's rationale did not revolve around "the alleged privacy interest" but was due to Kuhn's belief that "at this time, at this particular moment in our history, a large part of our population does not want that to happen." Doing this, Fritz placed before her again what she knew well from her representation of Black plaintiffs in racial discrimination cases: "Constitutional rights cannot be controlled by claims of unpopularity," Fritz wrote.

In that letter, Fritz had commented on Climenko's contention that Kuhn "is not required" to accede to "these concededly available alternatives" that

the judge proposed as solutions. Each of her suggestions, he'd claimed, would require "radical and undesirable changes in clubhouse practices." So Fritz advised Climenko to seriously reconsider each suggestion as a possible "least restrictive alternative" in case Judge Motley would find that Kuhn discriminated against me due to my gender.

A few weeks after Fritz had alerted the judge to baseball's lack of cooperation, Climenko sent her his own letter. "My dear Judge Motley," his began. In that May 16 letter, Kuhn's lawyer offered no solution that Judge Motley would see as equitable, then he asked her to grant Kuhn permission to call Mr. Meyers at *Sports Illustrated*, telling her that Kuhn "thinks that he can achieve a settlement with the publisher of *Sports Illustrated*." This would be Kuhn's second Hail Mary pass to try to work around SI's editorial staff since he'd spoken with the publisher the day before our complaint was filed.[7] This was a cockamamie idea that Climenko must have known Judge Motley would turn down. Of course, she refused.

Even him asking to speak with Meyers bespoke Kuhn's desperation.

Later in May, Fritz called me to say that Climenko had brought forth no resolution. *Ludtke v. Kuhn* was back with Judge Motley. She'd write her decision though no one knew when. Until the Southern District Court issued her order, neither lawyer could do anything more to affect its outcome. What each man had said in the hearing, his legal brief and memorandums, his side's affidavits and depositions, and the attorneys' last round of correspondence comprised the record of this case.

Judge Motley would use it all in issuing her order.

* * *

Meanwhile, my work at *Sports Illustrated* went on as usual as I spent days at the office and nights at a ballpark. On Sundays, I got home after midnight after fact-checking a baseball or basketball story. On our weekend, Tuesday and Wednesday, I went to my office to write stories I'd reported to submit under my byline. I was also planning our May 29 wedding and reception on Cape Cod and our ten-day honeymoon along Maine's coast.

As crocuses and daffodils poked up through patches of snow in Central Park, danger signs were alerting me to the mounting difficulties in my relationship with Eric. With increasing frequency, I'd scribble four words into my journal: "Eric and I fought." I didn't elaborate, so I've forgotten what caused most of our fights or how they ended. I just know that a lot of them happened. One morning, a dozen red roses were delivered to me at

work. I put them in a vase on my desk. Not long after, SI's hockey editor Mark Mulvoy poked his head in, and winking, he said, "Fought again, eh?" Roses as an "I'm sorry" gift were new for me, so Eric's effort that day had led to my forgiveness. After another fight, I'd come home to find a giant stuffed bear on the toilet seat in my bathroom. In one paw was Eric's note of apology.

The truth was that I'd become well versed in denying the obvious. That we weren't good for each other blared at me in neon, but I did nothing. We fought, but we never learned how to fight well; we rarely resolved what we'd fought about by the time the fight ended. When I told a close friend about our fights, she assured me that marrying him wasn't going to fix this. That is when I stopped telling friends about our fights. Then, at the start of April, shortly before the hearing, we moved into our first apartment together. Boxes remained unpacked for quite a while. If I wasn't flying somewhere for an assignment, I was working late at the office or a ballpark. In between work assignments, I hired a DJ, photographer, and florist for our wedding, then went to Cape Cod to sample appetizers and dinner food for our reception.

An hour before I walked down the aisle, I ran into the ocean for a bracing swim. I needed to clear my head. My impulsive dip left me barely enough time to walk home, shower, slip into my wedding dress, bobby-pin my veil to my blown-dry hair, and get in my father's duct-taped Pinto wagon for him to drive me to the church. The next day, Eric and I drove to Maine where we spent a cold, gray June week trying to have fun along the coast. I felt relieved to get back to New York City and liked being back at work. That week, an editor asked me to fly to San Diego to attend the NBA's summer meetings. Of course, I said yes. After checking into my room at the Del Coronado Hotel, Eric's phone calls came at me fast, frequently, and furious. I'd barely have said hello before he'd be complaining about me leaving him at home. The longer I stayed on the phone, the angrier he was. By the end of that first day, he was pestering me to fly home. His early morning calls from New York then woke me up in the middle of the night. I tried speaking softly to ease him off his ledge of despair, but nothing I said penetrated. He'd call pleading for me to come home, always in a demanding tone.

The next day, I avoided my room to avoid his calls, but had me paged in the hotel. I was less than a month into my marriage, and I knew I'd made a horrible mistake. Maybe our physical distance made my realization clear. Before our marriage, Eric once shared his vision of me being a bird who flew from his opened hand, then returned to that perch. When he said that, I sensed that he recognized my need for a modicum of independence in our

coupling. That vision had vanished, and his obsessive neediness replaced it. I gave in to him more often than I should have in an effort to ease the pain of these unpleasant encounters. On my third day of this San Diego trip, I finally gave in and took a red-eye flight to New York on Saturday. I'd miss the final morning of the meetings but I felt I had to escape his emotional sabotage. I could bear it no longer.

Work was my warm welcoming comforter. By challenging myself there, I kept myself afloat at home. Keeping busy was my secret sauce for survival. While keeping one eye on the NBA in its off-season, I was again going full force with baseball. Sometimes Eric met me at games. As stubborn as I'd been in getting married, I remained as headstrong in refusing to get out.

At home, I mostly kept quiet. I was afraid of stirring things up.

Chapter Twenty-Six

On the last Monday of the 1978 baseball season,[1] the Southern District Court issued Judge Motley's opinion in Case No. 77 CIV. 6301, aka *Ludtke v. Kuhn*.[2]

We had no warning of an imminent decision before it was released on September 25. Fritz called with the news when I was writing a scouting report for the pro basketball issue. His ebullient greeting said it all. A few minutes later, a messenger arrived at my office and handed me a copy of Judge Motley's thirty-four-page order. I skimmed her legal rationale, then slowed down when I came to her order telling Kuhn that he had to give me equal access. My eyes settled on a replay of her colloquy with Climenko about alternative solutions.

> This court need look no further than to the statements of defendants' counsel at the hearing on these cross-motions for summary judgment to find a number of alternative approaches which defendants might have implemented that would adequately protect the Yankee players' interests in privacy while at the same time enabling female sportswriters to enjoy precisely the same conditions of employment as their male colleagues.

THE COURT With respect to the assertion of privacy, at least by some of these players, isn't it possible for them to use curtains in front of this cubicle . . . to undress and hide (themselves) from these women?

MR. CLIMENKO It's possible, Your Honor.

THE COURT Or put swinging doors if he wants to get behind the door when a woman comes in, he can do that?

MR. CLIMENKO It's possible. It's possible to do what the plaintiff in this case says, "wear towels." It's not the way people who play baseball are accustomed to [*sic*] have the freedom of access after their own game.

If defendants' practice of total exclusion is derived, as counsel would appear to suggest, from a mere 'custom,' then it surely cannot stand against constitutional attack. The Supreme Court has held that mere administrative convenience cannot justify discrimination on account of sex.

The court holds that defendants' policy of total exclusion of women sports reporters from the locker room at Yankee Stadium is not substantially related to the privacy protection objective and thus deprives plaintiff Ludtke of that equal protection of the laws which is guaranteed her by the Fourteenth Amendment.

The other two interests asserted by defendants, maintaining the status of baseball as a family sport and conforming to traditional notions of decency and propriety, are clearly too insubstantial to merit serious consideration. Weighed against plaintiff's right to be free of discrimination based upon her sex, and her fundamental right to pursue her profession, such objectives cannot justify the defendants' policy under the equal protection or due process clauses of the Fourteenth Amendment.

Since plaintiff Ludtke has been deprived, under color of the authority of the state, of rights secured to her by both the due process and equal protection clauses of the Fourteenth Amendment to the Federal Constitution, 42 U.S.C. § 1983, she is entitled to the injunctive relief sought and to an award of counsel fees. 42 U.S.C. § 1988.

An injunction will therefore issue enjoining defendants from enforcing the policy of total exclusion of accredited women sports reporters from the locker rooms of the clubhouses at Yankee Stadium and requiring them to adopt one of the above alternative means of preserving player privacy.

Reading this, I felt like I was hearing Fritz's argument all over again.

With her order, Kuhn had to stop separating me from the men, which meant he had to turn her command into my reality at the stadium. The Yankees played next on Tuesday night, so this afternoon, I'd savor my victory with gratitude for my serendipitous privilege of waging this fight for equal rights. I didn't seek it. It had found me, and this is where we ended up. Even though Judge Motley's order only pertained to my situation, I was certain its ripple effect would give girls and women who loved sports as much I did a fair shot at doing a job like mine.

All of this made me think of my mom passing her love of baseball to me. I slid the frosted door of my office shut and dialed her phone number in Amherst. When she answered, the jubilance in my voice broadcast my news, just as Fritz's greeting voiced his. She and I talked until I heard gentle knocks on my door. I said I'd call back that night when my dad would be home. Colleagues were showing up, a few of them mouthing congratulations before moving on. Some pulled chairs from nearby offices into mine and sat down to talk.

In another Rockefeller Center office building, Kuhn was probably reviewing Judge Motley's order with anger and consternation. Although he might have taken some comfort in knowing that her order applied only to Yankee Stadium, he also knew that sportswriters and columnists would frame it as a bellwether of what these men feared. In the not-too-distant future, all baseball teams would have to provide equal access to women writers. For now, Kuhn's worry was how he'd handle the locker rooms on Tuesday night when the Toronto Blue Jays would be at Yankee Stadium while placating the men. Perhaps the only thing Kuhn feared more than me being in the Yankees' locker room was the other writers pummeling him if he kept them out. One thing seemed certain. After the Blue Jays and Yankees game, females assigned by editors at TV and radio stations, newspapers, and wire services would be in the locker room. And they'd be there to ask the ballplayers one question: What is it like to have women in their locker room?

Daily News sports columnist Mike Lupica was on strike, as were other New York newspaper writers. But he was writing for one of city's makeshift dailies, so he called to ask if he could stop by my office to gauge my reaction and hear about my plans for the Blue Jays' game. In the column he wrote, "The Clubhouse Case: How Melissa Lincoln Became a Precedent,"[3] Lupica described me as sitting "next to boxes of affidavits and reference material that are her souvenirs from a fight that took nearly a year to win." (That fall, I'd acceded to Eric's incessant demand that I change my last name to his, so he called me Melissa Lincoln.) Lupica told readers that I hadn't had time to do much more than skim the decision, then he quoted me as saying, "I'm going to read it over again, later on. I'm not the only woman who has won, who wants this decision. That's why it's been worth it."

After Lupica left, I did too. On foot, I zig-zagged east and south until I reached the corner of Thirty-Fifth Street and Second Avenue, where I went into our local grocery store to get food to cook for dinner. Eric and I ate in the living room while we watched CBS News anchor Walter Cronkite deliver

news of Judge Motley's decision. A few hours later, we hailed a cab to go to Runyon's, the restaurant on East Fiftieth Street where sportswriters, broadcasters, and athletes hung out. With a tip of his cap to legendary sportswriter Damon Runyon, its proprietor, Joe Healey, had opened his sports saloon ahead of the 1977 baseball season's Opening Day. That season, I joined the guys after games to indulge our hearty appetites for talking sports. At first, I sipped white wine while the men told stories that I committed to memory along with key stats. Over time, I started telling stories of my own. On some nights, some guys had girlfriends with them, but our conversational routines stayed the same. Alternating among sports media gossip, game news and our own anecdotes, we drank, ate, and talked into the morning hours. No one worried about driving home. We arrived on foot or by taxi, and that's how we'd get home. Beer flowed, bottles of wine were emptied, and when hungry, we ate burgers and fries.

* * *

Usually Monday nights were quiet at Runyon's, especially when local teams had the night off, as the Yankees did that night. Still, we found a larger-than-expected crew in the backroom when we arrived. When I walked in, a cheer rose from the tables; after I sat down, the guys recirculated stale lines from jokes about me with naked men. That night, I laughed along at the sexist humor. While we celebrated at Runyon's, copy editors around the country came up with headlines to put on stories they'd publish from the Associated Press and United Press International. The Associated Press sent its story on the national wire with the headline: "The Bare Facts: Let Women In," United Press International took a different tack with "Equality Beats Modesty." Across America, local editors created their own headlines which served as a Rorschach test of how each community viewed my court victory.

"Where's That Towel?" Flora, Illinois's *News-Record*
"Judge Says Gals Okay in Locker Rooms," *Canton (Ohio) Repository*
"Hey, Yanks, Keep Your Pants On," New York's *City News*
"Female Reporters Can Chat at Lockers," *Detroit Free Press*
"Gal Writer Beats Yanks," *Kalamazoo (Michigan) Gazette*
"Lady Judge Tells Yanks: Let Girls In," *Staten Island Advance*
"Where the Boys Are," *El Diario—LA Prensa*
"Men Have Right to Keep Fig Leaf," New York's *City News*
"Ladies Invade Dressing Room," *Cookeville (Tennessee) Herald-Citizen*

"Kuhn: Towel Is Not Enough Protection," El Paso's *Herald-Post*
"What Would Babe Say?" *Mobile (Alabama) Register*
"Women Check Out Yanks' Locker," *Philadelphia Daily News*
"Look Out Athletes! Today the Yanks . . ." *Lansdale, PA, North Penn Reporter*
"Women in the Locker Room? 1,000 Times No!" *New York Daily Metro*
"Is Nothing Sacred?" *Miami News*
"Pinups, Maybe—Not Live Ladies," *San Diego Union*

Back in New York City, sports columnist Dick Young[4] encouraged his peers to use this same legal tactic. "If Melissa Ludtke can interview Reggie Jax with a towel wrapped around him, then I can interview Chrissie Evert with two towels wrapped around her. This could be the next federal case,"[5] he wrote in his reaction story. Earlier, in his "Young Ideas" column, Young had told readers that he'd fulfilled his reportorial duties at the Women's Basketball Classic at Madison Square Garden "in the interest of equal rights for men, and with a touch of vestigial voyeurism."[6] To his dismay, the women athletes had not undressed in the locker room but stayed in their uniforms for the interviews. Still, he could not resist describing Louisiana Tech coach Sonja Hogg as " a doll [with] shining blonde bob, blue eyes, turned up nose, and just the sweetest Scarlett O'Hara drawl you ever did hear."

With New York City's newspapers closed by a lengthy strike, *Newsday* and the makeshift dailies, including the *City News* and *New York Daily Metro*, brought news of my victory to readers. *Newsday* stitched together a tableau of quotes using wire service stories.[7] Yankees' owner George Steinbrenner underscored his animus[8] toward Kuhn by delinking his team from Kuhn's beef with me. "We had no problems with her," he said of me. "The commissioner of baseball issued a directive that we followed. She took it to court and won." Ouch! *Newsday* shared a bland, lawyerly statement from Kuhn: "I am disappointed by the court's ruling. We are reviewing the lengthy decision with counsel so that we can determine what our next step should be."

Runyon's festivities quieted when the affable owner stretched his arms across the opening between his saloon's front and back rooms. He waited for his waiter and bartender to pour champagne into the glasses they'd placed before each of us. Tapping his glass, Healey, a die-hard Yankees fan, toasted me while assuring us that his beloved team would meet whatever challenges I posed for them. After talk resumed at tables, Eric drew me to Runyon's tiny dance floor as a slow favorite played on the jukebox. A few hours later, when

Healey turned off the lights, we followed him out. When he locked the front door, we hailed a cab home.

On Tuesday morning, I slept late feeling the aftereffects of my excessive drinking. I hung out with heavy drinkers, and usually I sipped as they chugged. But not last night. Fortunately this was my day off. At home, I fielded calls from friends, then I stayed home to watch the Yankees game on TV that night. Had Judge Motley not ruled, I would have been in the stadium press box that night with the Yankees in a tight race with the Red Sox to win the Eastern Division. But she had ruled, so I stayed home knowing that women who never covered baseball before—and never would again—would be in the Yankees' locker room after the game. It would be a media circus, and I didn't want to be part of this show.

My court case never was about being in locker rooms for the sake of being there. I went to court for one reason: to report as my male peers did. All a judge could decide was whether Kuhn discriminated against me. If she did, and Kuhn then decided writers would continue to interview players in the locker room, I'd be there. If he pulled all writers out of the locker room to meet her bar of equal access, I'd do my interviews with the men somewhere else. Either way, the principle of equal access would be upheld. But if I was in the Yankees' locker room after the Blue Jays game, the local TV cameras would roll as the other women there would ask me to talk about the effect our presence had on the ballplayers. I wanted to talk *with* players about the game, not about me being with them. When I went back to Yankee Stadium, I wanted to be in the locker room talking with players. That's what I'd fought in court for the right to do.

My prediction was right. Female broadcasters, trailed by men shouldering weighty TV cameras, circulated through the Yankees' locker room after Tuesday's game, asking players about their presence. When I heard these exchanges on late-night local newscasts, I cringed.

I was glad I'd stayed home.

* * *

On Wednesday morning, Kuhn got to work with Lee MacPhail, the president of the American League, and the New York Yankees Partnership. These men wanted Climenko to file a Notice of Appeal with the United States Court of Appeals for the Second Circuit. They wanted this court to render Judge Motley's ruling unenforceable until the full appellate bench

heard arguments about whether her order should stand. If her decision stood, Climenko wrote that its effects would be cataclysmic: "Nothing could be more grave than the Court's holding that the Constitution itself requires that a male professional athlete wear a towel around his waist to protect his privacy so that women sports reporters may indulge their livelihood at the expense of the players' rights."

In this filing, he used more flowery language than he did at the hearing when he insisted that no "less restrictive alternative" proposed by the judge could work. He described them as "violative of the right of privacy which inheres in the sanctum of the locker room."

In this fresh take on the case, he'd hoisted the locker room up to be a "sanctum." At the hearing, he'd presented this sacred space as a free-for-all atmosphere where men roamed free and naked—a bacchanal lacking the booze. Now he tempered, though did not abandon, his uplift of players' right to privacy above my Fourteenth Amendment protections. "It is not clear that the intrusion into the traditionally free atmosphere of the locker room—an intrusion into the players' privacy—is less intrusive of their constitutional rights than excluding women," he advised the higher court. In his dialogue with Motley, he had conceded that a player *could* use a towel to shield his private parts, but now he implied that asking a player to wear a towel was an onus that outweighed the downside of excluding me. Revisiting the idea of shielding "unclothed" players in cubicles, Climenko said it "could have serious detrimental effect on the morale of the team, their access to each other after the games . . . and the sense of coherence which the team must have to operate as a team."

On matters of law as well, Climenko remained obstinate in his view that state action could not be found in this case. In urging the higher court to nullify Motley's order, he pressed hard on this point of disagreement, saying her decision rested incorrectly on constitutional protections. Soon after he submitted that notice, Climenko also requested "an application for a stay" of Judge Motley's two-day-old injunction. When that notice reached her, she scheduled an immediate hearing. With Fritz overseas arbitrating another case, Robert D. Joffe stood in as my lawyer. He had very little time to review Judge Motley's order and Climenko's new pleading, and then respond to this request. Working with Fritz's two associates, he prepared his rebuttal. At four thirty that afternoon, my three attorneys were back in Judge Motley's courtroom to respond to Kuhn's application to halt her order.

As the party filing this application, Climenko spoke first. At the Yankees game, he told her, Kuhn had complied "with a decree that required us to admit women to the Yankees' locker room" despite his view that this "[is] inimical by the standards of the welfare of organized baseball." Joffe responded that he'd found "nothing in the moving papers that is new, no argument that has not been previously made and rejected by Your Honor, and so I would think you should deny the stay forthwith." He assured her that what she outlined in her opinion "would more than adequately protect any rights of privacy at issue here, so I do not see how the failure to grant a stay will cause irreparable injury."

When Judge Motley asked Climenko to comment on Joffe's observation that the players' privacy was adequately protected, he dodged her query. After saying that players used towels, as if speaking for them, Climenko complained that a towel "does not seem to him to be adequate protection." He'd shown no evidence that he or Kuhn had spoken with players, so his comment seemed more supposition than fact. "We feel that a player who must resort to a towel has lost his right of privacy," he told Judge Motley, before dismissing her suggestions as being impractical and unworkable. "The Yankees have not found a way of creating a cubicle [with privacy protection]," he said. "Nor do I think as a matter of fact that when a player is in the process of undressing, bathing, and getting back into his clothes that a cubicle would protect his right of privacy."

After this diatribe, Climenko tried assuaging her, perhaps fearing he'd overstepped the bounds of judicial courtesy. "I indulge in these arguments with great restraint out of respect to Your Honor," he said.

When Joffe rose again to speak, he reminded her that Climenko put nothing "in the record with respect to what happened last night at Yankee Stadium." Indeed, Climenko had not included any player's affidavit to substantiate his claims about the deleterious impact her order had on the players after Tuesday's game. Joffe then offered his take on what had transpired in the Yankees' locker room: "I guess we all know that women were allowed in the locker room and that chaos did not ensue. The nation's morals have survived, and it seems that all we have here, as Mr. Climenko was the first to say, is his own personal feelings." Had anything "of sufficient note to show irreparable injury" occurred in the locker room, Joffe went on to say, the burden then fell to baseball "to bring in affidavits which showed that the players' rights were irreparably injured." On the other hand, he told her, if she altered her original order, I'd be injured. With the season about to end, and the Yankees in pursuit of the division title, I would use the access she had given me in my

work for *Sports Illustrated*. After a hearing, she had ruled in my favor, and Joffe argued that she shouldn't injure me again by taking my full and equal access away.

"If Your Honor please," Climenko said. "It is true that the world survived the events of last night. It is not true it has been improved by them. It is not true that the players haven't been embarrassed by them." Citing a newspaper story, he told Judge Motley that "the whole matter was best summed up by one of the players who said, 'They all asked us how we felt about them being here, but nobody asked us anything about baseball.'"

After only fifteen minutes of hearing from the lawyers, Judge Motley spoke. Given his lack of evidence from any player "attesting to their irreparable injury" and the fact that the court had dealt with all the arguments he'd raised in requesting a stay, she told him that "to go over them again . . . would be wholly repetitious." She also denied his application for a stay, writing her brief opinion on the back of Climenko's application.

> The written application for a stay of this Court's injunctive order of September 25, 1978, pending appeal, is denied for the following reasons:
>
> 1) Defendants have failed to show any likelihood of success on appeal.
> 2) Defendants have failed to show any irreparable harm to themselves or to the non-party ballplayers pending appeal.
> 3) Plaintiffs have rightly directed the court's attention to the likelihood of irreparable harm to plaintiff if she is denied access to players on the same basis as male sports reporters during the last few remaining days of the Yankee Games during this season which ends on Sunday, October 1, 1978.
>
> N.Y. N.Y. So, Ordered
> 9/27/78 signed by Constance Baker Motley
> U.S.D.J.

Leaning on the defendant's table, Climenko read her denial. Then he asked permission to speak, which she gave him. Treading carefully to not anger her, he made another request, but got tongue-tied in the effort. "I wanted to know whether it was possible that Your Honor would permit us to have a construction of Your Honor's judgment that would permit organized baseball to decline the admission of any reporters, male or female, during the period when the players are undressed. . . . We would like to do that in order to take out of the situation any suggestion of discrimination against women reporters . . . and I now respectfully make that application directly to Your Honor."

"I can't just rule on things out of the air like that," she replied brusquely. "They [the plaintiff] are entitled to an opportunity to reply." To pursue this further, he'd need to file an application giving notice to the court.

In its story, the Associated Press succinctly assessed the situation. "The first-place New York Yankees would be out of the American League East pennant race by now if their record on the field was as bad as their record in the courts. As it is, the world champions keep winning games and losing decisions. They are dressing down the opposition and undressing in front of women reporters." The *Miami News'* story placed the onus on two women—the judge and me. Its headline, "She Won't Change Her Mind," pointed at Motley; its first sentence fell squarely on me: "That lady from *Sports Illustrated* who found a female judge to allow her to look at naked baseball players in the Yankee Stadium locker rooms won another one yesterday." In Wilmington, Delaware, where Mr. William H. Burton's precedent-setting state action case originated, the *News Journal's* editors could not restrain themselves from using a pun in their headline: "Judge Goes with Curves, Strikes Out Yanks Again."

At home, I'd waited for news from Fritz of whether baseball would bring us back to court. Turns out, it would. That night, I also watched the *CBS Evening News*. Its story on Monday had announced the judge's decision, but two nights later, Cronkite broadcast a lengthier piece for which I'd been interviewed. As the newscast neared its end, Cronkite looked into the camera and said, "The New York Yankees, involved in a pennant race, opened up a unisex locker room last night. It happened after a judge ruled favorably on a suit filed by a woman baseball reporter, who charged that being banned from that male preserve put her at a competitive disadvantage. Jim Kilpatrick has the story."

The video rolled as Kilpatrick set the scene.[9] "In a more typical locker room, there is some nudity. And the baseball barons thought female reporters would be shocked and the players' privacy might be invaded. Melissa Ludtke disagreed and filed suit," he began. Then I came on the TV saying, "I don't think nudity is the issue that women reporters are dealing with," though in the clip I didn't get to say why. As this forty-five-second piece wound down, it showed an exchange between a WCBS reporter and a Yankees pitcher in the locker room after Tuesday's game.

ROSANNE COLLETTI, A WCBS REPORTER "Do you find it embarrassing at all?"

CATFISH HUNTER, A YANKEES PITCHER "No. I wouldn't mind being a male reporter, though, if I get to go into the girls' locker room."

When the story ended, Cronkite gave an update: "Baseball commissioner Bowie Kuhn today appealed that judge's ruling," before his iconic sign-off. "And that's the way it is, Wednesday, September 27, 1978. This is Walter Cronkite, CBS News. Good night." I stared at my TV screen. It seemed unreal that this man, who stood next to an enormous map of Vietnam in February 1968 telling Americans that war was unwinnable, had just told my story too.

Cronkite had been a constant presence in my life since childhood. Hearing *him* tell my story was a thrill.

* * *

At 3:45 P.M. on Friday, we were back in Judge Motley's courtroom. Climenko was asking Judge Motley to modify her order to permit Kuhn "to close the clubhouse and locker room of Yankee Stadium to all reporters, female and male, for a period of ten to 15 minutes following the games, so that the players may shower and dress without the presence of women." When Joffe received a copy of this request, he'd asked me to write an affidavit opposing "the baseball defendants' request that this Court modify its order to permit the exclusion from the clubhouses at Yankee Stadium me and <u>all</u> reporters." He wanted me to describe my experiences and observations at the Yankees' game I'd attended on Thursday night when I'd rejoined the press corps at the stadium. By then, Tuesday's herd of mostly TV female reporters was gone. There were only two women in the Yankees' locker room—me and *Newsweek*'s Donna Foote, who was reporting a story about pitcher Ron Guidry.

"The players showed no reluctance to talk with me and the male reporters at the same time," I wrote in that affidavit. "The physical layout of the locker room afforded any player the opportunity to shower and dress without my observing him should he have wished to do so." I wrote this so Judge Motley would appreciate that her order giving us equal access had worked well once Tuesday night's media circus left the room. Guidry pitched a complete game, so after it he was soaking his left arm in a tub of ice. Foote and I had stood with the other writers outside of the trainer's room asking him questions from a distance since none of us could be in that room. I explained for the judge why Guidry, who'd raised his record to twenty-four wins that night with only three losses,[10] could not have been brought out of the locker room to speak with any writer not allowed inside. If she had not issued her order,

neither of us would have been able to interview Guidry that night, as I told her this in my affidavit:

> Equal and immediate access to the locker room on Thursday night afforded me as a woman sportswriter the opportunity to interview the winning pitcher, Guidry, who also had broken a 74-year club single-season strikeout record in the process. For at least 20 minutes he sat in the trainer's room with his left arm soaking in a tub of ice. There is no way that Guidry could have been brought into a separate interview room anywhere outside of the clubhouse. . . . The players' immediate responses were an element which I had never before been able to report on, as was the mood of the clubhouse in the first few minutes after a victory during a close pennant race. . . . As a result of the Court's order enjoining Organized Baseball from continuing its discriminatory policies against me and other female journalists, all writers now have the opportunity to fully and accurately report all the elements involved in a news event—from the thoughts of the players before the game to the reactions they express immediately afterwards.

> The actual experience at Yankee Stadium has been that the players have been able to protect their privacy at the same time that female reporters have been granted equal access.

Joffe claimed in his response that Climenko had not shown that "any injury has resulted from compliance with the injunction they seek to modify." His message to the judge: "if it ain't broke, don't fix it." He also raised the concern that if she let Kuhn keep all writers out of the locker room for a specified amount of time, then teams would enforce this policy "only when women reporters were present." If that happened, the male writers would blame the women for causing them not to have the access they needed. If women were seen as disrupting the men's routines, then editors might not send women to cover baseball games. Borrowing from Fritz's playbook, Joffe compared baseball's "desperate" reaction to actions whites took in the wake of judicial decisions in racial discrimination cases. In cases he cited, after desegregation orders were issued, defendants shut down schools or closed community pools to avoid integrating them.

Judge Motley seemed irritable from the start of this hearing. By now, I realized how much she wanted to be done talking about locker rooms, nudity, and why for some ungodly reason any woman would want to spend time around baseball. She was incredulous that Kuhn had not proposed his timed "solution" in May, when she had ordered us to resolve this matter. "During

the course of discussions between the plaintiff and your clients, and prior to the Court's decision, do you mean to suggest that the subject of barring everybody for a few moments until the players were dressed never came up?" she asked Climenko.

"No, I think what happened is this," he started to say, but shifted back quickly to 1977. In a tiresome stroll down memory lane, he retraced his client's supposed willingness to negotiate a solution until Time Inc.'s litigious urge ended that opportunity. Then he recalled his request of the judge to let Kuhn talk with SI's publisher to try to work out a deal, which she denied. Telling this last story burst the dam. Judge Motley could no longer hold back her anger. It spilled out under the guise of judicial guidance.

> I think it could have been avoided and the Court wouldn't have been now involved in this if Mr. Kuhn had done exactly what you now suggest you want me to tell you he could do, and this is to bar everybody from the locker room until the players are dressed, so they can have their privacy. If he had done that, there is no way in the world this plaintiff could have come into a federal court claiming denial of anything, let alone a constitutional right. And that's plain to anyone.

> I don't know why I have to advise him. You don't even have to be a law student to know that. If he is a baseball commissioner, he can exclude everybody from a locker room where players are dressing—everybody—until the players are dressed. And no one would have a claim of denial of any right, constitutional, state, or anything else. And we would not be here, spending a lot of time and gaining a lot of unfavorable publicity for New York and the courts and everybody else in this case.... And it is clear to everyone that could have been done, but it was not, and that's why we are here.

After having her say, she told Climenko that she'd watched the TV reports from the Yankees' locker room on Tuesday night. They'd upset her, she told him, when she saw that "no precaution at all apparently had been taken to protect the players' privacy."

"Is that right?" she asked. "How did that happen?"

"The only protection that we could give the players, according to the opinion and the order . . . is to give them a towel," Climenko replied.

Motley was having none of it. "That was not something ordered by the court—the admission of women without any protection being afforded the players' privacy—and anybody who took the time to even skim through the opinion would know this," she bellowed. Her words matched

her rising fury. After composing herself, she reminded Climenko of what she'd said at the hearing when she said that "nudity wasn't the real problem here." Then, she added: "I still don't see it because the nudity is injected, as far as I can see, by anybody who walks before anybody else nude if it offends him. And when the press is there and the television cameras, particularly—I can't dream of any ballplayer wanting to do that. That's what I mean by that."

"I well understand Your Honor's displeasure with the consequences of Your Honor's order, but that is not—" he'd said, when she cut him off.

"No," she declared, her tone of voice acting like flashing red lights at a railroad crossing, preventing him from taking another loquacious detour. "We have gone over that."

She'd heard enough.

Sensing this, Climenko retreated, but not before saying that he did not appreciate Joffe entering into the court record a comparison with racial discrimination cases in the context of the request to modify her order. "To equate this with racial segregation," Climenko said, "I disagree with that. I regret it."

Crisply, Judge Motley corrected him. "He equated it with discrimination."

"We will take a brief recess while I act on this motion," she said.

A few minutes later, Judge Motley granted baseball its modification with stipulations. The defendants, she instructed, "do not act to discriminate against plaintiff Ludtke or take any action the effect of which would be to discriminate against plaintiff Ludtke solely because of her sex."

She'd spoken. Climenko didn't.

Chapter Twenty-Seven

With October's league championships underway, the equal access issue moved through twists and turns away from Yankee Stadium.

When Fritz asked Climenko to agree for the "terms of Judge Motley's order to be extended to the City of Philadelphia so female reporters would be permitted locker room access" at Veteran's Stadium, Kuhn said no. So, on Wednesday, October 4, Fritz filed a new complaint with the Southern District Court contending that the amended order in *Ludtke v. Kuhn* was based "on the deprivation of equal protection of the laws secured and guaranteed by the Fourteenth Amendment to the United States Constitution," asking for an immediate hearing. To this new complaint, he added Kathy Andria, a *Sports Illustrated* reporter, as coplaintiff since the New York Mets had denied her access to their locker room in the final week of the baseball season. Meanwhile, *Sports Illustrated* had assigned Andria and me to the National League Series opening in Philadelphia that night.

Before Judge Motley could set a time for this hearing, however, Fritz withdrew our complaint "in the hope" that Kuhn "will not continue the ban." He did this after being told that a Philadelphia attorney had persuaded the Phillies to admit us into the locker rooms. Soon, a complication arose when another female sportswriter filed a complaint about her lack of access with the U.S. District Court in Philadelphia. Speaking on behalf of Samantha Stevenson, writing for *Sport* magazine, her attorney Larrick B. Stapleton was at the courthouse to ask Judge VanArtsdalen to issue a temporary restraining order against the Phillies. The team had granted Stevenson access to the field and interview room but not to the teams' locker rooms due to her gender.

"There is, obviously, Your Honor, the immediate possible precedence of the *Ludtke* decision in New York," Stapleton began, before addressing the role that the state action doctrine played in Judge Motley's decision.[1] He reminded this judge that Philadelphia residents had voted to spend public funds to construct Veteran's Stadium, which the team leased from the city. "What this case comes down to very simply is that the Phillies are using a publicly owned and operated facility, the only place these public exhibitions can be staged, and Miss Stevenson is pursuing rights as a member of the press," he told the judge. "Her right to pursue her occupation, and the Fourteenth Amendment, and they have said to her you can have access to all of the sources of news of this game but the most relevant and most critical, and that we are denying you because you are a woman and that's all this case comes down to."

The next morning, the *Philadelphia Inquirer* published a story about the hearing with the headline, "Women Writer Barred from Phils' Clubhouse."[2] The judge had refused to issue a temporary restraining order citing the complexities in the law involved in the case. In his mind, the Phillies were a "private, profit-making enterprise," and therefore he saw "no reason why a private individual cannot exclude persons, at least if it's based on some type of reasonable basis for excluding certain persons, from various areas." Since he didn't see entwinement of a state entity in his case, as Judge Motley saw in hers, he could not rely on the constitution's equal protection clause for a ruling, as he explained:

> I haven't had the opportunity to study the law in this area and it is fairly complex, but at least as I read the complaint I do not see where there is a sufficient showing based on the complaint of any state action on the part of the Philadelphia Phillies Baseball Club, Incorporated or on the part of the City of Philadelphia. . . . I do not believe the Supreme Court has ever held that a classification based on sex is in and of itself a constitutional violation of equal protection, provided there is some rational basis, at least, for such a classification and distinction.

The *Philadelphia Inquirer* quoted the Phillies PR director, Larry Shenk, as saying that "Major League Baseball takes the position that we take the athletes to the gals." Of course, he had some experience with this after Kuhn assigned him as my "runner" after Game 6 of the 1977 World Series. Notes from the PR directors' meeting in December 1977,[3] held a few weeks before my complaint was filed, show that Shenk believed that women in the press

"should be allowed in the clubhouse, thus avoiding any problems which occur by not letting them in." He'd come to this view after experiencing the "problems" with Kuhn's fetch-the-player plan with me. However, what he said in that private meeting was different than what he now said publicly, when he was expected to toe Kuhn's company line. The *Philadelphia Inquirer* told readers that Kuhn urged all of the teams "to maintain a unified stand in barring women from areas where men are nude," which left Shenk no choice but to wholeheartedly support Kuhn in this ongoing controversy.

Back in New York City, Climenko was deposing Kuhn that day for baseball's appeal of Judge Motley's order before three appellate judges. In it, Kuhn asserted that "first, the reputation of baseball has been disparaged by the events since the court's original order. As commissioner, I am concerned with the public reputation of baseball. It is apparent to me that the court's orders have attracted the public's attention to an unseemly situation; women reporters being admitted to the presence of naked male athletes in the locker room. . . . It is most uncustomary for men or professional baseball players to disrobe before women." Kuhn believed still that it was "simply not possible" for players to change clothes or attend to their hygiene needs "without some nudity," implying that women writers would see naked men. He swore to this despite knowing that only ballplayers could be in the shower area. Adding a new refrain, Kuhn also blamed the court for making "the presence of women there the unseemly object of national publicity, rather than the game itself."

In court, this time, Climenko had sent affidavits supporting its argument to the appellate judges. When he'd failed to do this in his hearing to amend the order before Judge Motley, my lawyer used his oversight to good effect by reminding the judge that baseball had presented no evidence to support its claims. Included in these affidavits for the appeal was one from Bob Lemon, the new Yankee manager who had replaced Billy Martin in July 1978. In his, Lemon called it "an affront to my personal dignity to submit to Judge Motley's order." He described for the three male judges that the "traditional atmosphere of the locker room is one of male camaraderie" and "the team's morale depends in part on this free atmosphere." He aligned his view with sportswriter Maury Allen's column "Women in Locker Room? 1,000 Times No!"[4] written after Motley ruled. Allen had described the clubhouse as "at once a meeting room, a shower room, a bathroom, a refuge." Again, neither he nor Lemon bothered to mention that no member of the press could be in its shower or bathroom area. In his affidavit, Lemon asserted, "I do not believe that women belong here; I feel their presence denies my rights. I do not feel this because I hate women or consider them inferior. Rather, it is a fact beyond

dispute that major league ballplayers are men, and the usual notions of decency are that men do not undress in front of women in locker rooms."

Kuhn, in his deposition, had said that Lemon demonstrated the "quality and extent of this invasion." Perhaps the judges noticed in reading Kuhn's praise of Lemon's perspective that the Yankees' manager had not certified his affidavit until October 5, one day later than Kuhn was deposed. Therefore, Kuhn had to divine what Lemon would say. All of this buttressed my belief that the Yankees' managers—both Martin and Lemon—signed their names to documents that Kuhn's attorney wrote for them. When Lemon applied the phrase, "the best interests of baseball," I saw him applying Kuhn's legal cudgel: "Finally, I wish to point out that the scene in the Yankees' locker room this past week had been utterly disruptive of the team. In fact, it reminded me of a circus. These events prove the wisdom of Commissioner Kuhn's determination that the presence of women in the locker room of major league ball clubs is harmful to the best interests of baseball."

Lemon's words were especially tough for me to read. They were not the words of the man I'd gotten to know well since he'd arrived midseason to the Yankees. One evening close to the end of the season, we'd exited the stadium by the same door at the same time, so we'd walked the semicircle around the stadium together, then ascended the iron steps to the subway platform. On the train taking us to Manhattan's East Side, I laughed along with him as he told stories from his decades in the game. Not then, or in the many times I'd been in his office at ballgames, did I detect the faintest whiff of antipathy toward me or distaste of what I'd done. He'd welcomed me courteously in his office. Had someone asked about our working relationship, I'd have said that we got along as well as a manager and a reporter does. In my affidavit for the appellate hearing, I wrote about my time with Lemon at the American League Championship Series: "He had never mentioned to me any problems which my presence has brought. In fact, the one time we spoke about women reporters having access to the Yankee locker room, following the Sept. 28th game, he didn't express any concern about any problems that my presence and other reporters' presence might be causing the team."

Fritz also asked Murray Chass, a veteran baseball writer who covered the Yankees for the *New York Times*, to submit an affidavit too. In his, Chass focused on Judge Motley's amended order that gave the Yankees permission to close the clubhouse to all reporters at specified times. He wanted these judges to understand the deleterious effects this policy had on comity in the press corps. In her amended order, Judge Motley had told Kuhn he could keep

the press out "to offer the players greater privacy and seclusion in undressing and dressing." Chass noted that "the Yankees chose an alternative that was most repugnant to reporters," and described how it sowed tensions in the press corps by provoking the men to "declare war" on the women.

> That has served as an infringement of rights that reporters have possessed certainly as long as I have been covering baseball and presumably since the first writer covered baseball. On the day that Judge Motley issued her amended order, the Yankees announced that "no media will be permitted in the clubhouse for 45 minutes after the conclusion of a game in order to permit sufficient time for the players to dress." There is hardly a baseball player alive who would not be showered, dressed, and gone by the time 45 minutes had elapsed. In other words, if reporters had to abide by that restriction, then very likely, from my experience, they would have no one to interview by the time the clubhouse door was opened. Furthermore, in many instances, reporters' deadlines would have passed by that time. I had the distinct impression that by invoking any kind of clubhouse restriction, the Yankees were trying to instigate the male reporters to declare war on female reporters and somehow to bring pressure on the female reporters to cease their quest for equal clubhouse rights.

Chass's testimony underscored what my attorney Robert Joffe predicted would happen if Judge Motley amended her order at Climenko's request. At the September 29 hearing, Joffe had cautioned that teams would apply this restrictive policy only when females were in the press corps. Chass affirmed Joffe's fear of the men turning against the women. In fact, Chass testified to this happening in the first game at the stadium after Judge Motley amended her order. Chass had joined other writers in vehemently complaining about being kept out of the locker room. As the men's rage intensified, the Yankees retooled its policy on the fly. The prescribed forty-five-minute wait was dropped, and all of the writers were allowed in the locker room for fifteen minutes. Then, the press had to leave for thirty minutes so players could dress in privacy. After this thirty-minute pause, no writer went back in. By then, they were filing their stories on deadline. As Chass told the judges, the ballplayers were on their way home.

I was at that game when the amended order ruled the roost. Like Chass, I was standing in the pack of writers being forced to wait at the locker room door. I didn't take part in the men's vociferous protest, but I did watch with

bemused irony as the men spewed hostile words and all but physically attacked the Yankees' PR people enforcing Kuhn's rules. Of course, I agreed with our need to be in the locker room, and far better than any of them I knew what denial of access felt like and how it harmed our ability to work. I doubted that the men appreciated the irony this moment held for me. On this *one* night, their access to the players was being limited; my access had been cut off at every game for the past two seasons without even a time limit. Also true was that most of the men protesting *their* treatment that night had never spoken up for me when I was treated in this same way. After Kuhn banned me, a few men had spoken on my behalf. My *Sports Illustrated* colleague Jim Kaplan and *New York Post* baseball writer Henry Hecht talked with Kuhn expressing support for equal access. For our April court hearing, *Newsweek*'s sportswriter Pete Axthelm, the *Daily News*'s Mike Lupica, the *New Yorker*'s Roger Angell, Chass, and Hecht each wrote affidavits to say why they felt the judge should rule in my favor.

In his October affidavit, Chass told the judges that "the foolishness of this new rule was that players who felt like it still undressed and dressed when the female reporters were in the clubhouse. In other words, they were not bothered by the presence of female reporters." While he worked under Judge Motley's initial order, Chass said, he "did not notice any undue behavior or feeling on anyone's part. The players who might have felt some uneasiness in undressing and dressing in the presence of female reporters solved it by one of several means. . . . There were simply no apparent problems created by female reporters in the clubhouse." Chass urged a return to the original order, and this time give it time to work. He concluded his affidavit with inside-baseball gossip that he thought the appellate judges might want to hear: "Interestingly, George Steinbrenner, principal owner of the Yankees, told me the night Judge Motley's order went into effect that the Yankees wanted no part of pursuing the Ludtke case. But that it was Commissioner Bowie Kuhn who insisted on appealing it."

Chass confirmed what I'd suspected.

* * *

On Monday, October 9, Climenko filed an Amended Notice of Appeal with the Second Circuit Court of Appeals. In it, he asked the three-judge appellate panel to suspend Judge Motley's September 25 order *and* her amended September 29 order. He contended that "irreparable harm has already resulted, and would continue to result, from the district court's action"

and called her decision "an abuse of discretion." His argument boiled down to this:

> In its opinion, the District Court has misunderstood the nature of our argument, has failed to grasp the essential point of the case—that it concerns a locker room, and has refused to consider the basic fact that men in locker rooms behave in a certain fashion which will not change merely because the Court thinks it should. Finally, we believe that the Court has completely failed to consider that "traditional notions of decency and propriety" are the very substance which informs constitutional guarantees. Yet the Court simply dismisses these arguments holding that they are "clearly too insubstantial to merit serious consideration." It is significant that the Court fails to cite any authority.

The next day, the appellate judicial panel for the Second Circuit heard him argue for his motion and our argument against it. Then, these three white male judges unanimously upheld Judge Motley's ruling. Kuhn had the right to request a hearing before the full Second Circuit appellate bench, but after several weeks of considering this option, Kuhn dropped his appeal just before Thanksgiving. Soon Kuhn visited our *Sports Illustrated* offices to inform managing editor Roy Terrell of his decision. I was told about this meeting only after it took place.

On January 16, 1979, the clerk of the Second Circuit Court informed Fritz that Climenko had filed an official motion to voluntarily dismiss his appeal. In February, when baseball teams were loading bats and balls and gloves and uniforms onto trucks to transport them to spring training to prepare for the 1979 season, Fritz and Climenko signed the document certifying that Kuhn's appeal was dismissed.

Ludtke v. Kuhn was over.

We'd changed the law.

But would a change in attitudes follow?

Chapter Twenty-Eight

In America's most populated metropolis, members of New York's elite legal circle mingled at celebratory occasions. Sometimes Fritz was seated next to Judge Motley on the dais or at a table, and when that happened, she'd sometimes talk with him about the accusatory letters she received in the aftermath of our case, expressing incredulity at their emotional intensity. Their abusive language stunned her. Fritz recalled her telling him that their words could be fiercer than the angriest things she'd heard in the South when she was fighting racial discrimination.

This stunned Fritz.

I was struck that Motley talked about this unexpected backlash with Fritz. That told me how much the letters affected her. From accounts I'd read, the sign-toting segregationists who had pressed in close to heckle her in the 1960s had failed to pierce her armor, at least outwardly. Why, Fritz wondered, did these abusive words in the wake of my case rattle her. Perhaps it was that she remained bewildered by how a silly case like mine could ignite such fevered vitriol. In the South, she absorbed the white people's hatred and demeaning insults in the way she did because she recognized this was the price she had to pay for being there to overturn their laws. In her mind, a case about a woman wanting to work in a baseball locker room didn't come close to that caliber of worthiness. In talking about this with Fritz, she was inviting the wisdom of this man who argued on my behalf believing that he might explain this to her.

But Fritz knew that that whatever he mustered as a response was unlikely to satisfy her. She could never appreciate the oversized role that baseball, in

particular, and sports, in general, played in uplifting men's sense of their privileged status. Sports had always been the men's realm. To protect it, they'd do and say outrageous things to maintain the status quo. By ordering baseball to treat me as an equal, she'd diminished them. Lacking the power to change her order, they'd unleashed the hate and anger they felt on her for doing what she'd done. That women were among her antagonists spoke to deeply ingrained notion of men's ownership of sports and the belief that women should stay on the sidelines.

* * *

Nine years before Judge Motley died in 2005, she assumed "senior status" on the Southern District Court after she had left the court as its chief judge. In organizing her judicial papers for posterity, she donated the letters about my case to Smith College's archives for historic preservation.[1] In reading this collection, I found a letter from Mr. Tom Whitby, who chastised her on the day after her initial order.

Tom Whitby
Washington, D.C.
26 Sept. 1978

Dear Judge Motley:

How ridiculous can you be? I would think that you judges would have more weightier matters than insisting that women have the right to go into the private preserve of the ballplayers and gaze upon naked men. Maybe that is your standard, but I think the overwhelming majority of the American people take a different view.

As a matter of fact, I think women sports writers are a fraud; they know nothing about baseball, or football, tennis maybe and horseback riding... but men's sports—no way.

The ver [sic] idea. Why if my son played ball and some broad tried to get into the clubhouse I wuld [sic] hope he would throw a bucket of cold water on them to cool them off.

Next thing, you judges will be trying to tell us that somen [sic] can PLAY football or baseball!

Women never, never belong in men's lock [sic] rooms, and I am surprised that simple fact was overlooked by you.... Better forget about the law books and use a little common sense once in awhile [sic].

From a neighborhood near New York City's Van Wyck Expressway came an eight-by ten-inch page filled with gigantic, all-capitalized words. Its author, Max, must have felt that enormous letters would more effectively convey his sentiments to the judge. "HOW DO YOU STAND ON ALLOWING MEN TO VISIT LADIES [sic] LOCKER ROOMS? WHAT IS SAUCE FOR THE GOOSE IS SAUCE FOR THE GANDERS, OR ARE YOU ANOTHER ONE OF THOSE FEMINISTS?"

Francis H. Bowen, a San Francisco resident, who described himself as a "concerned U.S. Citizen, Native born 1917," organized single-spaced paragraphs thematically as responses to the opening question he posed: "Have we males lost all privacy, even morality?" His conclusion: We have. His evidence: Judge Motley's decision in my case. "If your decision was well thought out and it is your true feeling, then I believe that I should be allowed in any female dressing room after a sports contest and view and review the naked women; re: track, tennis, volleyball, etc. I do not believe our forefathers thought the law would ever be used by a Court Judge to further the female immorality that they now enjoy without the use of a Court Judge decision."

From Van Nuys, California, Robert Bowman, who said he'd been a sports reporter, unspooled a string of adjectives to air his view of her ruling: "at best stupid, sexually biased, arrogant, naïve and discriminating." He still had more to get off his mind.

It is perfectly obvious to me that you are not at all familiar with athletes or sports of any type. . . . What you implied in your decision is that only the male enjoys contemplating the opposite sex in the starkers [sic] and only the female is embarrassed by being contemplated in the nude by the opposite sex. How naïve can you be?

May I enlighten you by telling you that even women are sexually healthy.

You thought you were protecting Melissa Ludtke's equal rights. What you have done is deny the New York Yankees the protection that women baseball players, tennis players and other female pro athletes enjoy. I just wonder how you would feel sitting on the bench trying a case in the nude. Just how comfortable would you feel? . . .

I suggest you take your clothes off and visit the Yankee clubhouse after one of their games.

You have aided the cause of female peeping toms [sic].

Bowman also lamented that her decision in *Ludtke v. Kuhn* had forced him to back away from casting votes for the only two women on that fall's California ballot—its first female chief justice of the supreme court, Rosa Bird, who faced a retention vote, and Yvonne Braithwaite Burke, running for attorney general after being the first African American congresswoman from the West Coast. "There is no way," Bowman told her, "[that] I could take a chance on more mediocrity in government by voting for these two women. It's a shame that two innocent people have to suffer because of your stupidity." He copied his letter to the two candidates and the Yankees, Dodgers, and Bowie Kuhn. (Without Bowman's vote, Justice Bird stayed on the court and Burke lost.)

Writing from Pennsylvania, Edward DiSanti upped the Californian by sending a copy of his letter to fourteen people other than the judge, including to me and Hugh Hefner, who owned *Playboy*. His intended audience was *Philadelphia Inquirer* readers, though I doubt his words ended up in newsprint.

> Another blow was struck recently to American manhood by allowing female sports reports [*sic*] to invade the territory of the Yankees dressing room.... Turn about is fair play; would Judge Motley grant an interview au naturel.... If the American male does not speak out now about this ruling it illustrates that he is content in being made a eunuch by the jockeyism of a female Federal Judge and the noise created by a handful of women sports reporters who have opened Pandora's Box.

> Ever since the burning of the bra, women have reinforced their position by leaguing together; forming alliances to barge into the so-called male world. They have infiltrated mens [*sic*] colleges, clubs, military academies, police departments, industry and religions, and the list goes on endlessly. It is obvious that fighting for female equality means leaving me with no rights at all.

> I refrain from arguing the competence of the women in these newly acquired positions as time will show the merit of the movement.... If we are going to sit back and let this ruling happen, it illustrated that we men are becoming nonchalant about being male. In case no one has noticed, there is both a physical and psychological difference between the sexes. Players require the freedom to cavort with each other especially after winning a game.... There is a time and place for everything, and the mens [*sic*] locker room is not a place for a lady. Do you see men trying to invade womens [*sic*] clubs or organizations?

In protest to this ruling, I feel that we should do something equally absurd, such as going into womens [*sic*] rest rooms in public places. Is that not public domain? Should we not have the freedom of choice. Equal rights have arrived. Well, let's all enjoy them.

On a pictureless card from Rockford, Illinois, with a typed signature, "Male Chauvinist," a man asked Judge Motley three questions before rendering his own verdict. "Under the 14th Amendment can Melissa Ludkte [*sic*] get a glimpse of a naked ball player??? Do naked ball players look different than most naked men? If Melissa got raped in the men's dressing room, would it make the ERA [proponents of the Equal Rights Amendment] happy or angry or frightened? Sad about all the unnecessary paperwork—should've said, 'Case dismissed.'"

That descriptor—male chauvinist—was in vogue. Looking back, it seems a relatively tame way for men to have staked their claim of superiority when their exclusive territories were shrinking due to a number of court decisions. Copy editors used that phrase in headlines, and writers took it for a ride in stories and columns about my case. When the *Washington Post*'s syndicated satirist Art Buchwald updated the 1888 baseball poem "Casey at the Bat" to fit my moment in October 1978, his eleven-stanza revision was published in some newspapers with the headline, "A Male Chauvinist 'Casey at the Bat.'"[2] His rendition provided a humorous take on my case.

> NEWS ITEM: Judge rules that women reporters must be permitted in baseball locker rooms.

> *It seemed extremely rocky for the Mudville Nine that day;*
> *They blew the game in Springfield on a stupid double play.*
> *So, when a girl reporter walked in their locker room,*
> *They decided to play ball with her to take away the gloom. . . .*

> *There was ease in Casey's manner, a smile on Casey's face.*
> *As he whispered to the lady, "Would you like to see my place?"*
> *'Pas ce soir,' the lady said, 'and please take off your hat.'*
> *'That's no way to talk,' Flynn said, 'when Casey's up to bat.'*

> *She frowned in great displeasure, a hand upon her hip.*
> *She stuck a mike in Casey's face and almost cut his lip.*

'Strike one,' the shortstop called out, as he doubled up and roared.
'Casey's swinging wildly and he hasn't even scored.' . . .

Oh, somewhere in this favored land, the moon is shining bright.
And girls are doing disco in pants that are too tight.
And somewhere men are laughing and drinking Guinness stout.
But there's no joy in Mudville—Mighty Casey just struck out.

A few of Motley's correspondents tried their hand at humor, but most of them wrote to air grievances. Some enclosed copies of stories that highlighted negative impacts of her decision. Sportswriters had echoed Climenko's prophecy of "grave danger" if the court ruled against baseball, and these letter writers wanted her to see this.[3] The *Courier* in Waterloo, Iowa, where my father grew up, published a piece by syndicated conservative columnist Pat Buchanan with the headline, "Locker Room Ruling Called ERA Preview."[4] In his column, Buchanan merged his pressing concern about me being in the Yankees' locker room with full-bore support for anti–ERA activist Phyllis Schlafly, who was stoking American's fears of "co-ed bathrooms" if the ERA passed: "In still another classic from our Imperial Court, U.S. District Judge Constance Baker Motley has ruled that the constitutional guarantees of equal protect and due process are meaningless if female reporters are forbidden to wander around the New York Yankees locker room," Buchanan declared, ". . . But the ridicule this decision has received is nicely balanced by the peek it has given us into the Brave New World we will enter if the Equal Rights Amendment is ever ratified."

In Wilmington, Delaware, where *Burton* originated, the *Morning News* editorialized about my case.[5] After describing Judge Motley's decision, editors opined on how unhelpful her judicial order was for ERA advocates trying to refute Schlafly's claims about the impossibility of maintaining separate bathrooms for men and women if the amendment went in the Constitution. Referring to Motley's decision, the editors wrote, "All well and good on a logical basis, but the inevitable next step is for male sportswriters to insist— probably in court—that they have equal rights to access to locker rooms for female sports figures. Also, all well and good, but another straw for people building that particular argument against the ERA: Today unilockerrooms, tomorrow unibathrooms." In the end, Schlafly's fear-based movement did defeat the ERA largely due to her intense focus on unisex bathrooms and her contention that it would result in women being drafted into the military.

A few of Judge Motley's correspondents felt the need to offer divine guidance. "God have mercy on your soul!" one man's letter began. In it, he reprimanded her for a decision that he claimed would lead to "perverts" going into "shower rooms to interview" young girls. "Can you," this Los Angeles resident asked, "rule against men's rights to interview naked young girls against their wishes?" In closing, he used biblical words to chide her: "Have you no decency? I should not cast pearls before swine! I pity you and these women reporters!"

Addressing her as "Dear Madam," Gerald Bjork from Denver, Colorado wrote in elegant cursive writing reminding me of schools teaching me proper penmanship. Uncharitably, he declared her decision "the most assinine [*sic*] ruling of this decade," before asking, "What ever happened to decency and good judgement [*sic*]? You apparently have neither. Such assinine [*sic*] permissiveness is on par with queers, child molesters and sodomy."

Judge Motley's law clerk, Nancy A. Kilson, replied to Bjork on her embossed courthouse stationery so he'd know instantly that this reply was from the chambers of Constance Baker Motley. "We have received your letter of September 29, 1978, commenting on Judge Motley's recent decision in the Ludtke case. Your expression of interest is appreciated. Judge Motley has asked me to forward a copy of the opinion to you so that you may be more fully informed with respect to this matter. Accordingly, I have enclosed the same with this letter."

Kilson replied to every letter Judge Motley received with a return address and the full name of its writer. She enclosed with each letter a copy of the judge's opinion in *Ludtke v. Kuhn*. Occasionally, reading this enclosed opinion did change a mind. A case in point was law student Brad L. Belke. When he'd read about her decision, he had written to say, "I was shocked." He saw her decision was "a clear violation of the player's civil rights." Then he added, "At worst, it makes a person wonder if you've ever read the constitution. Common sense alone as your guide, had you never heard of the right to privacy, would have prevented your decision." Belke also addressed the ERA issue by declaring that "the most disastrous circumstance" of her decision would be "its adverse affects [*sic*] on the Equal Rights Movement."

For years those of us who have labored for the passage of the ERA have had to combat the "horror stories" of the Ms. Schaflys [*sic*] of this world concerning co-ed restrooms and showers. To dispute this nonsense, we have always referred them to the safeguards provided by the constitution to an individual's right to privacy. Now your monumental lapse of judgment has given substance to

nonsense. It will make no difference that your decision will be reversed on appeal, the damage you've done to the ERA will be irreversible. For the first time, I understand Thomas Jefferson's concern over the powers of the Judiciary.

Replying to Belke's letter, Kilson observed diplomatically that although he had indicated that he'd read Judge Motley's opinion "some of your comments suggest that in fact you may not have seen the complete text." In enclosing the judge's opinion, Kilson added these words: "Best wishes for the success of your legal career." Soon after the letter went to Belke, Judge Motley delivered a speech and Belke showed up to listen. On a Post-it note that Kilson later affixed to her Belke correspondence, she wrote that he used the occasion of that speech to apologize to Judge Motley for his earlier offensive comments. At that event, he told her he now understood her legal reasoning.

John Cervase, who was a lawyer in Newark, New Jersey, was less likely than Belke to be swayed by a deeper read of Motley's rationale. His entire letter was one declarative statement about how her decision in my case was "as silly as most of your other decisions." In a letter from the Bronx, Dora D'Adamo worried that women like me could insist in the name of "locker room atmosphere" that "the male be interviewed in the same state of undress as he affords to an all-male audience." Maybe, she wrote, Judge Motley went too far. Don G. Mason from Webster, Florida pined for bygone days "when men were men and women were women—and both were glad of it." A Los Angeles man who signed his letter "Disrespectively, Dean Norton" told Judge Motley that he'd been a professional athlete. Then, he reminded her that "a <u>dressing</u> room also contains a toilet." It was difficult, he said, to keep his "comments decent in this idiocy," then added that I "shouldn't be reporting sports . . . men's sports . . . but more so, S.I. should have retained some measure of integrity and not given her [me] the forum to pump for these so-called 'rights.'"

Among my favorite letters was Mat Sibble's. He relayed his thoughts in the form of a memorandum—RE: Yankee Clubhouse memo. In the bottom two-thirds of his memo he had a photocopy of Murray Chass's September 27 story, "Women Invade Yankee Domain," that he'd cut out from the *Boston Globe*. "At first the players greeted the women with loud, needling remarks and some cursing," Chass had written in describing the locker room on the first night it was open to all writers at Yankee Stadium. "Generally, however, the players were unperturbed," including Willie Randolph, whom Chass described as "totally undressed when he spoke with one reporter." "If she wants to talk with me while I'm getting dressed, that's cool," he'd told Chass. "Anyway, they're grown women." It was Sibble's comments above Chass's story

that I liked the most. They befit a true Red Sox fan: "If the Yankees collapse over the next few days, my vote for MVP is Judge Motley," he wrote the judge. Reading his one-liner decades later, I chuckled ruefully since I knew the Yankees didn't collapse. Instead, they broke my heart again in beating my Red Sox in a one-game season-ending playoff.

From "anonymous" came a handwritten message on an unadorned post-card. "What kind of a freak are you or are you a frustrated female?" he asked before he squeezed into the tiny space remaining more nonsensical thoughts with words like "stupid" and "bathrooms." He signed off with this sentiment: "I feel sorry for a frustrated female like you—surely you aren't a bona fide woman?"

* * *

A few women worked as newspaper columnists in the late 1970s and some of them also weighed in after Judge Motley ruled. Not surprisingly, their perspectives tended to veer 180 degrees from the judge's correspondents. Anna Quindlen, arguably the most prominent woman columnist of that time, was on strike due to the pressman union's dispute at the *New York Times*. We talked for a profile she wrote for *Women's Sports* about three women in sports media.[6] I was the only print journalist, paired with Donna De Varona and Jayne Kennedy, who were in the vanguard of female sports broadcasters.

Just after the 1978 World Series, Quindlen visited me at my *Sports Illustrated* office that she described as an "untidy little office cubicle, the walls plastered with pictures of sports figures and family." She described me as "a straightforward woman who keeps a picture of herself rowing in a crew on one side of the wall and one of her taking notes in the press box on the other," adding that I was "more interested in doing the story and going home than in crusading." She also credited me with having a "sense of humor about what she did—she has also hung up a sportswear commercial featuring a pert young model wearing a blue jeans pantsuit and a perplexed look, holding a micro-phone in a locker room." Late in her story, Quindlen quoted me saying, "If anyone had made it [this issue] a crusade, it's the commissioner's office," which I'd said in response to the customary charge that like Joan of Arc, I had pur-sued this case as a personal crusade. She'd never reported in a locker room, so she asked me to describe what it was like. "There is nothing sexual about it," I told her. "And I think most players know that. . . . This is just a matter of fact do-the-story-and-go-home thing that has been tried, tested and worked

in basketball, hockey and soccer." After I had my say in her story, Quindlen had hers. In summary, she wrote, "More than one woman's right to pursue a story; it had become a feminist issue, a conservative scandal, a publicity event—titillating, irritating, divisive."

In the *Boston Globe*, columnist Diane White spoke to those of us who were working in men's locker rooms.[7] She reminded us of what we knew—by entering "a man's world," we had to "accept it on its own terms." I'd acknowledged this from the get-go by saying that when I was in the locker room, I was working in the players' space, so I had to roll with the way things were for them. That said, I'd also drawn a red line in my mind that if crossed by a player would cause me to exit and file a complaint about my treatment with the team. Short of things rising to that level, I'd stick it out with the men in charge. In her lead-in, White told readers that the Yankees' second baseman, Willie Randolph, had worn his only towel around his neck when female writers went into the Yankees' locker room. She quoted him saying, "If a woman wants to be one of the boys, she should be prepared to be treated like one of the boys." I saw things as he did, and was prepared. If verbal insults came my way or if players engaged in *reasonable pranks*—staying shy of my red line— I'd manage. Let's remember in those days, terms like "sexual harassment," "sexual abuse," and "misogyny" weren't even in common usage.[8] No one used those terms when I was covering baseball, so my uncrossable line was akin to what Supreme Court Justice Potter Stewart had observed about obscenity in 1964: I'd know sexual harassment and abuse when I experienced it, even if I didn't know what to call it.

I acted as most women did when working in these male-dominated spaces in the 1970s. I tried to act like the "boys" did so, only as a better replica. That approach wasn't my only choice but the other two were worse, as White listed our choices in newsrooms. The situation was more perilous for those of us covering sports: "She could act like a woman . . . and spend most of her time interviewing politicians' [athletes'] wives and writing cute stories about animals and children. Or she could be a bitch. Or she could be one of the boys." Like me, most women in my generation took the third route, but White cautioned us about what happens when we tried to be "one of the boys." Her words captured well my experience. "The problem . . . is that you may become one. Inevitably, there comes a moment when a male colleague will turn to you and say—as an attractive woman passes—'Look at the (euphemism of your choice) on that one.' What do you say? You could agree and say something like 'Woo woo!' You could shut up. You could object and lose your one-of-the-boys cover. Whatever you do you've got to feel slightly foolish."

Often, I'd felt humiliated after laughing at jokes the guys told at the expense of another woman. But my temporary sting was not enough to stop me from doing it again. My chameleon-like behavior was a survival mechanism in an environment where I felt I needed to behave this way to survive—and thrive.

White's column caught my eye, but the letter to the editor that Helen Moore wrote to the *Boston Globe* had grabbed my full attention. She was forty years old and single, working as a nurse, and described herself as a fighter for women's rights and a Red Sox fan. She'd written to respond to that preposterous test that sports columnist Leigh Montville had devised to determine if "the lady," which was me, knew "enough about sports to be a sportswriter."[9] He'd done this to show that only boys who grew up playing and following sports knew enough to report on the games men played. In his prelude to the quiz, Montville tried to shield himself from anticipated slings and arrows of scorn by writing, "I don't ask them [quiz questions] as some sort of a chauvinist. I am serious, and I wonder if the lady is serious."

The *Boston Globe* had published Moore's lengthy response along with a few others from readers similarly outraged by his test.[10] "You've Asked the Wrong Questions" was the headline on Moore's letter. "I have only a few questions—the real ones—that you should have asked," she wrote to open her letter. Then she settled into a rhythmic riff similar to Montville's mocking of girls for lacking sports experience, but her content was diametrically different than his.

Have you ever, as a young girl, tried to be part of sports, especially organized sports of any kind? Were you ever told, time and time and time and time again, that little girls could not and should not do what boys did? And if you persisted, did your parents give you a glove, a ball, a hockey stick, and a basketball, if you pleaded with them, all the while showering your brother with this equipment? Failing having your own equipment, were you able to borrow your brother's glove or hockey stick during the right season?

Did you ever get support from a friend's parent, only to find that the field was reserved for the boys' team only? Did you ever get a team together only to find there was no league? Did you ever feel invincible in a uniform? Of course, not. If you don't have equipment, a team, a league, and a field to play on, tell me, what use is there for a uniform? . . . Were these opportunities available to girls of your generation? I'm 40 and they weren't for me, and they weren't for my nieces, ages 18 and 19.

And didn't you know that most private golf clubs still exclude women for most of the hours between 6 A.M. and twilight. And on the public courses, have you ever listened to the remarks audible to everyone even before you've teed up on hole 1? . . . Have you noticed the disparity in money expended for girls' and boys' sports both in public schools and colleges? And the differences in salaries to their coaches?

The thrill of sport—haven't you noticed the female fans in sleeping bags waiting for Bruins, Red Sox, etc. tickets? You haven't ever listened to my mother and her love for Havlicek, Yaz, etc. You don't know about the half-season ticket to the Bruins that one of my colleague nurses delights in.

Have you noticed the relationship between encouragement and support and success on one hand and discouragement and prohibition and failure on the other? In any field?

As you said, sports is not brain surgery. In view of the continuing lack of opportunities for girls and women in sports, you've asked the wrong questions. Knowledge, interest in sports, delight in the home team, and ability are not gender related. In sports, as in most other areas, to use an example, males have been given advantages that allow them to start the 100-yard-dash on the 50-yard line. Females start from the beginning.

* * *

Soon after the 1978 World Series, the *New Yorker*'s baseball writer, Roger Angell, had called to ask if we could meet for lunch. When we did, he told me he was writing a story about women in sports media. Seated at a window table in a small restaurant on Seventh Avenue, we talked for nearly two hours. Ours wasn't a typical Q and A since we knew each other well. He knew just about as much about my experiences at ballparks as I did since we'd met soon after I'd joined SI's baseball beat. Early on, he'd tell me about he and his young son going to Shea Stadium to root for the Mets and I'd tell him about tracing my baseball passion back to my mom and the Red Sox. Working for magazines, we were often assigned adjoining seats at league championships and the World Series. At regular season games, we chose seats side by side as we'd watched the quarrelsome Yankees drive to a consecutive World Series from the press box. At many games, we were part of a friendly gang of New York and Boston writers who ate dinner together. Angell was seated next to me in the auxiliary press box when I was summoned to the main press box midway through Game 1 of the 1977 World Series. He was the perfect writer

to tell our story given his sensitivity to challenges I'd faced. I knew that his elegant, poignant writing would humanize us for those readers who needed his help to relate to our odd circumstances.

Through lunch, into dessert, and with refills of coffee, Angell and I talked. It felt like I was talking with a close friend, not an inquisitor. His many touchstones of familiarity with my baseball situation lent a verbal shorthand. I wasn't cautious with what I told him, nor was I afraid of letting my guard down. He understood me and my circumstance so well that I really had no guard to let down. I felt it crucial that he leave our lunch with as full an appreciation as possible for what I'd experienced in being the plaintiff in this case. He didn't know what it felt like to be targeted personally, so I tried to tell him. I responded forthrightly to his penetrating questions, never wondering if what I told him might reap a consequence for me later on. I'd walked through gauntlets of criticism and heard gaggles of laughter about my case and me, and I'd survived. Whatever he wanted to talk about, I was willing. After we said goodbye that afternoon, our paths crossed only once during that off-season. That was in that New Jersey Nets' locker room on the night when Phil Jackson grinned at me, then looked at Angell, and told him I was "a regular peeping Thomasina."

That winter, I had too much else on my mind to keep tabs on Angell's story. I figured the *New Yorker* would publish it around the time baseball started up again. Not long after we'd had lunch I'd started thinking seriously about finding another job. With my lawsuit over, the editors had given me no reason to think that a promotion was in the offing despite the numerous stories I'd written. My notoriety from the legal case also made me feel like this was the right time to leave sports behind me. So I contacted CBS News, where I'd tried to work when I first came to New York. I'd been rejected then, but I thought that maybe the skills honed at *Sports Illustrated* would give me a better shot at CBS News. Cronkite still anchored its evening news, and for a long while the idea of working with him had been an impossible dream.

In November 1978, I interviewed at CBS News, and in early December, I was hired. In January, my morning walk to work was lengthened by fifteen minutes since the broadcast studios for CBS News were on West Fifty-Seventh Street near the Hudson River.

I made it a point to walk by the Time & Life Building on my way north and west.

Chapter Twenty-Nine

I wasn't as sad as I thought I'd be when I left sports behind.

Harder to leave behind were the gender lessons my legal case taught me. No longer could I ignore the unequal status of men and women that I found at CBS News. It hit me hard to see men and women largely segregated by their jobs and, I suspected, by our salaries too. At lunch in the cafeteria, I'd talk with men whose work experience seemed similar to mine and discover they'd been hired as associate producers. In my pod of tiny cubicles for researchers, I was surrounded by women. After having my eyes opened at *Sports Illustrated*, I was disheartened to have landed in these gender divides. After I'd written numerous stories and columns, I'd left SI with the same job title I had when I was hired five years earlier. In the intervening years, I'd watched many men leave the bullpen when they were promoted to a writer-reporter or a writer's job. Age was on my mind too. What was okay at twenty-three didn't feel the same at twenty-nine, nor was I sanguine about starting again at the bottom of another editorial staff. To make matters worse, I'd watched what the guys did at CBS, and I knew I could do their job.

This time, I wasn't willing to stay silent. I wanted someone high up at CBS News to tell me I had growth opportunities leading to a promotion. I decided to talk to John Lane, a vice president at CBS News and senior producer of Cronkite's newscast. When I worked on that newscast, we'd interacted, but I had no reason to think he'd recognize me when I got to his office. I arrived early for our appointment and waited in his anteroom until his secretary told me to go in. I wasn't as nervous as I'd thought I might be. I knew why I was there, and I needed answers. Lane patiently listened without interrupting me, though early on he knew why I was there. But when I finished, he was frank in

reminding me that I'd interviewed for and accepted the researcher job. I'd stay in that job until I proved myself ready for a promotion. His rejoinder was reasonable, but as I left his office I knew that my time at CBS News would be short lived. I didn't quit that day, but already I was thinking of moving on.

By March, a few months into my job on Fifty-Seventh Street, I was missing my friends at *Sports Illustrated*. At CBS News, I had normal weekends, which set me apart from my SI buddies. Hanging out on our weird weekends had pulled us close. These valued friendships were slipping away at the same time that my marriage was faltering. The start of the 1979 baseball season served as a magnet emotionally tugging me back to the job I'd loved and left. When I'd walk past the reflecting pool at the Time & Life Building when I walked to and from CBS, it became more difficult to shake the feeling that I wanted to work again on that building's twentieth floor. On a Saturday in mid-March, when I knew Peter Carry had time to talk, I called him to ask if I'd be welcomed back at my old job of covering baseball. He seemed thrilled to hear of my interest and said he'd check with others who would need to be brought into a decision like this. He'd get back to me soon. A few days later, he called me with words I longed to hear—*Sports Illustrated* would be happy to have me return. In our call, we set in motion what needed to be done to make this happen. On Monday, I gave my two-week notice at CBS News, then spoke by phone with the human resources people at Time Inc.

My return was set for early April, just as the baseball season began.

* * *

Then the unthinkable happened.

Roger Angell's story "Sharing the Beat" about my legal case and women in sports media was published in the *New Yorker*.[1] His words spread across fifty pages. The issue's date was April 9, but the magazine was being sold on newsstands and sent to subscribers a week earlier, when I was gearing up for my return to *Sports Illustrated*. That's when Carry called to ask me to come to his office on Saturday at twelve thirty. He didn't say why, and I didn't ask. I had not expected to be back on the twentieth floor until I'd signed the papers that made my rehiring official. My hunch was that Carry wanted to talk about what I'd do when I got back on Thursday.

At the appointed time on April 7, I sat on the couch facing Carry's desk where I'd sat hundreds of times. I felt like I was home. But my contented feeling faded fast when Gil Rogin, SI's assistant managing editor, walked in and closed the door behind him. He slouched naturally, but he was carrying his

head so low that I couldn't see his eyes, nor did he greet me despite us being close friends. He sat as far away from me as he could at the other end of the couch and stared straight ahead as Carry opened his *New Yorker* to page 72 and read aloud sentences from Angell's story. He skipped past the part where I'd called him "the hero" for making my legal case happen, before he read my words back to me: "This crusade has worn me down. I'm a little discouraged by my own situation. I think I was a symbol for Time, Inc. More than fifty per cent of the employees there are women, and some of them filed a complaint about discrimination with the New York Division of Human Rights a few years ago. It was settled by agreement, and my suit was the most convenient way for Time, Inc. to show its support for women. But the basic workings of my magazine haven't changed much."

When Carry finished reading, neither man spoke. Nor did I. I could tell they weren't in the mood to hear about what I'd gone through as the plaintiff. And why would I tell them now since I had not confided in them when I was facing tough emotional times with this lawsuit. Nor had either man asked about my well-being during the months of disparaging news coverage when I'd performed my job well despite what was going on around me. Maybe I'd fooled them like I did my friends by plowing through those rough spots. Today's pressing concern—and the reason for our closed-door meeting—appeared to be their need to protect Time Inc. To them, what I'd said to Angell had besmirched SI and the company that owned it. This concern didn't seem all that different than Kuhn's top-line worry about upholding baseball's reputation. Now it seemed that these two company men had requested my company on Saturday so they could uphold Time Inc.'s honor and protect its reputation.

What I'd said, they found worrisome.

Seven years earlier, Time Inc.'s corporate leaders, all men, had signed the conciliation agreement—with no admission of fault on their part—to end the gender discrimination complaint filed by 146 women employees. Yet in my years at *Sports Illustrated*, it was hard to point to a lot of progress made on this front. What I'd told Angell at lunch in October still rang true to me. What I said about the "basic workings of the magazine" not having changed in any significant way would be tough to refute, which I sensed they realized. But we weren't here to discuss my word choices—such as using the word "most," as in "the *most* convenient way . . . to show its support for women." Had we talked about this, we'd likely agreed that "most" was a provocative choice of words, then moved on. But my word choice was not the issue at hand. I'd been brought here to respond to perception of my words as viewed through the lens of Time Inc.'s public relations. These two

men believed I'd crossed the line by airing my "truth" publicly, though I'd done this before I thought about leaving the magazine.

What I'd told Angell was not a bitter parting shot at the company or magazine that had supported my legal action. Nor were my words directed at these men who'd stood by me. If I'd spoken with malice in my heart or had said what I'd did to wound them, then I would have fretted about the publishing date of Angell's story, which I didn't. Before resigning at CBS News, I would have called Angell to inquire. But I hadn't done that and I was surprised when "Sharing the Beat" was published just after I told CBS News I was leaving—and before I was officially rehired at *Sports Illustrated*.

My timing could not have been worse.

I had no recollection of saying to Angell the words Carry had read back to me. But I also had no reason to believe that I hadn't said them either. Angell had recorded our conversation, so if he quoted me as saying this, then I'd said it. Besides, I believed what I'd said was true. Carry and Rogin were clearly angry at me and upset at what I'd done. But when Carry presented conditions associated with my return to *Sports Illustrated*, I was shocked.

"In any speeches you give or interviews you do about this case, you need to refer to these quotes and say you were misquoted," Carry instructed me. If I refused these terms, then the job I thought I had at SI would no longer be mine. Of course, he had the right to do this because my job was officially in limbo. Until I signed the papers with Time Inc.'s human resources people, I didn't have this job. He had me cornered. Added to the sting of his request was that it came from my close friend. We played tennis on weekends, and with his wife, Virginia, Carry had hosted a festive engagement party for Eric and me at their spacious apartment where I'd also gone to rest on the afternoon after I had my abortion. Now he was telling me I had to disavow what I said to Angell to return to a job that he knew I loved and wanted.

As an employee in waiting, I had no leverage. The verbal promise he'd made on the phone welcoming me back was superseded by his ultimatum. I agreed to his demand, or I left his office without a job. In my heart I knew my job was gone. I was not willing to say that I'd been misquoted since I wasn't. If I saved my job by doing this, *Sports Illustrated* would never be a joyful place for me to work again. How could I be collegial with people who'd forced me to do what I didn't feel they should have asked of me? I realized that it could not have been easy for them to treat me this way either, but I suspected that they feared their longtime careers at Time Inc. were on the line if they didn't. Corporate eyes were likely on them—or at least they thought they were—so they were doing their best to protect SI's reputation.

But I wouldn't do what they'd asked. I told them this, then I stood, and without saying another word, I walked past Rogin, his head still down, opened the door, and walked out, closing it behind me. I moved quickly through this corner suite of offices, then sped up as I headed down the long corridor to the elevator bank. I felt tears welling. I didn't want to run into anyone on my way out. Mercifully, the halls were empty. The elevator was empty too on my ride to the lobby. From there, I made a beeline to the building's exit, then flung my shoulder into a revolving door to hurry onto West Fiftieth Street. Once outside, I heaved pent-up sobs so loudly that they scared me. I had to get away from the building before anyone I knew saw me. I knew I couldn't speak, so I didn't want anyone to ask me to try. From Sixth Avenue, I moved in a daze walking whatever direction the lights took me using my forearm as a windshield wiper to clear the flood of tears rolling down my cheeks. Zigzagging through intersections, I tried to avoid bumping into anyone lest they stare at me as a woman in distress. I kept my head down while I replayed in my mind what had just happened.

When I got home, Eric wasn't there, I was relieved. His presence would not have comforted me. I needed to be alone. I collapsed into the soft cushions of our L-shaped couch, cocooning in its snug corner. When I felt ready to talk, I dialed the number I knew by heart calling my parents in Amherst. While dialing it, I thought I'd regained my composure, but when I heard my mom's voice, I sobbed uncontrollably. I tried to catch my breath, but I couldn't. I could tell I was scaring my mom who couldn't tell if I was injured. "Are you all right? Are you okay?" she kept asking. "Say something." When I could, I did, telling her and my dad, who was on the extension, about what happened at *Sports Illustrated*. Each comforted me in their own way. My mom soothed me with expressions of understanding and empathy that acknowledged my deep pain. My dad's comfort was always more practical; this time he advised me to look at this as offering a fresh start. "So what will you do next for work?" he asked. Did he really expect an answer? I knew this was his way of saying he'd be there to talk about this later. Their complementary responses in times of challenge weren't new and worked well at that moment. I told my dad I needed time to fortify myself, then expressed my gratitude for their heartfelt concern. What I hadn't shared with them was that while wrestling with my work decision, I'd also be grappling with my disintegrating marriage.

I'd work on the next steps, I assured them, but I had no idea how.

Too much had happened in too short of a time. First, the jolt of Kuhn's edict at the 1977 World Series, then Time Inc.'s decision to proceed with a

court case, met with the barrage of blistering media coverage. In the midst of this, I'd given my hasty yes to a marriage proposal for all the wrong reasons, then not backed down when friends warned me that I had made a wrong decision. I'd left *Sports Illustrated*—firm friendships and a job I loved—to experience a quick reckoning at CBS News before I'd tried to retreat to the workplace I knew as home. Now I'd been cast out by friends demanding that I deny my truth. My marriage cushioned me financially since Eric was now an assistant sports editor at the *New York Times*, and I was on his health insurance.

In time, I found out that my savings and freelance assignments would keep me going, as my embracing circle of dear friends stayed by my side offering advice, solace, and good times.

* * *

On my horrible walk home from SI on that Saturday afternoon, I'd passed a newsstand near Grand Central Station where the *New York Post*'s block-letter, front-page headline, "Angry Yanks Curb Locker Room Visits"[2] stared back at me. The Yankees' 1979 season was one game old, and already their owner, George Steinbrenner, was enraged. He'd threatened to throw all writers out

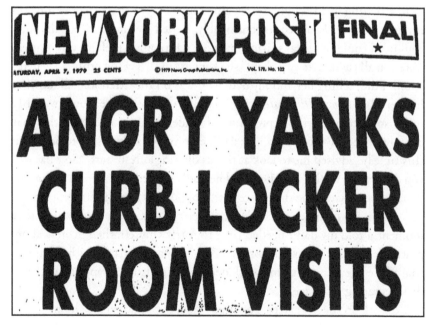

I saw this April 7, 1979, *New York Post* headline as I walked home after telling *Sports Illustrated* I would not agree to their conditions for returning to my job.

of the locker room for thirty minutes after each game, and Morabito, his PR director, was pointing the finger of blame at the "extremely poor judgment of editors at the *Post* and Channel 5 news" for pursuing what should not have been a "news story."

He was right. The tabloid hyped the locker room story to drive sales. Its editors had sent writer Maralyn Matlick to the Yankees' first game, so that she'd go into the locker room. There, the *New York Post*'s photographer shot pictures of her standing next to "partially dressed players." The *Post* ran the photo on its front page with the banner headline, "Our Gal Maralyn Catches Reggie with His Pants Down."[3] There she was standing with Jackson whose uniform pants were open at his waist. The *Post* had all but staged that photo—then played it huge in the paper—to bolster sales and draw reaction. They'd achieved both. Then, when Steinbrenner and Morabito blasted them, the *Post* shouted their anger on Saturday's front page using the subhead, "Bombers Bugged by Media Uncoverage of Coed Clubhouse." (The Yankees were called the Bronx Bombers.)

It was tabloid journalism at its best *and* worst.

Even before the *Post*'s stunt, PR directors had voiced discomfort with Kuhn's policy when asked about plans for providing equal access. In a mid-March *New York Times* story,[4] neither the Mets nor the Yankees said they'd made a "final decision on the exact procedure by which they will grant female members of the press corps equal access to locker rooms this year." Due to Judge Motley's decision, Steinbrenner stated that "we have no choice" except to treat the women equally, but he offered no specifics about how his team would do this. At the end of the 1978 season, the entire press corps had been allowed in their locker room for fifteen to twenty minutes after a game, and then all of the press corps had to leave. The Yankees mentioned three options for the 1979 season—the entire press corps was in the locker room with no time limit, or the team would keep the time limit they had the prior season, or media interviews would happen somewhere else. The team said the last was the least popular and least likely option.

In mid-March, Kuhn had sent a directive to all Major League teams to clarify the locker room situation. "You are hereby advised that previous guidelines issued by this office respecting female media personnel are hereby withdrawn," he'd written them, referring to his ban of female writers from team locker rooms. "Henceforth, each club is free to determine its own policy as regards access to be afforded female reporters."

On February 8, 1979, his lawyer had officially ended his appeal of Judge Motley's decision. That was a legal formality since Kuhn had shared his

decision with the managing editor of *Sports Illustrated* that past November. In follow-up correspondence with Climenko, Fritz had indicated that Time Inc. would look favorably on giving up "our right to attorneys' fees, as ordered by the District Court," if Kuhn withdrew "his order excluding female sports reporters from baseball clubhouses." By issuing his March 9 directive, Kuhn did this, even if he refused to urge all of his teams to provide equal access.

The *Star-Telegram News Service* relayed news of Kuhn's directive to readers with a roundup of the teams' policies:[5]

> One of the last male bastions has been invaded. Women reporters will be allowed entrance to most of major league baseball's locker rooms, according to a random survey conducted by the Associated Press. Most clubs contacted said they will allow all properly credentialed reporters into the clubhouse without any time restrictions. Several said they would open the locker rooms to everybody for a period immediately after the game, then close them to all reporters. And a few said special interview areas outside the locker room would be set up to accommodate women reporters. Only this approach would be contrary to baseball commissioner Bowie Kuhn's policy statement suggesting that clubs initiate a non-discriminatory policy and provide "identical access in one way or another to all reporters."

An Associated Press story quoted the Orioles' manager Earl Weaver—only partly tongue-in-cheek—saying that before woman were allowed into his locker room, they "should have to have a letter from their parents."[6] Meanwhile, that Orioles' general manager said that all women reporters needed were "proper press credentials" to have access to the clubhouse with no time limits. At the time, the Orioles were constructing a wall in the clubhouse several feet in front of the door from the locker room to the showers. In reading that news, I thought of how thrilled Judge Motley would be, though I doubted she would read about this wall. Again and again, she'd tried but failed to convince Climenko that changes like this could work for the ballplayers and writers. Now the Orioles were making this fix in giving female writers the equal access I'd won.

Still, issuance of a league-wide, equal access policy would have to wait for Peter Ueberroth, as Kuhn's replacement, to make equal access the rule in baseball. After a wait of six years, Ueberroth issued in 1985 a two-page directive, "Club/Media Procedures." In an accompanying letter, he singled out teams for their poor performance in not providing female writers the access they needed. Then he wrote words that Kuhn should have written in 1979: "We

now are saying that clubhouses will be open, and all accredited members of the media will be given the same access." Ueberroth also acknowledged that when teams had closed their clubhouse to *all* members of the press, even briefly, that men had blamed the women for limiting *their* access.

In writing about this policy change in the story "Baseball Adopts Open-Door Policy,"[7] the *New York Times* said teams "can't seek to contravene the intent of the order by setting equal but routinely limited access—a limitation that in the past occasionally caused men under pressure of deadlines to turn against female colleagues." This order, the *Times* said, "apparently begins to end a battle that female reporters have waged for the last decade, most notably in 1977, when Melissa Ludtke, then a staff member of *Sports Illustrated*, successfully sued Kuhn, the American League president and Mayor Beame, after she was denied admission to Yankee Stadium locker rooms during the 1977 World Series."

I felt the *Times*'s optimistic spin missed a larger mark. Even years later, Ueberroth's commendable action did not end the disrespectful treatment of women, just as our fight for equal access had not ended with Judge Motley's district court order. Ueberroth's directive could not rid baseball of the traditional attitudes that had stymied our progress for too long. Baseball had aligned its media policies with Judge Motley's decision, but the verbal and sexual harassment and the abusive treatment of women who did this job had not abated. In fact, it had intensified as women were seen increasingly as posing a real threat to the game's conventional ways. Even now, women in sports media deal with misogyny as part of their jobs as many detractors objectify them sexually, while others threaten their safety. But today these women have what I didn't—fellow female travelers who have their back, along with the solidarity of the powerful Association for Women in Sports Media, which didn't exist in my day. Today, these young women speak up and shout back, which I didn't do, perhaps because I was alone. I admire how they stand up to intimidation, though I also know that often their treatment drives women out of jobs they love doing.

Ludtke v. Kuhn pushed locker room doors open for women. I've watched with delight as tens of thousands of women walked through them, then demonstrated with their stories and broadcasts that they belong there. I've cheered the courage of women who keep on pushing against forces thwarting our progress. I marvel at these women proving their mettle as writers, broadcasters, columnists, editors, producers, and directors—each woman working in an arena that men once ruled and worked hard to be sure that women like me would not despoil.

Chapter Thirty

By the spring of 1979, I lost my professional footing, but I found my courage to speak.

Since Time Inc. had filed its complaint with the Southern District Court at the end of 1977, I'd stayed relatively quiet. I'd given a few speeches when invited to do so, appeared on TV and radio shows when my presence was requested, spoken with writers when they called to talk, and replied to letters people wrote to me. What I didn't do is put my views out for public consumption. I'd authored no op-eds nor sent a letter to any editor to respond to what a columnist or commentator had said about me or my case. At ballparks, I didn't approach writers who had sounded off against me to discuss what they said. Nobody said I couldn't do this; I just didn't. To some extent, I worried that I might inadvertently say something that could be turned against us in court or express an opinion that would be unwelcomed by my employer who was footing the bill for my legal case.

For these reasons and more, I stayed apart from the public fray as much as I could.

In Carry's office, what I worried could happen had happened. In saying what I believed to Angell, I paid the price that I'd feared I might. They'd reprimanded me, then in an instant, I was exiled. I was shaken by the experience, but in a few days I could feel my inner resolve strengthen. *Ludtke v. Kuhn* was settled law and I was no longer an employee. With my exile came my freedom, and that emboldened me to speak up after the *Post*'s front-page campaign, which I saw as an intentional act to distract from the Yankees from their obligation to demonstrate equity with their media policy. By turning the spotlight back to men's nudity, the *Post* was sexualizing my access again.

Had writers bothered to ask their female colleagues how sexual their locker room reporting experiences were, they'd have discovered that "it's so grubby and smelly that it's totally unsexual," as hockey writer Lawrie Mifflin had told Diane K. Shah in her *Newsweek* column "Locker-Room Lib."[1]

These tactics were achingly familiar. Nationally syndicated columnist Red Smith had kicked the media maelstrom off with his January 1978 witticism about ballplayers enjoying "exhibiting their manliness to some bit of fluff"— and that fluff was me. At the time, I'd said nothing but was thrilled to see *Milwaukee Journal* sportswriter Tracy Dobbs respond to Smith in her column "Taint Funny, Fella; It's a Tough Job."[2] She'd castigated his misplaced humor in mocking me and my quest for equal access. "I fail to see the humor," Dobbs began, before launching into her critique:

> Smith is not the first to be amused. Coaches have chuckled. Players have chortled. And locker room guards! I would rather go to hell than have to stand outside the gates of hell with the guards. They snicker at the naughty, naughty idea that a young woman wants to see naked men. Hee, hee.
>
> They miss the point. Those young women do not want to see naked men. They want to get a story. Going in a locker room is not the goal, the end. Going into the locker room is the means to the end. . . . It is a lot easier to see naked men than it is to get a story.

Free to be me, I no longer had to rely on women like Dobbs or men like Angell to defend the equal access I'd won. I could bring my voice into the conversation, and if I did, I wanted to reach the most influential audience I could. I called *New York Times* sports editor Le Anne Schreiber, who was that newspaper's first woman sports editor, to ask if I could write an op-ed about the locker room situation as the 1979 baseball season began. When she said yes, I worked in my home office rewriting draft after draft until my op-ed said what I wanted to say.

I faxed it to her, and she published it as I wrote it.

That Sunday morning, April 15, I bought the *Times* at our local newsstand. Propped up on pillows and sitting in the same spot on the couch where one week earlier I'd tucked myself into a sobbing ball, I opened section 5, the sports section, to its second page. There, I saw a big photo of me standing in the Fenway Park's bleachers at the 1975 American League Championship Series. Alongside it was the headline, "Locker Rooms: Equality with Integrity."[3] I knew that Schreiber wrote the headline since it conveyed a sensitivity to this issue that no other headline had done. Rarely had the words "locker

THE NEW YORK TIMES, SUNDAY, APRIL 15, 1979

Locker Rooms: Equality With Integrity

By MELISSA LUDTKE LINCOLN

Last fall, just a few days before the World Series would return to New York City, baseball's lawyers were back in court. This time their mission was to ask the three-man Court of Appeals for a stay that would prohibit female reporters from having access to the locker rooms at Yankee Stadium during the World Series games.

Such access had already been granted by Judge Constance Baker Motley, who had ruled on Sept. 27, 1978, that all reporters, regardless of sex, should have equal access to athletes, even if such access included the locker room.

In her decision, Judge Motley left up to the teams the logistics of exactly how to do this. However, she did suggest some alternatives to complete access. These included the postgame interviews, a limited amount of time in the locker room, visits by all members of the press, or closing the locker rooms to all sportswriters and broadcasters at all times.

Whatever solution was chosen, there was only one qualification. It must be equal for all reporters.

At first, the Yankees selected unlimited access, then switched to a variety of time restrictions in reaction to the chaos and attention that the ruling had brought to the clubhouse. That chaos was, however, caused not by the women who were there to report on the game, but rather by the reporters, mostly women, who flocked to the stadium to report on the female reporters.

Baseball Presents Its Case

So on that day, the opening of the World Series at Dodger Stadium, baseball was arguing before the Court of Appeals that Judge Motley's order had opened the Yankee Stadium locker rooms into a three-ring news circus and that, it was argued, equal access was not working.

Yes, the clubhouse had become a three-ring news circus. But, no, this did not mean, and does not mean now, that equal access and unrestricted visits were not working, nor could not work, in the future for all reporters.

As baseball proceeded to describe to the court the resulting chaos, one of the judges reflected on a similar circumstance that had occurred just a few years before. He said that what was happening at Yankee Stadium reminded him of what happened during the first few days that McSorley's Old Ale House in lower Manhattan had been forced by a court ruling to allow women inside.

After the newness of that situation passed and the rush of publicity seekers and nonregular patrons seemed as much a part of the restaurant as a pitcher of foamy beer.

Missing the Point

Now that a new baseball season has started, once again the public has been bombarded by newspaper accounts and television reports of the plight of women in the Yankee locker room. Again, not one reporter chose to address the issue of why women need access to the athletes to do their job. Instead, some newspapers and television stations assigned women to report on how their presence affected the ballplayers.

It is not surprising that athletes mind the silly questions posed by those reporters who do not, but rather the questions by women about baseball.

Many ballplayers have said repeatedly that if a woman is in the locker room to ask questions about the game, then she has a right to be there. What they object to, and rightfully so, are reporters who are there for the apparent reason than to do a story about themselves.

This season, like last, the Yankees' immediate reaction to the onslaught of stories by and about women who were in the locker room was to impose limitations on the press. A meeting between Yankee management and sportswriters stopped this from happening, which is fortunate.

Fortunately particularly for female reporters because when time restrictions are put into effect all writers and broadcasters suffer the same consequences in reporting a story, but it is the women among them who shoulder the blame for the inconvenience.

What this inevitably leads to is a growing resentment of the female reporters for causing this unhappiness.

Abusing a Privilege

Prior to this season, a majority of teams agreed to provide equal access to accredited female sportswriters, photographers and broadcasters. But what may happen in each of these cities is exactly what has now happened twice at Yankee Stadium. Newspapers and local television stations may be tempted to send one of their many reporters, most likely one who does not care in the least about access to any locker room and will not be reporting on the game, to determine the effect that a woman has in a baseball locker room.

This ludicrous approach will accomplish nothing. Once again, it will misrepresent the enormous value such access holds for a woman reporting on the game itself. Secondly, it is likely to result in a team, by its own irritation, adopting a policy that is restrictive to everybody. Undoubtedly the female sportswriters will be blamed for warning the access in the first place.

As clubs go about the task of deciding which policy they will use this season, it is important that whatever they decide must remain constant, whether a woman is at the game or not. If, from one night to the next, clubs are changing their policy to allow for female reporters, the sex issue will be, or whenever a woman is called up to cover a game she will become the focal point of the locker room and the determining factor in possibly making everyone's job there a bit more difficult to do. Should this happen, editors will think

twice before sending her to cover another game, which puts female reporters back right where they started.

Ever since the question of equal access to locker rooms was raised in October 1977, baseball has succeeded brilliantly in making equal access appear as a minut and not a political problem, and as sexy, but not the sexist issue that it is. I, and others like me, were presented as women who wanted nothing more than to wander aimlessly around a locker room, to stare needlessly at naked athletes and to invade the privacy of individuals whose privacy had already been disrupted for years by our male colleagues.

Nothing could be further from the truth. All I and other female sportswriters have wanted is to compete on an equal level with the men. That access to the locker room, that is not often possible.

No Problem in Other Sports

In pro basketball, pro hockey and pro soccer, female reporters have for several years had the same access to athletes as the men. Yet those sports have not been besieged by the publicity that accompanied baseball's attempt to join their ranks. The difference is that these sports did not publicly fight the right of women to gain access.

If was accomplished quietly, waged apart from national attention and was pleasantly devoid of the moralistic overtones that have been written over and over again for the last year and a half.

When the time comes that we no longer find a woman reporter in any locker room, and instead turn our attention to reading their stories and listening to their accounts of the game, then we will have reached the goal that I set out for in 1977.

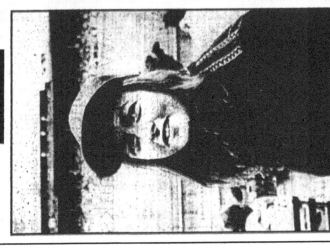

Melissa Ludtke Lincoln.

Melissa Ludtke Lincoln, a reporter for Sports Illustrated, initiated the suit against baseball's ban of women reporters from locker rooms in 1977.

In response to the locker room chaos at the start of the 1979 baseball season, I wrote this New York Times op-ed to explain why I'd fought for equal access in baseball.

room," "equality," and "integrity" been such close neighbors. Reading my op-ed felt surreal. Until then, others had spoken for me and about me, with men writing about me as invasive force, while the girls and women who wrote to me described my action as a beacon of hope. Midway into my op-ed, in a section the *Times* subtitled "Missing the Point," my voice came alive.

> Now that a new baseball season has started, once again the public has been bombarded by newspaper accounts and television reports of the plight of women in the Yankee locker room. Again, not one reporter chose to address the issue of why women need access to the athletes to do their job. Instead, some newspapers and television stations assigned women to report on how their presence affected the ballplayers.
>
> It is not surprising that athletes mind the silly questions posed by women *about* women; they do not mind the questions *by women about baseball.*
>
> Many ballplayers have said repeatedly that if a woman is in the locker room to ask questions about the game, then she has a right to be there. What they object to, and rightfully so, are female reporters who are there for no apparent reason than to do a story about themselves.

After I'd described the time limitations imposed on writers after the first night's chaos in the Yankees' locker room, I told readers how the team's response had led the men to blame the women for causing them inconvenience.

> Undoubtedly the female sportswriters will be blamed for wanting the access in the first place. As clubs go about the task of deciding which policy best suits their teams, it is important that whatever they decide must remain constant, whether a woman is at the game or not. If, from one night to the next, clubs are changing their policy to allow for female reporters, the result will be that whenever a woman is assigned to cover a game, she will become the focal point of the locker room and the determining factor in possibly making everyone's job there a bit more difficult. Should this happen, editors will think twice about sending her to cover another game, which puts female reporters back right where they started.

Toward the end of my op-ed, I told with crystalline clarity what it was like being the locker room poster girl.

Ever since the question of equal access to locker rooms was raised in October 1977, baseball has succeeded brilliantly in making equal access appear as a moral and not a political problem, and as sexy, but not the sexist issue that it is. I, and others like me, were presented as women who wanted nothing more than to wander aimlessly around a locker room, to stare endlessly at naked athletes, and to invade the privacy of individuals whose privacy had already been disrupted for years by our male colleagues.

Nothing could be further from the truth. All I and other female sportswriters want is a chance to compete on an equal level with the men. Without access to the locker room, that is not possible.

In his letter responding to my column, Gerhard J. Gattel from Elmhurst, New York quoted D. H. Lawrence: "Every woman has a tiny streak of the harlot in her." This, he wrote, applied to me and any other female who insists it is her "right (?) to interview and photograph players the way it was done in the Yankee locker room. Where do we go from here? The possibilities are endless, and I would not agree to any of them."

I'd ended my column with my wish: "When the time comes that we no longer read or hear about women in any locker room, and instead turn our attention to reading their stories and listening to their accounts of the game, then we will have reached the goal that I set out for in 1977."

It saddens me to say that this time has only partially arrived. I say this because middle schoolers, high schoolers, college students, lawyers, professors, journalists, podcasters, and TV broadcasters continue to invite my voice into discussions and debates about women in sport, women in sports media and equity. They weave my insights into their investigative pieces and stories about sexual abuse and harassment, misogyny, and verbal bullying that the women in sports media, along with female athletes, experience. I'm also asked to speak in college classes about the demeaning treatment and unfair pay involving women in sports, the success and ongoing challenges for Title IX, and the Fourteenth Amendment as the constitutional bedrock for women's rights. I participate in whatever ways I can be useful, not because I have answers to the stubbornly persistent challenges that women confront in sports but because I had an opportunity in my twenties to try to address those issues in a case that garnered international attention. With the greater wisdom I've acquired through the decades, I am pleased to join my voice with those who are encouraging girls and women to press on in our fight for positive change.

When I was the plaintiff in *Ludtke v. Kuhn*, I could not envision how this entanglement with issues of equity, access, and fair treatment would compel me to act against injustice into my seventies—and hopefully through whatever years are left to me. Little did I know that when a powerful man banned me from baseball's locker rooms he'd launched me on a path that I still walk today.

At first, I stumbled, with my marriage and my silence, but since righting myself, I no longer ask for permission to speak my truth.

Epilogue

Two years after leaving *Sports Illustrated*, I left my marriage.

After tossing clothes and my toothbrush into a suitcase, I stormed out of a union that never should have been. I'd angered Eric, as I tended to do, and when I saw him cock his arm to aim a wooden clog at me, I'd ducked. His clog missed my head by inches, but his temper frightened me. Usually when he was mad at me, I'd retreat to my workspace, shutting the door to emerge when he cooled down.

This time I needed to leave the apartment, then get out of this marriage.

For months we'd coexisted amid the shaky remnants of our decaying marriage. I'd thought of leaving before but never did. I'd married Eric for illusionary reasons, then stayed with him by paying more attention to the urgent press of other situations in my life—my legal case, a new job I didn't want, then an old one I couldn't have, and finally a medical diagnosis that had reduced my expected lifespan to months. I wasn't trying to hurt him, but I knew that my words and actions often did. He hurt me too, but I accepted that our tangled layers of constant conflict emanated mostly from me. From the get-go, I'd felt hemmed in by Eric's neediness. I chafed at his efforts to control me and I hated that he pushed my friends away. I wasn't in love with him, even if once I'd tried to be.

When I slammed the door behind me that night, I wasn't worried about hurting him, only saving me. The taxi I hailed on Second Avenue took me to stay with friends in the West Village. I'd called them from the bedroom phone

to say I was on my way, and they were not surprised. I stayed with them for a few weeks before embarking on eighteen months of what became my vagabond Manhattan life. Every few weeks I took a cab with three suitcases in hand to a new apartment to house-sit for a friend on vacation. Eric prolonged the inevitable when he refused to sign the legal separation papers that my attorney drew up. Then he didn't appear in court for our divorce hearing when the judge signed the divorce papers telling me I was free. I moved into a one-bedroom rental apartment on West Eighty-Sixth Street near Central Park West. For the first time since I'd moved to New York City a decade earlier, I lived on my own. I bicycled through Central Park to my new job as a reporter at *Time* and after work I reveled in the renewal of my cherished close friendships as I rediscovered the independence I'd craved.

With this came the stability, tranquility, and joy I'd been seeking since a shocking cancer diagnosis had forecast my early death.

* * *

At the end of April 1980, a year after I had abruptly left *Sports Illustrated*, a surgeon sliced open my belly. While I was under anesthesia, stage 4 liver cancer was diagnosed. Leading up to this surgery, I'd been in New York Hospital for nearly a month with spiking fevers alternating with teeth-chattering chills, along with my extreme weight loss and utter exhaustion. For a month before that, sweat soaked through three flannel nightgowns every night. At the hospital, a large team of doctors poked and prodded me before deciding to biopsy enlarged lymph nodes they'd found deep inside my abdomen. With two days of blood transfusions, they'd strengthened me for the surgery, warning me that I might wake up with my ovaries tied back to protect them from the radiation treatments I might need. My parents had driven to New York that morning and when they got to the hospital, Eric told them I had months to live. The doctors had based this prognosis on a pathologist's reading of the frozen tissue samples the surgeon sliced from my liver. When my surgeon received that pathology report in the operating room, he'd sewn me up without taking tissue samples from the enlarged nodes beneath my pancreas. Later, he told me, he tried to move my pancreas to get at them, but when it swelled he decided to leave it be.

I woke up with a mild case of pancreatitis and a fatal cancer diagnosis.

The shots given to lessen the pain of my ten-inch vertical cut through my abdominal muscles made my appreciation of this diagnosis a hazy abstraction. Then, two days later, as my pain eased, my surgeon came to tell me that

the pathologist's reading of the "permanent section" biopsy of my liver had introduced skepticism into his initial diagnosis. My surgeon wanted to operate again so he could biopsy my lymph nodes in the hope of reaching a definitive diagnosis. I declined his offer telling him he'd one chance and I wouldn't give him another. Instead, I set myself to the task of rebuilding my strength so I could go home. Nurses took me on a tour of the oncology ward where they expected I'd be as my illness persisted. Meanwhile, samples of my tissues were sent to pathologists at leading cancer hospitals in New York City so they could weigh in with their analyses.

The cause of my illness was never solved, nor was it ever given a name. And I did not return for cancer treatments and I never experienced anything like that horrible illness again.

My late twenties' brush with mortality did gift me with a wisdom about my life that was way beyond my years. Neither life nor health was promised to anyone; each was a precious gift to be greeted daily with gratitude and lived with purpose. My new outlook smoothed my rougher edges and slowed me down. I embraced contentment rather than expecting happiness, though if that came my way, I'd welcome it as a bonus. My temperamental shift didn't mean I was ready to abandon ambition, but I did forge healthier pathways to achieve it. I recovered with my family on Cape Cod that summer, and when I returned to New York I was still living with Eric, but I didn't think I would be much longer.

In the wake of my illness, I also received job offers. I appreciated the supportive letters sent by former colleagues at CBS News, SI, and *Time*, where I'd freelanced before getting sick. When *Time*'s managing editor, Ray Cave, asked if I'd be interested in a full-time position, I said yes. I longed for the stability of a full-time job and daily company of fellow journalists. Cave and I knew each other at *Sports Illustrated*, when he was an assistant managing editor. With his offer in hand, I went to the Time & Life Building and signed the necessary papers to be put on staff. Returning now as a reporter was fine. After the gravity of my mistaken diagnosis, to be alive and back at Time Inc. was enough. Cave had given me a new foothold in journalism and my own salary, which gave me the peace of mind I needed to deal with my turbulent life at home. Eric's salary and health insurance had sustained us through my illness, but my job at *Time* secured my own solid foundation. On it, I'd build the chapter I'd live next.

In the fall of 1983, *Time* promoted me to be a correspondent and moved me to Los Angeles to cover the 1984 Olympic Games. I'd work out of our news bureau there. At the age of thirty-two, I was single, healthy, and

content as I restarted my life on this other coast. Never again would I fact-check somebody else's story. Instead, I'd be reporting stories full time, and at times I'd write them. My first assignment—to cover the Olympic Games—lasted nearly a year as I was told to learn everything there was to know about two world champion athletes whom I'd cover at the Summer Games. One was sprinter and long jumper Carl Lewis; the other was the platform and tower diver Greg Louganis. My plum assignment—and the promotion that came with it—was rooted in my work at *Sports Illustrated*, which Cave knew well. My two athletes didn't disappoint; Louganis won two gold medals with flawless dives and Lewis won four golds, three on the track, the other in the long jump, equaling the feat of the legendary Jesse Owens at the 1936 Berlin Olympics. Reporting I sent to New York about Lewis midway through his gold-medal ran as *Time*'s cover story with my byline on it.[1] When the Olympics ended, so did my career as a sportswriter, which was fine with me. In September, editors put me on Vice-President George H. W. Bush's campaign plane. After the November election, I returned to Los Angeles, where I carved out a new beat at *Time* exploring issues affecting the lives of America's children, teens, and women.

I never looked back.

* * *

The same year that *Ludtke v. Kuhn* had burst into the news, a less heralded and remarkable change happened in women's sports. Three women invented a piece of clothing to stop their breasts from bouncing when they ran. After pain had made it impossible for them to run as fast as they could or go the distance they wanted, they'd cut pouches out of jockstraps, sewed them together, then affixed a thick elastic band along the pouches' bottom to hold their breasts firmly in place. They named it a Jockbra, a fitting name since everything about sports revolved around men, but then they changed its name to Jogbra.[2]

Sports were conflated with masculinity and women's sporting feats were filtered through the male gaze. To persuade women to exercise, sports were marketed as "a desirable path to beauty, grace, and sex appeal," as Danielle Friedman observed in her book *Let's Get Physical: How Women Discovered Exercise and Reshaped the World*.[3] The men in charge of women's sports told the "ladies" to look beautiful and act feminine. So members of the mid-twentieth century's All-American Women's Baseball League had to slide into bases wearing short skirts. Ouch! Off the field, they attended requisite makeup

and etiquette classes. Friedman concluded that "when women started exercising en masse, they were participating in something subversive: the cultivation of physical strength and autonomy, which scared men. So, when women showed up to compete in sports, the tighter their outfits are and the more of their bodies are revealed, the more men show up to watch them play."

In 1970, a *United Press International* writer told readers that "it figures to be a great day for girl watchers," in describing an exhibition soccer game between European women's teams. He added, "While none of the players is considered a rival of Gina Lollobrigida in the glamor department, most of them are certain to improve the scenery around the old stadium on Randall's Island."[4] A West Coast news story introduced "two gals' soccer teams" that were playing during the fifteen-minute halftime of a men's game. Asked about the women's brief opportunity to showcase their game, a male sports team president said their play was "hilarious," adding that "a few women can pass and dribble, but most stagger all over the field."[5]

* * *

In Manhattan, a district court judge's order had transformed sports media for women in 1978, but it would be decades before acceptance and respectful treatment of us caught up with this legal change. Sadly, instances of demeaning treatment of women covering sports *and* those who compete in sports remind us that men's attitudes about women in sports still trail behind policy. In the 1970s, men were in positions of power, so we had to fit ourselves into the way things were done, then work harder to earn respect while adhering to the men's rules to show we belonged. For women writing sports, this mindset stymied progress. In 1997, Jane Leavy, a *New York Times* best-selling author of sports biographies, most recently *The Big Fella: Babe Ruth and the World He Created*, wrote with personal insight about why it took women so long to value their own perspectives and experiences enough to carry them into their sports writing. A short-lived magazine, *Sports Illustrated Women*, published Leavy's essay with this headline: "The Phallic Fallacy: Every Men's Locker Room Is Filled with Sweaty, Hulking, Naked Guys Who Know Exactly What Women Want—or Do They?"

When I became a sportswriter in 1977, the unstated goal was to write lean, mean, macho prose. We couldn't make ourselves invisible in the locker room, so we tried to make ourselves invisible in our writing. How many times did I dare my friends to remove the byline from my stories and try to find any place

where my words sounded as if they were written by a girl? We weren't supposed to acknowledge the differences gender might produce, much less flaunt them. But the truth is, women in the locker room do see things differently—and I don't mean anatomically. We come to sports with different assumptions and experiences. We are outsiders, which is what reporters are supposed to be. The femininity we sought to hide is actually our greatest asset, our X-ray vision.

For far too long, too many men refused—as some still do—to accept or treat women as their equal in sports. For expressing an opinion, social media trolls come at women with misogynistic insults and threats. Some women writers and broadcasters have dealt with sexual harassment or abusive treatment from players, managers, or officials of teams they've been assigned to cover. Athletes have been abused by team doctors and coaches. When soccer player Megan Rapinoe called out the former United States Soccer Federation president for embarrassing "everything and everyone with caveman levels of misogyny," she was expressing the anger her fellow players felt about Carlos Cordeiro's tenure. His "caveman levels of misogyny" reminded me of the derisive words tossed my way for my audacity in wanting a fair shot to write baseball. When I look back, those men's words seem tame in comparison to the nauseating put-downs and repulsive threats made against women involved in sports today.

I never shouted back in the 1970s. Today, athletes and women in the media fire back at unjust and cruel treatment of them. I admire how smartly they do this—tweeting out sassy responses to those maligning them—and I envy their temerity, though I'm saddened to hear how this relentless firehose of insults exhausts them emotionally. "When men face online harassment and abuse, it is first and foremost designed to embarrass or shame them. When women are targeted, abuse is more likely to be gendered, sustained, sexualized and linked to off-line violence," Julie DiCaro wrote in *Sidelined: Sports, Culture, and Being a Woman in America*.[6] In the early 1990s, *Boston Herald* sportswriter Lisa Olson paid an exorbitant personal price for the "blame the victim" strategy that powerful men used against her when New England Patriots players exposed their genitals to her while a player told her, "Here's what you want. Do you want to take a bite out of this?" Team owner Victor Kiam insulted her and the fans' degrading treatment literally drove Olson out of the country. She went as far away as she could go—to Australia. Now back in the United States, she writes for *The Athletic*, and in 2021 she reported the story, "The #MeToo Movement Comes to Sports, a Reckoning Long Overdue,"[7] in which she wrote,

There's a famous line every female inevitably learns when she enters the world of sports: *Check your dignity at the door.* From a young age, girls are told to not make trouble, and if those girls yearn for a career in sports they might as well write that adage on the back of their hand. Forget your dignity, keep your head down and you'll get along fine. If you're extremely lucky you might even go an entire season without an incident that demeans or belittles you, makes you feel as if you barely exist. . . . It used to be just a whisper of harassment here, a rumor of bad behavior over there, hardly surprising considering the sports world is heavily male dominated and the power structure severely skewed. But rarely were perpetrators made public; rarely did the women who were mistreated give voice to these violations. Thanks to the whistleblowers in Hollywood, the #MeToo awakening is universal. . . . It's cultural and societal and it's coming for sports, hard and fast, where the machismo is thick and so few women are in position to bring about real change.

A lifetime ago, I had one very public, very ugly situation that has been chronicled ad nauseam. . . . The actual hurtful acts from that day don't haunt me, though the vile reverberations from the periphery linger. There were the private investigators, the victim shaming—she's a slut, she's a whore, she's a prude, she shouldn't have been there, she should've spoken up earlier—and, most awful, the fans who retaliated with actual violence. Forgiveness saved me, along with being blessedly surrounded by supportive bosses and colleagues, from Boston to Sydney, from the Bay Area to New York and many points in between.

Despite these challenges, women's prominence in sports is soaring. As Mark Whicker wrote in a January 2024 Substack "The Morning After," "The world of women's sports is not just having a moment. It is living the life that it created." TV ratings and the millions of dollars paid for broadcast rights are surging for women's sports, especially for championships, collegiate and pro. Season ticket sales for women's teams have rocketed to record levels and advertisers are getting on board to sponsor women's games and pay female athletes to advertise their products.

* * *

Baseball is where my story began, so with baseball it will end.

When I fought for equal access, girls were told to go away when they applied for entry-level jobs as "batboys." Bans of us gave way, reluctantly, to tolerance, which morphed into a decades-long phase of acceptance. But within the past few years, teams have hired women for jobs previously done only by

men. More women than ever before write about baseball and broadcast games. At their microphones in broadcast booths, those women hear in their headsets the voices of the show's female directors. Women are also leading sports columnists, and some are editors who decide what sports and games to cover. Overall, however, a lot more men do all of these jobs, even as the gender gap narrows.

A few young women even play on, or manage, or coach, pro baseball teams In 2019, the Yankees hired Rachel Balkovec to be their first female minor league hitting coach; in 2024, the Miami Marlins hired her to run player development. When the Yankees introduced Balkovec as a minor league manager, her male bosses steered clear of inquiries about her gender with talk about her unquestionable talent that led them to promote her. The mlb.com story's headline—"It's Just the Beginning for Women in Baseball"[8]—had no sexist pun on its story trumpeting the fact that ten on-field coaches with major and minor league baseball teams were women; eight had been "hired for [or promoted into] their current role in either 2021 or 2022." Not included in this number were the women whom baseball teams hired as strength and conditioning and mental health coaches. Include them, and the total number of women working directly with ballplayers almost doubled. That same week, word arrived from Down Under that Genevieve Beacom, a seventeen-year-old left-handed pitcher, was the first woman to pitch on a pro baseball team, the Melbourne Aces. After entering a game in relief, she'd pitched her way past a leadoff error followed by a walk to a scoreless inning.

That week's double infusion of estrogen into the Grand Old Game knocked *Deadspin* off its game. Known for its crude, irreverent humor toward women, *Deadspin* is not where I turn to read about women in sports. But when a female writer wrote a story about the two Bs—Balkovec and Beacom— I read it, though I had a hard time getting past one word in its headline: "The Women Are Coming *for* Baseball"[9] (my emphasis). Not "into" baseball or even "to" baseball. The editors chose "for." I might be more sensitive than most people, but this headline left me feeling like a time machine had whisked me back to the 1970s, as if I'd been "coming *for* baseball," not *into* it, as I wanted to do.

Despite such headlines, real changes are happening *for* women in baseball's front-office positions too. In November 2020, the Miami Marlins made the game's highest-level hire ever of any woman by bringing fifty-one-year-old Kim Ng in as its general manager (GM). Ng was also the first women GM of any men's team in major North American sports. Although her hire was rightly celebrated, it was also too long delayed. Had she been a man, Ng would

have been a GM years earlier based on her meritorious service as an assistant GM with several successful baseball teams. (Ng resigned her job in 2023.) In other corner suites, the Milwaukee Brewers promoted Marti Wronski to be chief operating officer (COO) near the end of 2022. A few weeks later, Caroline Perry moved into that same job with the San Diego Padres, making them the only two female COOs in the history of baseball.

These talented women paid their dues to earn the jobs they hold in baseball, while my path onto the baseball beat was serendipitous. Before working at *Sports Illustrated*, I'd never attended a baseball game as anything other than a fan., and once I was on the baseball beat I could count with my fingers the number of women writers who showed up at regular season games. When I leap ahead—to now—I hear Melanie Lynne Newman,[10] who was born on the same day I was only forty years later, doing play-by-play on Baltimore Orioles broadcasts. She worked her way up through the minor leagues calling games for six seasons. When the Orioles hired her in 2020, she followed Jenny Cavnar, whose 2018 Colorado Rockies broadcast had made her the first woman TV play-by-play announcer for a regular season Major League Baseball game and my dear friend Suzyn Waldman who has done color commentary for Yankees' radio broadcasts for two decades.[11]

To say that good changes are happening for women in baseball is not to diminish how tough this road has been for those who've walked it. Ng's decades of steadfast service in various front offices without the promotion she deserved required perseverance. The same could be said of Waldman's dogged dedication.[12] Her first Yankee broadcast on WPIX TV was in 1994 when Newman was four years old. Waldman's sports broadcasting career had started in 1987 with her doing sports updates on New York 's radio station WFAN. Her male bosses were doing what they could to force her out, but she went to her union, saved her job, then volunteered to go to nightly sporting venues and collect sound bites for the station's shows. Hers was the first female voice WFAN listeners (mostly men) heard talking sports and they voiced their strong displeasure by sending vile letters to her. In her "fan" mail, she found used condoms and toilet paper coated with feces. When Yankee's owner George Steinbrenner heard about this—and the death threats made to Waldman—he had his security people follow her car from the protected parking area at Yankee Stadium to her home. When Waldman got to the parking lot and her car was running, she knew the Yankees had received a threat against her during the game.

Since 2005, Waldman has been in the Yankees' radio broadcast booth alongside John Sterling. When the Yankees played the Philadelphia Phillies

for baseball's championship in 2009, Waldman became the first woman to broadcast a World Series game. Her microphone is in the Baseball Hall of Fame in Cooperstown, displayed near my 1978 World Series press credential and the 1977 Daily Clubhouse Admission pass that Mickey Morabito gave me before Commissioner Bowie Kuhn denied my entry and we went to court.

* * *

My baseball seasons without access, and then my fight to win it.

Waldman's persistence despite the threats, and her longevity in the broadcast booth.

Young women, with baseball careers underway, carving paths for the next generation.

Each of us stands on the strong shoulders of foremothers who punctured barriers put up to prevent our progress. Regretfully, too many women's stories of sport triumphs from times past remain untold, especially ones involving women of color. But as millions of girls and women now compete in sports, their stories are shared widely so we can celebrate their gutsy actions and grand achievements. Our curiosity sparked, we go back to find the women who acted boldly in their time to give us the stepping stones we walk on today.

When the Association for Women in Sports Media awarded me the Mary Garber Pioneer Award in 2003, I learned about Garber's remarkable career. Raised in North Carolina, she loved two things—sports and journalism, which she combined in her seven-decade sports writing career. World War II gave her the chance to fill in for a man when he enlisted. Fortunately for her, when the men returned, the man in charge of her newsroom recognized Garber's passion and ability for writing sports, which launched her lifelong career. Still, she needed help along the way. At North Carolina State games, a security guard helped her out by going into the locker room and dragging players out to talk with her. Among her dozens of awards was the prestigious Red Smith Award and her induction into the Basketball Writers Hall of Fame. Still, in my years at *Sports Illustrated*, I never heard anyone say her name.

Not every girl or woman whose sporting life we'd benefit by knowing about has an award named after her, but if you are open to learning, these stories find you. A while back this *New York Times* headline—"A Girl Wanted to Try Out for Boys' Tennis. Ginsburg Helped Make It Happen"—caught my eye.[13] Reading this story, I learned about fifteen-year-old tennis player Abbe Seldin who was told in 1972 that she could not play on the boys' tennis team at her Teaneck, New Jersey school when there was no team for girls. At

that time, Ruth Bader Ginsburg taught law at nearby Rutgers University and she agreed to represent Seldin in court . Working as cocounsel, Ginsburg filed a gender discrimination case against the New Jersey Interscholastic Athletic Association in the U.S. District Court in Newark just before Title IX became law. Ginsburg argued that the rules prohibiting girls from competing alongside boys on school teams violated the Equal Protection Clause of the Fourteenth Amendment.

New Jersey agreed that girls could try out for boys' team, so the case was dropped. Seldin joined the tennis team, but when teammates treated her poorly and the coach didn't intervene, she quit. Early in the season, the coach put the players through a brutal conditioning workout that involved crawling up a stairway while someone held their legs up in the air behind them. Seldin recalled that when she was doing the drill, the boy holding her up abruptly dropped her near the top of the stairs and she'd tumbled painfully back down on her chest.

"I ran home," she said. "I was black and blue. And I told my mom, 'I quit.' So, I never played."

Seldin derived no personal benefit from her groundbreaking case, but girls who came after her had an easier time, just as I benefited from the infrequent presence of female writers at baseball games before I got there. One by one, they chipped away at other denials of access—to the field, press box, dining room, and hotel ballroom—leaving the locker room as the remaining forbidden ground for me. Opportunities have been pried open for girls in youth sports, and after decades of competing, girls and young women have kicked a huge hole in the stubbornly held, negative attitudes about them as top athletes. Similarly, as Ginsburg went on to press cases like Seldin's, she managed to heighten the judicial standing of gender, and that transformed how the courts treat sex discrimination.

It mattered for me that she persisted.

The girls and women mentioned here stand in for so many others to whom I owe a debt of gratitude, which I hope I've repaid. Did I meet Shirley Chisholm's challenge at my 1973 college commencement, when she told us to engage in the struggles of our time for equality? I like to think I did, not only as the plaintiff in an infamous gender discrimination case but because of the life I've led after that brouhaha settled down. I've looked for ways to share as broadly and meaningfully as I can lessons I learned from my small role in our centuries-long struggles for equal rights. Whenever I can, I engage with students and mentor young women. I write op-eds and essays. I tell this story on podcasts and TV and radio and share it on social media and on

Substack, and I've written this book. I follow women's sports today, something I didn't do when I was younger. And I do my best to connect my long-ago fight for access to ongoing issues still riling women's lives and women's sports today, whether the issues involve transgender women competing in women' sports, or violations of Title IX, or harassment issues, or the misogyny that women in sports still endure.

Congresswoman Chisholm liked to say that "if they don't give you a seat at the table, bring a folding chair." Of course, I'm not the first woman who has carried a folding chair to the table. Nor will I be the last person to do what I must to have a seat at the table where others have been deciding our future. By the time Judge Motley earned her seat on the federal bench, she'd carried more than her share of folding chairs into places where she wasn't welcomed but she knew her mind and voice were needed. I doubt that she ever understood why I needed to bring my folding chair into baseball locker rooms, but maybe she saw in my fight a glimmer of the gumption she displayed when she walked into southern courtrooms. She didn't like baseball, but even she might have appreciated what happened at the July 7, 1915, Philadelphia Phillies game, when women sold thousands of tickets for what they called the "suffrage day" game. They'd hung yellow streamers and pennants in Baker Bowl Stadium that day and handed out "Votes for Women" fans to those in attendance. With men in most of the seats at most games, they thought a ballpark was a good place to change a few minds.[14]

In the suffragists' time, men went to ballgames in suit jackets with ties, fedoras on their heads, and their feet in polished shoes. The few women dotting ball crowds showed up in showy dresses and decorous hats. On another "suffrage day" at a New York ballpark, it is possible that Trixie Friganza, a vaudeville star and suffragist, was there to show her steadfast devotion to this cause. But even if she wasn't, Friganza secured her place in history by inspiring her one-time beau, Jack Norworth, to write a catchy song about the baseball-loving Katie Casey, who appears in Norworth's most popular song, "Take Me Out to the Ball Game." When he wrote this song's lyrics in 1908, he was having an affair with Friganza, and her photo appeared on the cover of its sheet music.[15]

Every baseball fan knows the chorus of "Take Me Out to the Ball Game." But very few—myself included, until I researched this for my book—has ever heard of Katie Casey. Nor do we have any idea that Norworth wrote this song about a baseball-mad girl who begged to go to a ball game. As the heroine of this song, Casey rejects her boyfriend's offer to take her to see a show by telling him she'd rather go to the ballpark to root, root, root for her team.

What if I'd known about Katie Casey when I was a girl who loved baseball? Or a woman going to ballparks to report? Would knowing about Katie Casey have made a difference? Oddly, I think it would have. To not see yourself in a place where you want to feel you belong makes it harder to keep taking to steps to get yourself inside. Or in Chisholm's way of thinking, I'd have known to bring a folding chair so I'd have had a place to sit when I got inside.

Katie Casey was baseball mad,
Had the fever and had it bad.
Just to root for the hometown crew,
Ev'ry sou
Katie blew.
On a Saturday her young beau
Called to see if she'd like to go
To see a show, but Miss Kate said "No,
I'll tell you what you can do:

Take me out to the ball game,
Take me out with the crowd;
Just buy me some peanuts and Cracker Jack,
I don't care if I never get back.
So let's root, root, root for the home team,
If they don't win, it's a shame.
For it's one, two, three strikes, you're out,
At the old ball game.

Katie Casey saw all the games,
Knew the players by their first names.
Told the umpire he was wrong,
All along,
Good and strong.
When the score was just two to two,
Katie Casey knew what to do,
Just to cheer up the boys she knew,
She made the gang sing this song:

Take me out to the ball game,
Take me out with the crowd;

Buy me some peanuts and Cracker Jack,
I don't care if I never get back.
So let's root, root, root for the home team,
If they don't win, it's a shame.
For it's one, two, three strikes, you're out,
At the old ball game.

Katie Casey reminds me of my mom.
And sounds a lot like me.

Acknowledgments

Locker Room Talk took me many more years to write than I'd thought it would. Only by pushing myself past several unsuccessful attempts at telling my story did I realize that the story I needed to tell was the one that no one else had told despite millions of words being expended about women, locker rooms, baseball, and me. In some of those rougher times, when I questioned if I could make this book work, the unwavering love, encouragement, and support of my daughter, Maya, and her fiancé, Matthew, my niece, Allison, and my sister, Betty, and her four children sustained me. Without them in my life, I don't know if this book would exist. When I faltered, they lifted me up. When I needed to step away to figure out how best to move forward again, they were with me.

With resolute trust, Danielle Bukowski, my literary agent at Sterling Lord Literistic, Inc., pulled my book and me across the finish line. Thank you, Danielle. For her steady counsel and amiable spirit, I am grateful to my former literary agent, Philippa (Flip) Brophy, who brought Danielle and me together. I am indebted to Peter Mickulas, executive editor at Rutgers University Press, for deciding to publish *Locker Room Talk* and for his insightful editorial guidance. Olga Seham, who edited my first book in the 1990s, rejoined me on this one; her masterful hints, crystal-clear notes, and splendid companionship made my numerous rewrites pleasurable. The two Janes— Jane Isay and Jane Leavy—dished out generous helpings of invaluable advice, and Lois Fiore listened patiently to me through my book's many twists and

turns, always steering me back on course. Ellen Fitzpatrick's verbal encouragement buoyed me, and the words she suggested helped me move through sticky patches. Bernice Harleston's generous research proved essential in me bringing my legal case to life.

I am grateful to Fritz Schwarz Jr., my lawyer in *Ludtke v. Kuhn*, for his careful reading of various versions of many chapters, and for him sharing his own writings with me. His comments and corrections clarified what I'd written, especially about the law, and I cherished our time together revisiting my case. However, on more than one occasion, I had to turn to his assistant, Antrina Richardson, to decipher Fritz's illegible scrawl. Then, at Cravath, Swaine & Moore, as I unearthed treasures from my case in files preserved in big boxes of archived legal documents,, Antrina's above-and-beyond assistance made my time there productive. I also want to thank Frank Barron, a lawyer at Cravath, for his quick and comprehensive responses to my questions.

I am grateful to the staff at the Schlesinger Library on the History of Women in America at the Radcliffe Institute for organizing my legal case's papers after I donated them, and for the abundant assistance they gave me when I went there to research my book. Thank you also to the Sophia Smith Collection of Women's History at Smith College for providing me with copies of the letters that Judge Motley received after she ruled in my case. I appreciate, too, the gracious assistance of Joel and Isolde Motley, the son and daughter-in-law of Judge Motley.

Former colleagues at *Sports Illustrated* filled in memory gaps whenever I turned to them for help in recounting moments and events, and for their help I am enormously grateful. From my time in SI's "bullpen" to the writing of this book, I have cherished their companionship—Stephanie Salter, Don Delliquanti, Jim Kaplan, John Papanek, Sarah Ballard, Peter Carry, and Betty and Walter Bingham. I'm also grateful to my fellow media travelers, some of whom buttressed me in the 1970s, others who boosted me through this project, and some who went the distance: Barbara Roche, Lynn Povich, Lawrie Mifflin, Lesley Visser, Robin Herman, Henry Hecht, Claire Smith, and Suzyn Waldman. And to those women and men in sports media, their names too numerous to mention here, who inform me daily with your stories, podcasts, and social media posts, thank you for helping me to appreciate what this work is like today,

Finally, a hearty, boisterous shout of thanks to my "Goldfish" crew—three women, Anupa Bir, Kathleen Turland, and Lisa Laskin, with whom I row in a quad on the Charles River. Among us, the word "sorry" is never uttered after

the many rowing mistakes we make. On we row, always with the goal of rowing a better next stroke—a valuable lesson I carry with me to the keyboard each morning. In the boat, my Goldfish crew brings out the best I can give to them. Off the water, they give me the greatest gift of all—a fiercely devoted friendship. Thank you, too, to my dear friend Risa Greendlinger for returning me to rowing—a renewal that has made all the difference in carrying me through the writing of *Locker Room Talk*.

Notes

Prologue

1 Breyer, Sotomayor, and Kagan, JJ, dissenting, Supreme Court of the United States, No. 19–1392 Thomas E. Dobbs, State Health Officer of the Mississippi Department of Health et al., Petitioners v. Jackson Women's Health Organization, et al. June 24, 2022, https://www.documentcloud.org/documents/22067295-dobbs-dissent.

2 Breyer, Sotomayor, and Kagan, JJ, dissenting, Supreme Court of the United States, No. 19–1392 Thomas E. Dobbs, State Health Officer of the Mississippi Department of Health et al., Petitioners v. Jackson Women's Health Organization, et al. June 24, 2022, https://www.documentcloud.org/documents/22067295-dobbs-dissent.

Chapter One

1 Doris O'Donnell, "Cleveland Girl Had Fun Trying to Crash Fenway Press Box," *Cleveland News*, May 22, 1957.

2 Associated Press, "Doris Denied Admission—Boston Press Box Exclusively Male," May 22, 1957.

3 Pat McManamom, "Female Journalist Doris O'Donnell Drew Ted Williams' Ire, Then His Respect," September 14, 2010, http://www.clevelandwomen.com/people/doris-0%27donnell.htm.

4 Roger Angell, "Sharing the Beat," *New Yorker*, April 9, 1979.

5 Frank True, "The Press Box: A Delicate Subject," *Sarasota Herald-Tribune*, February 17, 1973.

6 Roger Kahn, *October Men: Reggie Jackson, George Steinbrenner, Billy Martin and the Yankees' Miraculous Finish in 1978* (New York: Harcourt, 2003), 185–186.

7 Howard Cosell, "ABC Sports Magazine," Sunday, January 15, 1978 (3:15–3:30 P.M. EST).

8 Heather Hirschfeld, "Kuhn Describes Effects of Religion on Career," *Daily Princetonian*, February 16, 1987.

9 C. C. Johnson Spink, "What's Sauce for the Goose," *Sporting News*, April 1, 1978.
10 Email correspondence between the author and Kathleen A. Doyle, July 11–12, 2019.

Chapter Two

1 Red Smith, "Another View of Equality," *New York Times*, January 9, 1978.
2 Roger Angell, "Sharing the Beat," *New Yorker*, April 9, 1979.
3 Maurine Neuberger won a special election to the U.S. Senate seat left vacant by the death of her husband, Richard, in 1960, and then won the general election for that seat in 1962.
4 Constance Baker Motley, *Equal Justice under Law: An Autobiography by Constance Baker Motley* (New York: Farrar, Straus and Giroux, 1998), 222.
5 Paul Hofmann, "Mrs. Motley Inducted as Federal Judge," *New York Times*, September 10, 1966.

Chapter Three

1 In our case against Major League Baseball, a court reporter captured what was asked and answered in all of the depositions, and copies to these records were shared with the court and with each side in the case. All quotes from depositions in this case come from these records retained by Cravath, Swaine & Moore, the legal firm representing me.

Chapter Four

1 Doug Bradford, "'Hell Hath No Fury . . . Gal Throws Baseball a Curve," *Detroit News*, January 18, 1978.
2 "*60 Minutes* (CBS)," Burrelle's TV Clips, April 16, 1978.
3 "New Theory Explains Why the Dodgers Lost the World Series," *Playgirl*, May 1978.
4 Rick Hassler, "Ladies in the Locker Room?" *Artesia (New Mexico) Daily Press*, February 1, 1978.
5 "Maxwell's Plum, a 60's Symbol, Closes," *New York Times*, July 11, 1988.

Chapter Five

1 The official name of this congressional committee was the U.S. Senate Select Committee to Study Governmental Operations with Respect to Intelligence Activities.
2 Church Committee testimony of Fritz Schwarz in his exchange with Mondale at 1:06.18 in video of his testimony, November 18, 1975, https://www.c-span.org/video/?409760-1/church-committee-hearing-fbi-intelligence-activities.
3 Frederick A. O. Schwarz Jr., "An Awakening: How the Civil Rights Movement Helped Shape My Life," *New York Law School Law Review* 59, no. 1 (2014/15): 59.
4 Schwarz, "An Awakening." After reading a speech that Fritz had given to young African graduate students in the *Harvard Law Bulletin*, the American Committee on Africa, focused on fighting apartheid in South Africa, asked him to join its board, which he did.

5 Julie K. Brown, *Less Is More: Decluttering the State Action Doctrine*, Missouri Law Review 73, no. 2 (2008), https://scholarship.law.missouri.edu/mlr/vol73/iss2/8. The distinction between public and private actors, and the resulting effects on constitutional claims, is commonly known as "state action doctrine."

Chapter Six

1 "Casey Stengel Quotes," Baseball Almanac, https://www.baseball.almanac.com/quotes/quosteng.shtml.
2 Steve Jacobsen, "Writers Block a Damsel at the Plate," *Newsday*, January 29, 1973.
3 "Baseball Dinner Keeps a Tradition, Ousts Woman," *New York Times*, January 29, 1973.
4 "Gal Strikes Out at BBWAA Fete," *New York Post*, January 29, 1973.
5 Associated Press, "Dinner Bars Gal Writer," *Spokane (Washington) Daily Chronicle*, January 29, 1973, 53.
6 Associated Press, "Dinner Bars Gal Writer."
7 As part of discovery in my case, my legal team received copies of the correspondence among Salter, SI managing editor André Laguerre, Time Inc. vice president Bob Steed, and assistant managing editor Jack Tibby following her expulsion from the BBWAA gala in January. These excerpts are taken from these documents.
8 Merrill Fabry, "The Inextricable Role of Gender in the History of Fact-Checking," *Time*, April 2, 2019.

Chapter Seven

1 Gary L. Ford Jr., *Constance Baker Motley: One Woman's Fight for Civil Rights and Equal Justice under Law* (Tuscaloosa: University of Alabama Press, 2017), 52.
2 Constance Baker Motley, *Equal Justice under Law: An Autobiography* (New York: Farrar, Straus and Giroux, 1998), 223.
3 Motley, *Equal Justice under Law*, 226.
4 *Blank v. Sullivan Cromwell*, 418 F. Supp. 1 (S.D.N.Y. 1975).
5 Tomiko Brown-Nagin, "Identity Matters: The Case of Judge Constance Baker Motley," *Columbia Law Review* 117, no. 7 (2017): 1–33.
6 Brown-Nagin, "Identity Matters."
7 Motley, *Equal Justice under Law*, 45.

Chapter Eight

1 Roger Kahn, *The Boys of Summer* (New York: Harper Perennial, 1998), 185.
2 Joe Falls, "No Skirting the Issue: Keep Out, Gal Writers," *Detroit Free Press*, February 23, 1978.
3 Melissa Ludtke Papers, 1977–1997, item description, dates. 99-M58–99-M155, folder #. Schlesinger Library, Radcliffe Institute, Harvard University, https://id.lib.harvard.edu/ead/sch00045/catalog.
4 *Women's Wear Daily*, April 10, 1973.
5 Roger Angell shared with me his conversation with Shawn in a conversation we had in Maine in 2017. Also, Elon Green had spoken with Angell who told him about this exchange. Elon Green, "Annotation Tuesday! Roger Angell and the Pitcher with a Major-League Case of the Yips," *Nieman Storyboard*, March 11, 2014,

https://niemanstoryboard.org/stories/annotation-tuesday-roger-angell-and-the
-pitcher-with-a-major-league-case-of-the-yips/.
6 Melissa Ludtke Papers, 1977–1997; item description, dates. 99-M58–99-M155,
 folder #. Schlesinger Library, Radcliffe Institute, Harvard University, https://id.lib
 .harvard.edu/ead/sch00045/catalog.

Chapter Nine

1 Hala Ayoub, "The State Action Doctrine in State and Federal Courts," *Florida State
 University Law Review* 11, no. 4 (1984), https://ir.law.fsu.edu/lr/vol11/iss4/3.
2 Jessica Masulli Reyes, "Marker Unveiled for Civil Rights Icon Louis L. Redding,"
 News Journal, October 18, 2016, https://www.delawareonline.com/story/news/local
 /2016/10/18/marker-unveiled-civil-rights-icon-louis-l-redding/92348972
 /redding/92348972/.
3 Fritz discovered the commissioner's intraoffice memo through legal "discovery"
 that happens when lawyers prepare for a hearing. Major League Baseball had to
 share all of its memos and documents relevant to our case, just as Time Inc. and
 Sports Illustrated were obligated to share with Kuhn's attorney their relevant
 materials.
4 Richardson 411 U.S. 677 (1973), in which Justice Brennan stated, "Traditionally,
 such discrimination was rationalized by an attitude of 'romantic paternalism':
 which, in practical effect, put women, not on a pedestal, but in a cage. They
 reinforced not remedy, women's inferior position in the labor force."

Chapter Ten

1 Rich Ashburn, "The Naked Truth: Melissa Has a Case," *(Philadelphia) Evening
 Bulletin*, January 3, 1978.
2 Bill Schey, "Fluff in the Locker Room," *News Tribune*, January 27, 1978.
3 Chuck Roames, "'Battle of the Sexes' Invades Sports' Locker Rooms," Fort Meyers
 (Florida) *News-Press*, January 22, 1978.
4 Doug Bradford, "'Hell Hath No Fury . . . Gal Throws Baseball a Curve," *Detroit
 News*, January 18, 1978.
5 Robin Herman, "Breaking the Locker Room Barrier," *Girl in the Locker Room*
 (blog), March 26, 2012.

Chapter Eleven

1 Mark Kram, "What Do You Say to a Naked Pitcher?" (Baltimore) *News American*,
 January 28, 1979.

Chapter Twelve

1 Robin Herman wrote extensively about her career as a hockey writer in the 1970s in
 her blog *Girl in the Locker Room*, and her first experience as a woman writer
 entering a men's locker room was also much written about by others. On March 26,
 2012, she reposted a 2004 blog entry titled "Breaking the Locker Room Barrier" in
 which she recounts her experience at the All-Star Game in Montreal

(http://girlinthelockerroom.blogspot.com/2012/03/breaking-locker-room-barrier
.html). Lynn Zinger, "The First Woman through the Locker Room Door, 35 Years
Ago," *New York Times*, January 21, 2010, https://archive.nytimes.com/slapshot
.blogs.nytimes.com/2010/01/21/the-first-woman-through-the-locker-room-door-35
-years-ago; Robin Herman, "Reporter's Notebook: Equal Rights and Hockey,"
New York Times, February 9, 1975, Sports Section, 1.

2 Red Fisher, a longtime hockey writer with the *Montreal Gazette*, recounted what
happened when Robin Herman went into the Campbell Conference locker room
in a 2007 story he wrote about the Devils hiring a female color commentator.
Herman linked to his story in her November 11, 2007, blog post, "Girl in the
Radio Booth!" She wrote, "Just the other day my Google Alerts picked up this
article by Red Fisher in the *Montreal Gazette* mentioning me. Red has a long
memory, more than three decades long in fact. After all this time, I got another
point of view from that room in the Montreal Forum where the so-called 'locker
room barrier' was broken in 1975 by a lady (that's how he refers to me—thank you
Red). He describes a startled Phil Esposito." Red Fisher, "Devils Make Good
Move by Adding Female Voice of Reason as Radio Colour Commentator," *The
Gazette*, October 20, 2007.

3 Herman, "Breaking the Locker Room Barrier."

4 Robin Herman, "Reporter's Notebook: A Look at Equal Rights and Hockey,"
New York Times, February 9, 1975.

5 Sheryl Flatow, "The Unholy Locker Rooms: Women Sportswriters Invade Inner
Sanctum," *Republican and Herald* (Pottsville, PA), February 5, 1978.

6 Sheryl Flatow, "There's a Girl in Our Locker Room," *New Haven Register*, Febru-
ary 5, 1978.

7 Sheryl Flatow, "Lib in the Locker Room," *Pittsburgh Press*, February 5, 1978.

Chapter Thirteen

1 In his telephone conversation with Bob Wirz in November 1977, *New York Times*
sportswriter Leonard Koppett expressed concern that if Time Inc. filed a case on my
behalf and baseball defended itself based on gender, then Kuhn might lose. From
Wirz's contemporaneous memo, which we acquired in the discovery phase of our
hearing: "Koppett believes that if we use the point of her being excluded merely on a
sex basis that we have very shaky legal ground. His primary concern, however, was
that we have ulterior motives and might in some way use this in finding some way to
make further exclusions of the male writer in the clubhouse. I assured him we did
not have any such thing in mind. He also offered that it was his opinion we should
leave these decisions up to the players because he did not feel that a woman
journalist could have the success in overcoming the objections of a play that she
might in overcoming our male v. female stand."

2 Frank Deford, *Over Time: My Life as a Sportswriter* (New York: Grove, 2013).

3 On March 26, 2012, Herman reposted her 2004 blog entry, "Breaking the Locker
Room Barrier," in which she recounts her experience at the All-Star Game in
Montreal (http://girlinthelockerroom.blogspot.com/2012/03/breaking-locker-room
-barrier.html).

4 Tomiko Brown-Nagin, *Civil Rights Queen: Constance Baker Motley and the Struggle
for Equality* (New York: Pantheon, 2022), 83–84.

Chapter Fourteen

1 In the "Munich massacre" at the 1972 Olympic Games, eleven members of Israel's Olympic team and four Arab terrorists were killed after Arabs invaded the Olympic Village. A shootout involving German police occurred at a military airport as the Arabs were preparing to fly to Cairo with their Israeli hostages.

2 "Sunday Scroll, the Battle of the Sexes," *The Gist*, September 19, 2021.

3 Neil Amdur, "Mrs. King Defeats Riggs, 6–4, 6–3, 6–3, amid a Circus Atmosphere," *New York Times*, September 21, 1973.

4 Roy Peter Clark, "Cauliflower and the Champ," *Tampa Bay Times*, June 1, 2003.

Chapter Fifteen

1 Morabito's recollections of what happened that night come from a phone conversation with the author on March 19, 2013.

2 Leigh Montville, "But Is She Serious?" *Boston Globe*, October 1, 1978, 58.

3 Lesley Visser, *Sometimes You Have to Cross When It Says Don't Walk: A Memoir of Breaking Barriers* (Dallas: BenBella, 2017).

4 Lesley Visser, "He Asked for It, So He'll Get It—My Answer," *Boston Globe*, October 8, 1978, 90.

5 Dan Jenkins, "The Touchdown That Didn't Count," *Sports Illustrated*, November 18, 1974, pg. 28.

6 Letters to the Editor: 19th Hole: The Readers Take Over, "Twelfth Man." *Sports Illustrated*, December 2, 1978, pg. 110.

Chapter Sixteen

1 Craig F. Arcella, "Major League Baseball's Disempowered Commissioner: Judicial Ramifications of the 1994 Restructuring," *Columbia Law Review* 97, no. 8 (December 1997): 2420–2469.

2 Red Smith, "Another View of Equality," *New York Times*, January 9, 1978.

Chapter Seventeen

1 In 1961, when a ten-year-old girl named Gwen Goldman inquired about being a batgirl, the Yankees' general manager replied with these words: "While we agree with you that girls are certainly as capable as boys, and no doubt would be an attractive addition on the playing field, I am sure you can understand that in a game dominated by men a young lady such as yourself would feel out of place in a dugout."

2 Frank Trippett, "The Sensible Limits of Non-discrimination," *Time*, July 25, 1977.

Chapter Eighteen

1 Robert M. Bastress Jr., "The Less Restrictive Alternative in Constitutional Adjudication: An Analysis, a Justification, and Some Criteria," *Vanderbilt Law Review* 5, no. (1974): 972–1041, https://scholarship.law.vanderbilt.edu/cgi/viewcontent.cgi?article=3231&context=vlr.

2 Judge Owen had held his evidentiary hearing on *Forts v. Ward* in January 1978, but he did not rule in that case until November 1978, which was seven months after our

April hearing. Owen ordered that the male guards' duties be restricted, writing in his opinion that "equal job opportunity must in some measure give way to the right of privacy." However, when Judge Motley posed her question about *Forts v. Ward* to Fritz in our hearing, Judge Owen had not ruled in favor of the women's right to privacy nor restricted the scope of the men's jobs.

3 Stephanie Salter, "Kuhn Challenges Women and Time," *San Francisco Examiner*, November 7, 1977.
4 Kay Holmquist, "Distaff Reporters Jockey for Interviews," *Fort Worth Star-Telegram*, February 10, 1978.
5 Samantha Atchley, "Anita Martini: Houston's First Lady of Sports," *Texas Living*, August 2020.
6 Tim Panaccio, "Men's Locker Rooms Still Bane of Women Writers," *Houston Chronicle*, April 6, 1985.
7 "Anita Martini; Sports Journalist, 54," Associated Press, July 12, 1993.

Chapter Nineteen

1 Richard Justice, "'Best Interests of Baseball,' a Wide-Ranging Power," mlb.com, August 1, 2013, https://www.mlb.com/news/richard-justice-best-interests-of-baseball-a-wide-ranging-power-of-commissioner/c-55523182#:~:text=In%20 1921%2C%20the%20owners%20defined,exactly%20what%20it%20sounds%20like.

Chapter Twenty

1 Rich Podolsky, *You Are Looking Live! How the NFL Today Revolutionized Sports Broadcasting* (Guilford, CT: Lyons Press, 2021), 45.
2 Melissa Ludtke, "More than a Pretty Face," *Sports Illustrated TV Radio Column*, August 11, 1975. Three years later. I wrote a second TV Radio column in *Sports Illustrated* when Phyllis George left CBS Sports. Headlined, "Fancy Figures vs. Plain Facts" (July 31, 1978), I wrote about CBS's search for her successor for which I won a Front Page Award from the Newswomen's Club of New York.
3 Jane Myers, "Let Them Keep Their Pants On," *Ann Arbor News*, May 7, 1978.
4 Cravath, Swaine & Moore, the law firm that handled my case, has archived several boxes of documents from my case. I spent a lot of time reviewing those files, and I discovered there the correspondence I'd had with many girls and women who wrote to me about my case. The excerpts from their letters come from these files.
5 Virginia Savage's case is the one that Bowie Kuhn referred to in his deposition when he informed Fritz that the Yankees' owner, George Steinbrenner, had told him about a batgirl case.
6 Years later, when I showed this *Today Show* clip to my then teenaged daughter, Maya, she commented only about the puffy-sleeved blouse I'd worn. Its billowy sleeves tightened into ruffles at my wrists, so she asked me, "Mom, why did you pick that pirate shirt from *Seinfeld*?" Of course, I'd worn this blouse long before Seinfeld did his show, but I realized that she'd nailed it. I must have thought the blouse was stylish, or maybe I had not paid enough attention to my outfit when I left for the studio at four thirty that morning.
7 Diane K. Shah, "Locker-Room Lib," *Newsweek*, January 16, 1978.
8 Burrelle's TV Clips, *The* Today Show *Transcript*, January 4, 1978, 7:00–9:00 A.M. NBC Today, Jane Pauley reporting.

Chapter Twenty-One

1 "Diamond Quotes," *Nine: A Journal of Baseball History and Culture* 14, no. 2 (2006), https://muse.jhu.edu/pub/17/article/195185 N1.
2 Constance Baker Motley, *Equal Justice under Law: An Autobiography of Constance Baker Motley* (New York: Farrar, Straus and Giroux, 1998), 221.
3 *Seidenberg v. McSorley's Old Ale House, Inc.*, 317 F. Supp. 593 (S.D.N.Y. 1970), Court Listener, https://www.courtlistener.com/opinion/1415390/seidenberg-v -mcsorleysold-ale-house-inc/?
4 Burrelle's TV Clips, January 4, 1978, 7:00–9:00 A.M., NBC *The Today Show*, Jane Pauley reporting.
5 Red Smith, "Another View of Equality," *New York Times*, January 9, 1978.

Chapter Twenty-Two

1 *Fortin v. Darlington Little League, Inc. (American Div.)*, 376 F. Supp. 473 (D.R.I. 1974), Justia US Law, https://law.justia.com/cases/federal/district-courts/FSupp /376/473/1468661/.
2 Kuhn had reached out to Jack Meyers, the publisher of *Sports Illustrated*, who played no role in the magazine's editorial decisions, including which reporters are assigned to cover events. Prior to this phone call, Kuhn had met with *Sports Illustrated*'s baseball editor and in-house attorney. But in December, he appealed to its publisher, who was in charge of the business side of operations.
3 *Charles O. Finley & Co., Inc. v. Kuhn*, 569 F.2d 527 (7th Cir. 1978), Justia US Law, https://law.justia.com/cases/federal/appellate-courts/F2/569/527/35231/.

Chapter Twenty-Three

1 Howard Cosell, *ABC Sports Magazine*, Sunday, January 15, 1978 (3:15–3:30 P.M. EST).
2 Cosell's questions and my responses come from a transcription from a cassette tape recording of the show done in March 1978.

Chapter Twenty-Four

1 That subscriber wrote, "I was going to cancel my subscription to the magazine when I read about your lawsuit, but then I saw you had some pictures of women in bathing suits, and now I know that you really understand what women are here for, so I will not cancel my subscription."
2 On the *Today Show*, on January 4, 1978, Jane Pauley ended her interview with me with these words: "I would like to know, if I could ask a rhetorical question, the sex of the camera that was allowed into the locker room to take that photograph when you weren't allowed there. And I don't know if anybody can answer that question. Melissa Ludtke, thank you for being with us, and we'll be following your case."

Chapter Twenty-Five

1 "Statement by Bowie Kuhn of the *New York Times*," released by the Major League Baseball Commissioner's office, December 30, 1977.
2 Jane Gross, "Woman Sues over Locker Room Access," *Newsday*, December 30, 1977.

3 P. J. Creedon, ed., *Women, Media and Sport: Challenging Gender Values* (Thousand Oaks: Sage, 1994), 89.

4 Roger Angell, *Late Innings: A Baseball Companion by Roger Angell* (New York: Simon & Schuster, 1982), 135.

5 In his affidavit, Kuhn speculated that my own motivation for filing this case was a quest for fame: "Ms. Ludtke, previously an obscure, fledgling journalist, has appeared on numerous national radio and television shows, and both she and *Sports Illustrated* have received broad national attention in the print media." His lawyer said the same thing at the hearing, so I wasn't surprised when Wirz reprised this idea during our phone conversation.

6 From contemporaneous notes I took during our phone conversation on March 19, 2013.

7 As publisher, Meyers directed the business side of *Sports Illustrated*, and a strong firewall existed between the business and editorial functions of Time Inc.'s magazines. Kuhn was more comfortable with Meyers than he was with SI's editors or writers, but he should have known that he had nothing to do with my case and he had no power to change the course of our case.

Chapter Twenty-Six

1 The Yankees and Red Sox were tied at the end of the regular season, so they had a one-game play-off in Fenway Park to determine the American League East champion. The Yankees won.

2 *Ludtke v. Kuhn*, 461 F. Supp. 86 (S.D.N.Y. 1978), https://law.justia.com/cases /federal/district-courts/FSupp/461/86/2266331/.

3 Mike Lupica, "The Clubhouse Case: How Melissa Lincoln Became a Precedent." *San Francisco Examiner*, September 27, 1978.

4 Several decades earlier, Young had revolutionized coverage of baseball games by going into the locker room and grabbing scoops by talking with players. Before he did that, baseball writers wrote their game stories without leaving the press box.

5 Dick Young, "Men in Gals' Clubhouse?" *Daily News*, September 28, 1978.

6 Dick Young, "Young Ideas," *Daily News*, January 2, 1978.

7 "Judge: Locker Room Open to Women," *Newsday*, September 26, 1978.

8 In 1974, Kuhn had suspended Steinbrenner from baseball for two years after the Yankees' owner was convicted in federal court of making illegal political campaign contributions.

9 Transcript of *CBS News* story on my case, September 27, 1978.

10 That fall Guidry would win the Cy Young Award as the most outstanding pitcher in the American League.

Chapter Twenty-Seven

1 These excerpts come from the transcript of the October 4, 1978, hearing about a temporary restraining order, *Samantha Stevenson vs. The Philadelphia Phillies, et al.*, before U.S. district court Judge Donald W. Van Artsdalen, reported by Emery C. Tompkins, official court reporter, Room 2722, U.S. Court House, Philadelphia, Pennsylvania.

2 Jan Schaffer, "Woman Writer Barred from Phils' Clubhouse," *Philadelphia Inquirer*, October 5, 1978.

3 My legal team learned about Shenk's comments about female writers' equal access at the 1977 Major League Baseball meetings by reading recorded notes of the proceedings that baseball had to turn over to them during discovery in my legal case.

4 Maury Allen, "Women in the Locker Room? 1,000 Times No!" *New York Daily Metro*, September 28, 1978.

Chapter Twenty-Eight

1 Constance Baker Motley Papers, Sophia Smith Collection, SSC-MS-00110, Smith College Special Collections, Northampton, Massachusetts.

2 Art Buchwald, "A Male Chauvinist 'Casey at the Bat,'" *Boston Globe*, October 8, 1978. In other newspapers, including the *Los Angeles Times*, Buchwald's column appeared with the headline, "Locker Room Lib: Casey's Still Batting Zero."

3 Climenko had warned of this "grave danger" in his Notice of Appeal with the court.

4 Pat Buchanan, "Locker Room Ruling Called ERA Preview," *The Courier* (Waterloo, Iowa), October 19, 1978, 4.

5 "Anti-ERA Line Gets a Boast," *Morning News* (Wilmington, Delaware), September 27, 1978.

6 Anna Quindlen, "Reporting on the Reporters," *Women's Sports*, October 1978, 19.

7 Diane White, "Women Will Be Women," *Boston Globe*, September 30, 1978, 10.

8 In 1975, Lin Farley, a university instructor, used the term "sexual harassment" for the first time in public when she testified about treatment of women in the workplace in a hearing before the New York City Human Rights Commission.

9 Leigh Montville, "But Is She Serious?" *Boston Globe*, October 1, 1978, 58.

10 *Boston Globe*, Sports Section: Letters, October 15, 1978.

Chapter Twenty-Nine

1 Roger Angell, "Sharing the Beat," *New Yorker*, April 9, 1979, 72.

2 "Angry Yanks Curb Locker Room Visits," *New York Post*, April 7, 1979.

3 "Our Gal Maralyn Catches Reggie with His Pants Down," *New York Post*, April 6, 1979.

4 "Locker Room Policies Pondered," *New York Times*, March 19, 1979.

5 "Kuhn Lifts Ban on Locker Rooms," *Star-Telegram News Service*, March 9, 1979.

6 "Birds Prepare for Women in Clubhouse," Associated Press, March 8, 1979.

7 "Baseball Adopts Open-Door Policy," *New York Times*, March 22, 1985.

Chapter Thirty

1 Diane K. Shah, "Locker-Room Lib," *Newsweek*, January 16, 1978.

2 Tracy Dobbs, "Taint Funny, Fella; It's a Tough Job," *Milwaukee Journal*, January 10, 1978, 12.

3 Melissa Ludtke, "Locker Rooms: Equality with Integrity," *New York Times*, January 15, 1979.

Epilogue

1 Melissa Ludtke, "Carl Lewis: Man in the Eye of a Media Hurricane," *Time*, August 13, 1984.

2 David Davis, "The Mostly Untold Story of How the Sports Bra Conquered the World and Tore Its Inventors Apart," Defector, April 20, 2022.

3 Danielle Friedman, *Let's Get Physical: How Women Discovered Exercise and Reshaped the World* (New York: Putnam, 2022).

4 United Press International, "Women Soccer Teams Vie in New York Today," Summer 1970.

5 "And Now It's Women's Soccer," *San Francisco Examiner*, September 12, 1970.

6 Julie DiCaro, *Sidelined: Sports, Culture, and Being a Woman in America* (New York: Dutton, 2021), 115.

7 Lisa Olson, "The #MeToo Movement Comes to Sports, a Reckoning Long Overdue," *The Athletic*, December 21, 2017, https://theathletic.com/192516/2017/12/21/the-metoo-movement-comes-to-sports-a-reckoning-long-overdue.

8 Molly Burkhardt, "It's Just the Beginning for Women in Baseball," MLB.com, January 12, 2022, https://www.mlb.com/news/rachel-balkovec-model-for-women-in-baseball.

9 Grace McDermott, "The Women Are Coming for Baseball," Deadspin, January 13, 2022, https://deadspin.com/the-women-are-coming-for-baseball-1848355898.

10 Elyssa Kaplan, "Melanie Newman: Paving Her Path to the Majors," *Birdland Insider*, December 17, 2021, https://www.mlb.com/orioles/news/featured/melanie-newman-paving-her-path-to-the-majors.

11 Scooby Axson, "Jenny Cavnar Makes History Calling MLB Play-by-Play on TV," SI.com, April 24, 2018, https://www.si.com/mlb/2018/04/24/jenny-cavnar-calls-rockies-broadcast. Cavnar called that game twenty-five years after Gayle Gardner was the first woman to do play-by-play in a televised Major League Baseball game in which the Rockies played. Gardner did not stay in this role.

12 Laura Albanese, "Pioneering Yankees Broadcaster Suzyn Waldman Had Had to Deal with Sexism and Abuse throughout Her Career," *Newsday*, March 30, 2019, https://www.newsday.com/sports/baseball/yankees/yankees-suzyn-waldman-s11171.

13 Andrew Keh, "A Girl Wanted to Try Out for Boys' Tennis. Ginsburg Helped Make It Happen," *New York Times*, September 23, 2020.

14 Rachel Bachman, "When Women and Politics Took Over Baseball," *Wall Street Journal*, October 19, 2020. Baseball was a venue for political actions for and against suffrage. In 1915, in Boston, those who opposed women getting the vote mimicked the suffragists' strategy by distributing booklets of the city's two baseball teams' schedules with anti-suffrage arguments on them. According to a *New York Tribune* account of a New York Giants game played that same year at which suffragists went to great lengths to proclaim their cause, "a poll of the Giants showed that the baseball players were almost unanimous in their opposition to votes for women."

15 Bachman, "When Women and Politics Took Over Baseball."

Selected Bibliography

Angell, Roger. *Late Innings: A Baseball Companion by Roger Angell*. New York: Simon & Schuster, 1982.

Brown-Nagin, Tomiko. *Civil Rights Queen: Constance Baker Motley and the Struggle for Equality*. New York: Pantheon, 2022.

Creedon, P. J., ed. *Women, Media and Sport: Challenging Gender Values*. Thousand Oaks: Sage, 1994.

DiCaro, Julie. *Sidelined: Sports, Culture, and Being a Woman in America*. New York: Dutton, 2012.

Ford, Gary L. Jr. *Constance Baker Motley: One Woman's Fight for Civil Rights and Equal Justice under the Law*. Tuscaloosa: University of Alabama Press, 2017.

Kahn, Roger. *The Boys of Summer*. New York: Harper Perennial, 1998.

———. *October Men: Reggie Jackson, George Steinbrenner, Billy Martin, and the Yankees' Miraculous Finish in 1978*. New York: Harcourt, 2003.

Lannin, Joanne. *Who Let Them In? Pathbreaking Women in Sports Journalism*. Lanham, MD: Rowman & Littlefield, 2022.

MacCambridge, Michael. *The Franchise: A History of* Sports Illustrated *Magazine*. New York: Hyperion, 1997.

Motley, Constance Baker. *Equal Justice under Law: An Autobiography by Constance Baker Motley*. New York: Farrar, Straus and Giroux, 1998.

O'Donnell, Doris. *Front-Page Girl*. Kent, OH: Kent State University Press, 2006.

Podolsky, Rich. *You Are Looking Live! How the NFL Today Revolutionized Sports Broadcasting*. Guilford, CT: Lyons Press, 2021.

Povich, Lynn. *The Good Girls Revolt: How the Women of* Newsweek *Sued Their Bosses and Change the Workplace*. New York: Public Affairs, 2012.

Schiff, Louis H., and Robert M. Jarvis. *Baseball and the Law: Cases and Materials*. Durham, NC: Carolina Academic Press, 2016.

Shah, Diane K. *A Farewell to Arms, Legs & Jockstraps: A Sportswriter's Memoir*. Bloomington, IN: Red Lightning Books, 2020.

Visser, Lesley. *Sometimes You Have to Cross When It Says Don't Walk: A Memoir of Breaking Barriers*. Dallas: BenBella Books, 2017.

Collections of Papers

Constance Baker Motley Papers, Sophia Smith Collection, SSC-MS-00110, Smith College Special Collections, Northampton, Massachusetts. https://findingaids .smith.edu/repositories/2/resources/913.

Melisa Ludtke, Washington Press Club Foundation, Women in Journalism Oral History (C3958); the State Historical Society of Missouri Research Center-Columbia.

Series I. Ludtke v. Kuhn. Papers of Melissa Ludtke, 1977–1997, 99-M58–99-M155. Schlesinger Library on the History of Women in America, Radcliffe Institute. https://id.lib.harvard.edu/ead/c/sch00045c00001/catalog.

Index

Note: Page references in italics indicate illustrations. Page references with an n indicate notes.

About the Author

MELISSA LUDTKE was a reporter for *Sports Illustrated*, a correspondent for *Time*, and editor of *Nieman Reports* at Harvard University. In 1978, she won her court case, *Ludtke v. Kuhn* that gave women equal access so she could interview ballplayers alongside the male writers. Her books include *On Our Own: Unmarried Motherhood in America* and *Touching Home in China: in search of missing girlhoods*. She received the Yankee Quill Award and Mary Garber Pioneer Award and was a Nieman Fellow at Harvard University and a Prudential Fellow at Columbia University's Graduate School of Journalism.

$-3x^-$

-3×2

$x + x = 10$
$2x = \dfrac{10}{2} = 5$
$x =$

$16.$
$x - \dfrac{1}{4}x = 12$

$\dfrac{4}{4}x - \dfrac{1}{4}x = 12$

$\dfrac{3}{4}x = 12$

$10 = \dfrac{m}{3} + \dfrac{3m}{1}$

$\dfrac{m}{3} + \dfrac{9m}{3}$

$10 = \dfrac{10m}{3}$

$3 \cdot 10 = 10m$
$30 = \dfrac{10m}{10}$

$3 = m$

$x = 12, 13$

$3x = 12, 13$

$x = \dfrac{48}{3}$

$x = 16$

$\dfrac{11}{8}$